MAINE *in America*

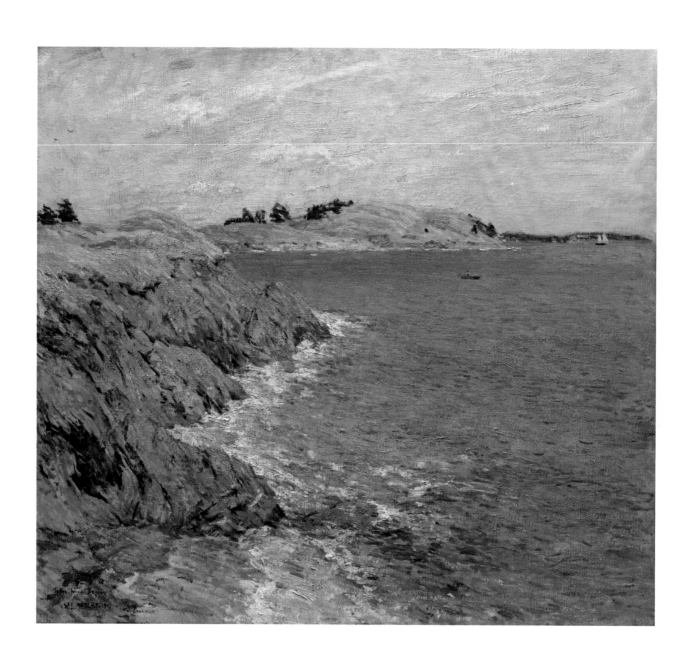

MAINE *in America*

American Art at
The Farnsworth Art Museum

BY PAMELA J. BELANGER

Foreword by Christopher B. Crosman

Essay by William H. Gerdts

THE FARNSWORTH ART MUSEUM

Distributed by University Press of New England

The research and publication of *Maine in America: American Art at The Farnsworth Art Museum* has been funded by grants from the National Endowment for the Arts, The Getty Grant Program, the Davis Family Foundation, Mr. and Mrs. Matthew R. Simmons, Craig A. Brown, and the Henry Luce Foundation.

Designer: Malcolm Grear Designers, Providence, Rhode Island
Separations: Elite Color Group, Providence, Rhode Island
Printing: Meridian Printing, East Greenwich, Rhode Island
Binding: Acme Bookbinding Company, Charlestown, Massachusetts

Clothbound ISBN 0-918749-08-5

Library of Congress Catalogue Card Number: 98-74626

Published by The Farnsworth Art Museum, Rockland, Maine

Distributed through the University Press of New England
23 South Main Street, Hanover, New Hampshire 03755-2048

All Reproductions of works of art by Melville D. McLean.
Figs. 2 and 10 by Brian Vanden Brink.

COVER: Fitz Hugh Lane, *Camden Mountains from the South Entrance to the Harbor*, 1859, (detail, no. 8)

FRONTISPIECE: Willard Leroy Metcalf, *Ebbing Tide, Version Two*, 1907, (no. 30)

Contents

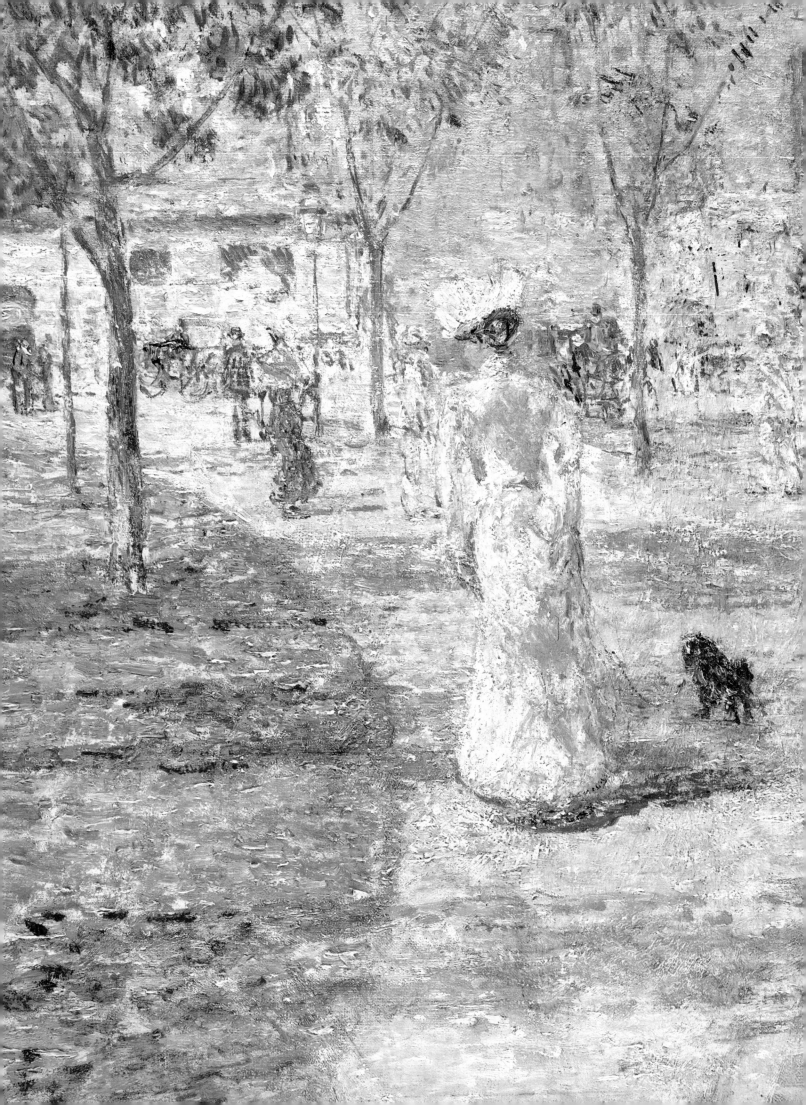

Foreword

When the Farnsworth family "daughtered out," in the vernacular of Maine, with the death of Lucy Copeland Farnsworth in 1935 at age ninety-seven, the terms of her will provided that the estate be used to create a library and gallery dedicated to the memory of her father, William A. Farnsworth. Her original intention, including preservation of the family's home on Elm Street, was somewhat altered by her trustee, the venerable Boston Safe Deposit and Trust Company (now a subsidiary of Mellon Bank). Instead of a library (Rockland already possessed an endowed Carnegie library that, at the time, was well supported by the community) the bank petitioned Maine Probate Court to be allowed to build a substantial art museum that would also include a modest library (with a non-circulating book and periodical collection focusing on Maine and world art and local history). Owing to construction delays imposed by material shortages during World War II, the museum was finished and opened to the public only in 1948. The new William A. Farnsworth Library and Art Museum was from the outset an anomaly among American art institutions, a status that continues to the present. The Farnsworth is a closely focused, regional museum with a substantial collection emphasizing Maine's role in the history and development of American art. Still relatively small and underendowed, the museum, in a rural, fishing community known as "the Lobster Capital of the World" located one and a half hours from the nearest interstate highway, is nearly unprecedented in the corpus of art museums in America.[1] Lucy Farnsworth might not have envisioned the present manifestation of her gift with its physical growth, ever-expanding collections, and energetic array of educational programs, but she surely would appreciate its idiosyncratic nature, proud independence, self-reliance, and farsighted dedication to community, qualities she herself possessed in abundance.

The original course of the Farnsworth was set by a group of remarkable advisors to the Boston Safe Deposit and Trust Company long before the museum opened to the public. During the early 1940s, Robert Bellows, who was later joined by Philip Hofer and others, began buying the initial collection. Bellows, who was primarily responsible for these early purchases, emphasized marine paintings, and works by New England artists including those living in Maine (among them Andrew Wyeth, then in his twenties) that he felt would be appropriate in the context of a small,

CHILDE HASSAM
Union Square in Spring, 1900
(detail of no. 29)

7

largely working-class, seaside community. It is likely that frugality and the relatively small scale of the original building pointed Bellows to smaller objects. Many of these early purchases of modest size include gemlike works by Eastman Johnson, Maurice Prendergast, Thomas Cole, and others. Although certain European works with nautical subject matter were purchased, Bellows focused most of his attention on American painters, and his selections featured such treasures as Maurice Prendergast's *St. Mark's Square, Venice (The Clocktower)*, with its original frame by his brother Charles Prendergast, and Winslow Homer's *A Girl in a Punt*. The original collection emphasized watercolors, and in subsequent years "the American medium," as it has been called, is an area in which there has been a conscious attempt to broaden our scope beyond Maine and to build something like an encyclopedic collection of works by artists throughout the country.

It is interesting to note that at a time when even the best-known American artists from the nineteenth and twentieth centuries were considered secondary to European masters and thus undervalued, Bellows's original collecting impulses were far in advance of scholarly interest and, not incidentally, the marketplace. Those who came after Bellows added judiciously to the collection, and under its early directors, James Brown, Wendell Hadlock, and Marius Peladeau, the Farnsworth continued to acquire, mostly through gift, significant examples by Maine and American artists: Fitz Hugh Lane, Eastman Johnson, William Harnett, Frank Benson, Louise Nevelson, and others. The museum also sought to acquire multiple examples of work by selected artists, especially those with ties to Maine. Several smaller collections exist within the larger. The entire life's work of the early-nineteenth-century pastor from Blue Hill, Maine, Jonathan Fisher—from allegorical paintings to botanical studies of local flora—was acquired in 1965. Among the museum's most comprehensive holdings are paintings, drawings, collages, jewelry, theater sets, prints, and sculpture by Louise Nevelson, spanning her entire career. These works were donated by the artist and her family over several years beginning in 1955 (undoubtedly the first works by Nevelson to be acquired by an American museum).

Gifts from individuals have always been the museum's lifeblood and continue to provide breadth and depth to the collection. In recent years, the gifts and bequest

of Elizabeth Bottomley Noyce greatly bolstered the collection with important works by Fitz Hugh Lane, George Bellows, Frank Benson, John Marin, and Edward Hopper, among many others. Indeed the Noyce collection, which she divided largely between the Farnsworth and Portland museums, built on strengths and filled gaps in both institutions.[2] In our case, the Noyce gifts caused us to reassess and expand the scope of this publication.

In the early 1990s the Farnsworth embarked on a modest program to upgrade its existing facilities, mostly to provide additional exhibition space for its growing collection. During the original expansion the gift of the Olson House from Mr. and Mrs. John Sculley spurred us to consider further expanding our physical plant to include a permanent home for Maine-related works of art by N. C., Andrew, and Jamie Wyeth, already a central part of the collection. With enthusiastic support from the Wyeth family and major support from MBNA America and other major donors such as Charles Cawley, Linda Bean Folkers, Mary Louise Cowan, the Dillon family, and many others, including the entire board of directors, it became possible to consider a new Center for the Wyeth Family in Maine. To create this "museum within the museum" the Farnsworth built a new research and study center wing focused on the Wyeths in Maine and new exhibit galleries in a nineteenth-century church building that now features a continuous rotating display of works by all three generations of Wyeths. Seeking to balance and provide greater context for the Wyeth collection, the museum is currently engaged in another expansion, to provide additional exhibit space for the collection and changing exhibitions featuring Maine artists, past and present. This new facility, appropriately facing Rockland's Main Street, will open in June 2000, thereby completing a "master plan" that no one really envisioned in its "campus" configuration but one that now seems inevitable and right.

This first, scholarly catalogue of the collection coincides with and provides the rationale for the museum's rapid growth. It is the culmination of extensive research over the past seven years. Initiated by our Curator of Contemporary Art, Suzette Lane McAvoy, who obtained early seed money from the National Endowment for the Arts, the catalogue is the child of our Curator of 19th and Early 20th Century Art, Pamela J. Belanger, who was brought on staff to coordinate and provide the first in-depth

research into the permanent collection, culminating in this publication. Despite the existence of detailed log books, handwritten by Robert Bellows and recording every work originally acquired (including prices paid), little in the way of information about our collection existed. Indeed, the collection had never been cataloged. The task of conducting primary research on the collection fell to Ms. Belanger. Her seven years of labor show a profound depth of scholarship and commitment to the Farnsworth collection. Along with Pamela Belanger, I especially thank William H. Gerdts for his early support and belief in smaller, regional museums, and other contributing scholars who provided insightful essays for various works in the collection. This project has required the support of many. The Farnsworth staff and board of directors would like to express their heartfelt gratitude to the National Endowment for the Arts, the Getty Grant Program, the Davis Family Foundation, Mr. and Mrs. Matthew Simmons and the Otter Island Foundation, Mr. Craig A. Brown, and the Henry Luce Foundation.

Clearly, an undertaking of this magnitude for a small museum with limited resources is an act of faith—faith in the important role that small museums have in the history of American culture as a whole and faith in the art we research, interpret, exhibit, care for, and make accessible for an ever-widening and appreciative audience. Like the sudden, short Maine summer, the Farnsworth Museum is an unexpected and welcome joy, and through this publication one that we hope will last in memory and imagination.

CHRISTOPHER B. CROSMAN
Director

Acknowledgments

The production of *Maine in America: American Art at the Farnsworth Art Museum* has spanned nearly seven years, and its successful completion is due to museum director Christopher B. Crosman, as well as the museum trustees, and their unstinting support and encouragement.

I would like to thank the National Endowment for the Arts for the generous grant awarded in 1992, which initially supported and indeed allowed the museum to begin the first thorough and systematic research of the Farnsworth Art Museum collection of American paintings and watercolors. My appreciation also to the Davis Family Foundation and the Getty Grant Program grants received in 1992 and 1994 respectively, for additional support during the research phase of the project. I would also like to express my deep gratitude to the Henry Luce Foundation, for the 1997 award through its American Collections Enhancement initiative, in support of our 50th Anniversary Permanent Collection Celebration and the publication of *Maine in America*. I am most grateful to Ellen Holtzman for her kind encouragement. Thanks also to Mr. and Mrs. Matthew R. Simmons and Craig A. Brown for their support of the project.

The magnitude of this project led me to institutions and scholars throughout the country. Rockland is remote from any major art library and I have relied heavily on major sources throughout this project. The first of these is the Smithsonian Institution's Archives of American Art Depository for Unrestricted Microfilmed Collections. The second is the Maine State Library and especially the Interlibrary Loan Department, which helped provide a vast number of publications to the museum during the course of the research project.

Much of the information in the following entries depended on the effort and support of scholars, curators, researchers, registrars, librarians, archivists, dealers, collectors, artists, and the families of artists. I cannot list all these individuals, but it is with deep gratitude that I acknowledge their generous contributions. I would, however, like especially to thank William H. Gerdts for his guidance during the early shaping of the project and his introductory essay. Also, I would like to thank Suzette Lane McAvoy for her contributions to the early development of the "History of the Collection." Additionally, I appreciate the assistance from the following: Henry Adams,

Fred B. Adelson, Nancy Anderson, Diane Apostolos-Cappadona, Jean Baxter, David Bjelajac, Doreen Bolger, Jeffrey R. Brown, Kathleen M. Burnside, Sarah Cash, Donna M. Cassidy, Susan Danly, Marianne Doezema, Tracy Felker, Abigail Booth Gerdts, Patricia Hills, Erica E. Hirshler, Donelson Hoopes, Franklin Kelly, Joni Kinsey, Karol Lawson, David M. Lubin, Maura Lyons, Michael Marlais, Lynn Marsden-Atlass, Suzette Lane McAvoy, Gwendolyn Owens, Ellwood C. Parry III, Lisa Peters, Michael Quick, Gail Scott, J. Gray Sweeney, Alan Wallach, John Wilmerding, and Lesley Wright.

A project of this kind makes demands on many individuals, and I would like to thank all members of the museum staff for their continued interest and enthusiasm for this collection catalogue. Several interns and very talented museum volunteers assisted with components of catalogue research over the years, I want especially to thank Janet Hartman, Catherine Hilyard, Betsy Kate Jewell, Billie MacGregor, Molly Mulhern, Rachel Owen-Williams, and Deborah Wheelock.

Special thanks to Fronia W. Simpson who thoughtfully edited and refined this manuscript, and Dawn Hall, who tirelessly prepared the manuscript for design. Also, to photographer, Melville D. McLean, and Malcolm Grear Designers who produced a very handsome book. To all these individuals and institutions my earnest thanks. Without their consistent support, thoughtful sharing, and long-standing patience, this major project would not have been completed in this happy way—with the publication of *Maine in America*.

PAMELA J. BELANGER
Curator of 19th and Early 20th Century American Art

NOTES TO THE READER

This catalogue lists objects of American art that entered the Farnsworth Art Museum from its inception to 1 June 1998. Oil paintings and watercolors are included, and selected works on paper and sculpture. The most important works are organized thematically and loosely chronologically and treated with an essay, full-color illustration, and extended object data. A secondary section includes an alphabetical listing of a selection of artists and works, accompanied by artists' biographies (unless already treated in full essay) and object data. All other artists in the catalogue are listed only in the index.

Artists: The artist's name is listed in full in the heading, in essays by the name by which the artist is commonly known.

Titles: Each work is listed under the title the artist gave it or the title under which it was first exhibited or published. In the few instances when a popular title exists for a painting, it follows the original title in parentheses.

Media and Supports: This catalogue defines paintings as works in oil, tempera, or watercolor done on canvas, paper, or panel. Descriptions of supports exclude backings and linings added by conservators.

Measurements: Dimensions of the support are given in inches. Height precedes width precedes depth.

Signatures, Dates, and Inscriptions: Artists' signatures, dates, and inscriptions, where available, are given, along with their locations on the supports. A firm date or an approximate date based on documentary and stylistic evidence and listed as "circa" (c.) is sometimes supplied when a work was not inscribed with a date by the artist.

Provenance: The names of previous owners of a work are listed from the earliest known to the last, along with their places of residence and the years they are known to have had possession of the painting, when this information is available. If no other information about provenance is known beyond the donor or vendor to the museum, the provenance line is dropped.

Exhibitions: Listings of exhibitions in which works have appeared are selective. All verifiable exhibitions, including those before a work's acquisition by the museum, are given in chronological order. The listings exclude, however, all display other than conventional art exhibitions: loans to private borrowers or residences, for example, do not appear. The name of the institution, gallery, or exhibition hall appears first, followed by the city where the exhibition took place—unless it is obvious from the venue's name—then the title of the exhibition, dates of the show, and finally the catalogue number, if known.

References: Listed are publications in which works have been discussed and/or illustrated. All verifiable publications, including those before the work's acquisition by the museum, are given in chronological order.

Credit Line: The Farnsworth Art Museum official credit line notes the donor/donors who made a gift or bequest of the work, or the fund or funds that allowed the museum to purchase the work. The year of acquisition and the work's accession number follow.

Contributing Authors: The initials of the author are given at the end of each essay:

P.J.B.	Pamela J. Belanger	D.H.	Donelson Hoopes
J.B.	Jean Baxter	D.M.L.	David M. Lubin
S.C.	Sarah Cash	M.L.	Maura Lyons
D.M.C.	Donna M. Cassidy	M.M.	Michael Marlais
C.B.C.	Christopher B. Crosman	L.M.A.	Lynn Marsden-Atlas
S.D.	Susan Danly	S.L.M.	Suzette Lane McAvoy
M.D.	Marianne Doezema	G.O.	Gwendolyn Owens
H.A.F.	Helen Ashton Fisher	G.S.	Gail Scott
A.B.G.	Abigail Booth Gerdts	J.G.S.	J. Gray Sweeney

History of the Collection

PAMELA J. BELANGER

American art with a strong emphasis on art related to Maine has been the focus of the Farnsworth Art Museum collection since its founding in the 1940s. This collecting mission became stated museum policy in 1962 when the director at the time, Wendell S. Hadlock, announced, "Our primary purpose should now be to collect and exhibit the best that has been produced in Maine."[1] Through a series of astute acquisitions by the four directors who have administered the Farnsworth Museum, this institution has grown to become a major presence in the cultural life of Maine. The history of the museum and its succession of directors and their acquisitions is also a story of Maine and its rich artistic legacy.

Unlike most art museums, the Farnsworth was not created with the help of collector-patrons and a core collection. Rather, Lucy Copeland Farnsworth, the last in the line of a prominent Rockland, Maine, family, who died in 1935 at the age of ninety-seven, endowed the museum. Her estate of $1.3 million was set aside for the establishment of a local art museum and library in memory of her father, William A. Farnsworth.[2] Her action was particularly remarkable because during her lifetime no one could recall that she had ever shown any special interest in art or culture. The walls of the Farnsworths' Greek Revival home (1849–50) were decorated with handsomely framed chromolithographs, family portraits, and needlework pictures, but there were no works of art to form the core of a museum collection. As part of her bequest, Miss Farnsworth stipulated that the Homestead be preserved intact and opened to the public on a regular basis (figs. 1, 2). The house's chaste white exterior belies the elaborate furnishings of its interior, with its perfectly preserved high-Victorian furnishings and the household objects of the Farnsworth family lending a sense of recent occupancy. In 1972 the Homestead was placed on the National Register of Historic Places.

Lucy Farnsworth left the task of forming and maintaining the museum and library to her sole executor and trustee, the Boston Safe Deposit and Trust Company. Challenged with carrying out the directives of her will, in 1941 the bank engaged as its consultant Robert Peabody Bellows (1877–1957), a partner in the Boston architectural firm of Aldrich and Bellows. At the time, Bellows was serving as chairman of the Boston Art Commission and as a trustee of the Boston Athenaeum.

MAURICE PRENDERGAST
St. Mark's Square, Venice, 1898–99
(detail of no. 31)

Bellows's involvement was to prove a fortuitous one for the proposed art institution. His interest in art had been sparked during the five years he spent in Paris studying at the Ecole des Beaux-Arts following his graduation from Harvard in 1899. "A lively appreciation of beautiful things has led me to almost every picture gallery at home and abroad," he wrote in his Harvard class notes in 1939.[3] He was also a practicing watercolorist and had served as an architectural adviser to the restoration of Colonial Williamsburg. His interest in cultural history was also manifested in his role as one of the architects of the New England exhibit at the 1939 New York World's Fair.

With his experience as a professional architect, his familiarity with exhibit design, and his broad appreciation of art, Bellows was especially well suited to be an adviser to the newly conceived museum. Under the auspices of the bank, he visited art museums throughout the country in 1941 and 1943, gathering impressions and information for the yet-to-be-built Farnsworth Museum. His written accounts of these trips reveal that he was particularly interested in seeing examples of "up-to-the-minute 'fluorescent' lighting," publicly accessible art reference libraries, and children's studio classrooms, all ideas later incorporated into the museum building.[4]

The shortage of building materials imposed by World War II caused unforeseen delays in the construction of the Farnsworth Museum, and it was not until 15 August 1948 that the museum officially opened to the public. The handsome red brick Colonial Revival building was designed by Wadsworth, Boston and Tuttle of Portland, Maine. Its interior plan features flanking symmetrical wings, punctuated by a graceful, sweeping staircase, which provides access to the building's three levels. On the main floor, large exhibition galleries are to the north and east; to the south is an elegant paneled library. A highlight of the library is the beautifully carved white marble fireplace surround, originally designed for the robing room of the Supreme Court chambers in the U.S. Capitol. Variously attributed to Charles Bulfinch or Benjamin Henry Latrobe, the surround was acquired by Robert Bellows from the widow of Justice Horace Gray.[5]

Throughout the seven years the building was being planned and constructed, Bellows was engaged with the daunting task of forming the museum's collection.[6] His early thoughts were to assemble a broad survey of the world's arts, but with a special emphasis on American art. In a preliminary report written in 1941, he describes the "Museum Aims" as

> *Largely American, perhaps, but with some notice of the great arts of Egypt, Greece, Rome, the Middle Ages, the Renaissance, the Low Countries, France, England and today. I would also advocate the recognition of Oriental art, . . . as well as that of early Central America. A few fine examples of each might be sufficient for the time being.*[7]

To his credit, Bellows did not undertake the formation of the museum collection solely on his own. Following the example of the Addison Gallery at Andover, Massachusetts, he suggested that an advisory committee be formed. "Besides giving advice and counsel on matters of art has the power delegated to it from the trustees to pass on all art matters, such as the acceptance or rejection of a picture."[8]

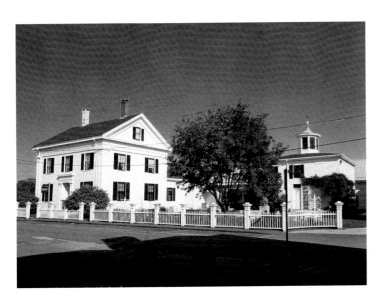

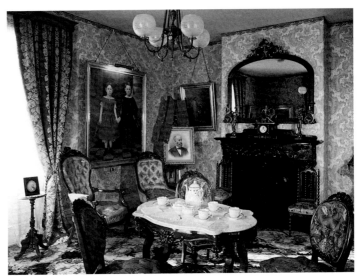

figure 1
The Farnsworth Homestead, 1849-50, photograph, 1999

figure 2
The Formal Parlor, The Farnsworth Homestead, 1849-50,
photograph, 1985

In 1942 a committee of experts was assembled, composed of Philip Hofer, the
founder of the department of printing and graphic arts at Harvard's Houghton
Library; Merle James, an established watercolorist and father-in-law of the rising
young artist Andrew Wyeth; and Stephen Wheatland, "a distinguished business man
with excellent taste."[9] The three advisers were all longtime summer residents of the
Rockland area and were instrumental in recognizing the value of giving the collection
a Maine focus. Hofer recalled in 1982:

> We three advisers were not paid, but were honored to take a friendly and often
> active interest in so worthwhile an enterprise. Robert Bellows had had active
> experience in Boston, we three advisers were more familiar with the Maine art
> scene, in particular the Penobscot Bay area.[10]

As a noted collector and professional curator, Hofer played a critical role in
guiding the formation of the Farnsworth collection. "He had an eye for buying that
which no one else had, works that were not popular at the time," wrote his Harvard
colleague Konrad Oberhauer in 1984 in tribute to Hofer's keen professional exper-
tise.[11] As was his own practice, Hofer advised Bellows to think of the Farnsworth col-
lection in "'long-range' terms":

> You are making a mistake in not formulating a carefully defined purchasing
> policy for the Museum. . . . Posterity and the art world judge shrewdly and
> often harshly. Can the Museum enter the very competitive field of art purchas-
> ing without the most careful planning if it is to have a first rate reputation?[12]

Hofer's insistence on establishing collecting guidelines did influence Bellows's initial
enthusiasm for a survey collection. Following Hofer's advice, the early purchases
reflect a strong commitment to work appropriate to an institution in Maine: marines,

figure 3

Entry for *American Farmer* by Eastman Johnson, Museum Register, Farnsworth Art Museum Archives

EXHIBITION OF
SOME EARLY 19th CENTURY
AMERICANS

March 12—31, 1945

MACBETH GALLERY
11 East 57th Street, New York 22, N.Y.

figure 4

MacBeth Gallery, "Exhibition of Some Early 19th Century Americans," 1945, Museum Register, Farnsworth Art Museum Archives

American landscapes, American prints and watercolors, and a diverse body of works related to Maine themes.

Bellows carefully documented his acquisitions for the museum in a series of five notebooks that span the period 30 June 1943 to 1 July 1948. These notebooks, titled "Farnsworth Gallery Book of Possessions," provide an invaluable record of the origins of the core collection. In them, Bellows kept handwritten accounts of the 915 objects he acquired in these five years.[13] Along with the purchase price and source of each item, Bellows often included detailed comments regarding provenance, framing and condition, as well as photographs, exhibition checklists, letters from scholars and curators, and other related documentation.

For example, the entry for Eastman Johnson's *American Farmer* (figs. 3, 4, 5; no. 18a) includes basic object data such as purchase price, title, and date, as well as a copy of the exhibition brochure from Macbeth Gallery. From this record we learn the context in which *American Farmer* was exhibited in 1945: it was shown with works by Albert Bierstadt, Jasper Cropsey, Asher B. Durand, John Kensett, and Worthington Whittredge. Bellows also included a brief critical review of the Macbeth show from the *New York Times* (fig. 6). It reveals the contemporary interest in mid- and late-nineteenth-century American painting, and it singles out *American Farmer*:

> *A score of American landscape paintings of the middle fifty years of the 19th century have been assembled at Macbeth's. Examples by Cropsey, Birch, Durand, Whittredge and Kensett especially serve notice that we may well reappraise the quality of much of this work and that much of it may return to favor, as in fact, there are many signs at present. The small Eastman Johnson figure piece compares favorably with some of Homer's similar subjects. A look backwards may lead to a step forward and as such this is a provocative show.*[14]

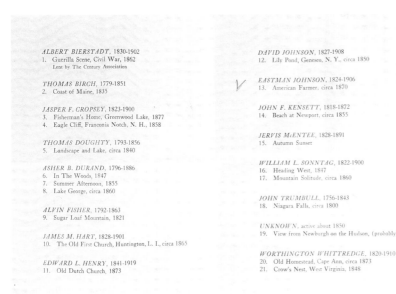

figure 5

No. 13, MacBeth Gallery, "Exhibition of Some Early 19th Century Americans," 1945, Museum Register, Farnsworth Art Museum Archives

figure 6

"Then and Now," *New York Times*, 18 March 1945, Museum Register, Farnsworth Art Museum Archives

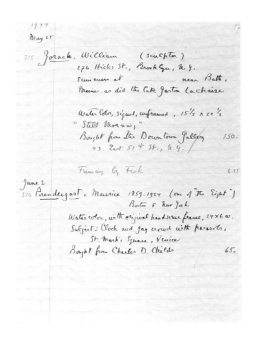

figure 7

Entry for *St. Mark's Square, Venice* by Maurice Prendergast, Museum Register, Farnsworth Art Museum Archives

A number of the early acquisitions were testaments to Bellows's eclectic tastes and obvious love of acquisition at a good price. As Hofer recalled, Bellows sometimes needed "to be restrained from purchasing too hurriedly the works of art he discovered and considered great bargains!"[15] While several references in letters and primary sources document Bellows's zeal for bargains, in retrospect it is clear that most of his purchases were astute as well. The most impressive example is his acquisition of the Maurice Prendergast watercolor *St. Mark's Square, Venice (The Clocktower)*, (fig. 7; no. 31) in its original Charles Prendergast frame from Childs Gallery in Boston, for only sixty-five dollars—certainly, one of the museum's most important and treasured works.

In a descriptive account of one of his buying trips, which he humorously titled *Three Days in New York Picture Shops: or Watson and the Shark*, Bellows acerbically notes that "the red and ready check book induces discounts." At Kennedy & Co. he bought eighteen items including "4 early wash drawings of the Maine sea-coast . . . and 3 good water colors of Maine scenes along the shore . . .—$750. A more than 10% discount from marked prices." At Babcock Galleries he "succumbed to two very well framed 'Prendergasty' little watercolors by George Luks to the sum of $250, for the pair, knocking them down from $275."[16]

Regrettably on this same trip, Bellows found the prices at Brandt Gallery too steep for his tastes. "I came to get a line on Marin prices and to know more about Marsden Hartley, a Maine painter who recently died and is 'en vogue,'" he writes. "A little tinted sketch by Marin called *The Cliffs* for $1500. . . . A 30 inch square oil of brilliantly colored fish called *The Migration*, by Hartley, $500." As a buyer by price these opportunities were missed because the prices struck him as too high. Bellows wrote, "It all seems a little too South Seas Bubbly. We too can hope to find some good ones before they become too famous and expensive."[17]

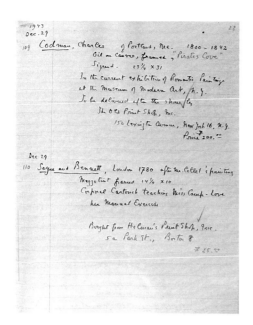

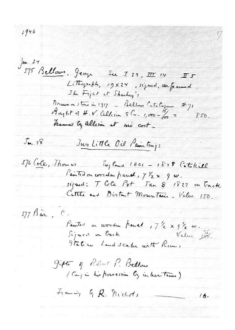

figure 8

Entry for *Pirate's Retreat* by Charles Codman, Museum Register, Farnsworth Art Museum Archives

figure 9

Entry for *Cattle and Distant Mountain* by Thomas Cole, Museum Register, Farnsworth Art Museum Archives

In January 1944 Bellows's hope to find "good ones before they became too famous" was realized when he purchased four works by a then little-known twenty-seven-year-old artist named Andrew Wyeth from Macbeth Gallery. He selected the watercolors *Clam Flats, Clouds and Shadows, Road to Friendship* (no. 199), and a preliminary drawing for the latter which was purchased by Hofer, in Maine, from an exhibition at Colby College.[18] Later that year Bellows purchased two more watercolors from the Wyeth exhibition at Doll and Richards, in Boston—*Off Teel's Island* and *White Dory*. This exhibition also included the tempera *Turkey Pond* (no. 65), which entered the museum collection more recently, in 1995.[19]

Bellows frequented other leading Boston galleries as well as Doll and Richards, especially Vose Galleries. A veteran dealer, S. Morton Vose II remembers Bellows as "a rotund and genial gentleman who was seriously intent on making purchases, and obviously commanded the wherewithal with which to do so."[20] Between 1944 and 1946 Bellows purchased thirty works from Vose, including *Whale Fishing* (no. 2) and *Packet Ship Bolton* (no. 180) by Robert Salmon, *In the White Mountains* (no. 14a) by George Inness, and *New England Coast* (no. 23) by Winslow Homer.

Bellows's other purchases from the Boston galleries consisted largely of water-colors by artists who had worked in Maine and were members of Boston art groups, including Samuel P. R. Triscott, Augustus Buhler, William P. Burpee, Frank W. Benson, James Fitzgerald, Charles Hopkinson, Sears Gallagher, and Charles Copeland.[21] Bellows noted: "A good and representative collection of water-colors, a medium peculiarly suited to our American dash and go, is a simple way to smuggle color as well as line into the rather drab city streets of Rockland."[22] This early emphasis on watercolors was continued and today is extensive enough for the museum to mount a survey exhibition of the medium.

Bellows made several other important acquisitions: two wonderful small Monhegan oils by George Bellows, *Beating Out to Sea* and *Sea in Fog* (nos. 43, 43a); Charles Codman's *Pirate's Retreat* (fig. 8; no. 4), which he bought after seeing the picture in the exhibition "Romantic Painting" at the Museum of Modern Art; Joseph DeCamp's *Seascape* (no. 27), which is one of the few extant landscapes by the artist; and works by Frank Duveneck, John La Farge, Charles Woodbury, and William Zorach. And from his own collection, he donated a small panel by Thomas Cole, *Cattle and Distant Mountain* (fig. 9; no. 3), which is now acknowledged to be the earliest oil painting by Cole extant.[23]

With the official opening of the museum building in the summer of 1948, Bellows concluded his consultancy. During his tenure, the museum had evolved from an idea to a reality—a new building, a permanent collection, and a well-established direction for its future. In April of that year the bank trustees hired James M. Brown III as the first professional director. Although Brown was the youngest director of a New England museum at the time, he brought considerable education and professional experience to the position. A graduate of Amherst College and the renowned Harvard University museum program, prior to his appointment at the Farnsworth he had been a researcher at Dumbarton Oaks in Washington, D.C., and assistant director of the Institute of Contemporary Art in Boston.[24]

Brown spent less than three years in Rockland before resigning to become director of the new Corning Glass Museum in Corning, New York, but he was instrumental in shaping the future direction of the Farnsworth Museum. With the collection well established by Bellows, Brown concentrated his efforts on strengthening the museum's ties to the community and broadening its base of support. In an article written for the *College Art Journal* in 1949, he wrote:

> The long range task of these first few years is to develop in a population which had never known a museum and, moreover, did not ask for one, a real consciousness of its worth. The museum must actively enrich the life of the community and not wait for the mildly curious to wander in. It must accomplish this without pushing. Rather by suggestion it must create the demand and then satisfy this demand with adherence to local interests combined with the highest standards of quality.[25]

With this intelligent precept, Brown set the museum on a course it follows to this day: musical concerts, cinematic presentations, scholarly lectures and art classes, and a strong school program. Most important, there are exhibitions in which, as Brown advocated, "local interest and top quality find a meeting point."[26]

After the years of active purchasing by Bellows, museum acquisitions under Brown's directorship were relatively few in number. However, significant additions to the collection were made. Andrew Wyeth's watercolor *Rocks and the Sea* was purchased in June 1948 through the Childe Hassam Fund of the American Academy of Arts and Letters, and a Boston cityscape by Thomas Fransioli (no. 122) was purchased in January 1949 with money awarded by the Society of Independent Artists in Boston.

However, in his "Plans for the Future," a report written for the museum trustees in 1949, Brown noted that the museum should place "an even greater emphasis on

the achievements of those artists who live and work in Maine and New England."[27] His mission was to "take the quality of strangeness from art" and "convince the public of the practical as well as cultural value of an art museum in a community of this size."[28] His wise agenda called for the museum to exhibit "that which had been created in Maine by the better-known artists of the region, thus making the institution the cultural center of the coastal region."[29] Before his resignation, Brown set into motion plans for the first museum exhibition of the art of Andrew Wyeth. Organized in cooperation with the Currier Gallery of Art in Manchester, New Hampshire, the show was held at the Farnsworth in the summer of 1951.

A major exhibition by any standards, the Wyeth show provided a most auspicious beginning for Brown's successor, Wendell S. Hadlock. Described by Philip Hofer as a "true Maniac who had a good sense of what Rocklanders would wish to have, study, and see,"[30] Hadlock was a native of Cranberry Isles, Maine, with a degree in anthropology from the University of Pennsylvania. Before coming to the Farnsworth, Hadlock served as administrative assistant at the Peabody Museum, Salem, Massachusetts, and as curator of the Robert Abbe Museum in Bar Harbor, where he was also museum curator at Acadia National Park.[31]

Hadlock's long directorship, 1951–1976, saw the Farnsworth collection grow measurably in both strength and numbers, with, however, a decided bias toward his own conservative views. An article on the museum in the *Maine Trail* in 1958 characterized it as a "conservative museum where one may enjoy the work of contemporary Maine artists and of the nineteenth- and twentieth-century American and European artists represented in the permanent collection."[32] At a time when the national art scene was dominated by abstract expressionism, a Farnsworth Museum brochure from the 1960s pointedly used the word "representational" to describe the collection, and emphasized "the sea" and, again, "the Maine scene."[33]

The museum made national headlines when it purchased *Her Room* from Andrew Wyeth in September 1964—the most expensive painting ever acquired from a living American artist.[34] Among the other significant acquisitions made during Hadlock's directorship were Martin Johnson Heade's *Storm Clouds on the Coast* (no. 11), Fitz Hugh Lane's *Shipping in Down East Waters* (no. 9), and the sagacious purchase of the Jonathan Fisher estate in 1965, which included *A Morning View of Blue Hill Village* (no. 1).

The generous donation of Gifford Cochran's collection of American paintings over the years 1962 to 1971 included William M. Harnett's *The Professor's Old Friends* and *For a Pipe Smoker* (nos. 19, 19a), Thomas Eakins's *Study for The Thinker* (no. 20), and Eastman Johnson's *Young Girl* (no. 142). Several other individual donors made key gifts by artists new to the collection: Gilbert Stuart's *Portrait of George Hamilton as a Baron of the Exchequer* and *Portrait of Mrs. George Hamilton* (figs. 12, 13), Washington Allston's *Miriam the Prophetess* (no. 16), Thomas Sully's *Snider Children* (no. 17), and Lilian Westcott Hale's *Daffy-Down-Dilly* (no. 32).

Director Hadlock continued to strengthen the already strong ties between the Wyeth family and the museum by acquiring Andrew Wyeth's watercolors *Young Fisherman and Dory* in 1954, *The Wood Stove* (no. 66) in 1962, and *Alvaro and*

Christina (no. 67) in 1969. He also purchased an oil, *Bronze Age* (no. 69), 1967, by James Wyeth and three paintings, *Portrait of a Young Artist* (no. 62a), *Cannibal Shore* (no. 200), and *Three Men on a Raft,* by N. C. Wyeth. There were also significant gifts of Wyeth family works during Hadlock's directorship, including the watercolors *Alvaro's Hayrack* and *Cat Nap* by Andrew; the oil paintings *The Blind Leading the Blind* and *Bligh Fights Purcell* by N. C.; and the watercolor *The Capstan* (no. 69a) by James.[35]

In December 1976 Marius B. Peladeau was named the museum's third director. Under his leadership the museum expanded into contemporary art with major exhibitions of work by Louise Nevelson, Will Barnet, Robert Indiana, and Neil Welliver. This new focus resulted in a number of gifts, particularly archival materials, paintings, and sculpture by Louise Nevelson, the majority from the artist herself. From 1981 to 1985 Nevelson donated to the museum fifty-six works of art by herself and another thirty-one works by other artists.[36]

During Peladeau's tenure several important works entered the collection. The key purchases were Nevelson's *Dawn Column I* (no. 77a), Marsden Hartley's *Stormy Sea No. 2* (no. 47), and Willard Metcalf's *Willow Road, Brunswick, Maine* (no. 30a); major gifts included John Twachtman's *Frozen Brook* (no. 28), Childe Hassam's *Sundown on the Dunes, Provincetown* (no. 29a), and Norman Rockwell's *Tom Sawyer Whitewashing the Fence* (no. 178). Peladeau is also credited with establishing a strong print collection. Working closely with Sinclair Hitchings, curator of prints at the Boston Public Library, Peladeau amassed an impressive collection of late-nineteenth- and early-twentieth-century prints by Winslow Homer, Frank Benson, George Bellows, John Sloan, and John Marin, and contemporary prints by Robert Indiana and Neil Welliver, among numerous others.

In 1988, Christopher B. Crosman came to the Farnsworth having previously served as director of the Heckscher Museum, Huntington, Long Island, and as curator of education at the Albright-Knox Art Gallery in Buffalo, New York. During the next decade several key changes occurred, including the establishment of an independent Board of Directors in 1995, a narrowing of the museum's mission to focus exclusively on American art, and the establishment of the first substantial endowment funds for acquisitions.[37] In addition, the professional staff was expanded and for the first time curatorial support was recruited nationally. Suzette Lane McAvoy (1988–1995 and 1999 to the present), Susan C. Larsen (1996–1998), and Pamela J. Belanger (1993 to the present) each brought special expertise and interests that are reflected in the collection's growth during this period. The museum's exhibitions and acquisitions signal a marked shift toward a commitment to lesser known, living Maine artists such as Dozier Bell, Brett Bigbee, Alan Bray, David Dewey, Lois Dodd, Linden Frederick, Harold Garde, Ken Greenleaf, Stewart Henderson, Alison Hildreth, James Linehan, Frederick Lynch, Alan Magee, William Manning, Marjorie Moore, Dennis Pinette, Celeste Roberge, Marguerite Robichaux, Mark Wethli, and numerous others. In many instances the Farnsworth was the first museum to acquire their works and many have subsequently attracted a national audience, entering the collections of major museums throughout the United States. Other key purchases include: John Marin's *On the Road to Addison, Maine, No. 2* (no. 50), Marguerite

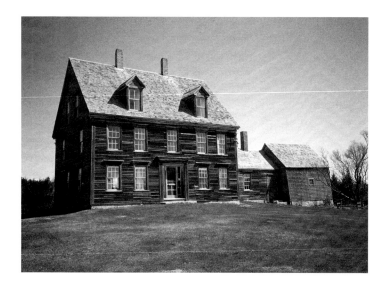

figure 10

The Olson House, Cushing, Maine,
photograph, c. 1994

figure 11

MBNA Center for the Wyeth Family in Maine,
Farnsworth Art Museum, photograph, 1999

Zorach's *Land and Development of New England* (no. 56), Carl Sprinchorn's *Loggers' Cabin by the Stream* (no. 74), Neil Welliver's *Rock Barrier—East Twin* (no. 84a), and Robert Indiana's *Love* sculpture that now welcomes visitors to the new museum campus. Nineteenth- and early-twentieth-century works were also purchased, including paintings and watercolors by Alvan Fisher, David Johnson, Sanford R. Gifford, Beatrice Whitney Van Ness, Yasuo Kuniyoshi, and Walt Kuhn.

In 1997 the bequest of sixty-six works from the estate of Elizabeth B. Noyce, who formed an important collection related to Maine and its artistic legacy, greatly strengthened the historical collection and provided new opportunities to better explore Maine's role in American art. Increasingly, the exhibition program draws on key works from the Noyce collection: Fitz Hugh Lane's *Camden Mountains from the South Entrance to the Harbor* (no. 8), George Bellows's *The Teamster* (no. 46), Frank Benson's *Portrait of Parker R. Stone* (no. 35), Edward Hopper's *Railroad Crossing, Rockland, Maine* (no. 53), Fairfield Porter's *Beach Flowers No. 2* (no. 80a), and Neil Welliver's *Prospect Ice Flow* (no. 84).

During the 1990s the museum's longstanding commitment to the Wyeth family was reaffirmed and eventually led to plans and a major capital campaign to establish a Center for the Wyeth Family in Maine that would stand as a northern outpost of the Wyeth family's legacy and complement the Pennsylvania-related collection housed at the Brandywine River Museum in Chadds Ford. The significant acquisitions of Wyeth family works that entered the collection include N. C. Wyeth's *Bright and Fair— Eight Bells* (no. 64), Andrew Wyeth's *Turkey Pond* (no. 65), and James Wyeth's *Portrait of Orca Bates* (no. 70).[38] In 1991 the museum acquired the Olson House (fig. 10), the subject of Andrew Wyeth's *Christina's World* (The Museum of Modern Art, New York), and numerous other works. In 1998 the MBNA Center for the Wyeth Family in Maine at the Farnsworth Art Museum (fig. 11) opened, with several galleries for exhibitions and an archive to house over three thousand works of art and over three thousand primary documents.[39]

The building program for the Wyeth Center contained provisions for the remodeling and enhancements to virtually all public areas within the Farnsworth Museum buildings, as well as a reshaping of exterior landscape throughout the entire campus. These architectural and campus changes followed expansion and renovation of galleries in the original museum building in 1994 that enabled the initial installation of the permanent collection "Maine in America" and the dedication of the Nevelson-Berliawsky Gallery.[40]

As this collection catalogue is completed plans are in place for yet another expansion of the museum's facilities, the renovation of an existing building on Main Street—almost six thousand square feet of exhibition space that will nearly double the Farnsworth's current gallery space. These additional galleries will support an expanded program for temporary exhibitions that had previously been too large for the museum to mount and also allows the museum to show more work by artists living in Maine. This expansion will also dramatically increase the museum's ability to exhibit its permanent collection and to better explore the theme of "Maine in America," particularly the art of the second half of the twentieth century.

The permanent collection is a powerful source of countless thematic exhibitions, both large and small scale. The museum has recently mounted exhibitions that draw from and contextualize works from the permanent collection: "Maine at Work" in 1997, "Benson and Bellows: Reality and the Dream" in 1998, and in 1999, "Inventing Acadia: Artists and Tourists at Mount Desert." The latter exhibition and accompanying book established a new standard for scholarship on Maine art for the institution. The Farnsworth has from its beginning focused on the quality of the collection, and on the collection as the core around which all museum activities revolve. Robert P. Bellows's good words of advice from his 1941 "Preliminary Suggestions on The William A. Farnsworth Museum," seven years before the museum opened to the public, have served us well and prevail as the watchwords of the institution: "Not size or number but quality should be its aim."[41]

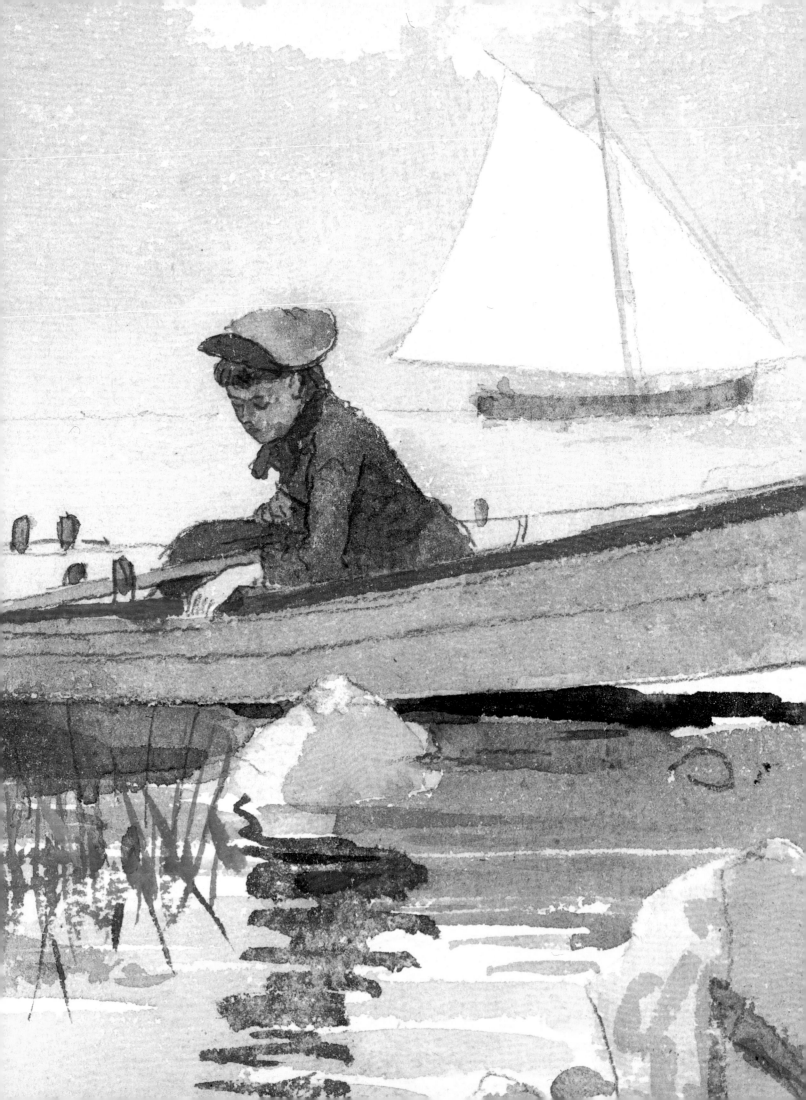

American Art at the Farnsworth

WILLIAM H. GERDTS

Characteristic of the strengths of the Farnsworth Art Museum's collection is *Miriam the Prophetess*, an 1821 biblical subject by Washington Allston. This would be a rare and highly desirable work of art in any public collection in the United States—indeed neither the Metropolitan Museum of Art in New York nor the National Gallery of Art in Washington is able to represent Allston's pivotal role in American art as effectively as the Farnsworth Art Museum. Moreover, Allston's painting is just one of the spectacular surprises to be found in this museum dedicated to the history of American art. For a relatively small institution, the Farnsworth is, in fact, full of wonderful treasures.

Until the publication of this catalogue the Farnsworth's collection, which is truly national in scope, has remained little known except to a few scholars and residents of Maine. But Maine is exceptionally fortunate, for at the Farnsworth the broad sweep of American painting may be traced from the late eighteenth century to the present. The museum is particularly rich in works related to the long and impressive cultural tradition of artists who have painted Maine.

Portraiture was the earliest tradition in American art, and the museum possesses a number of fine early portraits. Among these, Gilbert Stuart's depictions of Mr. and Mrs. George Hamilton (figs. 12 and 13) are outstanding. The former is an unusually important example of this expatriate artist's style. The Hamiltons are Irish portraits, and they represent the cosmopolitan sophistication that Stuart brought back to America when he returned in 1793 from Dublin and London. With Stuart, American portrait painters began to turn away from the factual materiality of the colonial tradition. In the United States, Stuart's influence was felt in the portraiture of later generations of artists, most notably in that of Thomas Sully of Philadelphia, represented in the Farnsworth collection by the elegant *Snider Children* (no. 17), painted in 1841.

One of the glories of the Farnsworth collection is Washington Allston's major painting *Miriam the Prophetess* (no. 16). A history painting of impressive size and ambition, it is particularly important because it is one of only three biblical images Allston completed in the last twenty-five years of his career. Allston had returned to the United States in 1818 after seven years in England, where he had achieved acclaim, but he found Boston unsympathetic to his desire to make history paintings in the grand manner of the British Royal Academy. Gradually he became alienated

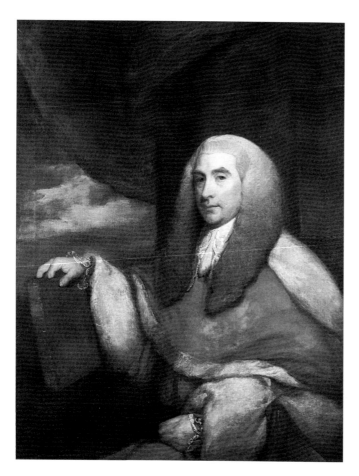

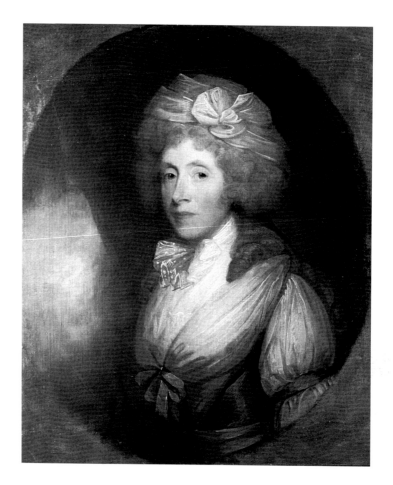

figure 12
GILBERT STUART
Portrait of George Hamilton as a Baron of the Exchequer, c. 1790
Oil on canvas, 48 x 37⅟₁₆
Gift of Mr. and Mrs. J. Philip Walker, 68.1594

figure 13
GILBERT STUART
Portrait of Mrs. George Hamilton, c. 1790
Oil on canvas, 30 x 25
Gift of Mr. and Mrs. J. Philip Walker, 68.1595

and introverted, never completing his huge painting *Belshazzar's Feast* (The Detroit Institute of Arts).

Around the beginning of the nineteenth century the United States began a rapid and dramatic cultural development. The expansion of the nation westward coupled with the prosperity of a new market economy brought with it a desire to foster a national culture equal or even superior to that of the Old World. For the visual arts, this meant the development of patronage and the creation of institutions dedicated to the training of young artists and to the exhibition and sale of art. Artists began to investigate themes other than portraiture, and, as Allston discovered, history painting commanded little respect. In response to these changes, artists began to paint images acceptable to a speculative, rather than a commissioned market. Many responded to the demands of the emerging American culture by painting native themes. Above all, they investigated the dramatic possibilities of the American landscape, because it combined elements of national pride and the site of an unfolding American history.

One of the most exciting discoveries that resulted from the research for this catalogue was the discovery of a rare, early painting by Thomas Cole in the Farnsworth col-

lection. Cole's *Cattle and Distant Mountain*, painted in 1822 (no. 3), is now recognized by Cole scholars as his earliest known oil painting and a work that provides a fascinating foreshadowing of his later interests in representing the pastoral American landscape. Cole's work in turning landscape into history influenced a generation of painters of the Hudson River School, of which he is acknowledged as one of the founders.

Contemporaneous with the Cole, but a production of Maine's own rich artistic tradition, is the wonderful image of the local landscape by Jonathan Fisher, *A Morning View of Blue Hill Village* (no. 1), painted in 1824. Jonathan Fisher, who worked near Rockland at Blue Hill, is especially well represented at the Farnsworth by an extensive collection of oils and watercolors. Fisher, a Congregational minister, was skilled as an artist painting portraits, still lifes, figure paintings, animal images, and religious subjects.

Jonathan Fisher was exceptional, however; for the most part, professional artists resided in Portland, Maine's largest city. In the 1820s Charles Codman, one of the country's earliest painters of romantic landscapes, established himself in Portland. Many of his paintings were straightforward, topographical views, but others, such as his imaginary *Pirate's Retreat* (no. 4). were influenced by the work of Cole. Codman's early success paved the way for the more naturalistic art of Harrison Bird Brown around midcentury. Brown was Maine's finest member of the Hudson River School. He is represented at the Farnsworth by his beautiful estate portrait *Norlands Homestead, Livermore, Maine* (no. 92).

The rugged beauty of Maine's coastal scenery inspired numerous painters who visited the state in search of sublime or picturesque landscapes. Alvan Fisher may have been among the earliest. He was the first professional landscape painter active in Boston, and may have visited Maine as early as the 1830s. The landscape around Camden seems especially to have attracted his attention, as seen in views painted there, from the wilder, more romantic *Camden Harbor* (no. 7), painted in 1846, to the superb topographical *Camden Hills and Harbor* (no. 5), painted about 1852. Later he participated in the fascination with Maine's Mount Desert Island by artists and tourists, and his work from there is represented by *Sutton Island, Mount Desert* (no. 6), about 1848.

Fitz Hugh Lane, a Gloucester, Massachusetts, native, was another artist who frequently painted the Maine coast. He is noted for a crisp clarity of form that captured the luminous effects of light reflecting off water. The Farnsworth is fortunate to have five important works by Lane, who was particularly attracted by the landscape around Castine and at Mount Desert, but also around Camden. Lane's later *Camden Mountains from the South Entrance to the Harbor* (no. 8), of 1859, is based on drawings made during a cruise he had taken in the late summer of 1855. His *Penobscot Bay from the Southwest Chamber Window* (no. 153), from 1850, and *Shipping in Down East Waters* (no. 9), from 1854, are fine examples of what have been termed his style of luminism. Lane's *Pretty Marsh, Mt. Desert Island* (no. 152), from the mid-1860s, suggests the deepening mood of introspection that entered his work around the period of the Civil War.

Recent scholarship has found similar sentiments in Martin Johnson Heade's *Storm Clouds on the Coast* (no. 11), of 1859. The idea that the painting represents a metaphoric image of the ship of state, the Union, imperiled by the approaching Civil

War is an intriguing concept that has been explored in a recent exhibition of Heade's thunderstorm paintings, which argued that there are deeper social meanings residing in Heade's works.

The New York City landscape painter Alfred Thompson Bricher, who painted *Rocky Head with Sailboats in the Distance* (no. 26), found a favorite coastal subject matter along the New England shore north of Boston, and he frequented Maine, traveling all the way north to Grand Manan Island, which he began visiting in 1874. Greater precision of form is introduced in the panoramic *Seascape* (no. 25), of 1884, by William Trost Richards, an artist who had been deeply influenced by the English Pre-Raphaelites and the theory of extreme fidelity to nature preached by the English art critic John Ruskin.

Because of the centering of both population and trade on the Atlantic coast, it is not surprising that coastal and harbor scenes, along with ship portraiture, figure large in American art, and also, of course, have a special place in a collection based on the Maine coast. One of the earliest marine painters active in the United States was the English-born Robert Salmon, who settled in Boston in 1828. He had already established a reputation for himself in Britain where he painted the *Packet Ship Bolton* (no. 180), in 1822, but he expanded his repertoire in America, painting his *Whale Fishing* (no. 2) here a decade later.

Salmon's enthusiasm for the marine subject was continued a generation later by James Buttersworth, another British-born artist who settled in the New York area in 1848. Buttersworth often depicted competing sailing yachts in the famous races for the America's Cup. The Farnsworth's collection has his impressive picture *The Puritan and the Genesta* (no. 24), the former the American winner, and the latter the British challenger. Another painter in the tradition of ship portraiture was Antonio Jacobsen, a Dane who settled in West Hoboken in 1873 and painted many ship portraits including the *Schooner Marion N. Cobb* (no. 138) in 1909.

But increasingly from the late 1850s on, American landscape painters began to derive their approach from the pastoral French Barbizon School as they sought to introduce a more poetic and lyric mood into their paintings. Artists such as Jervis McEntee in his *Flight of the Birds* (no. 13), 1866, combined the specificity of the older Hudson River School with a more moody and introspective aesthetic, specializing in melancholy autumnal scenes with overcast skies and veiled allusions to metaphysical themes. The key figure in the introduction of the Barbizon aesthetic was George Inness. His 1859 painting *In the White Mountains, Summer* (no. 14a), and his 1860 *Sunrise* (no. 14), stand at the crossroad between the older Hudson River School and the later development of an American Barbizon style. Indeed, in just the year separating the two works, Inness moved from the image of a panoramic expanse of landscape to a more intimate, poetic emphasis on nature's changing moods.

For much of the nineteenth century, landscape painting flourished as "the" American theme because of America's vast landscape and natural wonders, but genre painting—anecdotal scenes of everyday American life—also found favor. Eastman Johnson was among the most successful American genre painters from the 1850s through the 1870s. His work is represented at the Farnsworth by a contrasting pair of figure studies: the dark, more formal image of *Young Girl* (no. 142) painted in a

Rembrandtesque palette; and the vigorous outdoor representation of *American Farmer* (no. 18a). The latter is a heroic image of an agricultural worker perhaps created to contrast with representations of humble, burdened European peasantry so popular at the time. Though Johnson was born in Lovell, Maine, and later painted a series of scenes of maple sugar camps at Fryeburg, where he had lived as a child, he was not, until recently, represented in the Farnsworth collection by a Maine subject. But in 1997 the museum received the superb *A Boy in the Maine Woods* (no. 18), somewhat related to but not part of the series of studies for the never-completed final version of his maple sugar camp picture, and very likely a Maine scene. The picture's Maine derivation seems pretty well assured, since it appeared under its former title in the artist's estate sale in 1907. *A Boy in the Maine Woods* is, in fact, a far more finished picture than the majority of Johnson's Maine paintings and relates to a number of smaller paintings of single woodcutters of this period. In the isolation of the lone figure on the pathway, it is a very poignant work, though the young man's uprightness echoes the slender trees amid which he stands, allying him with the natural environment.

A contemporary of Johnson's with whom he is sometimes compared is Winslow Homer, who is represented in the Farnsworth collection by three superb works, all of 1880: a Gloucester drawing with Chinese white pigment, *New England Coast— Sailing Ships in Harbor* (no. 23); a luminous watercolor, *A Girl in a Punt* (no. 21); and the newly acquired *Pulling the Dory* (no. 22). Homer had first explored the watercolor medium in 1873 in Gloucester and returned there in 1880 to produce a substantial body of work, ranging from beautifully drawn and delicately tinted transparent washes, which appear in *Pulling the Dory*, to explosive experimental works almost bordering on the abstract. Indeed, 1880 was a key year for Homer, when his watercolor style truly matured, leading him the next year to his crucial period on the northeast coast of England and then back to America, where he soon settled in Prout's Neck on the coast of Maine.

An important aspect of the Farnsworth collection is its extensive holdings in American watercolor painting. Many of the greatest specialists in the medium—John La Farge, Dodge MacKnight, Maurice Prendergast, Charles Hovey Pepper, George Luks, Arthur B. Davies, John Marin, Charles Demuth, Frank Benson, Edward Hopper, and John Whorf, as well as more regional masters—are well represented, so that a survey of the medium over the course of a century could easily be mounted. The achievement of Maurice Prendergast can especially be seen in one of his finest earlier Venetian watercolors, *St. Mark's Square, Venice (The Clocktower)* (no. 31), of 1898–99. This work with its brilliant color vividly reveals how he first exploited the watercolor medium to its fullest.

Art historians sometimes pair Winslow Homer with his Philadelphia contemporary, the figure painter Thomas Eakins, because the two artists are now often considered as the greatest of America's realist masters of the late nineteenth century. Eakins is represented at the Farnsworth by two important works, both studies for famous canvases. One of these is *Composition for Rush Carving Allegorical Figure*, about 1876 (the final canvas is at the Philadelphia Museum of Art), a tribute to the sculptor William Rush, who had been Eakins's great Philadelphia predecessor in the depiction of the human form. The other is an oil sketch for one of his most moving,

introspective portraits, *The Thinker* (The Metropolitan Museum of Art), of 1900. The sketch is a full-length standing portrait of his brother-in-law, Louis N. Kenton, and was influenced by Eakins's study of Velázquez on an early trip to Madrid.

Eakins's contemporary William Michael Harnett is considered today America's finest still life painter of the late nineteenth century. Until Harnett, the great majority of American still life paintings consisted of representations of flowers and fruits and were often referred to as "dining room pictures." Harnett's still life paintings were based almost entirely on man-made objects and are often directed specifically toward a masculine audience. This is especially true of his early *For a Pipe Smoker* (no. 19a), of 1877, one of the first in a series of pipe-and-tobacco paintings with which the artist established his reputation. Even more sophisticated is Harnett's 1891 *The Professor's Old Friends* (no. 19), with its emphasis on objects of age, rarity, and culture, including books, musical instruments, and sheet music. The poignancy of the work, one of only two paintings Harnett completed in 1891, may be associated with the artist's illness and death that same year.

By the time Eakins and Harnett had painted *Study for The Thinker* and *The Professor's Old Friends*, the impressionist aesthetic from France had begun to dominate artistic practice in the United States. Among the most acclaimed American impressionists was Childe Hassam, who was equally at home in his ravishing coloristic works painted in New York City and those he created in and around small New England towns. His superb *Union Square in Spring* (no. 29), of 1900, and *Sundown on the Dunes, Provincetown* (no. 29a), of 1900, are excellent examples. His contemporary John Twachtman evolved a more personal approach to impressionism on the land around his home in Greenwich, Connecticut, where he painted *Frozen Brook* (no. 28).

Both Hassam and Twachtman probably saw their first French impressionist paintings in Paris, but other American artists helped established Giverny in France, the home of Claude Monet, as an art colony that nourished several generations of American painters. One of these was Josephine Lewis, the first woman to receive a bachelor of fine arts degree from Yale University, who painted her 1900 *Young Girl in Swing* (no. 33) a few years after her return from Giverny. One of the most unusual impressionist paintings in the Farnsworth collection is *Coasting—Boston Common* (no. 198) by Charles Woodbury, a painter associated with the artists' colony in Ogunquit, Maine, and with depictions of the coast and the sea. *The Glory of October* (no. 156) is by Philip Little, another New England impressionist of Boston and Salem, Massachusetts, who is now being reappreciated.

Boston impressionists, especially, devoted much of their artistry to depicting elegant women in genteel interiors, often aglow in a soft, pervading light, and none with more subtlety and finesse than Lilian Westcott Hale, as in her lovely *Daffy-Down-Dilly* (no. 32), of 1908.

From the 1870s on, the rugged coast near Cape Ann, Massachusetts, and the rapidly disappearing fishermen of the region attracted many artists from the nearby cities. In particular, Augustus Waldeck Buhler from Boston enshrined the local fisherfolk in his many canvases. He is well represented in the Farnsworth collection by *Shipwreck off Cape Ann* (no. 38), of 1908, with its obvious debt to Homer. His con-

temporary Walter Dean of Boston, who is also closely associated with images around Cape Ann, Massachusetts, painted his naturalistic evocation of the hard life of the Gloucester fisherman in his 1901 picture, *On the Deep Sea* (no. 37), which was also influenced by Homer.

As one moves into the early twentieth century, the Farnsworth collection becomes increasingly concerned with artists working in Maine. This is entirely appropriate for a museum located midway up the Maine coast, surrounded by the rich scenery that attracted artists to paint in the nearby regions. This panorama of the art of Maine itself is the Farnsworth's second commitment, because artists working and living in Maine have contributed so much to the broader development of American art.

Impressionism established itself in Maine when Frank Benson of Boston and Salem, Massachusetts, began summering on North Haven Island in 1901. It was there that this master impressionist painted many of his luminous outdoor figure subjects. He usually depicted his own children and grandchildren in sparkling sunlight and brilliant color-filled canvases. Occasionally he would apply these pictorial approaches to commissioned portraits, such as his wonderful, light-filled 1908 portrait *Laddie* (no. 34), the child of one of Benson's neighbors. Yet, like many American impressionist painters, Benson throughout his career maintained the structural clarity and dramatic tonal contrasts that he had mastered when studying in Paris in the mid-1880s when undertaking portraits. This is demonstrated by the 1922 *Portrait of Parker R. Stone* (no. 35), although both the slightly tense and anxious expression, and the backlighting that casts half of Stone's face in shadows is highly unusual. The work is particularly relevant to both Maine and the Farnsworth Museum, for the young Stone was Benson's close friend, fishing companion, guide, and model for numerous etchings, as well as a neighbor on North Haven, but later moved to the mainland and settled in Camden.

Benson's friend and colleague Willard Metcalf became something of the impressionist-laureate of New England, painting throughout the region. He first made his commitment to that aesthetic at Clark's Cove on the Damariscotta Peninsula in Maine in the winter of 1903–04. He returned to the state on a visit to Benson in North Haven in 1907, where he painted *Ebbing Tide, Version Two* (no. 30) and made a present of it to his host.

Winslow Homer inspired a group of able followers who achieved considerable reputations while working on the Maine coast, especially on Monhegan Island. These artists are well represented at the Farnsworth. They included Paul Dougherty who first visited Monhegan in 1908, and is represented by *The Crow's Nest* (no. 40), of that same year; Frederick Judd Waugh who went there about 1911; and later, Jay Connaway who was on Monhegan from 1931. Monhegan, in fact, became one of the most active painting grounds in Maine during the twentieth century. A great majority of these artists were summer visitors, but Samuel P. R. Triscott, who first visited the island in 1892, bought property and settled permanently in 1902. Triscott worked almost exclusively in watercolor, employing a traditional aesthetic of colored drawing to capture a nostalgic pleasure in the fast-disappearing fish houses and dories of the local fishing industry as well as the coves and beaches of the island. His use of pale,

subtle color tonalities, as seen in his evocative *Old Dory, Monhegan* (no. 39), and his dramatic treatment of light, as in *Fish Houses and Beach* (no. 39a), mark him as one of the finest practitioners of the medium of his time.

Robert Henri may have been the earliest among the artists of national, rather than regional, reputation who found inspiration in Monhegan's rugged terrain. He first visited the island in 1903. Henri's impressive *Monhegan Island* (no. 41), painted in the tradition of Winslow Homer, dates from that visit. Like many artists who came later, Henri was deeply impressed by the power of the ocean battering away at the rocks on Monhegan's headlands. Henri, who was a consummate teacher to a generation of American artists, returned to Monhegan in 1911 with George Bellows, who was so inspired by the visit that he returned again in 1913. In some of his Maine paintings of that year, such as *Beating Out to Sea* (no. 43), Bellows adopted the dramatic palette and swirling paint that mark Henri's first encounter with the island. On another visit in 1916, Bellows painted on other Maine islands. *The Fish Wharf, Matinicus Island* (no. 45), documents the fishing trade practiced among the six hundred residents of the state's most remote island. The artist was also active on the mainland at Camden, where his *Romance of Autumn* (no. 44), based on his new, extended use of the Maratta color system, introduces the Down East landscape as a modern American Eden. Bellows's Maine paintings of that summer constitute some of his finest and most monumental subjects painted in the state. One of the most magnificent of these, and one of his finest Maine subject pictures, is *The Teamster* (no. 46), one of five paintings Bellows created in Camden in August of 1916 that concentrate on the giant wooden framework of a boat being built. The vessel here and in its companion paintings looms large and pushes forward, looking almost like the biblical ark. The stalwart figures and their animals suggest their mastery of the enormous task before them, while elements of nature, both sky and ground plane, seem to pulsate and dynamically activate the scene. This is also one of many of Bellows's paintings of the period to embody the artist's patriotic concerns, for it testifies to the revival of the shipbuilding trade, a result of the hostilities of World War I.

Another of Henri's students was Rockwell Kent, whom Henri urged to visit Monhegan in June 1905. Kent spent much of the next five years on the island, even opening the short-lived Monhegan School of Art for one season in 1910. Kent's Monhegan pictures, such as his *Maine Coast* (no. 42), represent the artist's true maturation and express the reductive combination of grandeur and isolation that became the hallmark of his approach to landscape painting, which originated in his Monhegan experience. Kent was not to return for almost forty years, but when he did, in 1947, he repurchased his old house and studio and remained for another six years. His later work on the island, such as his 1950 *Lone Rock and Sea* (no. 145), continued, sometimes in a more reflective and personal vein, his earlier fascination with the grandeur and vastness of the island.

That same year, Edward Hopper began to summer on the island, continuing through the rest of the decade. During the 1920s, Gloucester, Massachusetts, claimed his presence for most summers, and beginning in 1930 he began his abiding residence in South Truro on Cape Cod. But in 1926, before his arrival in Gloucester, he traveled to Eastport, which he found disappointing, then went briefly to Bangor, and subse-

quently spent seven weeks in Rockland. This was a happy time, and the artist was prolific, painting about twenty of his finest watercolors. The Farnsworth is fortunate indeed to have four works from this Rockland series, including *Haunted House;* the sun-filled *Railroad Crossing, Rockland, Maine,* which features empty railroad tracks as symbols of the mobility of modern life; *Lime Rock Quarry No. 1;* and *Schooner's Bowsprit,* (nos. 52, 53, 54, and 55).

In more recent times, Monhegan has continued to attract artists such as Reuben Tam, working there in a more modern vein from 1948, and Andrew Winter in 1942, using more impressionist strategies, as in his *Monhegan Village in Winter* (no. 196). They had chosen to become year-round residents. A recent addition to the Farnsworth collection has been Jan Domela's *Monhegan Island,* (no. 60), painted during that Dutch-born artist's first summer on the island in 1938, when he met Connaway; and, sharing similar artistic sensibilities, the two developed a close friendship. This panoramic view portrays a harmonious combination of rugged landscape, a busy fishing fleet, and an orderly, well-kept community of houses nestled among the foreground hills. It is doubtful whether Monhegan should be considered an "art colony," despite the wealth of activity there, since the painters worked relatively separately and exhibited their island productions elsewhere. In that light, the most significant such colony established in Maine in the early twentieth century was Ogunquit, farther south on the coast, where Charles H. Woodbury first painted in 1888, building a studio there in 1896, and a home two years later, when he began two decades of summer teaching. In 1911 Hamilton Easter Field established a rival Summer School of Graphic Arts there, and by the 1920s Ogunquit enjoyed the activities of teachers and students as well as of visiting painters of national renown such as Walt Kuhn, there for many seasons from 1911; Bellows and Prendergast, who summered there in 1915; Edward Hopper and Leon Kroll, both of whom summered there in 1914 and 1915; and Yasuo Kuniyoshi, from 1918 to 1924. Also, during the 1920s Ogunquit witnessed the establishment of an art association and of both public exhibitions and commercial galleries. Among Woodbury's most distinguished early students, many of whom were women, was Gertrude Fiske, here represented by *Grandmother* (no. 116). Like other artists of her time, Fiske's aesthetic divided between tight, linear figure work and painterly impressionist landscapes.

European-influenced modernism first reached Maine in the work of John Marin, who discovered the landscape there in 1914. He was active in various parts of the state, first at Casco Bay and then, from 1919, in the Stonington and Deer Isle area on Penobscot Bay; his *Maine Landscape* (no. 48), with the abbreviated, even ideographic natural forms enveloped in soft atmosphere, dates from his first summer in that region, while *Fishboat No. 1 at Eastport, Maine Coast* (no. 49) testifies to Marin's long-standing devotion to the region, as well has his exploration of the coast all the way to its easternmost harbor in 1933, where he painted at least four watercolors. Marin was one of the modernists most integrated into the Stieglitz circle of avant-garde painters exhibiting in New York at Alfred Stieglitz's famous 291 gallery in the early twentieth century. The other major watercolorist among this group of artists was Charles Demuth, much of whose artistic production consists of superb fruit and flower still lifes. Those of the late 1910s are characterized by free-flowing

washes, but by the beginning of the next decade, Demuth had begun to opt for more clarity of form through careful outlining and structural, somewhat cubist-derived emphasis, as in his 1922 *Cluster* (no. 51).

Marguerite and William Zorach also spent their first Maine summer at Stonington in 1919, often visiting Marin, and four years later the Zorachs bought a farm on Georgetown Island, making the state their permanent summer home. By about 1914 both had adopted a style of modernism based on European cubism. To be sure, their experiences in Maine may have modified these modernist strains because Maine remained an indelible part of their art. This is particularly evident in Marguerite's monumental 1935 tribute to the region, *Land and Development of New England* (no. 56), which the museum was fortunate to acquire in 1991. This mural-sized canvas combines multiple themes of family, regional history, and American folk art and deals with issues of gender that were important to Zorach. William Zorach's 1963–66 sculpture *The Wisdom of Solomon* (fig. 14) also typifies the indelibility of Maine in William's work. Sculpture was a medium that Zorach investigated initially in 1917 and to which he turned fully in 1922, his stone pieces often carved directly from Maine's glacial boulders. But as the great scholar John I. H. Baur has discussed, the encounter with the primal natural forces of Maine pretty well tempered the investigation of pure abstraction among the early modernists.

figure 14

WILLIAM ZORACH

The Wisdom of Solomon, 1963-66 (cast 1971)

Bronze, 39¼ x 28 x 24

Gift of the Zorach and Ipcar children, 92.1

Although the great majority of Maine's painters, residents, and visitors, in both the nineteenth and twentieth centuries, have focused their attentions on the coast and the islands, a number of artists, beginning with Frederic Edwin Church, have found inspiration in the state's wild interior. Marsden Hartley, who was born in Lewiston, was one whose art began to mature with his Maine mountain subjects in 1906–07 and after, painted around Center and North Lovell. These works, such as *Song of Winter No. 6* (no. 47a), of about 1908–09, which embody high colorism and expressionistically flowing brushwork, celebrate the eternal wilderness of the remote Maine interior in very modernist art terms, while acknowledging the forbidding impenetrableness of the landscape and the ferocious weather he was experiencing in that winter. Hartley's seven paintings of the *Song of Winter* series, surely including the present example, were exhibited in New York at Stieglitz's 291 gallery in May of 1909, constituting Hartley's first one-artist show.

After four years of firsthand exposure to European modernism, Hartley was back in America and spent the summer of 1917 in Ogunquit, but his greatest Maine paintings were created in the last decade of his life, from 1937 on, some on the coast at Georgetown, Vinalhaven, and Corea. Among the most powerful, however, is the great series depicting Mount Katahdin, painted in Bangor, where Hartley was befriended by Waldo Peirce. The Farnsworth painting, *Stormy Sea No. 2* (no. 47), of 1936, was painted, not in Maine, but immediately before this period, on Eastern Points Island in Nova Scotia, the year of a great tragedy for Hartley, when two young men to whom he was devoted were lost at sea. Something of the artist's response to this catastrophe can be seen in this dark marine, reflecting the loneliness and violence of the ocean. A reflection of Hartley's haunting vision of Maine's wildness can also be seen in the painting of his close friend of almost thirty years, the Swedish-born Carl Sprinchorn, who had studied with Henri in New York and began to stay in

Monson, a Swedish-American lumbering settlement near Moosehead Lake in 1917; he later worked at Shin Pond in the 1930s and 1940s. Both Sprinchorn and Hartley shared an abiding love of the state, Hartley admitting great admiration for Sprinchorn's physical endurance of the state's lumber camps, the frequent subject of his brush. His greatest Maine paintings were created in the last decade of his life. Among the most powerful are the great series depicting Mount Katahdin, painted in Bangor.

Some regular summer visitors to Maine identified with other communities. One of these was the Chicago painter Allen Philbrick, who taught at the School of the Art Institute of Chicago for almost fifty years but spent most of his summers in Damariscotta and captured the beauty and warmth of small-town life there in his 1936 oil *Maine Street, Damariscotta, Maine* (no. 58). In 1946 a major center for the arts was established in the central part of the state, bordering Lake Wesserunsett, when the Skowhegan School of Painting and Sculpture was founded by the portraitist Willard Cummings to provide art students from around the country the opportunity to study with creative figures of national stature; Lois Dodd, represented here by *The Painted Room* (no. 81) of 1982, is one such artist. Dodd has been associated with Maine for almost thirty years, exhibiting in various centers throughout the state beginning in 1968.

Yet, perhaps reflecting the individuality that seems to be a trademark of Down East artists, a great many of the state's leading painters have located separately in different communities or nested on their own particular island, much as Homer had earlier chosen to settle in isolation at Prout's Neck. These artists were not reclusive and often entertained friends and colleagues, but they were "their own men and women." Thus, the rare landscapes such as *The Boatyard, Vinalhaven* (no. 73), and *At the Shore, Maine* (no. 73a), painted by Raphael Soyer, otherwise a master of working class urban imagery, were created on Vinalhaven, where the artist summered from 1957. Working in a more modern idiom, the semi-abstract landscape painter William Kienbusch had his studio on Great Cranberry Island, though Kienbusch had worked earlier in Stonington, following in the footsteps of Marin, who was in part his inspiration.

Among the modern realists who are indelibly associated with Maine is Fairfield Porter, who was a longtime summer resident of Great Spruce Head Island in Penobscot Bay, where he found both inspiration and isolation. It was there that he painted the brilliantly luminous close-up *Beach Flowers No. 2* (no. 80a), in 1972, and *The Dock* (no. 80), in 1974–75, one of his final works. Neil Welliver is a younger artist, a year-round resident of Lincolnville and a painter of nature's seasons. He has created monumental close-up interiors of the Maine woods since the early 1960s and a very different pictorial experience in the expanse of his *Prospect Ice Flow* (no. 84) of 1976, a work that, in its vast distances and massive, cold blue-and-white forms, recalls the paintings of Rockwell Kent. Finally, one should acknowledge the solitary splendor of the art of Will Barnet, one of Maine's greatest figural artists, whose works making up the monumental series *Woman and the Sea*, such as the Farnsworth's 1977 *Woman and Tall Trees* (no. 83), embody both the traditional spirit of Maine—her dependence on the sea and the stalwart resignation of those who wait for the return of the fisherfolk—and the long, close association of women and the sea, all carried

out in a modern idiom. Barnet and his wife, Elena, have spent their summers on the Maine coast since the mid-1950s.

Finally, there are two special art collections at the Farnsworth that deserve special recognition. One is that of the Wyeth family—the "first family" of Maine landscape painters. The family patriarch was N. C. Wyeth, the illustrator and painter, who lived most of his life in Chadds Ford, Pennsylvania, but began summering in Maine in 1920 at Port Clyde, the mainland port for, and ten miles from, Monhegan. He is represented here by four personally resonant paintings, including a 1936 landscape *Bright and Fair—Eight Bells* (no. 64), the designation of his Port Clyde home, significantly named after one of Winslow Homer's most famous oils, along with a beautiful, sun-filled rendering of a neighboring building, *The Morris House, Port Clyde* (no. 63), painted about 1935. Wyeth's *Sounding Sea* (no. 62) of 1934 is a powerful coastal scene of massive rocks and crashing water, harking back to the Prout's Neck paintings of Homer himself and more recently to the early twentieth century work of Henri and Bellows. *Portrait of a Young Artist* (no. 62a), of about 1930, documents his young son, Andrew, as a tyro painting among an elemental scene of rocks and waves, which had decades earlier been Homer's signature theme. While these are all very intimate works, it should be noted, too, that they are all very much *Maine* landscapes. (Parenthetically, the Farnsworth collection also numbers some of N. C. Wyeth's illustrations in addition to his easel paintings, and another subcollection here includes works by many of the famous artists of America's Golden Age of illustration: Howard Pyle, Charles Dana Gibson, and Norman Rockwell.)

The finest paintings in the Farnsworth collection by N. C.'s son, the great realist master Andrew Wyeth, who divides his time between Chadds Ford and Cushing, Maine, are pictures of the 1960s: the haunting tempera *Her Room* (no. 68), painted in 1963, and two other gouache interiors, *The Wood Stove* (no. 66) of 1962 and *Alvaro and Christina* (no. 67) of 1968. (The shells on the window ledge in *Her Room* are yet another tribute to Winslow Homer, gathered by Wyeth's wife near Homer's Prout's Neck studio.) The two watercolors are tributes to Alvaro and Christina Olson, Wyeth's neighbors who represented for the artist the rugged independence of the spirit of Maine and who lived in the house depicted in these pictures. Christina, crippled by polio and the subject of Wyeth's most famous painting, *Christina's World* (The Museum of Modern Art, New York City), increasingly spent much of her time in a wooden chair near this kitchen wood stove. Alvaro Olson, a fisherman and lobsterman, refused to pose for Wyeth, but is instead represented by symbols of his work in the house in which he lived and died. Today, the Olson house, which is seen in so many of Andrew Wyeth's paintings, is part of the Farnsworth Museum, and is open to the public as a historic site. It is a place indelibly imprinted on the imagination of the world as a symbol of all that is Maine because of the achievement of Andrew Wyeth.

James Wyeth, Andrew's son, followed his father's path of evocative realism while exploring the local Maine landscape in paintings such as the 1967 *Bronze Age* (no. 69) and *Screen Door to the Sea* (no. 71) of 1994, though much of his subject matter was found on Monhegan. Andrew's sister, Henriette, a portrait and still life painter, married the famous southwestern artist Peter Hurd and ultimately made her home in that region; her 1935 *Death and the Child* (no. 61) is an unusual work of

personal poignancy. And another sister, the composer, Ann Wyeth, married the Wilmington, Delaware, painter John McCoy, who had trained under N. C. Wyeth, beginning in 1934. He is represented here by his 1944 painting, *Wawenock Hotel.*

The other great modernist collection within the Farnsworth consists of the paintings and sculptures of Louise Nevelson, among the most famous of Maine's twentieth-century sculptors. Born in Russia, Nevelson moved to Maine as a child in 1905, and before turning to the wooden abstract assemblages that won her international fame, she painted expressionist figure pieces and landscapes in the area of Rockland during the 1930s. These include paintings such as *Woman, Child and Cats* (no. 76) and *Maine Meadows, Old County Road* (no. 75). As a sculptor, she worked first in a cubist idiom, seen in *Bronze Bird* (no. 76a), of 1952, and then began to assemble found-wooden objects, painted all black, and then turned to all-white assemblages with *Dawn's Wedding Feast* of 1959, which included *Dawn, Column I* (no. 77a). These last are works created not in Maine but in New York City, where Nevelson was one of the major sculptors of the 1970s and 1980s. But her Maine experience was important, even crucial to her. In the 1980s Nevelson, in remembrance of her years in Maine, donated a large collection of her early works and her papers to the Farnsworth.

Today, the Farnsworth Art Museum is one of the jewels in the rich crown of great cultural institutions in Maine. With the publication of this collection catalogue, authored by a diverse group of noted scholars, the treasures of the collection once only known to students of American art will become accessible nationally. Long a well-kept secret of art lovers in the region, the Farnsworth Art Museum, with its outstanding collection of historic American art and its incomparable collection of work by artists working and living in Maine, is proudly poised on the threshold of a new era. The recent renovations of the museum, the acquisition of the Olson House as a historic Maine site, and the addition of the Farnsworth Center for the Wyeth Family demonstrate that the institution is well positioned to further enhance its important contributions to the cultural life of the state of Maine. Indeed, whereas Maine provided inspiration for many of the artists represented in this publication, that inspiration can now be shared with all those who view this outstanding collection.

MAINE *in America*

Jonathan Fisher (1768–1847)

Although by profession Reverend Jonathan Fisher was a clergyman and not an artist, throughout his life he created pictures—paintings, drawings, and engravings. Born in New Braintree, Massachusetts, Fisher graduated from Harvard University in 1792, and four years later settled at Blue Hill, Maine, where he was minister at the Congregational Church for over forty-one years.[1] In addition to his work administering to his congregation and his interests in art, Fisher also found time to develop several other skills—as inventor, scientist, poet, linguist, architect, surveyor, farmer, naturalist, and craftsman. Fisher's sermons, copies of his correspondence, and the diary he kept for over forty years were written in an ingenious shorthand code that he developed to save on paper. Fisher built his own house and much of his furniture, and also designed and made survey instruments that he used to lay-out the village of Blue Hill.

Fisher's interest in painting began during his years at Harvard; however, he received no formal art training other than a course in mechanical drawing that was required at the University. He studied from the available art manuals and copied a variety of illustrations from published sources. During his life Fisher created a variety of works of art: landscapes, still lifes, portraits, and religious and literary scenes. Although Fisher's paintings and other works of art show a fondness for meticulous detail, in his panoramic *A Morning View of Blue Hill Village* he defers to a grander interpretation in a cohesive and harmonious depiction of the landscape, economy, ecology, and religious aspirations of his cherished community.

The orderly composition expresses much about Fisher's aesthetic, ecological, and theological outlook. The village area is demarcated, yet Fisher's aim is the cooperation of nature and man to shape the dynamic and prosperous village. In the foreground, the land is cleared and appears to be outside the village area, but functions as a stage to view Fisher's object of civic pride and spiritual reverence—the village. Two women quietly observe the sprawling landscape and gaze toward the church steeple, Fisher's church, and the focal point of the painting. The man attacking a snake is an effective allusion to the devil and the chasing out of evil, and recommends the minister's hope of an Eden in Blue Hill. The village has not yet evolved a centralized and industrialized center and its aspects of commerce are still dispersed. Three ships are shown in stages of construction, and another ship sails into the harbor and is about to dock. Substantial homes and two churches along a single road lead from the harbor to Fisher's church at the horizon. Some buildings show the new federal style and Fisher's own Congregational Church is influenced by the neoclassical style, suggesting that even in this remote area, recent architectural schemes are embraced.

A Morning View of Blue Hill Village is a nearly topographically accurate depiction that captures the life and energy of a thriving community and marks the reshaping and the march of civilization on a Down East coastal wilderness. Most of the landscape has been cleared, and only a small wilderness remains at the left. The charred stumps are quiet reminders of a common practice for clearing land, and the original forest is now only a memento of the original forest wilderness. However, Fisher's composition does not dwell on a subjugation of the landscape. He concentrated on the union of man's efforts and nature's bounty, and the clear definition and construction of a well-orchestrated rural community, whose economy was based on agriculture and shipbuilding.

P. J. B.

1 A Morning View of Blue Hill Village, 1824

Oil on canvas, 25⅝ x 52¼

Signed and dated lower right, "A Morning View of Bluehill / Village / Sept. 1824 / Jon Fisher pinx."

Museum purchase, 65.1465.134

PROVENANCE: Roland M. Howard, Blue Hill, Maine

EXHIBITIONS: Colby College Art Museum, Waterville, Maine, 4 April–10 May 1970, Bowdoin College Museum of Art, Brunswick, Maine, 21 May–28 June 1970, and Carnegie Gallery, University of Maine, Orono, 8 July–30 August 1970, "Landscape in Maine, 1820–1970," no. 2; Old Sturbridge Village, Sturbridge, Massachusetts, "The Landscape of Change: Views of Rural New England, 1790–1865," 9 February–16 May 1976; Farnsworth Art Museum, "Through a Bird's Eye: Nineteenth-Century Views of Maine," 10 July–28 September 1981, no. 2; Wadsworth Atheneum, Hartford, Connecticut, 21 September–30 November 1986, and The Corcoran Gallery of Art, Washington, D.C., 17 January–29 March 1987, "Views and Visions: American Landscape before 1830"

REFERENCES: Gertrud A. Mellon and Elizabeth F. Wilder, eds., *Maine and Its Role in American Art, 1740–1963* (New York: The Viking Press, 1963), 43 (illus.), 149; *Landscape in Maine, 1820–1970* (Waterville, Maine: Colby College Museum of Art, 1970), 2, 3, (illus.); Alice Winchester, "Rediscovery: Parson Jonathan Fisher," *Art in America* (November–December 1970): 94 (illus.), 98; Alice Winchester, *Versatile Yankee; The Art of Jonathan Fisher, 1768–1847* (Princeton: The Pyne Press, 1973), 24, jacket (illus.); Jay E. Cantor, *The Landscape of Change, Views of Rural New England, 1790–1865* (Sturbridge, Mass.: Old Sturbridge Village, 1976), n.p., fig. 3; Christine B. Podmaniczky and Earle G. Shuttleworth, Jr., *Through a Bird's Eye: Nineteenth-Century Views of Maine* (Rockland, Maine: Farnsworth Art Museum, 1981), 4 (illus.), 6; Joseph S. Czestochowski, *The American Landscape Tradition: A Study and Gallery of Paintings* (New York: E. P. Dutton, Inc., 1982), 60 (illus.), 61; Edward J. Nygren and Bruce Robertson, *Views and Visions: American Landscape before 1830* (Washington, D.C.: The Corcoran Gallery of Art, 1986), 214 (illus.), 258, 259; William H. Gerdts, *Art Across America: Two Centuries of American Painting, 1710–1920* (New York: Abbeville Press, 1990), vol. 1, 17–18, 17 (illus.); John Wilmerding, *The Artist's Mount Desert: American Painters on the Maine Coast* (Princeton: Princeton University Press, 1994), 14 (illus.), 15, 47, 185, no. 8; Neil Rolde, *An Illustrated History of Maine* (Augusta, Maine: Friends of the State of Maine, 1995), 65 (illus.)

Robert Salmon (1775–after 1845)

The finest marine painter in New England during the first half of the nineteenth century, Robert Salmon turned his strong sense of authenticity and meticulous treatment of subject to imagined scenes of a rising economic industry—whaling.[1] The new machinery of American industry required an ever-increasing need for lubricants supplied by the whalers, and by the 1850s New Bedford, Massachusetts, had become the whaling hub of the world.[2] During the early nineteenth century, seascapes frequently incorporated images of national identity as well as the more practical interests of American commercialism. Paintings like *Whale Fishing* glorified American exploration, commercial expansion, and American Manifest Destiny, bringing a national presence to the whaling expeditions in the distant South Seas. These paintings were also very marketable to a range of patrons, indeed, some who were actually involved in the thriving industry.

Born in the Parish of St. James, Whitehaven, Cumberland, England, Salmon had achieved considerable success in London, living and painting also in Liverpool and Greenock. When Salmon painted *Whale Fishing* he had been in America only four years, arriving in 1828 at New York on the packet ship *New York*. Within days he had made his way to Boston. During the 1830s he kept a studio on Marine Railway Wharf, Commercial Street. By 1829 Salmon was exhibiting at the Boston Athenaeum and by 1832 was quite successful, receiving consistent favorable notices in newspapers.

In 1832 Salmon completed two "whale fishing" pictures, which are numbered in his register, "Catalogue of Robert Salmon's Pictures, 1828 to 1840," as no. 754 and no. 755.[3] The entries are identical except for the time spent on each canvas. Salmon recorded the museum's painting as "No. 755 6½ day. 24 by 16. Whale fishing. Solld," and the companion picture, No. 754, as taking 7½ days to complete. The artist had already depicted the subject the previous year with another pair, *South Sea Whale Fishing* and *South Sea Whale Fishing, II* (both Museum of Fine Arts, Boston).[4] All four paintings are identical in size. The Farnsworth painting is very like *South Sea Whale Fishing*, with the right foreground boats and seamen positioned almost identically, and on the largest ship men busy with the work of "cutting in." *South Sea*

Whale Fishing depicts a calmer sea, but *Whale Fishing*'s overcast sky, strong wind, and choppy sea warn of a coming storm and present a somewhat wilder and more sublime scene.

Whale Fishing tells the story of the profitable yet dangerous whaler's trade but does not focus on the threatening aspects of whaling, which would not have been popular with patrons. Yet whales were known to surface beneath a boat and stave it in half, jettisoning the crew in all directions; or they could breach, sometime crushing a boat with their head. The painting is filled with ships involved in various stages of hunting and killing, including some specific aspects of "cutting blubber."[5] Indeed, Henry T. Tuckerman observed that "Salmon painted with great care, and his pictures are almost miniatures in their detail."[6]

Salmon highlighted the area around the largest ship, giving the viewer a more intimate view of the process of "cutting." Moored to the side of the ship, the great mammal's flesh is cut in strips and hoisted on board by the crew with ropes drawn through a block rigged to the main mast. From the cutting stage—a wooden platform lowered at the ship's side to a working height by the whale—one sailor cuts the blubber into manageable sections and another works at separating it from the bloody carcass. A number of seabirds circle the area, scavenging the scraps of whale flesh.

The small whaleboats at the right foreground appear to be positioning the next whale for cutting, while other ships in the background are occupied in their own pursuits of the whale. Even as the most prominent vignettes in the painting observe the harvesting of several animals, several live whales are included, confirming the rich supply still to be harvested and the vast commercial opportunities of these waters. *Whale Fishing*, with prominent national and commercial flags unfurled, announces that the forces of the sea have been subjugated to the economic purposes of America.

P. J. B.

2 Whale Fishing, 1832

Oil on panel, 16⁹⁄₁₆ x 24⅛

Signed and dated lower right, "R.S. (in monogram) 1832"

Signed and dated verso, "No. 755 Painted by Robert Salmon August 1832"

Museum purchase, 45.524

PROVENANCE: Charles H. Taylor, 1929; Vose Galleries, Boston, 1929–45

EXHIBITIONS: DeCordova Museum, Lincoln, Massachusetts, "Robert Salmon: The First Major Exhibition," 26 March–30 April 1967, no. 46; Whitney Museum of American Art at Champion, Stamford, Connecticut, "Realism and Romanticism in Nineteenth-Century New England Seascapes," 15 September–29 November 1989

REFERENCES: John Wilmerding, *Robert Salmon: Painter of Ship and Shore* (Boston, Boston Public Library, 1971), 93, no. 755, 107, no. 29; *Goodly Ships on Painted Seas: Ship Portraiture by Penobscot Bay Artists William P. Stubbs, James G. Babbidge and Percy A. Sanborn* (Rockland, Maine: Farnsworth Art Museum, 1988), 15 (illus.); Gertrude Grace Sill, *Realism and Romanticism in Nineteenth-Century New England Seascapes* (Stamford, Conn.: Whitney Museum of American Art at Champion, 1989), 3–4, 4 (illus.), 12

2a Coast of Wales, 1834
Oil on panel, 14⁵⁄₁₆ x 16⁹⁄₁₆

Museum purchase, 47.683

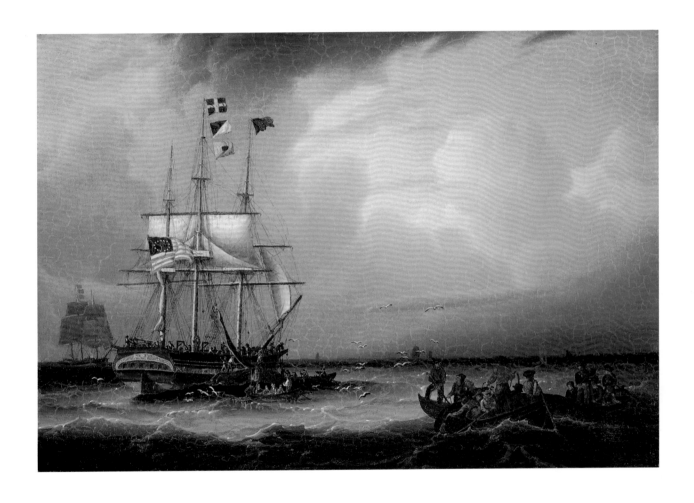

Thomas Cole (1801–1848)

3 Cattle and Distant Mountain,
1822

Oil on wood panel, 7½ x 9¹⁄₁₆

Signed and dated verso, "T. Cole Pxt /
Jan 18 / 1822"

Gift of Robert P. Bellows, 46.576

The discovery of the earliest known oil painting by Thomas Cole in the collection of the Farnsworth Art Museum adds to our knowledge of this major artist's earliest development. The fortuitous coincidence of this discovery with the first exhibition of Cole's art in a generation at the National Museum of American Art came at a time when scholars were reassessing how Cole historicized his depiction of the American landscape.[1]

The Farnsworth panel shows that, even as a youth of twenty-one struggling to define his artistic identity, Cole was already developing the complex iconography of landscape that would become the hallmark of his later work. As the Cole scholar Alan Wallach demonstrated in his essay for the recent exhibition catalogue, Cole elaborated throughout his career on the pastoral landscape constructed within the conventions of the picturesque tradition.[2]

Cole immigrated to the United States in 1818 from Lancashire, the seat of the English Industrial Revolution and where his family were middle-class artisans. Cole developed from this early experience an antipathy toward industrialization and its dislocations. He also came to feel that the lifestyle of the aristocracy, with its refinement and ostensible love of art, was preferable. Before he left England Cole had received some artistic training as an apprentice to an engraver in the calico printworks around Lancashire. His later biographers tried to represent him as entirely self-taught, and in fact he was an autodidact who thoroughly assimilated the established conventions of English landscape painting by looking at prints and voraciously reading about landscape theory.

The Farnsworth panel was painted at a particularly difficult period at the beginning of the artist's career. It is important evidence of the process whereby Cole made himself into an artist as he struggled to establish a career in the remote Ohio River Valley frontier. Although his early works are primarily portraits, the Farnsworth picture, with its boldly inscribed signature and date of *Jan 18, 1822*, indicates that even at this early point he was experimenting with formulas for landscape compositions. According to Ellwood Parry III, who authenticated the panel, Cole might have seen a copy of *Picturesque Views of American Scenery*, which contained aquatints after designs by Joshua Shaw. Certainly, the pastoral composition in the "beautiful mode" is reminiscent of some of Shaw's designs, which in turn were influenced by William Gilpin, the well-known English writer on landscape aesthetics. In 1820 Cole read an English work on painting, which was lent to him by the itinerant portrait painter John Stein in Stubbenville, Ohio. The book, whose title is unknown, had a profound effect. Cole later wrote:

> [the book] was illustrated with engravings, and treated of design, composition, and color. This book was my companion day and night . . . painting was all in all to me. I had made some proficiency in drawing, and had engraved a little . . . but not until now had my passion for painting been thoroughly roused—my love for art exceeded all love—my ambition grew, and in my imagination I pictured the glory of being a great painter.[3]

With its tranquil agricultural image, Cole's 1822 picture is far removed from both the harsh reality of industrial England he had left and the crude lifestyle the aspiring painter encountered in his disheartening search for patronage in the frontier wilds of Ohio. On one level its simple appearance may relate to his early work in Philadelphia as an engraver. Yet the composition reflects Cole's assimilation of Claude Lorrain, the seventeenth-century French landscape painter, while the slightly elevated prospect shows his embryonic understanding of the convention that positioned the spectator so as to overlook an expansive landscape in the distance. The dense vegetation in the foreground is the first step in Cole's tentative exploration of an idea he would expand with much success in later works: a representation of the temporal sequence of historical development. The wilderness in the foreground gives way to the cowherd with his cattle, and in the distance cultivated fields suggest the further development of agriculture. In the far distance a church spire reveals the final stage of transformation of the wilderness by civilization's progress.

It is clear that Cole's 1822 panel is not a topographical "view" but, to use the terminology of Edward Nygren, more of a "vision."[4] To what degree it can specifically be called an American vision cannot readily be determined, but it does reveal that as early as 1822 Cole had made significant progress in his quest to paint in a manner that could appeal to the emerging taste for paintings of the landscape—a taste that Cole would successfully capitalize on and champion for the next two decades. By his death a quarter of a century later in 1848, Thomas Cole had emerged from such inauspicious frontier beginnings to become in the minds of his countrymen America's own Claude.

J. G. S.

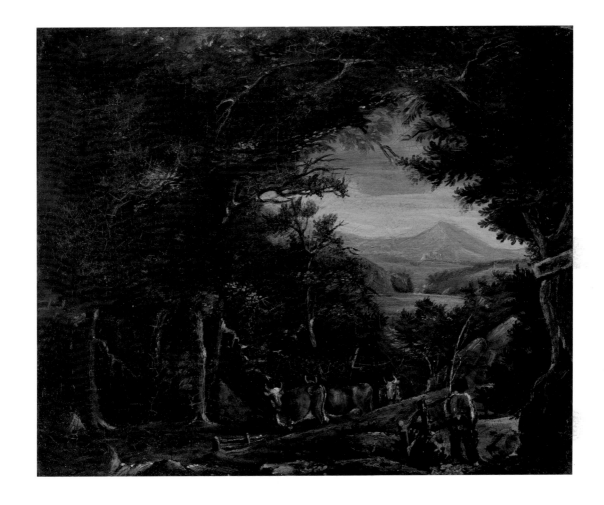

Charles Codman (1800–1842)

Although Charles Codman was primarily an ornamental painter and never stopped doing such work, his ability as a painter is most clearly seen in highly imaginative and romantic landscape dramas like *Pirate's Retreat*.[1] By October 1822 Codman had left Boston and the recently established portrait and decorative painting business he shared with his brother William P. Codman, to settle in Portland, Maine. The surplus of ornamental painters in Boston and the economic rise of Portland may have persuaded Codman to make the change.[2] He quickly advertised his ornamental painting services in the Portland *Eastern Argus* on 29 October 1822. Codman's advertising technique followed that of his mentor Penniman. He frequently announced his readiness to provide a variety of services. By 1825 he boasted of the "Boston touch at Portland prices."[3]

Heavily influenced by the sublime landscapes of Salvator Rosa, Codman's *Pirate's Retreat* evokes a much earlier time when pirates prowled the eastern seaboard and brought contraband ashore at secret locations. In the foreground pirates are glimpsed around a fire in a deep cave, while above, two figures, one with a spyglass, appear to stand watch. In the middle distance, secure in the well-protected harbor, a two-masted sailing vessel with sharply raked masts suggests the pirates' ability to make speedy runs from their refuge with their contraband cargoes. The rocky landscape, which is derived from Codman's study of prints after Rosa, is as fantastical as it is evocative of the sublime.

By the 1820s the aesthetic categories of painting as articulated by Edmund Burke—the beautiful, the sublime, and the picturesque—had become conventions widely practiced by landscape painters. Although it is hard to know the pictures Codman would have been able to view in Portland, given the lack of support for American art at the time, Codman shared similar aesthetic preoccupations with his famous contemporary, Thomas Cole. Cole's pictures were on view at the Boston Athenaeum from 1827 to 1830, the same time Codman himself had works exhibited.

Codman was "discovered" in 1827 by America's first art critic, the journalist John Neal, who published the story of his first encounter with the artist's work:

One day, soon after my return from abroad, I happened to dine at the Elm Tavern in Portland. While at table, my attention was directed to what seemed the strangest paper-hangings I had ever seen, - a forest of large trees, reaching from the floor to the ceiling, and crowded with luxuriant undergrowth. Upon further examination, I found these paper-hangings to be painted in oil; and learned, upon inquiry, that they were the work of a sign painter. They were masterly, and I lost no time in hunting the artist up. I found him in the midst of his work shop, half buried in signs, banners, fire-buckets, and all sorts of trumpery.[4]

Neal first published a review of Codman's work in 1828 and consistently included the artist in his art criticism and other publications for over forty-five years, long after the artist's premature death.[5] In Neal, Codman had an enthusiastic patron and promoter.

Neal found Codman's paintings compelling because they provided illustrative analogies for his romantic discourses. Neal believed that art should excite the imagination and impress the deeper emotions. In his novel, *Seventy-six*, written in 1823, Neal described the sublime in nature:

Let a man go with me . . . out into the wilderness . . . before the hurricane broke down upon us . . . and feel the soft air whispering about his heart; or hear the thunder breaking at his feet; and see the great trees bending and parting, in the wind and blackness of God's power—I care not who he is, or what he is—where born—or how educated—I defy him not to fall down, with his forehead in the dust, and acknowledge the presence of God.[6]

Likely the result of prodding by Neal, in 1828 Codman first exhibited his work at the prestigious Boston Athenaeum. Two years later Codman submitted seven paintings for exhibition at the Athenaeum, including *Pirate's Retreat*.[7] The *Portland Advertiser* boasted of Codman's critical success with his picture: "We observe that the critics of 'the Boston Athenaeum [*sic*] Gallery of Paintings' speak in strong terms of praise of Mr. Codman of this town.—'His "Pirate's Retreat" is one of the finest works in the Gallery.' We are glad to hear of his success abroad—it is the echo of what we have long heard at home."[8] In 1838 the Charitable Mechanic Association, founded twenty-three years earlier, held a fair that included a fine art component. Codman submitted thirty-six landscapes, including *Pirate's Retreat*. Since Neal wrote the catalogue, he seized the opportunity to praise the painting—declaring that it was a "picture which hundreds of years from to day, if it be in existence, will be sufficient to establish the reputation of the painter. Taken as a whole, it is one of the four or five best things he has ever produced."[9]

This romantic fantasy would also inspire the eminent Oliver Wendell Holmes. After seeing *Pirate's Retreat* on view at the Athenaeum in 1830 he wrote the following poem:

On a solitary coast,
* In quiet gloom it lay;*
A silent and a sombre place
* Half-hidden from the day.*
The tall cliffs rear their heads above,
* The grey rocks frown below;*
And the waves with a cold, dark-heaving swell,
* Idly around it flow.*
Here—the lone eagle love to build
* His far-off eyry high,*
The sea-bird rests his rapid wing,
* And away to the sunny sky!*

In the fir-shaded mountain caves
* That line this rocky glen,*
There dwelt of old a pirate band
* Of brave sea-nurtured men;*
Men who had lived in toil and care,
* And been where blood was spilt;*
For years by common danger bound,
* And stained by common guilt.*
Against all human-kind beside,
* In arms, from early youth;*
Each other's exile they had shared,
* And tried each other's truth!*

Away! Away! The pennons fly,
* The sails flap in the breeze;*
Swift onward, silent and alone,
* The light bark skims the seas.*
Fleet as the wild bird cleaves the air,
* It cuts the foaming water,*
Although upon its deck it bear
* The messengers of slaughter.*
Full many a league of dark blue sea
* It ploughs with rapid keel—*
A prize! There's gold within the purse,
* A die upon the steel!*

6 Sutton Island, Mount Desert, c. 1848

Oil on canvas, 22 x 27

Signed lower left, "A Fisher"

Museum purchase, 1960 (Roswell Dwight Hitchcock Fund), 60.1153

PROVENANCE: Mrs. Sumner Brown, Dedham, Massachusetts (grand-daughter of the artist); Childs Gallery, Boston, 1960

EXHIBITIONS: The Boston Athenaeum, Boston, 1856, no. 239; Colby College Art Museum, Waterville, Maine, 4 April–30 August 1970, Bowdoin College Museum of Art, Brunswick, Maine, 21 May–28 June 1970, and Carnegie Gallery, University of Maine, Orono, 8 July–3 August 1970, "Landscape in Maine 1820–1970"; Farnsworth Art Museum, "Inventing Acadia: Artists and Tourists at Mount Desert," 13 June–24 October 1999

REFERENCES: *Landscape in Maine (1820–1970)* (Waterville, Maine: Colby College Art Museum, 1970), 6, 7 (illus.); Fred B. Adelson, "Alvan Fisher in Maine: His Early Coastal Scenes," *American Art Journal* 18, no. 3 (1986): 71, 72 (illus.); John Wilmerding, *The Artist's Mount Desert: American Painters on the Maine Coast* (Princeton: Princeton University Press, 1994), 23, 24 (illus.), 185, no. 18; Pamela J. Belanger, *Inventing Acadia: Artists and Tourists at Mount Desert* (Rockland, Maine: Farnsworth Art Museum, 1999), 34 (illus.), 35

7 Camden Harbor, 1846

Oil on canvas, 29¼ x 36⅛

Signed and dated lower left,
"A Fisher / 1846"

Gift of Mrs. Elizabeth B. Noyce, 95.27

PROVENANCE: Shipmasters Gallery, Bath,
Maine, 1993; Mrs. Elizabeth B. Noyce,
1994–95

EXHIBITIONS: Farnsworth Art Museum,
17 July–18 September 1994 and Portland
Museum of Art, Maine, 29 October
1994–20 January 1995, "An Eye for
Maine"; Portland Museum of Art, Maine,
"A Legacy for Maine: Masterworks from
the Collection of Elizabeth B. Noyce,"
1 October 1997–4 January 1998

REFERENCES: Donelson Hoopes, *An Eye
for Maine* (Rockland, Maine: Farnsworth
Art Museum, 1994), 12, 20 (illus.);
Donelson Hoopes, "Two Centuries of
Maine Art," *Island Journal* 11 (1994):
47, 50 (illus.); Jessica F. Nicoll, *A
Legacy for Maine: The November
Collection of Elizabeth B. Noyce*
(Portland, Maine: Portland Museum
of Art, 1997), 26 (illus.), 62

Fitz Hugh Lane (1804–1865)

8 Camden Mountains from the South Entrance to the Harbor, 1859

Oil on canvas, 22⅛ x 36¼

Signed and dated lower right, "F H Lane 1859"

Bequest of Mrs. Elizabeth B. Noyce, 97.3.30

PROVENANCE: Mrs. William J. Underwood, Newport, Rhode Island, 1954; Vose Galleries, Boston, 1954; New England estate (William H. Claflin), 1954–91; Sotheby's, New York, 1991; Mrs. Elizabeth B. Noyce, 1992–96; Estate of Mrs. Elizabeth B. Noyce, 1996–97

EXHIBITIONS: Farnsworth Art Museum, 17 July–18 September 1994, and Portland Museum of Art, Maine, 29 October 1994–22 January 1995, "An Eye for Maine"; Portland Museum of Art, Maine, 1 October 1997–4 January 1998, and Farnsworth Art Museum, 12 April–14 June 1998, "A Legacy for Maine: Masterworks from the Collection of Elizabeth B. Noyce"

REFERENCES: John Wilmerding, *Fitz Hugh Lane, 1804–1865: American Marine Painter* (Englewood Cliffs, N.J.: Salem Press, 1964), 56, no. 24; John Wilmerding, *Fitz Hugh Lane* (New York: Praeger Publishers, Inc., 1971), 66, 68, (illus., no. 63); Donelson Hoopes, *An Eye for Maine* (Rockland, Maine: Farnsworth Art Museum, 1994), 4 (illus.), 5, 8, 12; Christopher Crosman and Peter Ralston, "An Eye for Maine: One Collector's Embracing Passion for the Art of Maine," *Island Journal* 11 (1994): 46; Donelson Hoopes, "Two Centuries of Maine Art," *Island Journal* 11 (1994): 51 (illus.); Jessica F. Nicoll, *A Legacy for Maine: Masterworks from the Collection of Elizabeth B. Noyce* (Portland, Maine: Portland Museum of Art, 1997), 63 (illus.), 69

In the mid- to late 1850s Fitz Hugh Lane began to produce more complex and nuanced paintings like *Camden Mountains from the South Entrance to the Harbor*—an intense vision of a traditional maritime wilderness soon to pass into history with the arrival of the steamboat. Although he is regarded today as a central figure in American landscape painting, in his own time Lane was comparatively little known. He exhibited in Boston and Gloucester, and only occasionally in New York at the American Art-Union. Since he worked in relative isolation in Gloucester, Lane was only distantly influenced by Thomas Cole and developments in landscape painting as practiced by the artists of the Tenth Street Studios Building, and Lane's pictures received little contemporary comment in the press. However, the artist did have important patrons who were well connected in the New York art world; because of this, he recast his art in response to his experiences in Maine and the art market conditions that prevailed during the 1850s. At the time of his death, Lane's paintings were praised for their "perfect accuracy in all the details of marine architecture and thought and true natural position on the canvas and complete equipment of vessels." It was Lane's faithfulness in the delineation of vessels that "procured him orders [for paintings] from the largest ship owners of New York and Boston, who did not consider their country rooms (and even their parlors sometimes) furnished, without one of Lane's paintings of some favorite clipper."[1]

Clarence Cook, the art critic of the weekly New York newspaper the *Independent*, one of the few who took interest in Lane, urged him to send pictures "to New-York for exhibition. It could not fail to make an impression, and to call forth criticism. A finer picture of its class was never in the Academy." Cook, who was to become one of New York's most powerful art critics, wrote: "Mr. F. H. Lane, whose name ought to be known from Maine to Georgia . . . in knowledge, feeling, and skill, has had no rival, certainly in America, and I doubt if more than two abroad."[2] However, Cook was also critical:

Four years ago, I was doubtful if I should find in Mr. Lane the poetical element that must be a constituent in the artist's mind . . . something in them too hard and practical to permit enthusiastic admiration: the water was salt, the ships sailed, the waves moved, but it was the sea before the Spirit of God moved upon the face of the deep. . . . Lane knows the name and place of every rope on a vessel; he knows the construction, the anatomy, the expression—and to a seaman every thing that sails has expression and individuality—he knows how she will stand under this rig.[3]

Cook was emphatic about what he believed was sorely lacking in Lane's painting, declaring that he "missed in them the creative imagination of the artist."[4] Lane heeded the critic's advice, and by the mid-1850s the artist had probably been introduced to the transcendentalism of Ralph Waldo Emerson, perhaps in lectures in Gloucester or Boston, and he had definitely absorbed Frederic E. Church's Calvinist ideas of representing transcendence visually. Paintings like *Camden Mountains* dramatically demonstrate Lane's development as he became increasingly connected to national art production centered in New York.

Penobscot Bay was a favorite subject for Lane, and in 1855 Lane joined his friend, the yachtsman Joseph L. Stevens, Jr., on an extended trip along the Maine coast, sketching at Camden and Owl's Head, which was the last trip to Maine Lane would make until 1863.[5] *Camden Mountains* highlights a heavily laden Maine lumber schooner, the type of vessel sometimes referred to as a hermaphrodite brig, or half brig, or even packet brig because of its adaptation to coastal economic needs and sailing conditions. Its central position announces its importance as a primary figure of Lane's visual narrative; the second most important is the steamboat at dock in the distance. Lane also demonstrated his attention to minute details in the particular way he represented the anchored vessel, and the turning blocks, ratlines, stays, and running rigging. While adding imagination and sentiment to please critics and to make his art more competitive, Lane still looked to the life of the sea in ships. His patrons' emphasis on factual detail could not entirely overshadow his new interests in producing a more cosmopolitan, sophisticated style of painting.

Lane's *Shipping in Down East Waters*, painted five years earlier, is a closely observed image of maritime practices in Maine during the heyday of the lumber schooners. In the center a deeply drafted brigantine is laden to the gunnels with its cargo of finished lumber products. Lane's image of a luminous sunset and calm waters reassured owners of such merchant vessels that their valuable and costly vessels would continue to return a profit and, seen from a larger perspective, emphasized the industry and importance of lumbering to the local and national economy during the period.

P. J. B.

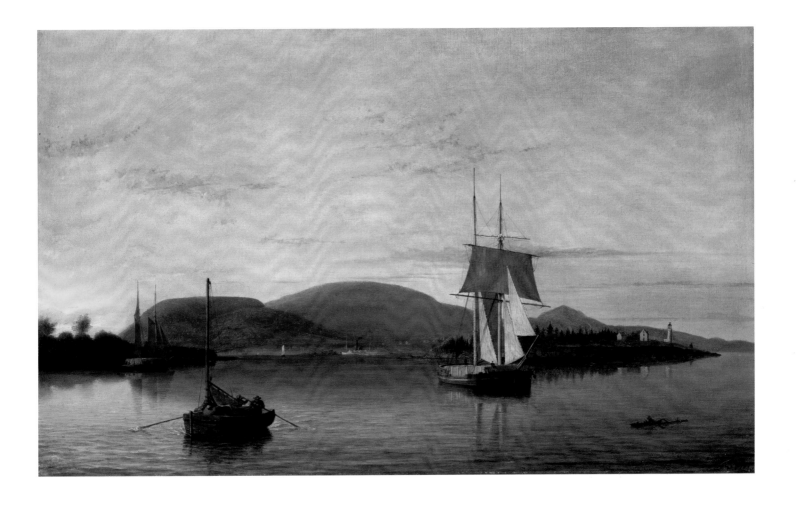

9 Shipping in Down East Waters, 1854

Oil on canvas, 17¾ x 29¼

Signed and dated lower right, "F. H. Lane 1854"

Museum purchase, 60. 1172

PROVENANCE: Childs Gallery, Boston, 1960

EXHIBITIONS: Farnsworth Art Museum, "Fitz Hugh Lane: 1804–1965," 12 July–15 September 1974, no. 40; National Gallery of Art, Washington, D.C., 15 May–5 September 1988, and Museum of Fine Arts, Boston, 5 October–31 December 1988, "Paintings by Fitz Hugh Lane," no. 32; Farnsworth Art Museum, "Inventing Acadia: Artists and Tourists at Mount Desert," 13 June–24 October 1999

REFERENCES: *Fitz Hugh Lane: 1804–1865* (Rockland, Maine: Farnsworth Art Museum, 1974), cover (illus.); John Wilmerding, *Paintings of Fitz Hugh Lane* (Washington, D.C.: National Gallery of Art, 1988), 90 (illus., 162); John Wilmerding, "Lure of the Maine Coast: Paintings by Fitz Hugh Lane," *Down East* (October 1988): cover (illus.); *Goodly Ships on Painted Seas: Ship Portraiture by Penobscot Bay Artists: William P. Stubbs, James G. Babbidge and Percy A. Sanborn* (Searsport, Maine: Penobscot Marine Museum; Rockland, Maine: Farnsworth Art Museum, 1988), 16 (illus.); Pamela J. Belanger, *Inventing Acadia: Artists and Tourists at Mount Desert* (Rockland, Maine: Farnsworth Art Museum, 1999), 92 (illus.), 92

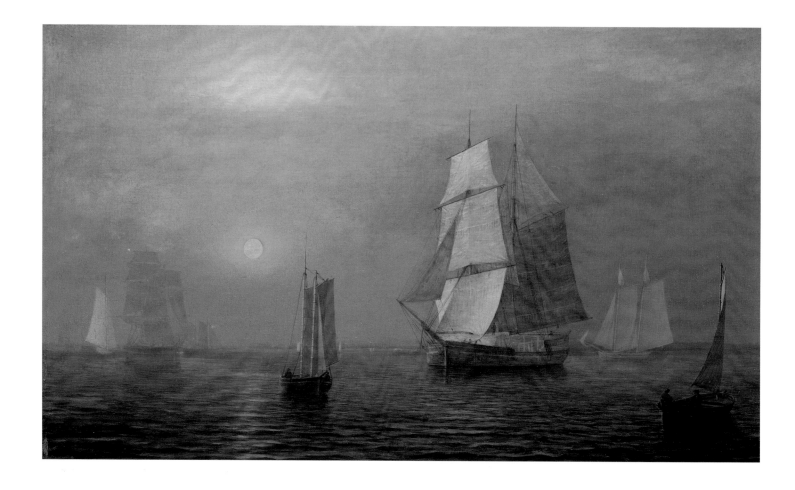

10 Owl's Head Light, Rockland, Maine, c. 1856

Oil on canvas, 20⅛ x 33⅛

Bequest of Mrs. Elizabeth B. Noyce, 97.3.31

PROVENANCE: Vose Gallery, Boston, 1983; Coolidge family, Manchester, Massachusetts, 1983–94; Shipmasters Gallery, Bath, Maine, 1994; Mrs. Elizabeth B. Noyce, 1994–96; Estate of Mrs. Elizabeth B. Noyce, 1996–97

EXHIBITIONS: Portland Museum of Art, Maine, "A Legacy for Maine: Masterworks from the Collection of Elizabeth B. Noyce," 1 October 1997–4 January 1998

REFERENCES: Jessica F. Nicoll, *A Legacy for Maine: Masterworks from the Collection of Elizabeth B. Noyce* (Portland, Maine: Portland Museum of Art, 1997), 69

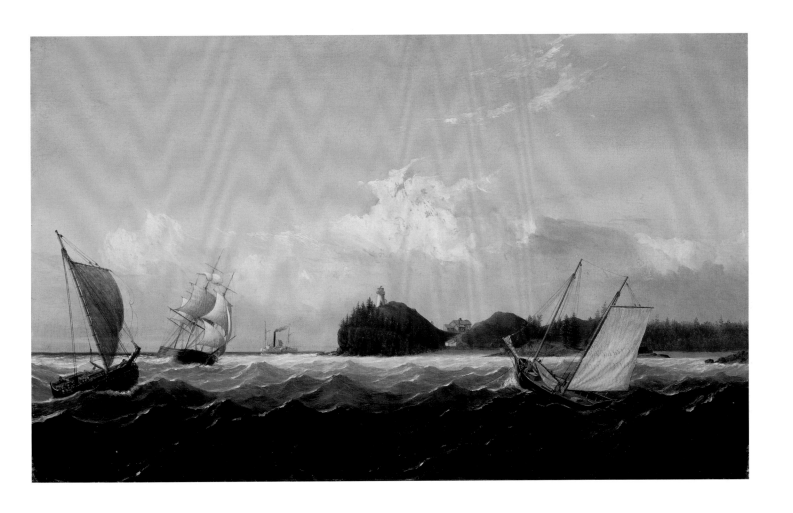

Martin Johnson Heade (1819–1904)

11 Storm Clouds on the Coast, 1859

Oil on canvas, 20 x 32¼

Signed and dated lower right, "M. J. Heade / 59"

Museum purchase, Charles L. Fox Fund, 65.1447

PROVENANCE: Henry Ward Beecher, 1859–63; George E. Davenport, Boston, 1863–1907; Mrs. Ralph Thompson (Davenport's daughter), until 1965; Vose Galleries, Boston, 1965

EXHIBITIONS: Museum of Fine Arts, Boston, 9 July–29 August 1969, University of Maryland Art Gallery, College Park, 14 September–23 October 1969, and Whitney Museum of American Art, New York, 10 November–21 December 1969, "Martin Johnson Heade," no. 7; The Lowe Art Museum, University of Miami, Coral Gables, Florida, "Nineteenth-Century Topographic Painters," 21 November 1974–5 January 1975, no. 54; Heritage Plantation of Sandwich, Sandwich, Massachusetts, "Images of the Land: 200 Years of Landscape Painting in North-eastern America," 1 May–20 October 1983, no. 19; The Monmouth Museum, Lincroft, New Jersey, "The Spirit of the Coast," 24 July–23 September 1984, no. 33; Amon Carter Museum, Fort Worth, Texas, 12 February–1 May 1994, Shelburne Museum, Shelburne, Vermont, 4 June–5 September 1994, and The Metropolitan Museum of Art, New York, 4 October 1994–8 January 1995, "Ominous Hush: The Thunderstorm Paintings of Martin Johnson Heade," no. 1

REFERENCES: *Catalogue of a Collection of Valuable Oil Paintings, Principally Painted by Eminent American Artists, Being the Property of the Rev. Henry Ward Beecher, To be Sold by Auction by D. W. Ives & Co.* (New York: Polhemus and DeVries, 1863), n.p.; Theodore E. Stebbins, Jr., *Martin Johnson Heade* (College Park, Md.: University of Maryland, 1969), n.p.; John Wilmerding, *Fitz Hugh Lane* (New York: Praeger Publishers, 1971), 76; *Nineteenth Century Topographic Painters* (Coral Gables, Fla.: The Lowe Art Museum, University of Miami, 1974), 29 (illus.); Theodore E. Stebbins, Jr., *The Life and Works of Martin Johnson Heade* (New Haven: Yale University Press, 1975), 65 (illus.), 66, 218 (illus.); *Images of the Land: 200 Years of Landscape Painting in Northeastern America* (Sandwich, Mass.: Heritage Plantation of Sandwich, 1983), n.p.; Sarah Cash, *Ominous Hush: The Thunderstorm Paintings of Martin Johnson Heade* (Fort Worth, Tex.: Amon Carter Museum, 1994), 12 (illus.), 24–25, 60 (illus.); Sarah Cash, "Martin Johnson Heade's Thunderstorm on Narragansett Bay," *The Magazine Antiques* 145, no. 3 (March 1994): 429 (illus.).

Martin Johnson Heade's *Storm Clouds on the Coast* plays a pivotal role in the artist's early career. The painting, depicting a storm gathering off a rugged coast, possibly that of Maine,[1] is the first of many seascapes the artist created.[2] Though he would become a prolific and skilled painter of landscapes, seascapes, and still lifes, at the time he painted *Storm Clouds* Heade was relatively inexperienced. Largely a self-taught artist, his minimal artistic training occurred in the late 1830s when he studied with the naive painter Edward Hicks, and possibly with his cousin Thomas Hicks, near Heade's native Lumberville, Pennsylvania. Heade then painted rather conventional portraits before taking up landscape painting in the mid-1850s. He had visited Europe twice and had also traveled extensively in the eastern and midwestern United States before establishing a studio in New York in 1859, when he painted *Storm Clouds*. He continued to move throughout most of his life, maintaining studios in Boston and Providence, Rhode Island, and traveling along the eastern seaboard to paint numerous salt marsh scenes. These works, along with the scenes of hummingbirds and orchids inspired by his three trips to South America and his cut flower still lifes, are those for which Heade is best known. In 1883 the artist married and forsook his frequent travels and northeastern roots to settle in St. Augustine, Florida.

In *Storm Clouds*, Heade employed a full range of brushwork and textural effects, signaling a departure from his earlier, less skillfully painted Rhode Island landscapes.[3] Despite this, the painting is still somewhat traditional in composition, style, and technique, and its tentative nature and somewhat awkward handling betray the artist's relative inexperience in the seascape genre. Foreground, middle ground, and background are discrete entities, although the long, crashing wave breaking dramatically over the large rocks at the right signals the transition from land to sea, and the long, sunlit rocky island and sailboats mark the transition from sea to sky. These three registers are similarly proportioned; the nearly identically sized triangular shapes of shore and sea fill slightly more than half the canvas and are balanced by the sky. Each of the three areas is enlivened in some way: the beach by the sandpipers and seaweed-laden rocks; the ocean by whitecaps; and

the sky by thick, gray storm clouds rising to envelop an otherwise bright sky. The overall mood is unsettling; despite the brightness of the shore and left portion of the sky, the two sailboats are clearly heading into the impending storm, not toward the safety of land. Heade's interest in depicting transitory light effects in thunderstorm views is evident here, as is his ability to create moods of uncertainty about the fates of vessels and their navigators.

Heade created one known pencil sketch for *Storm Clouds* (c. 1858–59, Collection of Spanierman Gallery, LLC, New York), which reveals much about his working methods.[4] In it, he has carefully delineated the rocks and trees, paying great attention to their shape and shading. Water is suggested only by a few loosely drawn horizontal lines around the rocks, and the sky is not filled in at all. Demonstrating a typical Hudson River School approach, in his studio the artist transformed these notations into the finished painting, adding choppy waves to the ocean and filling the sky with clouds. The rocks in the surf and on the shore have increased in number, and those at the left are now generalized and rounded rather than sharply faceted as in the drawing, though they retain their earlier configuration. Heade added the sandpipers and sailboats to the final scene for their anecdotal quality.

Storm Clouds on the Coast also plays an important role in Heade's oeuvre by introducing the series of at least eight coastal thunderstorm views he would paint over the course of the 1860s and culminating in his acknowledged masterpiece, *Thunder Storm on Narragansett Bay* (1868, Amon Carter Museum, Fort Worth). The group, which includes *Approaching Thunder Storm* (1859, The Metropolitan Museum of Art) and *Approaching Storm: Beach near Newport* (c. 1867, Museum of Fine Arts, Boston), may have been created by Heade and understood by his contemporaries as visual metaphors for the tumultuous years surrounding the Civil War and Reconstruction. The popular Congregationalist preacher Henry Ward Beecher, probably the first owner of *Storm Clouds on the Coast*, was one of many clergymen who, along with poets, were particularly sensitive to thunderstorm imagery during this period, using it extensively in their sermons and writings discussing the national crisis.[5]

s. c.

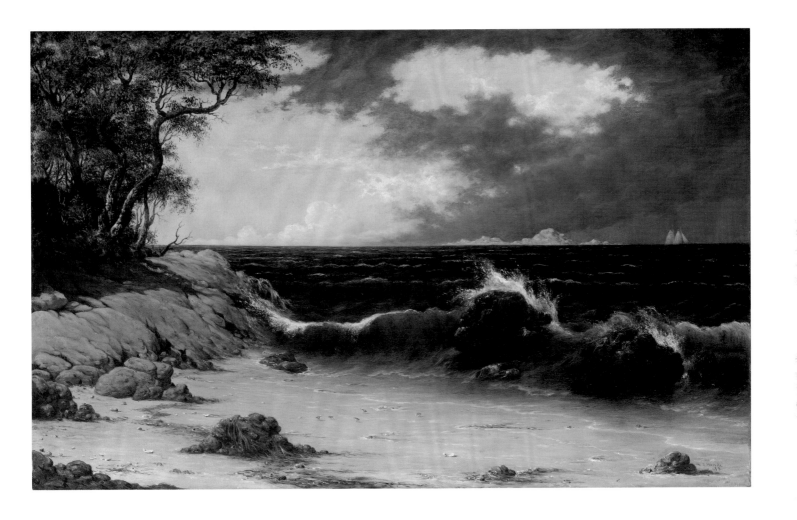

Sanford Robinson Gifford (1823–1880)

12 Rocks at Porcupine Island near Mt. Desert, 1864

Oil on canvas, 12½ x 9⅛

Museum purchase, 98.7

PROVENANCE: Terry DeLapp, Los Angeles, 1991; Christie's, New York, 1991; private collection; Questroyal Fine Art, LLC, New York, 1998

EXHIBITIONS: The Metropolitan Museum of Art, New York, "A Memorial Catalogue of the Paintings of Sanford Robinson Gifford, N.A.: Second Loan Exhibit, Winter 1880–81," no. 370; Thomas E. Kirby and Co., Auctioneers, New York, 1881, "The Gifford Collection, Part II," no. 123; Farnsworth Art Museum, "Inventing Acadia: Artists and Tourists at Mount Desert," 13 June–24 October 1999

REFERENCES: John F. Weir, *A Memorial Catalogue of Paintings of Sanford Robinson Gifford, N.A.* (New York: The Metropolitan Museum of Art, 1881; reprint, New York: Olana Gallery, 1974), 29, no. 370; *Catalogue: Part II of the Gifford Collection* (New York: Thomas E. Kirby & Co., 1881), 27; John Wilmerding, *The Artist's Mount Desert, American Painters on the Maine Coast* (Princeton: Princeton University Press, 1994), 130 (illus.), 131; Pamela J. Belanger, *Inventing Acadia: Artists and Tourists at Mount Desert* (Rockland, Maine: Farnsworth Art Museum, 1999), 101, 102 (illus.)

Sanford R. Gifford and his close friend from the New York Tenth Street Studios Building, Jervis McEntee, traveled to Mount Desert in the summer of 1864, during the Civil War. Gifford and McEntee had personal and professional reasons for visiting the island. Back from service at the front, Gifford needed a respite from army duty and the anguish of personal loss. His brother Edward had been captured during the Battle of New Orleans in 1863 during an extremely dangerous volunteer mission yet had escaped by heroically swimming across the Mississippi, but he later contracted typhoid and died. Gifford's other brother Charles had also been killed, at the outset of the war in 1861.

Gifford and McEntee had undoubtedly seen Frederic E. Church's impressive 1863 *Coast Scene, Mount Desert* (Wadsworth Atheneum) at the National Academy and perhaps had even seen it in process on Church's easel in his studio at Tenth Street. The painting had made everyone aware by means of its grand visual metaphor that New England's bedrock was indomitable and enduring, when all else seemed to be reckless madness. That *Coast Scene* was sold to New York's premier collector may have also sparked the artists' interest in capturing a few views of the island wilderness. For these reasons, as well as to escape from the heat of the city in July, they made the journey to the island to see for themselves its potential as scenery.

Gifford and his sister joined McEntee and his wife in Boston, where they proceeded north to Mount Desert by boat. They spent three weeks, from 14 July to 5 August, on the island, and Gifford filled two sketchbooks with pencil drawings and notations. Like Thomas Cole and Church before him, Gifford sketched the Porcupine Islands.[1] The physical exertion of exploring the island provided a good countermeasure to the background of frustration and dismay felt because of the immense toll of men and national treasure the war was taking. Gifford's brothers' deaths must have weighed heavily as he escaped to the pure air and clear, crisp light of northern New England. His destination also had distinct patriotic overtones. His friend Edmund C. Steadman went to New England to summer, declaring, "Goodbye New York. I go to a region where there are patriots still!"[2]

On his return to New York Gifford began to make oil studies of the island scenery including *Rocks at Porcupine Island near Mt. Desert*, which depicts dramatic cliffs, waves crashing against rocks, swirling seabirds, and massive rock faces that loom above the sea's surface.[3] A reporter for the *Boston Evening Transcript*, after interviewing Church while at work in his studio, turned his attention to Gifford's recent productions. "Then we climbed another flight to Gifford's studio. Here we saw a number of charming coast studies, chiefly from the neighborhood of Mount Desert. These were very successful in the life and motion of the waves, and the effect of distance."[4] One year before Gifford completed *Rocks at Porcupine Island*, the art critic for the *New York Times* commented on some of his pictures at the National Academy exhibition, naming them "superb specimens of the misty style which is just now so fashionable." He urged "a little more botany and geology in the foreground of this picture is due to its otherwise transcendent merits." In fact, compared with other pictures, "there are neither rocks nor trees in this exhibition so badly painted as those which disfigure the foreground of this picture."[5] Gifford may well have responded to such criticisms, for even the small-scale study *Rocks at Porcupine Island* is carefully rendered with a crisp, highly detailed delineation of the rocky cliffs.

The next year Gifford summarized the experience of Mount Desert in one of his most important paintings, *The Artist Sketching at Mount Desert, Maine* (Collection of Jo Ann and Julian Ganz, Jr.). Gifford's situation exemplified the response of New York artists during the Civil War. His military service, personal experience of the war at the front, and loss of his brothers and friends made him acutely conscious of national civil violence. He responded not with paintings of heroic action, but images of "inaction"—restful landscapes enveloped in mist and golden vapor.

P. J. B.

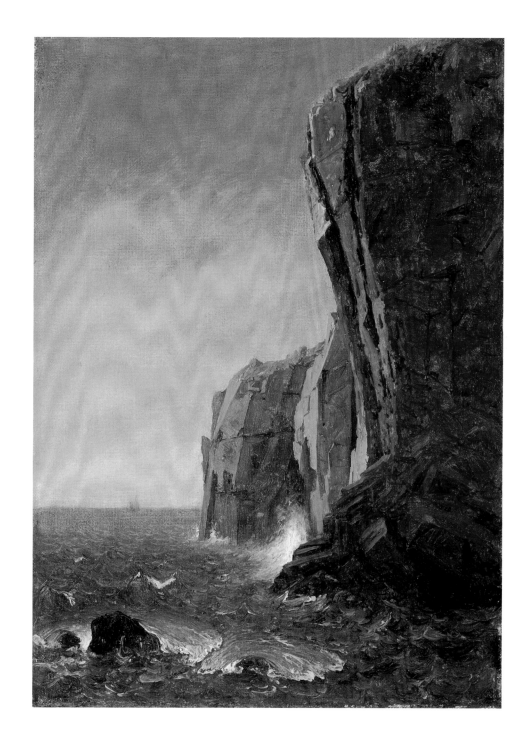

Jervis McEntee (1828–1891)

13 Flight of the Birds, 1866

Oil on canvas, 24 x 20 1/16

Signed and dated lower right, "JME (in monogram) 1866"

Gift of Mrs. Dorothy Hayes, 59.1180

PROVENANCE: Jervis McEntee to Walter Brown, Esq.; remained in the Brown family

EXHIBITIONS: National Academy of Design, New York, 1866, no. 449

REFERENCES: Henry T. Tuckerman, *Book of the Artists* (New York: G. P. Putnam & Son, 1867), 545

A somber image of a flock of birds returning to roost at twilight, by the Hudson River School painter Jervis McEntee, can be interpreted as a visual meditation on the national mood of weariness that followed the end of the Civil War. Painted in 1866, and probably the work McEntee exhibited at the National Academy of Design that year under the title *Flight of the Birds,* the image of a forlorn landscape without human figures resonates with melancholy sentiments of national promise deferred. The Farnsworth picture is related to *The Return of the Birds* and *The Departure of the Birds,* two works that McEntee exhibited in 1861 and 1862 at Young Men's Association, Troy, New York.[1] The associative ability of images of departure and return to convey complex symbolic messages was a well-established convention in mid-nineteenth-century American landscape painting thanks to the example of Thomas Cole. Departure and return were narrative devices often used by Cole's followers, especially Frederic Edwin Church, with whom McEntee had studied.[2]

In the Farnsworth painting, produced a few years later in 1866 at the conclusion of the traumatic Civil War, McEntee reprised the symbolism of birds returning to their nests at the end of the day. This image would have been readily understood by McEntee's audience as an emblem for souls of the dead returning to their resting places—an idea long sanctioned in Western painting.[3] Like Winslow Homer's *The Veteran in a New Field* (1865, The Metropolitan Museum of Art), McEntee's image speaks in the language of Ruskinian naturalism of the end of national conflict. The dominant sentiment of McEntee's picture is one of exhaustion and sadness. In the foreground, the remains of a ruined fence provide the only hint of previous human occupation in this lonely place. Yet the upright form of the forlorn fence post is cunningly contrived by McEntee to intersect a sapling with bright, blood-red autumn leaves. The motif of a natural cruciform carried a special burden of meaning

for artists of the Hudson River School and their audiences because of well-known precedents of Cole's and Church's use of this symbolic device.[4] For McEntee, subtly constructing a painted metaphor at the close of the Civil War, the return of birds to a desolate autumnal landscape holds forth a special promise of hope for the audience of his image possessing "eyes to see and minds to understand." The natural cross symbolizes the Christian promise all souls yearn for—the hope of life everlasting. Not coincidentally, one small emblematic bird has come to rest on the outstretched arm of this natural cruciform.[5]

McEntee's propensity for imbuing his landscapes with such special sentiment was recognized by his contemporaries. Henry T. Tuckerman, sometimes called the "American Vasari," wrote: "McEntee is fond of rendering landscape subservient to, or identical with, a special sentiment or general fact of interest." Tuckerman's commentary on another work by McEntee might well apply to the Farnsworth picture: "A 'Late Autumn' by McEntee is a variation on the theme which the pressure of orders has forced so often from this artist. This picture has all that sadness which was seen in his popular work, 'The Melancholy Days Have Come,' and more than that, for it possesses the thought of the resurrection, and the new life, too, in a brighter future."[6] In his eulogy for McEntee, his artist-colleague John F. Weir compared McEntee to the poet William Cullen Bryant, adding, "The painter found his theme in the late autumn, when the landscape is subdued in tone and the glories of the year have faded. In treating themes of this kind his art was quite perfect, evincing a subdued, yet intense, enjoyment of nature in her graver moods."[7] McEntee's close friend Worthington Whittredge recalled his work as "born of his peculiar disposition, which was not gloomy, but tinged with a gentle melancholy. They were poems. No painters of the period stamped his individuality upon his work more strongly than did McEntee."[8]

McEntee was fortunate to have been Church's only student early in Church's career, from 1850 to 1851. Although he never attained the great celebrity of his teacher, McEntee

earned a modest success with slow if steady sales in the very competitive New York market for landscape painters.[9] McEntee was accepted by the National Academy of Design, where he exhibited regularly from 1861 to 1890. He was a thirty-year tenant of the famed Tenth Street Studios Building, which put him at the center of the community of landscape painters in New York, and he was an active member of the elite Century Club. His closest friends were the leading artists of the Hudson River School, Sanford R. Gifford with whom he traveled to Europe, Eastman Johnson, John F. Weir, and Worthington Whittredge. McEntee's voluminous diary, which he kept for the last twenty years of his life, is a rich source of information about the art, patronage, and politics of the period, although McEntee was a staunch defender of the old guard, and deeply distrusted newer approaches that began to permeate the culture of American art following the Civil War.[10] McEntee, a native son of the Hudson River Valley, was born in Roundout, New York, in 1828, the son of an engineer who had helped plan the Erie Canal. After an unsuccessful attempt at a career in business, McEntee moved to New York where he opened a studio in 1858 and entered the profession of landscape artist. He died in Roundout in 1891.

J. G. S.

George Inness (1825–1894)

The Farnsworth Museum is fortunate in having acquired two important paintings by George Inness. *Sunrise* of 1860 is an early work that descended in the family of the original patron, while *In the White Mountains, Summer* exemplifies Inness's oil sketches in plein air. Both works were completed in the two years preceding the outbreak of the Civil War. This was a critical period of artistic growth for the artist, during which he began to transform the Hudson River School style of painting in which he had been trained. *Sunrise,* the larger and more important of the two works, was commissioned by the Reverend Dwight Roswell Hitchcock, a leading minister in Brooklyn and president of the Union Theological Seminary in New York for twenty-five years beginning about 1860.

A fascinating exchange of letters documents Hitchcock's acquisition of *Sunrise.* These contemporaneous texts provide an artistic and cultural context for the picture documenting Inness's emerging aesthetic concerns. On 15 November 1860 Inness wrote to Hitchcock, following an earlier meeting with the Reverend and his wife. "I suppose that you have a desire to possess one of my pictures at some future point, should you at any time act upon such a desire, I should be pleased if you would commission me directly instead of purchasing through another [dealer]."[1] At this time, Inness was only thirty-five, and he had been painting professionally for about fifteen years. In the early summer of 1860 he had moved to Medfield, Massachusetts, near Boston, in search of rural solitude, inspiration, and perhaps convalescence from stress. The year 1860 was an important one for the artist, according to the Inness scholar Nicolai Cikovsky, Jr. Some of his best works from that year exhibited a new creative energy and assertiveness.[2] This new spirit appears dramatically in his confident letter to the Reverend Hitchcock. Inness continued, "I could promise to give you a much better picture than any you have seen of mine at such a price as you might consider yourself justified in paying. Nothing would please me more than to have one of my best efforts in your possession for I know no one in whose hands a good picture painted by myself would led to greater profit."

Inness's appeal to the minister came only two weeks later on, 2 December 1860, when the painter responded to Hitchcock. Inness indicated that a painting he had begun in June was almost finished. "Although I had intended to ask considerably more than the amount of your commission $100. I determined that if it finished to my satisfaction I would send it to you."[3] He went on quickly to add:

Of course I cannot say that my desires are perfectly realized but the picture in all its subjective qualities pleases me better than anything that I have as yet painted. I consider this subjective the strong side of all morning and evening effects. And to me in most of my moods the charming side of everything. . . . The effect of my picture is to represent the sunrise.[4]

The subjective, or emotional, aspect of sunrise and sunset was an element of landscape painting that Inness had been deeply impressed by when he visited France in 1853–54. It was there that he first encountered the work of the artists who painted intimate, poetic scenes of the rapidly disappearing rural life around the Forest of Fontainebleau. They constituted a school of artists known today as the Barbizon painters.[5] Inness found in their quiet, pastoral scenes the kind of imagery that he would fully develop in the course of his later career. Yet his first efforts were hesitant and even awkward, and it was not until 1860 that Inness successfully transformed the style in his personal manner.

J. G. S.

14 Sunrise, 1860

Oil on canvas, 15 x 26⅛

Signed and dated lower right, "G. Inness 1860"

Gift of Mrs. Mary A. Boudreau, Ocean Point, Maine, in memory of Roswell Dwight Hitchcock, 57.1062

PROVENANCE: Collection of the artist; purchased by Reverend Roswell Dwight Hitchcock, 1860; remained in the Hitchcock family

EXHIBITIONS: The Fitchburg Art Museum, Fitchburg, Massachusetts, "The Maine Connection: Paintings and Sculpture from the Farnsworth Art Museum," 21 November 1993–27 January 1994

14a In the White Mountains, Summer, 1859

Oil on canvas, 10⅛ x 18⅛

Museum purchase, 44.339

John Joseph Enneking (1841–1916)

15 Mount Kineo, Moosehead Lake, Maine, 1871

Oil on canvas, 16¹⁵/₁₆ x 30⅛

Signed and dated lower right, "Enneking 71"

Museum purchase, 63.1277

PROVENANCE: Estate of the artist to Vose Galleries, Boston, 1962

EXHIBITIONS: Vose Galleries, Boston, "Paintings by John J. Enneking, 1840–1916: The First Comprehensive Exhibition of His Work in 35 Years," February 1962, no. 210; Brockton Public Library, Brockton, Massachusetts, "Exhibition of Paintings by John J. Enneking," 9–30 April 1962, no. 14

REFERENCES: *Paintings by John J. Enneking, 1840–1916: The First Comprehensive Exhibition of His Work in 35 Years* (Boston: Vose Galleries, 1962), n.p.

When John Joseph Enneking painted *Mount Kineo, Moosehead Lake, Maine*, he had recently married Mary E. Elliott, who was from Corinna, Maine. Mary would have known well the picturesque scenery of the popular tourist destination of Moosehead Lake and likely influenced her new husband to visit it in the summer of 1871. Corinna was only six miles from Dexter, "the terminus of the branch railroad which connects with the Maine Central" that brought tourists to Mount Kineo.[1] This area and its attractions had already been publicized eighteen years earlier. In 1853 both James Russell Lowell and Henry D. Thoreau visited Mount Kineo. Lowell's published account in *Putnam's Magazine*, entitled "A Moosehead Journal," contains a description of an excursion up Kineo. "The climb is very easy, with fine outlooks at every turn over lake and forest. Near the top is a spring of water, which even Uncle Zeb might have allowed to be wholesome. The little tin dipper was scratched all over with names, showing that vanity, at least, is not put out of breath by the ascent."[2] Thoreau visited in September, one month after Lowell, boarding the steamer Moosehead at Greenville to Mount Kineo. In fact, a few years earlier, in 1848, Thoreau's article "Ktaadn and the Maine Woods" was published in the *Union Magazine*.[3]

In the years after the Civil War, the tourism industry grew rapidly, owing in large measure to improved transportation. Like Bar Harbor, Mount Kineo, Moosehead Lake, and several other locations in Maine developed as tourist destinations. The summer visitors were desperate to escape the heat, disease, and pressures of life in northeastern urban centers and sought physical and spiritual rejuvenation at watering places like Mount Kineo and Moosehead Lake, which were popularized in print. Just before Enneking's trip to Kineo, a long poem by George B. Wallis, "The Lovely Rivers and Lakes of Maine," was published in *Harper's Weekly*.[4] In 1875 a major travel article entitled "Moosehead Lake" appeared in the *Harper's New Monthly Magazine*:

> *Moosehead Lake lies in the heart of Maine, and in the depths of its wilderness. It is thirty-six miles from Dexter, the terminus of the branch railroad which connects with the Maine Central, and is reached by excellent stages through a country which rolls up wild mountains as you proceed. . . . The lake is gemmed with numerous small wooded islands. . . . The pioneer village of Greenville—a hundred and twenty-five houses, with hotels, stores, post-office, and meeting-house—lies at your feet, the limit of civilization in North-western Maine. Beyond this point there are not more than a dozen houses on the lake; nothing between you and the St. Lawrence but "The howling wilderness."*[5]

After describing the bumpy stage ride to Greenville, the article detailed the scenic and more comfortable steamer trip to Kineo. "The Lady of the Lake, with steam up, is waiting at the wharf for the passengers to Mount Kineo, twenty miles distant. . . . Away forty miles to the east the seamed and hoary side of Katahdin comes in sight, unlike any thing else in the range of the eye."[6]

Enneking was well known for his autumnal canvases and impressionistic palette that dramatized the purity of nature:

> *Enneking has a belief, it may be styled a religion: it recognizes the spiritual constitution of life, and seeks to reflect the conception of his soul's ideality. He aims to paint types of figures, of landscapes, and of clouds, not as reproductions but as interpretations, thereby hiding the machinery and appealing to the imagination. . . . His work is as much in the way of prophecy as history.*[7]

Mount Kineo, Moosehead Lake, Maine is an unusual early work and an excellent example of Enneking's initial style. This more conventional Hudson River School composition is, however, painted in a looser style that anticipates the artist's later development and commitment to impressionism. In the foreground he positions two tourists who survey this grand view of Kineo, the lake, and leisure sailboats on a perfectly calm summer day. In the center of painting, the artist highlights the comforts of this tourist destination—the hotel at the foot of the mountain and the steamer that ferried passengers to and from the hotel. Enneking must have been enchanted with the state because in 1876 he purchased a house in Newry, Maine, where he summered with his family until he died.

P. J. B.

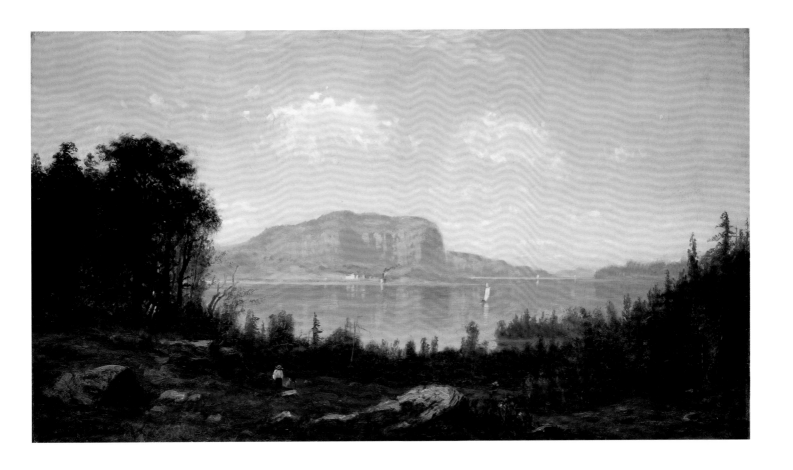

Washington Allston (1779–1843)

After Washington Allston returned to America in 1818, he continued to produce works in the grand historical style with Old Testament subjects that had been successful for him in England and that helped to reestablish his reputation in Boston. Allston's correspondence to friends in England clearly shows his enthusiasm for themes from Scripture. In May 1821 he mentioned three major biblical works, including *Miriam the Prophetess*,[1] and described the bold monumental figure of Miriam as "singing her song of triumph, large as life."[2] Another letter claims *Miriam* to be the "best I have ever painted," even describing background details of the "shore of the Red Sea, and on it the wreck of Pharaoh's army."[3]

Allston had been commissioned in 1820 by the wealthy philanthropist David Sears to paint a portrait of his wife Miriam.[4] Basing his composition on the biblical text, Allston visualized the song of triumph with Miriam holding a timbrel (tambourine) in her left hand and dramatically gazing up to heaven in thanks for the downfall of Pharaoh.

And Miriam the prophetess, the sister of Aaron, took a timbrel in her hand; and all the women went out after her with timbrels and with dances.

And Miriam answered them, Sing ye to the Lord, for he hath triumphed gloriously; the horse and his rider hath he thrown into the sea. (Exod. 15:20–21)

The shore in the background is littered with dead bodies, yet the space around the figure of Miriam echoes the musical harmony of her song. The upward motion of her outspread arms suggests flight, her joyous dance a release from the earth. "Aerial in her movement,"[5] the prophetess expresses the idea that she belongs to another world.

In his own writings Allston argued that "the wildest visions of poetry, the unsubstantial forms of painting, and the mysterious harmonies of music, that seem to disembody the spirit," confirm that we are essentially "creatures of the air."[6] In explaining how this portrayal could be achieved technically, the artist described his glazing as a method that "not only gives harmony and atmosphere but takes away the appearance of paint."[7] His accomplishment was applauded in 1855 by Asher B. Durand, who admired his colleague's facility for rendering invisible any evidence of paint and brush, leaving "nothing but the glow of light and color," and acknowledging that "the less apparent the means and manner of the artist, the more directly will his work appeal to the understanding and the feelings."[8]

Shown initially in 1827 at the First Exhibition of The Boston Athenaeum, *Miriam* received significant critical attention when it was included in an exhibition of Allston's paintings at Harding's Gallery in Boston in 1839.[9] Oliver Wendell Holmes delighted in Allston's success in combining history painting and portraiture, "producing one clear and instant impression."[10] The artists' chronicler Henry T. Tuckerman called this exhibition "an epoch in the history of Art in the United States; it illustrated the genius of a native painter by the most perfect productions . . . 'Miriam' sounded the timbrel . . . and formed an inexhaustible object of contemplation." Elaborating on the nature of his contemplation, Tuckerman remarked:

And perhaps no better proof of their superiority could be adduced than this very fact, that they not only bear, but invite study, grow upon the imagination, and haunt the memory. There is sometimes a kind of beaming atmosphere radiated from the human countenance when fervent emotions warm its features. It is a kind of expressiveness which makes the halos around the saints and virgins of the old masters scarcely appear unnatural—the soulful intelligence to which the poet refers when he describes spiritual elements as informing the body "till all be made immortal"; the loveliness created by sentiment, that Wordsworth recognizes in the rustic heroine of whom he says, "beauty born of murmuring sound shall pass into her face."[11]

Even more perceptive is the commentary by Elizabeth Palmer Peabody, a leading Transcendentalist:

The inspired songstress seems to start out of hoar antiquity in all the flush of life; and her voice sounds over the dark sea of time, in which so many kings and warlike hosts have sunk under many waters, even as it sounded over the Red Sea and its victims,—loud, clear, triumphant. We cannot choose but hear. Mr. Allston is the only artist that has ever seemed to us to paint sound. . . . Miriam is singing,—there can be no mistake. The reverberation of her timbrel is in our ears. The earth, the near cloud of fire and smoke, re-echo her song. It mingles its exulting sound with the low moan of the Red Sea that, darkly and gloomily, bases the ringing melody of her voice, and whose hoarse murmur is also painted in the background.[12]

Allston was little interested in the actual historical story of the Exodus. Instead, he concentrated on inspiring viewers by making visible Miriam's song of triumph. These "painted" sounds could have inspired antebellum Protestants who believed that in stimulating a spiritual response the arts cooperated with religion in saving souls. Sarah Clarke, Allston's former student, responded much like Peabody: "One feels called to sing triumphal songs with Miriam, and not to stand idly looking. The magnetism of the artist at the moment of conception powerfully seizes the beholder."[13]

This reading of the painting conforms to the values and objectives of Allston's patron, David Sears. Shortly after Sears inherited the family fortune in 1816, he acknowledged the "duties and responsibilities of public spirit and the furtherance of religion and philanthropy" by becoming one of the prime founders of Saint Paul's Episcopal Church in Boston. In 1820, the year he commissioned Allston to paint *Miriam*, he established the Sears Trust for the continued maintenance of Saint Paul's—the parish to which Allston also belonged—funding designated in part for the promotion of sacred music there.[14]

Sears, like others of the Boston elite who were predominantly Federalist and wary of the rise of democracy in America, supported the resurgence of sacred music in the church as a means of channeling the passions and material desires of parishioners toward moral improvement. They believed that in stimulating a spiritual response the arts cooperated with religion in saving souls. Allston's *Miriam* was emblematic of this purpose, its ethereal figure an instrument that could be seen, heard, and felt as the inflection of the soul and its expression of God.[15]

P. J. B.

16 Miriam the Prophetess, 1821

Oil on canvas, 63⅝ x 47½

Signed and dated lower left,
"W. Allston / A.R.A. / 1821"

Gift of Mrs. Miriam Sears Minot and
Mr. Richard D. Sears, 57.1092

PROVENANCE: Commissioned by David
Sears, Boston, 1820; remained in the
Sears family

EXHIBITIONS: The Boston Athenaeum,
"First Exhibition of Paintings in the
Athenaeum Gallery," 1827, no. 30, "The
Prophetess, / 'Sing ye to the Lord, for
he hath triumphed gloriously; the horse
and his rider hath he thrown into the
sea.' / Exodus, 15c. 21v"; The Boston
Athenaeum, "Fifth Exhibition of Paintings
in the Athenaeum Gallery," 1831, no. 28,
"Miriam, / 'Sound the loud timbrel o'er
Egypt's dark sea, / Jehovah has triumphed,
his people are free'"; Harding's Gallery,
Boston, "Exhibition of Pictures Painted
by Washington Allston at Harding's
Gallery," 1839, no. 3, "The Triumphal
Song of Miriam on the Destruction of
Pharaoh and his Host in the Red Sea /
'Sing ye to the Lord, for he hath tri-
umphed gloriously; the horse and his rider
hath he thrown into the sea.' Exodus,
Ch. XV"; The Boston Athenaeum,
"Exhibition of Paintings for the Benefit
of the French," 1871, no. 159; The Boston
Athenaeum, "Forty-seventh Exhibition
of Paintings at the Athenaeum Gallery,"
August 1871, no. 212; Museum of Fine
Arts, Boston, 11 December 1979–3
February 1980, and Pennsylvania
Academy of the Fine Arts, Philadelphia,
28 February–27 April 1980, "'A Man of
Genius': The Art of Washington Allston
(1779–1843)"; The Currier Gallery
of Art, Manchester, New Hampshire,
"Masterworks by Artists of New
England," 3 April–16 May 1982

REFERENCES: The Boston Athenaeum,
*Catalogue of the First Exhibition of
Paintings in the Athenaeum Gallery:
Consisting of Specimens by American
Artists, and a Selection of the Works of
the Old Masters* (Boston: Press of
William W. Clapp, 1827), n.p.; The
Boston Athenaeum, *Catalogue of the Fifth
Exhibition of Paintings in the Athenaeum
Gallery* (Boston: Press of John H.
Eastburn, 1831), n.p.; *Exhibition of
Pictures Painted by Washington Allston
at Harding's Gallery* (Boston: John H.
Eastburn, 1839), 4; S. Margaret Fuller,
Papers on Literature and Art (New York:
Wiley and Putnam, 1846), 113–14; *The
Atlantic Monthly* 15, no. 88 (February
1865): 9, 131, 133; Henry T. Tuckerman,
Book of the Artists (New York: G.P.
Putnam & Son, 1867), 149; *Catalogue of
the Exhibition of Paintings for the Benefit
of the French* (Boston: Rand, Avery, &
Frye, 1871), n.p.; *Catalogue of the Forty-
seventh Exhibition of Paintings at the
Athenaeum Gallery* (Boston: Rand, Avery,
& Frye, 1871), 9; Moses Foster Sweetser,
Allston (Boston: Houghton, Osgood and

Company, 1879), 112; Jared B. Flagg, *The
Life and Letters of Washington Allston*
(1892; reprint, New York: Benjamin Blom,
1969), 167; Edgar Preston Richardson,
*Washington Allston: A Study of the
Romantic Artist in America* (Chicago:
University of Chicago Press, 1948), 137,
143–44, 208–09; William H. Gerdts and
Theodore E. Stebbins, Jr., *"A Man of
Genius": The Art of Washington Allston
(1779–1843)* (Boston: Museum of Fine
Arts, 1979), 122–23, 122 (illus.); Robert
M. Doty, *Masterworks by Artists of New
England* (Manchester, N.H.: The Currier
Gallery of Art, 1982), n.p.; David Bjelajac,
*Millennial Desire and the Apocalyptic
Vision of Washington Allston* (Washington,
D.C.: Smithsonian Institution Press, 1988),
8, 37 (illus.), 135–38, 141 (illus.), 142, 145,
147; Diane Apostolos-Cappadona, "The
Spirit and the Vision: The Influence of

Romantic Evangelicalism on Nineteenth-
Century American Art," Ph.D. diss.,
Georgetown University, 1988, 196,
199–200; David Bjelajac, "Washington
Allston's Prophetic Voice in Worshipful
Song with Antebellum America," *American
Art* 5, no. 3 (Summer 1991): 68 (illus.),
70, 78–86; Mary Jo Viola, "Washington
Allston and His Boston Patrons: The
Exhibition of Pictures in 1839," Ph.D. diss.,
City University of New York, 1992, 124,
223 (illus.); Diane Apostolos-Cappadona,
*The Spirit and the Vision: The Influence
of Christian Romanticism in the
Development of Nineteenth-Century
American Art* (Atlanta: Scholars Press,
1995), 80, 81 (illus.); David Bjelajac,
*Washington Allston: Secret Societies and
the Alchemy of Anglo-American Painting*
(Cambridge: Cambridge University Press,
1997), 150, 151 (illus.), 152–59

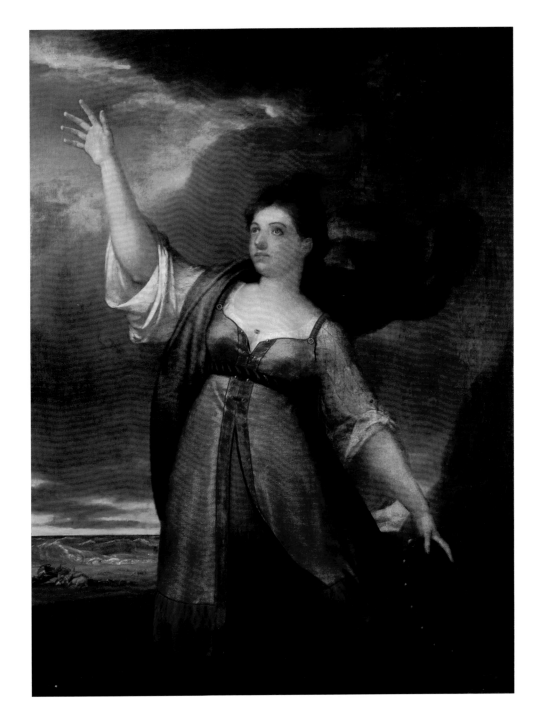

Thomas Sully (1783–1872)

For over fifty years Thomas Sully painted portraits of nearly all the prominent Philadelphians and their families. Sully's portraits were painted mostly for "families that had become affluent and deserted Quakerism for Assembly balls, the Philadelphia Club, and the fashionable Episcopal churches."[1] Sully left England and moved to Philadelphia in 1806 and worked there until he died in 1872. After Gilbert Stuart's death Sully was recognized as America's leading portrait painter. In his portraits of children like *Snider Children*, Sully's talents and interests for flattering his sitters led him to paint children clean-scrubbed, glowingly healthy, sweet-natured, and attentive—certain to please his patrons, the parents. Yet this portrait also subtly reflects the larger cultural issues surrounding the shifting social rules of conduct regarding children during the nineteenth century—namely, that children were no longer considered sinful creatures to be firmly disciplined but should be tenderly nurtured and loved. Raising children became a process of gentle guidance rather than that of conquering wills.[2]

Early in 1841 Sully was commissioned to paint this group portrait of the Snider children, which was included in the Pennsylvania Academy of the Fine Arts exhibition "Sixth Annual Exhibition of the Artist's Fund Society" the same year. A few years earlier he had completed portraits of the children's parents, Mr. and Mrs. Jacob S. Snider, Jr., of Philadelphia. Positioning Angelina, age eight, John Vaughn, age six, and Francis Huger, age four, in a vignette behind a table was typical of the artist's paintings of juvenile models. In fact, from the early 1820s, he often grouped multiple figures in this manner. He shows these children with seashells—likely a clever way the artist amused his young sitters. Sully was known to be "always delightful in any society" and was considered "especially charming in his studio. Sitters used to wish their posings prolonged for the sake of his conversation."[3]

Sully's handling of spatial elements had always been uncertain, and he preferred to show his subjects in shallow foreground spaces. In this work the background and setting are secondary to the figures—there is little suggestion of the room other than the table edge. A study of Sully's notebooks indicates a slow but decisive change in his method and style. From 1832 to 1838 the artist struggled to create more powerful portraits and retain the delicate balance between idealization and faithful likeness, and after 1839 his painting style became more harmonious.[4] Sully meticulously noted the details of his portrait production, including this one, in a register of paintings (The Historical Society of Pennsylvania): "Group of three children of Jacob Snider. Painting begun Feb. 3rd, 1841, finished March 26th, 1841. Signed 'TS 1841.'"

By 1840, with the increased number of portrait painters and the introduction of photography, Sully's portrait business decreased dramatically. However, he began to capitalize on the very thing that photography could not accomplish—he could paint flattering portraits, especially demanded by women (until 1841 Sully's portraits had been overwhelmingly of men).[5] Indeed, the artist was famous for his abilities:

He always seizes upon the redeeming element. . . . Sully's forte is the graceful. . . . He could realize upon canvas the mental as well as bodily portrait. . . . It seems a rule and habit with him never to send a disagreeable portrait from his easel. . . . He has an extremely dexterous way of flattering, without seeming to do so; of crystallizing better moments, and fixing happy attitudes. . . . They are invariably modest, refined, and graceful.[6]

Moreover, the art critic John Neal observed that not Thomas Gainsborough nor Benjamin West, in fact, "nobody ever painted more beautiful eyes."[7] Several years later, in his own book *Hints to Young Painters*, Sully advised that "in a portrait every part may be exactly rendered, but should be kept subordinate in regard to the face. From long experience I know that resemblance in a portrait is essential; but no fault will be found with the artist, (at least by the sitter,) if he improve the appearance."[8]

P. J. B.

17 Snider Children, 1841

Oil on canvas, 28½ x 36½

Signed and dated lower right, "T S (in monogram) 1841"

Gift of Mrs. Efrem Zimbalist, 62.1255

PROVENANCE: Jacob Snider, Jr., Philadelphia, 1841; John F. Braun, Merion, Pennsylvania, 1921; Efrem Zimbalist, Rockport, Maine, and Philadelphia, 1944–62

EXHIBITIONS: Pennsylvania Academy of the Fine Arts, Philadelphia, "Sixth Annual Exhibition of the Artists' Fund Society of Philadelphia," 1841, no. 25; Pennsylvania Academy of the Fine Arts, Philadelphia, "Memorial Exhibition of Portraits by Thomas Sully," 9 April–10 May 1922, no. 231; McClees Galleries, Philadelphia, Pennsylvania, "An Exhibition of Portraits by Thomas Sully," 28 April–20 May 1944, no. 41; Heritage Plantation of Sandwich, Massachusetts, "Young America: Children and Art," 12 May–27 October 1985, no. 5

REFERENCES: *Catalogue of the Memorial Exhibition of Portraits by Thomas Sully,* 2d ed. (Philadelphia: Pennsylvania Academy of the Fine Arts, 1922), 177; *An Exhibition of Portraits by Thomas Sully* (Philadelphia: McClees Galleries, 1944), n.p.; Edward Biddle and Mantle Fielding, *The Life and Works of Thomas Sully (1783–1872)* (Philadelphia, 1921; reprint, Charleston, S.C.: Garnier & Co., 1969), 277; *Young America: Children and Art* (Sandwich, Mass.: Heritage Plantation of Sandwich, 1985), 10, 41 (illus.)

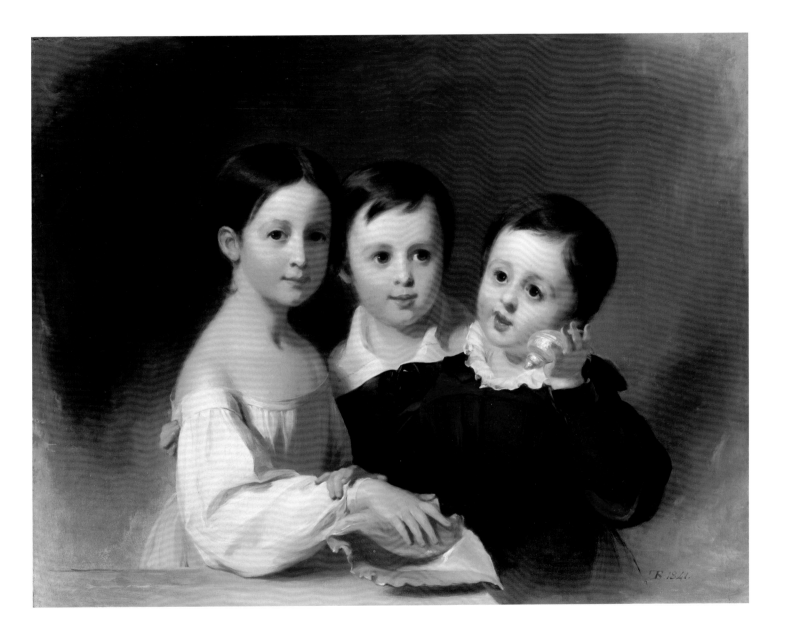

(Jonathan) Eastman Johnson (1824–1906)

18 A Boy in the Maine Woods, c. 1868

Oil on canvas, 12 x 20⅛
Signed lower right, "E. J." (in monogram)
Bequest of Mrs. Elizabeth B. Noyce, 97.3.23

PROVENANCE: Estate of the artist, 1906; American Art Galleries, New York, 1907; Kennedy Galleries, New York, 1967; Richard Dupont, Wilmington, Delaware, 1968; Sotheby's, New York, 1992; Mrs. Elizabeth B. Noyce, 1992–96; Estate of Mrs. Elizabeth B. Noyce, 1996–97

EXHIBITIONS: American Art Galleries, New York, "Estate of the Artist" 22–23 February 1907, no. 99; Farnsworth Art Museum, 17 July–18 September 1994 and Portland Museum of Art, Maine, 29 October 1994–22 January 1995, "An Eye for Maine," no. 8; Farnsworth Art Museum, "Legacy for Maine: Masterworks from the Collection of Elizabeth B. Noyce," 12 April–14 June 1998

REFERENCES: Donelson Hoopes, *An Eye for Maine* (Rockland, Maine: Farnsworth Art Museum, 1994), 8, 25 (illus.); Jessica F. Nicoll, *A Legacy for Maine: The November Collection of Elizabeth B. Noyce* (Portland, Maine: Portland Museum of Art, 1997), 68

Eastman Johnson celebrated the virtues of American rural life in many of his most popular works throughout a long career as one of the country's foremost genre painters. Along with other successful genre painters from William Sidney Mount to Winslow Homer and Thomas Waterman Wood, Johnson treated nostalgic themes of a powerful American mythology, the Jeffersonian ideal of the independent farmer working his own land, although that ideal had long since ceased to represent the true state of affairs in the United States.[1] In earlier works such as *The Barefoot Boy,* 1860 (Sotheby's New York), *Corn-Husking,* 1860 (Everson Art Museum, Syracuse, New York), and *Winnowing Grain,* 1860–80s (Museum of Fine Arts, Boston), as well as the immensely successful, *Old Stagecoach,* 1871 (Layton Art Gallery Collection, Milwaukee Art Center), Johnson responded to his urban patrons' nostalgia for the simpler life they associated with the earlier years of the country.[2] In the years between the Civil War and the centennial celebration of 1876, this taste for images drawn from the past had been intensified as American citizens tried to mend the fabric of a national pride rent by war.[3] Paintings with nostalgic subject matter could easily become trivial and sentimental; in Eastman Johnson's work, on the contrary, such images drawn from the past are often "transformed by an impressive sobriety of vision," which gives them a special dignity and force.[4]

Born in Maine, Eastman Johnson grew up in Lovell, Fryeburg, and Augusta, where his father held a post in state government. However, after extensive painting experience abroad in Germany, Holland, and France, Johnson later settled in New York, where he became an important figure in both the art community and social circles. He established his reputation as a genre painter with a country farmyard scene, *Life in the South,* 1859 (New York Historical Society), indicating in its rural theme a choice of subject that would dominate his genre work for the rest of his career. During the 1860s Johnson created works like *A Boy in the Maine Woods* that take a personal look into his own rural past. He returned to Maine during several springs to recapture memories of maple sugaring from his boyhood. In a letter of 1865 Johnson wrote to a friend, "I am about starting for the country to make studies for a month or six weeks. This will be my forth [*sic*] annual trip for the same purpose to the wilds of the state of Maine. The scene is a Down-east sugaring, a picturesque and to me very interesting one, partly perhaps on account of its being associated with my pleasantest early recollections."[5]

American Farmer, though a much smaller and less ambitious painting, is also filled with light—almost to the point of being a study of sunlight on three-dimensional objects. It has, however, a kind of monumentality all its own, Joshua Taylor's "impressive sobriety of vision." The familiar theme of rural life takes the form of the single figure of a farmer in the immediate foreground, filling the picture space from top to bottom. Johnson's farmer wears clothing familiar from other works of similar theme from the same period of the late nineteenth century: collarless shirt and loose tan trousers tucked in high-top boots, the farmer's signature straw hat shading his face from the sun which strikes his right shoulder. He has rolled his sleeves above the elbow, revealing strong forearms with muscles tensed to steady the blade against the whetstone. In Johnson's painting the farmer sharpens an old-fashioned farm implement, the scythe, long a symbol for rural simplicity, its clean sculptural form carrying overtones of both harvest and death.

The man-and-scythe theme was a popular one in the nineteenth century: Mount had already used it in the 1840s (*Farmers Nooning,* 1836, The Museum at Stony Brook), and Winslow Homer's paintings *Veteran in a New Field,* 1865 (Metropolitan Museum of Art, New York), and *Song of the Lark,* 1876 (Chrysler Museum, Norfolk, Virginia), are both works in which a single man works a hayfield with a scythe. In the postwar years paintings by such French artists as Jean-François Millet and Jules Breton, heroizing the farm laborer, were also well known in the United States.[6]

As a painting, *American Farmer* is puzzling in several ways: almost nothing is known about its history; although small and simply composed, it is certainly not a sketch; the brushwork is controlled, the edges of forms carefully delineated. Yet the farmer's face is generalized. Specific likeness, often a concern for Johnson, the painter of distinguished portraits as well as genre subjects, is lacking in this painting. No anecdotal details that might indicate setting or story identify this place, a country landscape as anonymous as the farmer himself.

One possibility for clues to the painting's function and meaning may lie in its genesis during the pre-centennial years. In the late 1860s and 1870s as the country was anticipating the celebration of its beginning, models of citizen heroes were used to jog the public memory and engender pride. At the exposition itself, a large granite sculpture titled *The American Soldier* was placed prominently on the grounds. The exhibition roster listed a painting by Winslow Homer, *The American Type* (unlocated), suggesting a similar concern with qualities that might be uniquely American. Farmers were popular as unambiguous exemplars of a simpler, sturdier historical moment, one that combined hard work, optimism, and independence. Eastman Johnson's farmer might be seen as the embodiment of that durable yeoman farmer, a nostalgic image rooted in the early years of the Republic. Sculptured by summer sunlight, the form of man and scythe project an icon of Americanism. Small, but monumental in effect, the painting seems elegiac, an image of time past but embodying an idea that continued to have powerful ties in memory for many Americans.

J. B.

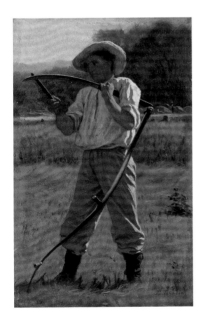

18a American Farmer, c. 1870

Oil on artist board, 11 x 7

Museum purchase, 45.439

William Michael Harnett (1848–1892)

19 The Professor's Old Friends, 1891

Oil on canvas, 27¹/₁₆ x 33³/₁₆

Signed and dated lower left, "W. M. Harnett 1891"

Gift of Mr. Gifford A. Cochran, 64.1417

PROVENANCE: Estate of the artist to Thomas Birch's Sons, Philadelphia, 1893; Knoedler's Gallery, New York, 1893; Downtown Gallery, New York; Macbeth Galleries, New York

EXHIBITIONS: Thomas Birch's Sons, Philadelphia, "Auction of W. Harnett's Effects" 23–24 February 1893, no. 28; Baltimore Museum of Art, "If Wishes Could Buy," 4 October–6 November 1955; The Albuquerque Museum, "Silent Things, Secret Things: Still Life from Rembrandt to the Millennium," 19 September 1999–19 January 2000

REFERENCES: *Auction of W. Harnett's Effects* (Philadelphia: Thomas Birch's Sons, 1893), n.p.; Alfred Frankenstein, *After the Hunt: William Harnett and Other American Painters, 1870–1900* (Berkeley: University of California Press, 1953), 174, no. 125; Alfred Frankenstein, *After the Hunt: William Harnett and Other American Painters, 1870–1900* (1953; rev. ed., Berkeley: University of California Press, 1969), 15, 92, 181, no. 125; Doreen Bolger, Marc Simpson, and John Wilmerding, eds., *William M. Harnett* (New York: Harry N. Abrams, 1992), 186, 267, 267 (illus.), 289; Selma Holo, *Silent Things, Secret Things: Still Life from Rembrandt to the Millenium* (Albuquerque, N. M.: The Albuquerque Museum, 1999), 60, 62, 64, 65 (illus.)

The reputations of few artists have changed as completely as that of William Michael Harnett. During his lifetime and for nearly fifty years after he died, he was a little known still-life painter who was not popular with the cultural elite but whose works were purchased for wall decoration in taverns and inns. He achieved little critical success, and it was only after some of his paintings were exhibited at the Downtown Gallery in New York in 1939 that the artist and his work became appreciated. Today he is considered America's greatest trompe l'oeil painter and an important contributor to nineteenth-century American art.

The *Professor's Old Friends* is an emblematic statement and a meditation on the transience of life and a memento of an unseen presence—the professor—but this painting is also about the artist himself and the traumas in his life. *The Professor's Old Friends* is considered to be "the next to the last painting that emanated from his [Harnett's] easel" and was painted a year before the artist's death. The same year Harnett lost his mother, Honora, to whom he was devoted. Harnett's father had died when the artist was a boy, and later Harnett financially supported his mother and would do so for much of his life. A few years before the artist experienced this shattering loss, in late 1888 he was diagnosed with kidney disease. Harnett must have suffered severely, and in the last four years of his life he produced only ten paintings.[1]

From the start of his short career, Harnett painted tabletop still-life works in a suggested space—a library, a study—that extends beyond the boundaries of the canvas. The space was a sphere for the meditation on life's mysteries, and in *The Professor's Old Friends* this space takes on an autobiographical significance. The tabletop composition is littered with odd objects in a casual and random order. Most of them Harnett had used in other paintings: books—one dated 1503, another by Chaucer, and another by Dumas—contemporary sheet music and a decrepit clarinet, and inkwell and

pen, beer tankard, and an oil lamp that has been extinguished make up the attributes of the professor's or the artist's mute friends. The dark melancholy tonality of the painting alludes to the central question of human mortality that certainly preoccupied the painter during the last years of his life.

Harnett was born in Clonakilty, County Cork, Ireland, and brought up in Philadelphia. He studied at the Pennsylvania Academy of the Fine Arts for two years and left for New York. There he attended classes at the National Academy of Design and the Cooper Union. He returned to Philadelphia in 1876, where he again studied at the Pennsylvania Academy of the Fine Arts and exhibited small images of mugs and pipes on tabletops, like the Farnsworth's *For a Pipe Smoker*, of 1877. In contrast to *The Professor's Old Friends*, this is a very optimistic picture. A production picture and one of the bachelor paintings, it is considered "the most persuasive, most unforced, of Harnett's still-lifes."[2] This was a very popular and successful type of masculine picture for Harnett and he produced many variations on this theme. The bits of clutter were arranged over and over again by the artist as he created in these small canvases an "intimate revelation of a tolerably untidy Victorian male."[3]

Because of the intensely personal air with which the paraphernalia of a single male life is assembled, the bachelor paintings seem to be a record of the man Harnett. As in the writing table still-lifes, the longing to establish some true, some fundamental communion is adumbrated in the bachelor paintings. But these paintings put the issue more bleakly because they are more personal. The meager private pleasures are depicted as cherished yet valueless, being but quickly consumed assuagements of the senses, as their absent-minded disposition indicates.[4]

P. J. B.

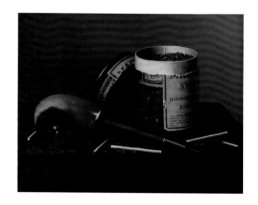

19a For a Pipe Smoker, 1877

Oil on canvas, 8¹/₁₆ x 10⅛

Gift of Gifford A. Cochran, 71.1805

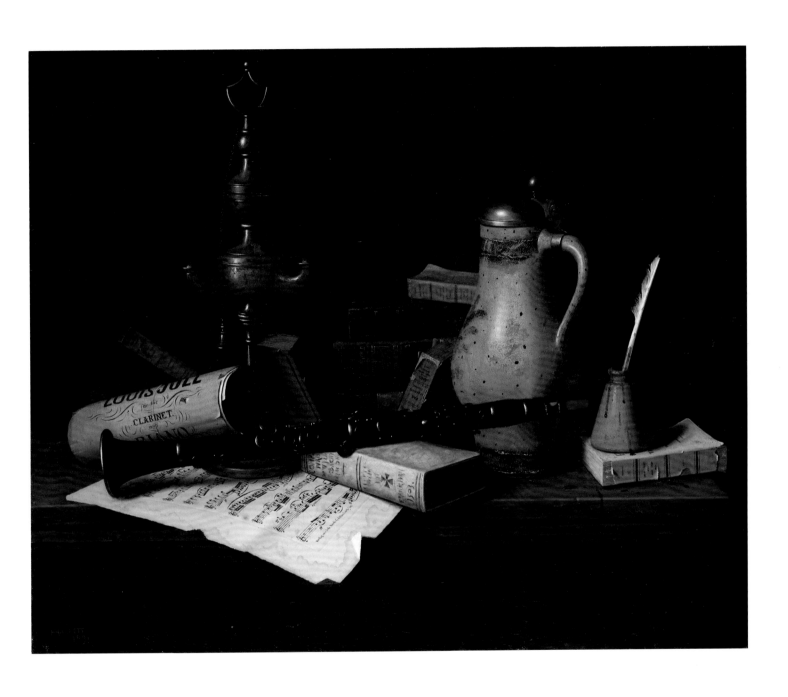

Thomas Eakins (1844–1916)

20 Study for The Thinker, 1900

Oil on paper adhered to wood panel, 14 x 10

Signed and dated upper left, "Original sketch for / the 'Thinker' / Thomas Eakins / 1900"

Gift of Gifford A. Cochran, 62.1484

PROVENANCE: David Wilson Jordan, New York, 1933; Saul Gurivitz, New York, 1939

EXHIBITIONS: Babcock Galleries, New York, "Thomas Eakins," 18–30 November 1929, no. 14; Baltimore Museum of Art, "Thomas Eakins, A Retrospective Exhibition of His Paintings," December 1936–January 1937, no. 32; Babcock Galleries, New York, "Exhibition of Sketches, Studies and Intimate Paintings by Thomas Eakins," 31 October–25 November 1939, no. 30; The Wilmington Society of Fine Arts, Wilmington, Delaware, "Paintings of Thomas Eakins," October 1944

REFERENCES: *Paintings by Thomas Eakins* (New York: Babcock Galleries, 1929), no. 14; *Bulletin of the Pennsylvania Museum of Art* (Philadelphia), March 1930, 28, no. 215; Lloyd Goodrich, *Thomas Eakins: His Life and Work* (New York: Whitney Museum of American Art, 1933), 19, no. 43; *Exhibition of Sketches, Studies and Intimate Paintings by Thomas Eakins* (New York: Babcock Galleries, 1939), no. 30

An oil sketch painted by Thomas Eakins in preparation for an unusually large portrait (over seven feet high) of his brother-in-law, Louis Kenton, this study is squared for enlargement. In the final version (1900, The Metropolitan Museum of Art), Kenton faces to the right, but otherwise the compositions are the same. After Eakins's death, the portrait was retitled *The Thinker*, probably by the artist's widow, who may have been alluding to Auguste Rodin's celebrated sculpture by that name.

Although the remarkably introspective quality of Eakins's finished portrait can be detected in the oil sketch, the effect is heightened in the final version by a variety of devices, among them the lengthening of the taut shadows on the floor, the illusion of a rear wall hemming the figure in from behind, the heavy solidity with which his black apparel is rendered, the addition of glasses that block his eyes from view, and, overall, a weighting down of the figure suggestive of the inexorable impact of time and gravity.

By means of these devices, *The Thinker* imparts a sense of its subject's inner, psychological activity. There appears to be a mental or spiritual drama here, the details of which are not and cannot be specified, but which are palpable nonetheless. Eakins shows a lanky, dour-faced middle-aged man dressed in black, his hands thrust into his trouser pockets, his gaze downcast, his eyes screened from sight by the pince-nez perched on his nose. By denying the viewer access to Kenton's eyes, permitting only a portion of one dark pupil to be seen, the portrait tantalizes the viewer, creating the impression that this is a man who plunges deep into thought in the same way that he plunges his hands into his pockets. This thought—whatever it may be, for it is as inaccessible as the eyes— is of such weight that Kenton's broad shoulders are bowed by it and his suit coat rumpled. The emotional gravity of the idea he confronts is delineated by the physical gravity that seems written across his body, or, to switch the metaphor, the wrinkling of Kenton's sleeve mirrors the wrinkling of his brow, both of which suggest a profound wrinkling of his mind.

The Thinker was one of the few portraits by Eakins to be given recognition during the artist's lifetime. On three separate occasions between 1901 and 1907, the art writer Charles H. Caffin praised it for "the grasp which it suggests of the subject's personality." In Caffin's estimation, this "record of a human individual is extraordinarily arresting and satisfactory," and he marveled at how Eakins had made it seem "as if the gentleman had been caught pacing the room in the solution of some problem and were unconscious of anybody's presence." The distinctly psychological language that Caffin employs—"the subject's personality," "record of an individual," "unconscious"—was new to Eakins criticism and, indeed, American art criticism in general, marking a shift away from an exclusive emphasis on the pictorial or biographical properties of a portrait to its apparent grasp or revelation of interiority.

The Thinker bespeaks a tendency toward asceticism. As an artist, Eakins himself was ascetic, austere, and self-denying in color and style, unlike his much more popular and acclaimed contemporaries William Merritt Chase, John Singer Sargent, and James McNeill Whistler, who were aesthetes, dedicated to the pursuit of sensuous beauty. The oil study for *The Thinker*, with its loose and flowing brushwork, conveys a lusciousness and energy that Eakins conscientiously eliminated from the final version, a sober depiction of a ruminative individual isolated in flat and empty space.[1]

D. M. L.

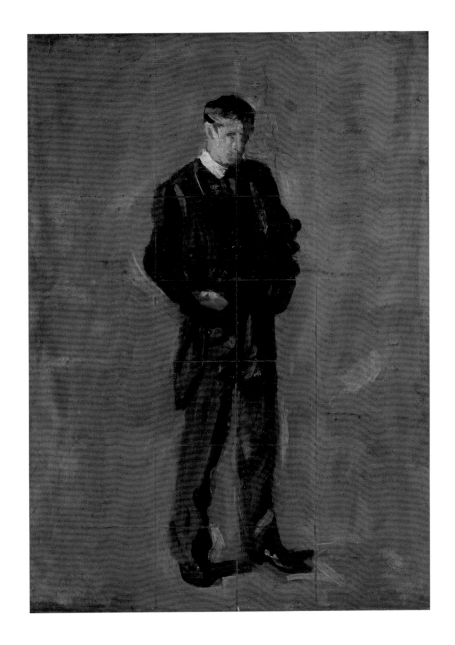

Winslow Homer (1836–1910)

Winslow Homer is, perhaps, the American artist least in need of introduction. Born in Boston and raised in Cambridge, at the age of nineteen he entered into a lithography apprenticeship in Boston. By the autumn of 1859, at the age of twenty-three, he left Boston for New York, which remained his base for the next twenty-five years. Homer rapidly developed a successful career, becoming increasingly respected as both an illustrator and a painter. During "the season," late October into June, he worked in his home-studio at the center of the New York artistic community, the Tenth Street Studios Building. But, like all artists of the period, Homer routinely passed the long summers away from the city. He early acquired the habit of an inveterate traveler, in response to the need for topical subjects to submit to the popular illustrated journals. Even after he no longer needed to make a circuit of prominent resorts, Homer followed a pattern of summer-long roaming—visiting friends' country homes, the Adirondacks for his favorite sports of camping and fishing, and making longer stays at places chosen specifically as sources for his paintings of scenes of rural life.

He is known to have twice lingered longer than usual at one of his summer stops, the fishing port of Gloucester, Massachusetts. The several months in 1873 he spent there were apparently for the purpose of training himself in the practice of the watercolor. Such were his gifts that before the summer was far advanced he was producing works at least equal to those of his contemporaries who were specialists in the medium. Gloucester was again the focus of the pivotal summer of 1880, when Homer seems to have begun to work out a resolution to the restlessness of the previous few years.

Much of Homer's summer itineraries can only be inferred—from titles under which he exhibited paintings in following years, from slight notices in newspapers, and from few other scraps of documentation. Such is the case with the summer of 1880. We know he had given up his New York studio by 15 June, and that he was in Gloucester by 4 July (from the inscription of that date on a watercolor). From the distinctive character of a group of watercolors, and the fact that one of the works Homer showed at the annual exhibition of the American Water Color Society early in 1881

was titled *Field Point, Greenwich, Conn.*, it seems likely he passed some of June 1880 in the area of Long Island Sound.

The eleven watercolors of early summer 1880 that survive have in common a shoreline locality where groves of trees and lawns gently slope to the water's edge, and water so placid and shallow that grasses poke above its surface, features that are more characteristic of the western Connecticut shore than of the rugged coast of northern Massachusetts. Given this topography, it is not surprising that these paintings also share a color scheme predominating in blues and greens. In this, and a consistent quality of bright, but softly atmospheric light, they are distinctive from the warm terra cottas, browns, and grays of the brilliantly lighted Gloucester subjects from later that summer. All but one of these paintings (an unpopulated landscape) feature the figure of a slender young woman, elegantly dressed in black. In most she wears a small hat with the brim turned up at the front. *A Girl in a Punt*, although frequently assumed to be a Gloucester subject, seems surely to belong in this group. Despite repeated attempts to identify the women who appear in Homer's paintings, and thereby establish for him some personal, romantic attachments, this model, like all his others, remains anonymous. And so should she. Not meant to be a portrait subject, she serves as the keynote of the gentle world she inhabits.

When Homer moved on to Gloucester it was to a more robust world. The ninety-six drawings and watercolors that survive from this period demonstrate a nearly exclusive focus on two subjects: small boys, grouped in twos, threes, and occasionally larger numbers amusing themselves with small boats, or just lazing about; and the grown-ups' fishing schooners and pleasure yachts anchored or under sail in Gloucester harbor. Frequently, these themes are blended, as they are in *New England Coast— Sailing Ships in Harbor*.

For the summer of 1880 Homer arranged room and board with the keeper of the lighthouse on Ten Pound Island, rather than staying at a local Gloucester hotel, as he had in the summer of 1873. Conditions allowing for maximum concentration seem to be what Homer was seeking in Gloucester that summer. The outpouring of drawings and watercolors, and the adventurous range of technical experimentation

they display, may reflect tensions beginning to build in Homer between the stylistic and expressive conventions of his work up to this time and a need to push himself to take the risks of change. *New England Coast—Sailing Ships in Harbor* is an outstanding representative of Homer's more conservative work of this Gloucester summer. It expresses the pleasures of being an irresponsible boy on a perfect summer day.

Just six months after this remarkably productive summer, Homer went to live and work in the small fishing village of Cullercoats, near Tynemouth and Newcastle on the northeastern coast of England. This was a longer and more intensely self-conscious period of artistic reformation, of which the summer of 1880 seems a prototype. He returned to New York at the close of 1882, a painter of larger, darker themes.

He also returned to find that his brothers had started on a venture that was at once a real estate investment and a means to establish a gathering point for family summer vacations. Homer adopted the scheme with more enthusiasm than probably was expected. The winter season of 1883–84 was the last Homer spent working in a New York studio. Thereafter Prout's Neck, Maine, was both his home and the vital source of the art that revealed him to be an American master.

A. B. G.

21 A Girl in a Punt, c. 1880

Watercolor on paper, 8⅛ x 11⁷⁄₁₆
Signed lower right, "Homer"
Museum purchase, 45.534

PROVENANCE: Artist to Alexander Wadsworth Longfellow, Portland, Maine, 1880, remained in the Longfellow family until 1945; Alexander Bower, Portland, Maine, 1945

EXHIBITIONS: University of Arizona Art Gallery, Tucson, "Yankee Painter: A Retrospective of Oils, Watercolors and Graphics by Winslow Homer," 11 October–1 December 1963, no. 50; Farnsworth Art Museum, "Winslow Homer, 1836–1910: Oils, Watercolors, Drawings, Wood Engravings," 10 July–7 September 1970, no. 31; Art Museum of South Texas, Corpus Christi, "Winslow Homer Watercolors," 22 September–5 November 1978, no. 9; Terra Museum of American Art, Chicago, "Winslow Homer in Gloucester," 20 October–30 December 1990, no. 20; Spanierman Gallery, New York, "Painters of Cape Ann, 1840–1940: One Hundred Years in Gloucester and Rockport," 13 April–22 June 1996, no. 8

REFERENCES: *Yankee Painter: A Retrospective Exhibition of Oils, Watercolors and Graphics* (Tucson: University of Arizona Art Gallery, 1963), 84, 85 (illus.); *Winslow Homer, 1836–1910: Oils,*

Watercolors, Drawings, Wood Engravings (Rockland, Maine: Farnsworth Art Museum, 1970), n.p., cover; *Winslow Homer Watercolors* (Corpus Christi: Art Museum of South Texas, 1978), 17 (illus.), 29; Gordon Hendricks, *The Life and Works of Winslow Homer* (New York: Harry N. Abrams, Inc., 1979), 144, 288 (illus.); D. Scott Atkinson and Jochen Wierich, *Winslow Homer in Gloucester* (Chicago: Terra Museum of American Art, 1990), 53, 54, 88 (illus.); Rachel Ann Carren, "From Reality to Symbol: Images of Children in the Art of Winslow Homer," Ph.D. diss., University of Maryland, 1990, 201; Karen Quinn, *Painters of Cape Ann, 1840–1940: One Hundred Years in Gloucester and Rockport* (New York: Spanierman Gallery, 1996), 4 (illus.); Carl Little, *Winslow Homer: His Art, His Light, His Landscapes* (Cobb, Calif.: First Glance Books, 1997), 41 (illus.)

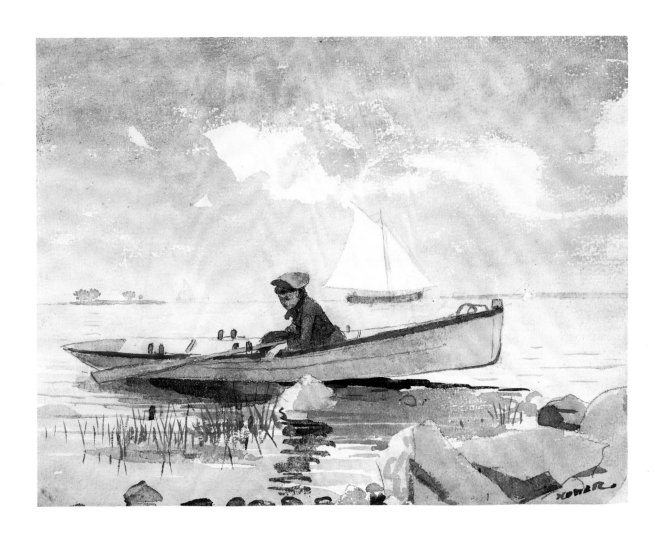

22 Pulling the Dory, c. 1880

Watercolor and pencil on paper laid down on board, $8^{7}/_{16}$ x $13^{1}/_{4}$

Bequest of Mrs. Elizabeth B. Noyce, 97.3.19

PROVENANCE: Family of the artist; Vose Galleries, Boston, 1993; Mrs. Elizabeth B. Noyce, 1993–96; Estate of Mrs. Elizabeth B. Noyce, 1996–97

EXHIBITIONS: Farnsworth Art Museum, 17 July–18 September 1994, and Portland Museum of Art, Maine, 29 October 1994–22 January 1995, "An Eye for Maine"; Portland Museum of Art, Maine, 8 June– 2 September 1996, and Farnsworth Art Museum, 16 February– 20 April 1997, "A Brush with Greatness: American Watercolors from the November Collection"; Portland Museum of Art, Maine, "A Legacy for Maine: Masterworks from the Collection of Elizabeth B. Noyce," 1 October 1997–4 January 1998

REFERENCES: Donelson Hoopes, *An Eye for Maine* (Rockland, Maine: Farnsworth Art Museum, 1994), 13, 22; Donelson Hoopes, "Two Centuries of Maine Art," *Island Journal* 11 (1994): 47, 53 (illus.); Jessica F. Nicoll, *A Brush with Greatness: American Watercolors from the November Collection* (Portland, Maine: Portland Museum of Art, 1996), cover, 1, 2; Jessica F. Nicoll, *A Legacy for Maine: The November Collection of Elizabeth B. Noyce* (Portland, Maine: Portland Museum of Art, 1997), 65

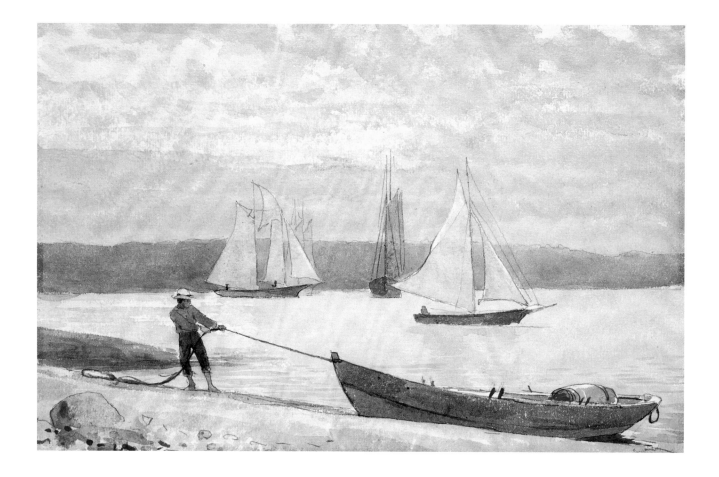

23 New England Coast—Sailing Ships in Harbor, 1880

Chinese white and graphite on paper, 7¼ x 13⅜

Signed and dated upper right, "Homer / 1880"

Museum purchase, 46.649

PROVENANCE: Larchmont Yacht Club, New York; Thomas E. Finger, New York, 1941; Plaza Art Galleries, New York, 1943; Leroy Ireland, New York, 1943; Macbeth Gallery, New York, 1943; David Findlay, New York, 1943; Vose Gallery, Boston, 1946

EXHIBITIONS: University of Arizona Art Gallery, Tucson, "Yankee Painter: A Retrospective Exhibition of Oils, Water-colors and Graphics by Winslow Homer," 11 October–1 December 1963, no. 49; Farnsworth Art Museum, "Winslow Homer, 1836–1910: Oils, Watercolors, Drawings, Wood Engravings," 10 July–7 September 1970, no. 28; Art Museum of South Texas, Corpus Christi, "Winslow Homer Watercolors," 22 September–5 November 1978, no. 14; Terra Museum of American Art, Chicago, "Winslow Homer in Gloucester," 20 October–30 December 1990, no. 34

REFERENCES: *Yankee Painter: A Retro-spective Exhibition of Oils, Watercolors and Graphics by Winslow Homer* (Tucson: University of Arizona Art Gallery, 1963), 40 (illus.), 84; *Winslow Homer, 1836-1910: Oils, Watercolors, Drawings, Wood Engravings* (Rockland, Maine: Farnsworth Art Museum, 1970), n.p.; *Winslow Homer Watercolors* (Corpus Christi: Art Museum of South Texas, 1978), 22 (illus.), 30; Gordon Hendricks, *The Life and Work of Winslow Homer* (New York: Harry N. Abrams, Inc., 1979), 288; D. Scott Atkinson and Jochen Wierich, *Winslow Homer in Gloucester* (Chicago: Terra Museum of American Art, 1990), 4, 58, 102 (illus.).

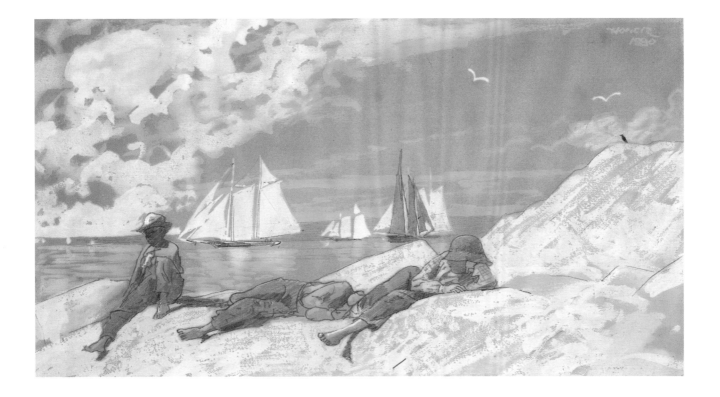

James Edward Buttersworth (1817–1894)

24 The Puritan and the Genesta, c. 1885

Oil on canvas, 24⅛ x 36¼
Signed lower right, "J. E. Buttersworth"
Gift of the estate of Edmund S. Davenport, 78.56.1

REFERENCES: John Gould, "The Home Forum," *Christian Science Monitor*, 30 January 1987, 30 (illus.)

James E. Buttersworth's painting of the 1885 America's Cup race between the British challenger *Genesta* and the American yacht *Puritan* off New York City at Sandy Hook, New York, vividly represents the excitement and patriotic feelings that accompanied such important sporting contests toward the end of the nineteenth century. With the recent loss of the America's Cup to the Australians it is easy for Americans today to appreciate the importance of these great yacht races that began more than a century ago, and the desire of artists such as Buttersworth to provide visual commemoration of them. The contest of 1885 was between the *Genesta*, which was a radical type of very narrow, "knife-blade" or "plank-on-edge" vessel, and the American-designed *Puritan*, "compromise sloop" combining characteristics of the traditional centerboard sailing vessel and the new, deeper draft cutter rigs, such as the *Genesta*.[1] The *Puritan* was designed by thirty-six-year-old Edward Burgess for a syndicate from the New York Yacht Club headed by the noted yachtsmen General Charles J. Paine and J. Malcolm Forbes. *Puritan* was the vessel that launched Burgess's career as one of America's leading yacht designers.

The image of the two fast-racing yachts is one with strong visual appeal. Buttersworth had started producing marine paintings before the Civil War, capturing the "excited spirit" that the late art historian David C. Huntington identified in the expressive lines of the sleek clipper ships and racing yachts of the period. The American sculptor Horatio Greenough expressed the sentiments embedded in some of Buttersworth's paintings of ships under sail when he wrote that the yacht *America* was "nearer to Athens" than those who would "bend the Greek temple to every use." For Greenough, as for Buttersworth and his patrons, a vessel under full sail was a type of sheer poetry in motion. "Mark the majestic form of her hull as she rushes through the water," Greenough noted. "Observe the graceful bend of her body, the gentle transition from round to flat, the symmetry and rich tracery of her spars and rigging, and those grand wind muscles her sails. . . . What academy of design, what research of connoisseurship, what imitation of the Greeks produced this marvel of construction."[2] The structure of Buttersworth's composition seems to echo Greenough's sentiments. By concentrating the action in the near middle ground, Buttersworth focuses attention on the enormous mass of *Puritan*'s billowing "wind muscles," some eight thousand square feet of canvas, which are illuminated by a spotlight of brilliant sunlight that seems to create a pyramid of cream-colored canvas filling the sky. The form is repeated farther off in *Genesta*'s sails at the left. Both vessels seem to embody pure motion, with their tiny crews represented as mere specks on their decks.

James E. Buttersworth painted the heyday of shipping in New York harbor from about 1850, when he arrived from England, to his death in 1894. In Buttersworth's period, ships of all kinds were as ubiquitous as the automobile or the airplane is today. His stock in trade as a marine painter was the sailing vessels and later the steamship that made New York a prosperous port and that provided the wherewithal for his patrons, who were often the owners or masters of the ships he depicted. For such patrons, as Roger B. Stein observes, "The value of a ship portrait lay for its owner-audience in its likeness to the original and the success of the portrait is in direct proportion to the visual accuracy of the observer-audience."[3] During the later part of the century, during the so-called Gilded Age, many of Buttersworth's patrons were flamboyant men of great wealth, such as James Gordon Bennett, founder of the *New York Herald*, who could afford the gentleman's sport of yacht racing. Evidently, Buttersworth's composition of the *Puritan* and the *Genesta* was successful, for two versions of the work are known. One version was in the collection of Catherine Spencer, whose family owned the *Puritan*.[4]

As a marine painter, Buttersworth was never a member of the elite group of New York artists who were associated with the National Academy of Design or the Tenth Street Studios Building. Instead, he made his living more as a tradesman who gained his patrons through referrals rather than through exhibitions or notices in the press. The prices for his paintings were extremely low by comparison to those of his contemporaries Frederic Edwin Church and Albert Bierstadt. Typically a ship portrait would sell for between five and fifty dollars. At times Buttersworth supported himself as a successful lithographer for Currier and Ives. Buttersworth is believed to have been illiterate and self-taught, and no documents have been discovered in his hand. His influence was negligible, although today his work is much sought after by collectors of maritime painting and his work commands high prices. The artist died in West Hoboken, New Jersey, in 1894.

J. G. S.

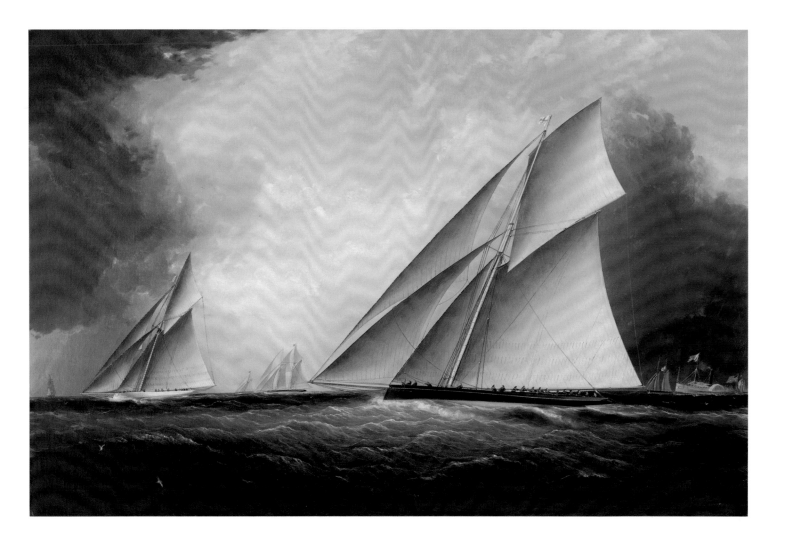

William Trost Richards (1833–1905)

25 Seascape, 1884

Oil on canvas, 18⅛ x 32⅛

Signed and dated lower left, "Wm T. Richards 1884"

Gift of William W. F. Brinley, Philadelphia, 79.96

Paintings like *Seascape* held great appeal for nineteenth-century viewers who were experiencing the end of the age of sail and its replacement by mechanized navigation. This type of picture had become a successful compositional formula that Richards often used during the 1880s and 1890s. The Richards scholar Linda S. Ferber described the essential elements of this particular theme as consisting of

> two nearly equal open-ended zones of sea and sky, here divided by a razor-sharp horizon line firmly containing, even compressing, the sea below while the subtle drama of the sky is played out by varied cloud forms through which radiates, from an unseen but known source, the glowing core of light that unifies the composition.[1]

This image of a vast expanse of sea bathed in light with the sail of a ship on the distant horizon would also have evoked spiritual associations. Richards greatly revered Thomas Cole and Frederic E. Church and, like them, imbued his paintings with subtle religious meaning, in his own search for "a higher purpose than to make a good picture."[2] Particular iconographic details in the painting—the passage of the distant schooner, the presence of three sea birds along with the opening in the clouds—would have been understood by Richards's audience as subtle reminders of the voyage of life and the hope of an afterlife. At another level, *Seascape* played on the nostalgia for the rapidly disappearing era of sailing vessels, which had been such an important part of national progress earlier in the century.

Seascape is a highly finished work closely resembling the large exhibition oil Richards completed as a commission "on approval" for the Corcoran Gallery of Art in 1883. Richards's most important commission, *On the Coast of New Jersey* was enthusiastically accepted by the institution. "It gives me great pleasure to state that your picture gives entire satisfaction to the committee, to the Trustees & Mr. Corcoran; and no picture has been brought here, more admired by the public."[3]

By 1854 Richards had an active landscape painting business in Philadelphia, but in 1867 he turned to painting the sea and the shore, a theme that would remain central to his career for the rest of his life. This passionate interest was kindled "when a great storm at sea on his return from Europe drew his attention to the ocean . . . he devoted more and more time to painting its various moods."[4] During the 1870s he established himself as a major painter of luminous seascapes—works that were serene yet evocative, and featured "long reaches of silvery shore."[5] To make his sketching easier, in 1874 Richards and his family made Newport their permanent summer residence. Prior to this, Richards had spent the summer months traveling to coastal spots from New Jersey to Maine. In his letters, Richards often wrote of his experiences and fascination with the movement and power of water—his close study of waves and surf firsthand and his attempts to capture these elusive aspects in his sketchbook.

> The early part of last week we had another tremendous surf, of which I got some record. But it is a little too much for me, perhaps for anybody for I do not remember any picture which gives any idea of the awful power of the breaking of a big wave against the rocks, much less of the tumult of the back action as it meets the incoming wave.[6]

A month later, in September 1876:

> All the saddest and wildest noises of nature are reproduced by the surf. . . . But above all noises could be heard the hiss of the swift breaker— as it came white and malignant—seeming to know its own fierceness—and, bursting in the cataracts on the rocks was followed by another and another fiercer and heavier; till it was a relief to turn away to the stillness of the town, and try to render coherent the tremendous impressions.[7]

Three years later, in July 1879:

> I watch and watch it, try to disentangle its push and leap and recoil, make myself ready to catch the tricks of the big breakers and am always startled out of my self possession by the thunder and the rush, jump backward up the loose shingle of the beach, sure this time I will be washed away; get soaked with spray, and am ashamed that I had missed getting the real drawing of such a splendid one, and this happens 20 times in an hour and I have never yet got used to it.[8]

P. J. B.

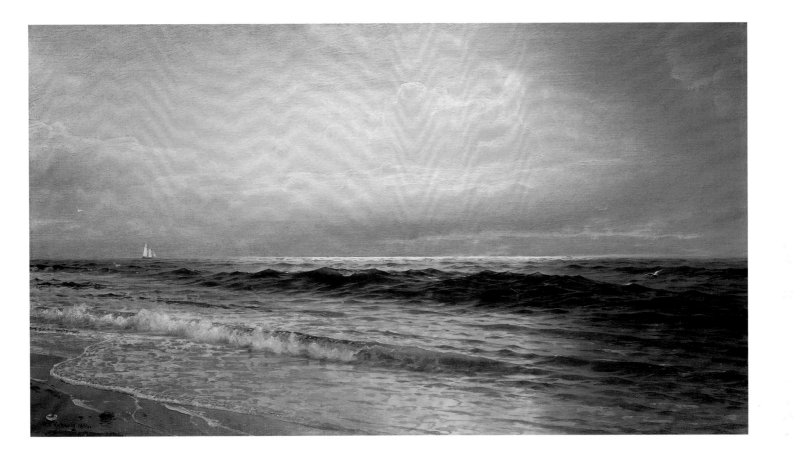

Alfred Thompson Bricher (1837–1908)

26 **Rocky Head with Sailboats in the Distance**, c. 1895

Oil on canvas, 10 x 14

Signed lower right, "A T Bricher" (in monogram)

Gift of Charlotte C. Dillingham, Rockland, Maine, 65.1434

EXHIBITIONS: The Fitchburg Art Museum, Fitchburg, Massachusetts, "The Maine Connection: Paintings and Sculpture from the Farnsworth Art Museum," 21 November 1993–27 March 1994

An artist associated with the later generation of the Hudson River School, Alfred Thompson Bricher was most noted for his crystalline, serene, and detailed marine paintings. Little is known of Bricher's personal life and early artistic training. Born in Portsmouth, New Hampshire, he grew up in Newburyport, Massachusetts, and opened a studio in Boston in 1859, in the building where Martin Johnson Heade also kept a studio. Bricher stayed in Boston until 1868, exhibiting at the Boston Athenaeum. That year he married Susan Wildes and moved to New York, establishing a studio in the Young Men's Christian Association building near the National Academy of Design, where he was in company with other such landscape painters as William Hart and David Johnson.

Bricher traveled to the popular North American "wilderness" areas in search of landscape and especially coastal subjects—Maine and its islands, Grand Manan Island and the Bay of Fundy, New Brunswick, New Hampshire, upstate New York, and Rhode Island. From the 1870s on, Bricher was well known as a painter of coastal views of uninterrupted horizons. After a second marriage in 1881, Bricher spent much of his time in Southampton, Long Island, yet kept his New York studio. Although some of his later paintings seem to be influenced by the Barbizon School, Bricher painted in his conservative style—careful compositions and highly finished canvases—until his death.

Bricher's *Rocky Head with Sailboats in the Distance* is a later work, a small-scale picture exhibiting the characteristic effects of light over water and rocks in a nostalgic reminiscence of a rapidly vanishing age of sail. The Bricher scholar Jeffrey R. Brown has observed,

In the sum of Bricher's paintings one senses his isolation. Ruler-straight horizons etch the boundary of these daily experiences while the rigidity of his underlying geometric structure accentuates the clarity of his vision. He gives us an optimistic outlook projected by a self-reliant individual on man's relation to his environment.[1]

As in *Rocky Head*, Bricher's paintings after the 1880s were usually devoid of human figures, and several techniques that he frequently employed in his work are present even in this small work. The boats in the distance are reduced to tiny shapes on the horizon, emphasizing the size and scale of the headland and the waves beating against the rocky shore. The sky has soft clouds and a bright light that drenches the boats, sea, and especially the headland and rocky shore. The contrast between the straight edge of the horizon and the dramatic and rugged headland is softened by the foreground waves, leading the eye of the viewer between the two.

The location of this particular view is not clearly established, but believed to be Maine, and likely Monhegan Island, where the artist visited in 1895. Bricher was a tireless explorer of the coast following in the footsteps of artists William Stanley Haseltine, Fitz Hugh Lane, and Frederic E. Church. In fact, Bricher's "first sketching season was passed on the island of Mt. Desert, Maine, in 1858, where he met up with the painters William Haseltine and Charles Dix."[2] Later in life and until 1908, Bricher continued to make these trips and more frequently to Maine, especially the Casco Bay region.

Today, Bricher's *Time and Tide*, about 1873 (Dallas Museum of Art), is considered to be his finest work, yet at its initial exhibition at the National Academy of Design in 1874 it received mixed reviews. The critic for the *New York Times* argued that it "merely re-echoes Mr. W. T. Richards' style";[3] however, another reviewer praised the work for its "careful observation of the quiet waves rolling in and breaking gently on the shore."[4]

P. J. B.

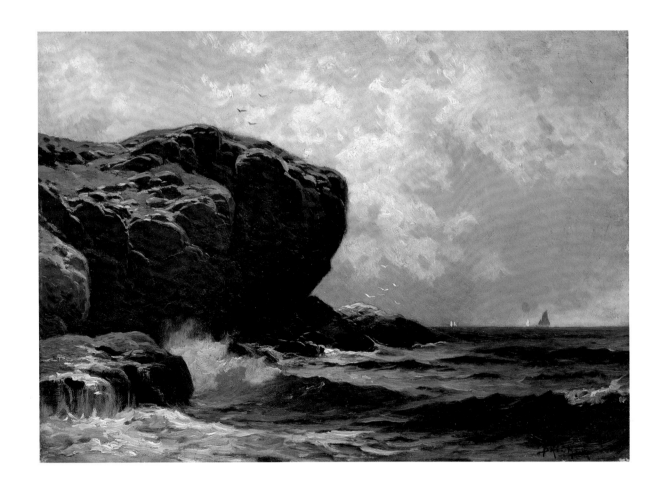

Joseph Rodefer DeCamp (1858–1923)

27 Seascape, 1891

Oil on canvas, 25 x 30

Signed and dated lower right, "Joseph-De-CAMP-91"

Museum purchase, 44.409

PROVENANCE: Charles D. Childs, Boston, 1944

EXHIBITIONS: Adelson Galleries, Inc., New York, "Joseph DeCamp, An American Impressionist," 3 November–16 December 1995, no. 3

REFERENCES: Kenneth Coy Haley, "The Ten American Painters: Definition and Reassessment," Ph.D. diss., State University of New York at Binghamton, 1975, 17–18, 56, 257 (illus., no. 48); Laurene Buckley, *Joseph DeCamp, Master Painter of the Boston School* (New York: Prestel, 1995), 43, 47 (illus., no. 7); *Joseph DeCamp; An American Impressionist* (New York: Adelson Galleries, 1995), n.p.; Carl Little, *Paintings of New England* (Camden, Maine: Down East Books, 1996), 19, 54 (illus.), 123

Famous for his dark, stern portraits of important businesspeople and academics, Joseph Rodefer DeCamp also painted brightly colored impressionist works like *Seascape* of 1891. Indeed, throughout the early to mid-1890s he painted landscape subjects at Annisquam, Lanesville, and Folly Cove on Cape Ann, Massachusetts. Early critical reception to this work praised DeCamp's "atmospheric effect" and "vivid blue" water, observing that the "middle distance is no farther from the eye than the foreground."[1] By 1894 DeCamp was considered an important artist, and it was his "*plein air* work that first caught the attention of the national press and placed him among the avant-garde painters of his day."[2] On 29 June 1891 the local newspaper, the *Cape Ann Breeze*, noted, "Mr. DeCamp, the artist, is expected early in the month" to begin his very popular summer classes.[3] Also, on 15 September the same paper shared with its readership the fact of the artist's departure and also that his days as a bachelor were near an end. "Mr. DeCamp, the well known artist, left here yesterday for his winter home. Report says that next week, he will enter the ranks matrimonial."[4] Indeed, on 21 September 1891 DeCamp married Edith Franklin Baker. Born in Boston, Baker had been his student at the School of Drawing and Painting at Boston's Museum of Fine Arts. They lived at her parents' home at Medford, Massachusetts, and bought their own home three years later.[5]

Seascape was probably painted the summer just before DeCamp married and depicts Cape Ann and, more specifically, Halibut Point. The DeCamp scholar Laurene Buckley described the work as an "elemental view of land, sea, and sky, . . . which superbly captures the wildness for which the spot is known."[6] Nearly two-thirds of the canvas is given over to the foreground effects. The lush vegetation and swirling brushwork contrast with the staccato paint handling used in the rendering of the brisk day in the white-capped choppy sea and blustery sky. In his landscapes, DeCamp often used key compositional elements to guide the viewer through the painting—a pathway in the foreground, a screen of trees, or, as in this case, a huge scrubby bush. Halibut Point is also the site of another DeCamp painting, *Bayberry Bushes* (c. 1895, private collection).[7] DeCamp, however, found less and less time to paint landscapes. With the responsibilities of marriage and the arrival of a daughter the following year, he pursued portrait commissions, which were more lucrative. In 1893 DeCamp won the Charitable Mechanics' Association gold medal for his *Portrait of Joseph L. Breck* (Collection of St. Botolph Club, Boston), an honor that established him as an important portrait painter.

Unfortunately, many of DeCamp's paintings from the 1880s and early 1890s—several hundred works, and many of the early landscapes—were lost in a fire that destroyed his Harcourt Street studio in Boston in 1904.[8] This was a tremendous loss, and the artist announced at the St. Botolph Club in Boston that for only fifty dollars he would paint portraits of any of the members. The following summer DeCamp painted the *Portrait of Albert H. Chatfield, Sr.* (no. 108), a strong supporter of the arts in Cincinnati who had built a studio near his summer home in Camden, Maine, to be used by DeCamp as well as another Ohio artist, Lewis Meakin.[9]

DeCamp had begun his study of art at the McMicken School of Design in his hometown of Cincinnati. After two years there, he left for Europe and entered the Royal Academy in Munich, where he met other American artists studying with Frank Duveneck. In 1884 he settled in Boston and began exhibiting regularly at the Boston Art Club, the St. Botolph Club, and the Guild of Boston Artists. He also was included in exhibitions at Macbeth Gallery, the Society of American Artists in New York, and in exhibitions in Philadelphia, Washington, D.C., and Chicago. In 1897, along with his friends Edmund C. Tarbell and Frank W. Benson, he was a founding member of the Ten American Painters.

P. J. B.

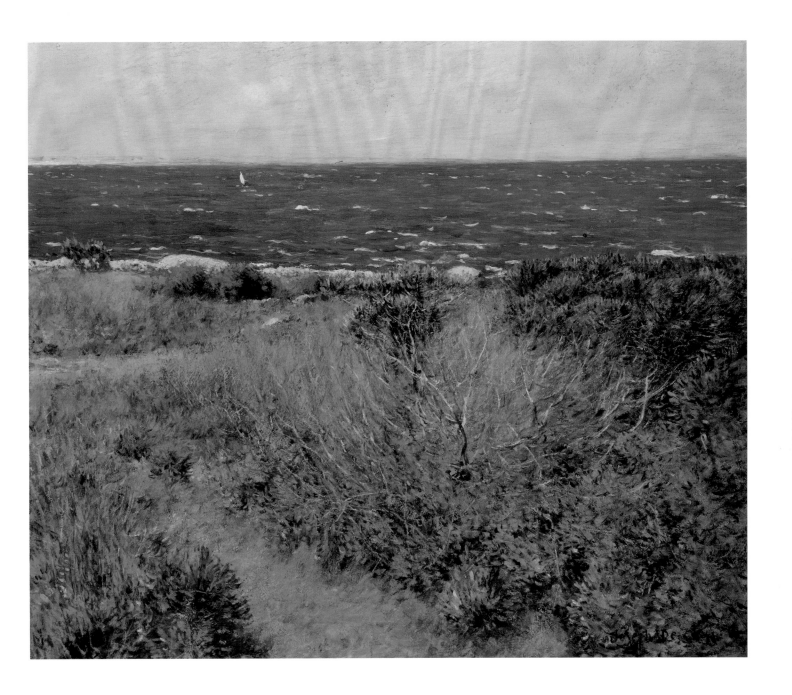

John Henry Twachtman (1853–1902)

28 Frozen Brook, c. 1889–1902

Oil on canvas, 22½ x 20½
Signed lower left, "J. H. Twachtman"
Bequest of Mr. Clifford Smith, 85.4.3

PROVENANCE: Estate of the artist to
American Art Galleries, New York, 1903;
E. A. Rourke, Brooklyn, New York, 1903;
Silas S. Dustin, New York, 1918; Vose
Galleries, Boston, 1919; Harry W. Jones,
1919; Clifford Smith, Rockport, Maine,
1940-85

EXHIBITIONS: American Art Galleries,
New York, "Sale of the Work of the Late
John H. Twachtman," 19 March 1903,
no. 58; Vose Galleries, Boston, "Exhibition
of Selected Works by John H. Twachtman,"
27 January–15 February 1919, no. 5

REFERENCES: *Exhibition of Selected
Works by John H. Twachtman* (Boston:
Vose Galleries, 1919), n.p.

John H. Twachtman was one of the most innovative American impressionists of the late nineteenth century. The son of German immigrants living in Cincinnati, he developed a highly personalized style and by 1890 was at the height of his career. He had been in New York since his return from Europe in 1885, but the rushed city pace annoyed Twachtman, and in 1890 he bought a farm on Round Hill Road, in Greenwich, Connecticut. There he painted some of his most important canvases—mature works that reflect his own brand of impressionism—most of which take the farm as their subject. Twachtman painted familiar things, recording the appearance of sites in all seasons and under a variety of weather conditions but always finding in the familiar the mysterious and suggestive. He would focus on small parts of a landscape, as in *Frozen Brook,* and often painted the same subject with only subtle tonal or coloristic variations.

Twachtman preferred winter, when the landscape would be enveloped in and transformed by snow. "Never is nature more lovely than when it is snowing," Twachtman wrote to his close friend, the artist J. Alden Weir, in a letter on 16 December 1891. "We must have snow and lots of it. . . . Everything is so quiet and the whole earth seems wrapped in a mantle. . . . All nature is hushed to silence."[1] The paintings that show aspects of his Greenwich farm in winter best express what he so loved—silence and solitude. Although Twachtman had painted winter scenes throughout his career, first exhibiting a painting with this subject matter in 1879, he now focused on the theme like never before.[2]

Frozen Brook is one of a series of winter pictures Twachtman painted of the brook on his farm. This quiet and contemplative image, in delicate warm tones, presents a close-up view of the hillside engulfed in a gauzelike mist. The snow is damp, heavy and weighed down, and in places is barely covering the ground. As the writer for *Art Amateur* observed, Twachtman preferred "broken ground and cloudy weather. . . . He seldom attempts to render the delicacy of a fresh fall of snow, preferring as a rule, to wait a day or two until the snow has begun to sink down between the rocks and to melt from the higher points."[3] To create a surface texture that would give the appearance of an atmospheric mist—an important part of the mood of the picture—Twachtman primed the canvas with numerous layers of paint mixed with mastic. Each layer was dried and left to bleach in the sun, a process that created a rich and deeply modeled matte surface. The composition of *Frozen Brook* is not rendered in conventional perspective. The high horizon line, the close-up view of only a part of the hillside, the strong diagonals in the foreground, and the attenuated curve of the tree deny a progression into space, forcing the viewer to read the picture in an abstract way. These elements of the painting and the elegant and subtle tonal relationships suggest the influence of Japanese art and that of James McNeill Whistler.

Twachtman's one-man show at Wunderlich Gallery in March 1891 drew several comments on his new more abstract work, not all complimentary. However, Clarence Cook was sympathetic and observed that "Twachtman's work strikes for some of us a deeper, tenderer note; it charms in spite of argument, and when they talk of his incompleteness, we answer that we like Twachtman's half loaf better than some other people's whole ones."[4] When Twachtman died in 1902, his close friends Weir, Childe Hassam, and Thomas Wilmer Dewing were named executors of his estate. They understood his art and believed that it had not been properly appreciated by the public and worked to include his paintings at major exhibitions throughout the country.

P. J. B.

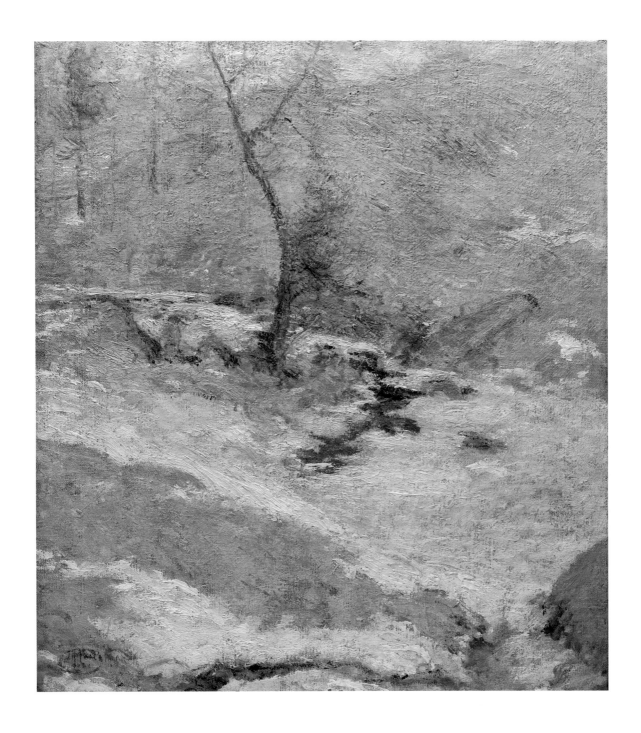

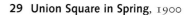

29 Union Square in Spring, 1900

Oil on canvas, 19½ x 31½

Gift of Mrs. Stuart Symington, 98.16.4

PROVENANCE: Mrs. Stuart Symington, 1970–98

EXHIBITIONS: Sotheby's, New York, "Works of Art from the Private Collections of Alumnae Families of the Ethel Walker School," 28 May–2 June 1998

(Frederick) Childe Hassam (1859–1935)

Childe Hassam painted works of New York City that are considered among the most important images of American impressionism and earned him the reputation as "our street painter *par excellence*" around the turn of the century.[1] Years later he would declare that "New York is the most beautiful city in the world. There is no boulevard in Paris that compares to our own Fifth Avenue."[2] Hassam returned from a three-year trip to Paris in 1889, where he studied at the Académie Julian, under Jules-Joseph Lefebvre. During this time Hassam evolved an impressionist style of staccato brushwork and a high-keyed palette to depict atmospheric effects of light and air. He settled in New York, where he distinguished himself as one of the most successful impressionist painters in the country and an influential maker of urban landscapes.

Hassam had a studio in the city at 95 Fifth Avenue, close to Union Square, and painted numerous views of the square in all seasons. He had painted *Union Square in Spring* in 1896 (Smith College Museum of Art), a view from a high vantage point; however, the Farnsworth painting, completed four years later, is a close-up view at pedestrian level. In *Union Square in Spring* a fashionable young woman walks her dog in an uncrowded parklike corner of the square, while in the distance other well-dressed figures leisurely stroll. On the street ahead, horse-drawn trolleys and other cabs provide a lively picturesque effect against the brightly colored awnings on the windows of the storefronts. Hassam avoided, as did other artists during this period, showing the actual realities of the street and presented instead "beauty removed from urban realities."[3] With Hassam's newly developed technique, this work is a very inviting and vibrant image, filled with dazzling light—a brighter and simpler view, a picture of the best aspects of city life in broad strokes rather than its true distractions and complications.

Hassam frequented the summer resorts that were popular with artists and painted *Sundown on the Dunes, Provincetown* the same year he completed *Union Square in Spring*. This view of Provincetown is a fine example of how American impressionists veiled New England in an atmosphere of history and nostalgia. The white church spire and the play of shadows on the buildings evoke a mood of times past. The invention of New England as a place of picturesque seaside villages with colonial church steeples was one of the great artists' constructions at the turn of the century which forged an identity for the region which has endured to the present.[4] The aestheticization of these places served Hassam well as he sought to create a market for his pictures and as he in turn served the agendas of tourism and cultural identity. The painting shows the Universalist Church from a point on Town Hill, and, as in *Union Square*, Hassam's new style is evident in the play of dappled sunlight on the hill and trees, set off against the luminist sky and a rising moon.

P. J. B.

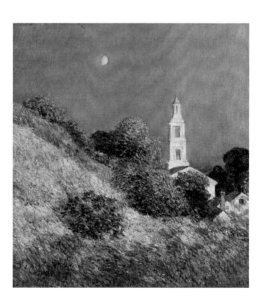

29a Sundown on the Dunes, Provincetown, 1900

Oil on canvas, 24⅛ x 22⅛

Bequest of Mr. Clifford Smith, 85.4.1

Willard Leroy Metcalf (1858–1925)

Willard Leroy Metcalf, a leading member of the Ten American Painters, had achieved notable success by 1907, the year he completed *Ebbing Tide, Version Two*.[1] He was awarded the Corcoran Gallery's gold medal for *May Night*, which the gallery bought for its permanent collection, the first purchase of the artist's work by a museum. The following year *May Pastoral* (1907, private collection) was acquired by the Museum of Fine Arts, Boston, and *On the River* was purchased by the Cleveland Museum of Art. The general reaction by critics to Metcalf's work produced in Maine was favorable, and Christian Brinton praised the artist's "pure landscapes" and keenly observed sensibilities.

Few American painters are more national in feeling or less influenced by foreign modes or methods. . . . Unlike his colleagues of the "Ten," Mr. Metcalf devotes his energies almost wholly to pure landscape with only now and then the rarest and faintest suggestion of the figure. It is no, however, ideal landscape or landscape in general which he paints, but those scenes and localities with which he can boast lifetime familiarity and the keenest artistic sympathy.[2]

Metcalf's *Ebbing Tide, Version Two* is a work painted during a period of great emotional stress for the artist. His wife, Marguerite, had recently left him, running away with Robert Nisbet, Metcalf's student for three years. Metcalf retreated to Maine, first to Clark's Cove on the Damariscotta Peninsula. He also visited the summer home of his close friend Frank W. Benson on Wooster Farm, North Haven, Maine. The impact of Benson's support and his lively, caring family helped Metcalf through this period of loneliness and depression. Indeed, what is fascinating about *Ebbing Tide, Version Two* is that it so little betrays his unhappy state of mind.

A sun-drenched seashore, with broken brushwork, bright color, and dappled light on water, carries the viewer's eye into an impressionist meditation on the ensouling powers of the landscape. The view, painted from the dock and what Benson called his "front yard," looks toward the northeast, to Southern Harbor and the Fox Island Thorofare, which lies between North Haven Island and Vinalhaven Island. The pleasureable sounds of waves breaking on rocks must have served to revive the artist's spirits, and the inscription at the bottom left, "En Souvenir to my Friend Benson," records Metcalf's appreciation of his host and fellow artist during his time of personal duress. Metcalf exhibited the first version of the painting, *Ebbing Tide* (location unknown)—produced the same year and nearly identical—and it was highly praised. A critic described the scene as a "stretch of sun-flected water that Benson, the painter—who lives up on the hill—calls his 'front yard'—it is wonderfully seized and rendered, all the usual problems in light and air being disposed of with Metcalf's ease of manner."[3] Another reviewer remarked on the artist's ability to evoke a true sense of the actual experience of the place. "With the sea again, nearer the shore on which it laps lazily against rocks of red to find the movement suggested with accuracy and feeling, the sense of floating seaweed and underlying rocks being felt rather than portrayed, and by consequence that much more effective."[4]

Metcalf's 1877 painting, *Willow Road, Brunswick, Maine*, shows pollarded willows and fences that line a country lane and a picturesque flock of sheep, painted in a style that reveals his early training. He often visited his parents at Clark's Cove on the Damariscotta River, and from there made sketching trips to many parts of Maine, including Brunswick. Born in Lowell, Massachusetts, in 1874 Metcalf apprenticed to a wood engraver, then began the following year to study with George Loring Brown, also taking classes at the Lowell Institute. In the autumn of 1876, Metcalf enrolled as the first scholarship student at Boston's Museum of Fine Arts School.

P. J. B.

30 Ebbing Tide, Version Two, 1907

Oil on canvas; 26 x 29

Signed, dedicated, and dated lower left, "To my friend Benson / W. L. METCALF 1907 / en Souvenir"

Gift of the estate of Mrs. Sylvia Benson Lawson, 82.7

PROVENANCE: Gift of the artist to Frank W. Benson, 1907; remained in the Benson family

EXHIBITIONS: Farnsworth Art Museum, 5 October 1979–28 November 1979, and Portland Museum of Art, Maine, 18 December 1979–27 January 1980, "Masters in Maine"; Museum of Art, Science, and Industry, Inc., Bridgeport, Connecticut, 25 March 1990–20 May 1990, and Center of Fine Arts, Miami, 17 June–21 August 1990, "Sounding the Depths: 150 Years of American Seascapes"

REFERENCES: Elizabeth de Veer and Richard J. Boyle, *Sunlight and Shadow: The Life and Art of Willard L. Metcalf* (New York: Abbeville Press, 1987), 90, 92, 220, 222 (illus.); Faith Andrews Bedford, Susan C. Faxon, and Bruce W. Chambers, *Frank W. Benson: A Retrospective* (New York: Berry-Hill Galleries, Inc., 1989), 150, 151 (illus.)

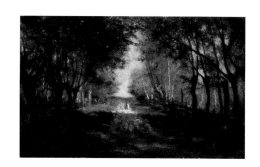

30a Willow Road, Brunswick, Maine, 1877

Oil on canvas, 15⅝ x 25⅝

Museum purchase, 87.14

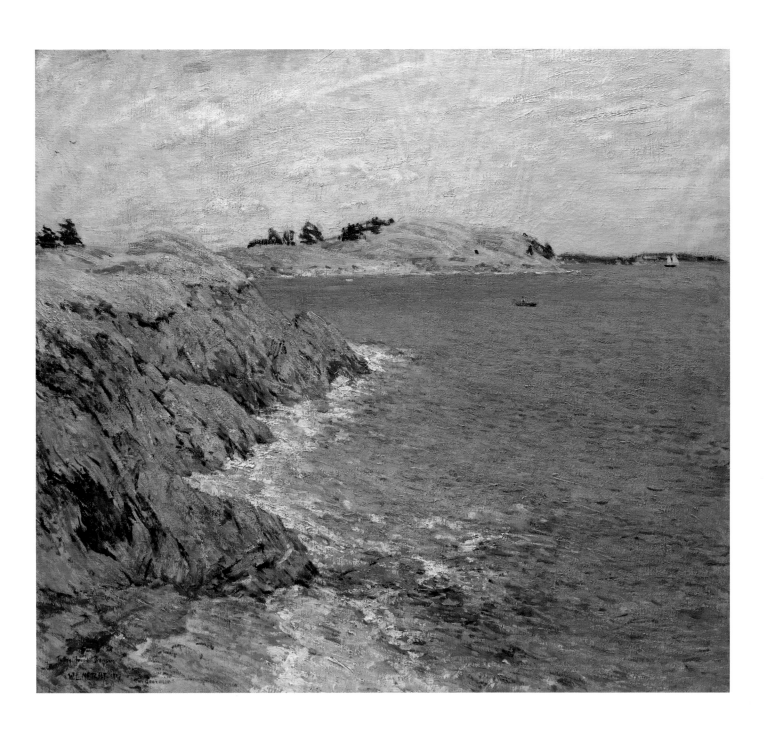

Maurice Brazil Prendergast (1858–1924)

31 St. Mark's Square, Venice (The Clocktower), c. 1898–99

Watercolor and graphite on paper, 23⅞ x 6⅛

Signed lower left, "Prendergast"

Museum purchase, 44.316

PROVENANCE: Collection of the artist; purchased by Mrs. J. Montgomery Sears (Sarah Choate Sears); Mrs. J. D. Cameron Bradley; Childs Gallery, Boston, 1943

EXHIBITIONS: Boston Watercolor Club, "Twelfth Annual Exhibition of the Boston Art Club," 2–16 March 1899, no. 106; Sterling and Francine Clark Art Institute, Williamstown, Massachusetts, "Watercolors by Maurice Prendergast from New England Collections," 11 November–17 December 1978, no. 21; Coe Kerr Gallery, New York, 19 October–16 November 1983, and The Boston Athenaeum, 23 November–18 December 1983, "Americans in Venice, 1879–1913," no. 54; The Fine Arts Museums of San Francisco, California Palace of the Legion of Honor, 20 October 1984–24 January 1985, and The Cleveland Museum of Art, 27 February–21 April 1985, "Venice: The American View, 1860–1920, no. 35; Coe Kerr Gallery, New York, "The Remembered Image: Prendergast Watercolors, 1896–1906," 23 October–6 December 1986, no. 11; Whitney Museum of American Art at Champion, Stamford, Connecticut, 31 May–2 September 1990, Williams College Museum of Art, Williamstown, Massachusetts, 6 October–16 December 1990, Los Angeles County Museum of Art, 21 February–22 April 1991, and The Phillips Collection, Washington, D.C., 18 May–25 August 1991, "Maurice Prendergast," no. 23

St. Mark's Square, Venice (The Clocktower) is among Maurice Prendergast's most lyrical watercolors. Painted in Venice during the artist's 1898–99 trip (or perhaps shortly thereafter using sketches), the delicately painted work expertly delineates the colorful tower's decorative motifs and the crowd of people—most likely tourists to the Italian city—emerging from the passageway below. On paper trimmed to evoke the elongated format of the clock tower, the watercolor has a custom-made frame of carved wood with gold leaf created by Charles Prendergast, the artist's brother. The result is a pleasing decorative composition in the tradition of artistic souvenirs of Venice that have, for centuries, been produced by painters as well as by writers and poets.

Although Maurice Prendergast came late to his profession as an artist, he made the transition from sign painter to professional artist in a relatively short time. Born in Newfoundland but raised in Boston, Prendergast was a painter of show cards, signs made for businesses, working in the firm of Peter Gill, a Boston designer in the 1880s.[1] It was not until 1891, when Maurice was already thirty-three and Charles twenty-eight, that the two brothers left home to begin formal art instruction in Paris.[2] After several years studying at the Académie Julian and Colarossi's studio, discussing art with other expatriate painters, and traveling to the seaside on sketching trips, Maurice and Charles returned to Boston. Maurice immediately began submitting works to art club exhibitions and annuals in various cities. By 1896 his address was listed in the directory of the artists in the Pennsylvania Academy's annual exhibition as Trinity Court, a Boston building with residences and studios exclusively for artists.[3]

The subject most often associated with Maurice Prendergast's work in the 1890s—colorful, gay pictures of people at leisure in parks and by the seaside—was well suited for depictions of Venice. In the works he produced on his eighteen-month trip to Italy, the extraordinary Renaissance and medieval architecture served as a picturesque setting for the anecdotal pictures of visitors (particularly women) on holiday; strolling with their colorful umbrellas, they seem to waltz across the picture plane.

The original owner of this Venetian watercolor was Mrs. J. Montgomery Sears, the wife of a prominent supporter of music in Boston, but who was also known in her own right as Sarah Sears, an artist and photographer. According to an early article on Prendergast by William Milliken, Mrs. Sears financed Prendergast's 1898–99 trip to Italy.[4] This painting, whether or not Sears received it as repayment for her support, is a personal work of a specific subject with a frame designed to enhance its presentation.[5]

By the turn of the century, Prendergast's works could be found in many Boston homes, and had the artist chosen to continue painting the same type of picture, he likely would have continued to find buyers for his appealing holiday views for many years. Not content, however, to continue making works in the same style, Prendergast began to paint more abstract and challenging works of art. He gave up making monotypes, the delicate single-impression prints that he had been creating since the mid–1890s, and began working more in oil, often drawing his subject matter from his watercolors but presenting the scenes of holiday strollers in a much more stylized fashion. Boston collectors like Sarah Sears did not buy these more challenging and modern works. But despite years of slow sales and little encouragement from critics who had formerly found his work delightful, Prendergast remained true to his artistic ideals and did not return to painting more of the same charming vignettes.

The evolution in Prendergast's style brought his work to the attention of his fellow artists and the New York art dealer William Macbeth. In 1908 the artist was included in the landmark Eight exhibition made up of a group of painters led by Robert Henri who sought to challenge the conservatism of other artists, particularly those who kept works by younger and more adventurous artists out of the large annual exhibitions held in major cities. In the years following the Eight exhibition, a new generation of critics and collectors discovered the work of Prendergast and he again found success, but with works of a nature very different from his 1890s watercolors and monotypes.

G. O.

REFERENCES: Van Wyck Brooks, "Anecdotes of Maurice Prendergast," *The Prendergasts: Retrospective Exhibition of the Work of Maurice and Charles Prendergast* (Andover, Mass.: Addison Gallery of American Art, 1938), 38–39; Eleanor Green, *Maurice Prendergast: Art of Impulse and Color* (College Park: University of Maryland, 1976), 40; Gwendolyn Owens, *Watercolors by Maurice Prendergast from New England Collections* (Williamstown, Mass.: Sterling and Francine Clark Art Institute, 1978), 48–51, 50 (illus.); Donna Seldin, *Americans in Venice, 1879–1913* (New York: Coe Kerr Gallery, 1983), 91; Margaretta M. Lovell, *Venice: The American View, 1860–1920* (San Francisco: The Fine Arts Museums of San Francisco, 1984), 77–80, 79 (illus.); Margaretta M. Lovell, "American Artists in Venice, 1860–1920," *The Magazine Antiques* 127 no. 4 (April 1985): 78, 79 (illus.), 80; Donna Seldin, *The Remembered Image: Prendergast Watercolors, 1896–1906* (New York: Coe Kerr Galleries, 1986), n.p. (illus.), 10; Margaretta M. Lovell, *A Visitable Past: Views of Venice by American Artists, 1860–1915* (Chicago: University of Chicago Press, 1989), 30–33, 31 (illus.), 45; Nancy Mowll Mathews, *Maurice Prendergast* (Williamstown, Mass.: Williams College Museum of Art; Munich: Prestel-Verlag, 1990), 16–19, 68 (illus.), 98, 102, 175; Carol Clark, Nancy Mowll Mathews, and Gwendolyn Owens, *Maurice Brazil Prendergast, Charles Prendergast: A Catalogue Raisonné* (Williamstown, Mass.: Williams College Museum of Art; Munich: Prestel-Verlag, 1990), 19, 377 (illus.); Richard J. Wattenmaker, "Maurice Prendergast at the Whitney," *The New Criterion* (November 1990): 39; Richard J. Wattenmaker, *Maurice Prendergast* (New York: Harry N. Abrams, Inc., and the National Museum of American Art, Smithsonian Institution, 1994), 43–45, 46 (illus.), 106, 160

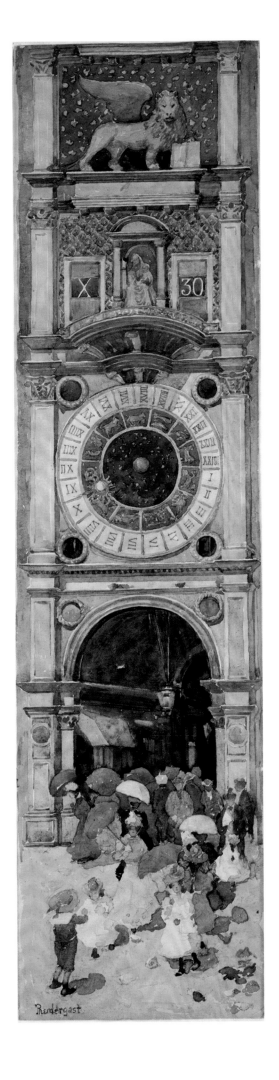

Lilian Westcott Hale (1881–1963)

32 Daffy-Down-Dilly, 1908

Oil on canvas, 36 x 20

Gift of Mrs. Augustus Putnam from the estate of Mrs. Ernest Amory Codman, Cambridge, Massachusetts, 61.1238

PROVENANCE: Collection of the artist, purchased by Mrs. Ernest Amory Codman, Cambridge, Massachusetts, 1909–61

EXHIBITIONS: Pennsylvania Academy of the Fine Arts, Philadelphia, "One Hundred and Third Annual Exhibition," 4 February–24 March 1908, no. 506; Galleries of the Guild of Boston Artists, Boston, "Exhibition of Paintings and Drawings by Lilian Westcott Hale," 6–18 November 1916, no. 5

REFERENCES: *One Hundred and Third Annual Exhibition* (Philadelphia: Pennsylvania Academy of the Fine Arts, 1908), n.p.; *Exhibition of Paintings and Drawings by Lilian Westcott Hale* (Boston: Galleries of the Guild of Boston Artists, 1916), n.p.

The turn-of-the-century aestheticization of women is superbly represented in Lilian Hale's *Daffy-Down-Dilly*, a woman enveloped in a luxurious shawl arranging flowers. This rarefied world of upper-class leisure and decorative femininity was a major theme in *fin-de-siecle* American painting in Boston and New York. Such lovely impressions served a variety of artistic and social purposes.[1] On the one hand, images of such feminine refinement served to place women on pedestals just as they neutralized them politically and socially. An early work in Hale's career, *Daffy-Down-Dilly* appears to endorse a subordinate societal role for women, although later Hale painted portraits that established her own voice in the circle of artists with whom she was associated.

Hale studied at the Hartford Art School with William Merritt Chase and at the Boston Museum School with Edmund Charles Tarbell and Philip Leslie Hale, whom she married in 1901. Hale's oeuvre reflects her training based on an aesthetic that combined acedemic drawing and impressionistic technique. Her work also reflects the Boston School's teachers' interest in Japanese culture—decorative Oriental objects, carefully planned asymmetrical compositions, and compressed space. Hale, however, brought something else into this work, an interpretation of the Art Nouveau style that seems to be relevant to her view of women.

Daffy-Down-Dilly shows a woman dressed in a sumptuous shawl and veil, bathed in the soft light from the window, leaning gracefully to arrange flowers. The image describes a world that is intimate, refined, and idealized, and the figure of the woman is perceived as a part of the room and not as an individual personality. In 1908 *Daffy-Down-Dilly* was included in the 103rd annual exhibition of the Pennsylvania Academy of the Fine Arts. That same year Hale exhibited a black chalk drawing of the identical subject, *Daffydowndilly* (1908, Museum of Fine Arts, Boston), in her first solo exhibition of drawings at Rowland's Galleries in Boston. The Hale scholar Erica E. Hirshler observed that "she [Hale] frequently completed both oils and charcoals of the same subjects; each is an independent, finished work and the drawings should not be considered preparatory studies. The drawings usually precede the oils, sometimes by a number of years, but in the case of *Daffy-Down-Dilly*, both were completed in early 1908."[2]

Another drawing related to *Daffy-Down-Dilly*, titled *The Old Ring Box* (1907, Museum of Fine Arts, Boston), brings some significance to the object the figure holds tightly in her right hand, perhaps adding a personal note to this otherwise faceless woman. In *The Old Ring Box* the same figure now faces the viewer but looks down at the ring box in her hand. *Daffy-Down-Dilly* features Hale's favorite model, Rose Zeffler, who posed for the artist as well as for her husband, Philip Hale. The Hales' daughter, Nancy, published a book in 1969, *Life in the Studio*, that provided insight on the working and personal relationship between Hale and her model "Zeffy," as well as the life she shared with her artist parents.

P. J. B.

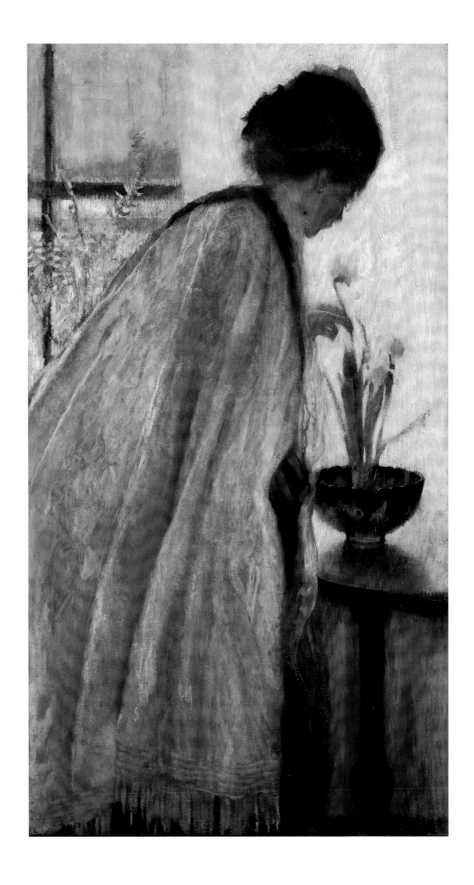

Josephine Miles Lewis (1865–1959)

The first woman to receive a bachelor of fine arts degree from Yale University, Josephine Miles Lewis studied with John F. Weir and John H. Niemeyer, graduating in 1891. The following year, she traveled to Europe to study in Paris at the Académie Julian. In 1894 Lewis spent an enjoyable summer studying in Giverny accompanied by her sister, Matilda. Paul Cézanne happened to be in residence at their pension, and Matilda humorously recorded, "I thought he looked like a cut throat with large red eyeballs standing out from his head in a most ferocious manner, . . . with an excited way of talking that positively made the dishes rattle."[1] Lewis returned to the United States in 1897 and established a studio in New York, dividing her time between the city and her home and studio in Scituate, Massachusetts, where she preferred to summer.

Lewis enjoyed a long and acclaimed portrait career, specializing in portraits of children and single figures in interior settings. *Young Girl in Swing*, along with the earlier *Girl in the Sunshine*, completed in 1895 (Yale University Art Gallery), are among the artist's most compelling works, and both are from early in her career. The direct gaze of the subject in *Young Girl in Swing* establishes a potent image with interesting psychological overtones. The pensive and anxious quality of the young girl's stare suggests a hidden text—the fear and trauma of adolescence and the loss of innocence. This stage in a girl's life marks the point of entrance into a new social role and responsibility that held special significance in Victorian America. In fact, the "way in which a woman negotiated the physiological dangers of puberty was believed to determine her health not only during her child-bearing years but at menopause as well. A painful, unhealthy, or depressed puberty sowed the seeds for disease and trauma at menopause. Indeed, so intertwined were these events that physicians used the age of puberty to predict the age when menopause would occur."[2]

Even in the idealized life of leisured well-to-do Americans, here signified by the elegant dress with elaborate lace ruffle and the hammock, the difficult transition to womanhood could not be completely obscured. Paintings depicting just this sort of leisure activity were popular among patrons of the period. However, it may also signify one of the few activities a girl of this age was allowed. During this period, a young girl's mother was required to "carefully oversee her puberty." It was believed that the female body "contained only a limited amount of energy" and "at the commencement of puberty, a girl should curtail all activity." At all cost they had to "avoid the display of any strong emotions . . . [and] spend much of their time in the fresh air."[3] Lewis's canvas of a lovely young girl on a beautiful summer day is ultimately a portrait of the dangers that arise during the transition to womanhood.

P. J. B.

33 Young Girl in Swing, 1900

Oil on canvas, 24¼ x 32¼

Signed and dated lower left, "J. M. Lewis 1900"

Gift of Mrs. Irving Hall, Chestnut Hill, Massachusetts, 59.1142

PROVENANCE: Collection of the artist; remained in the Lewis family

EXHIBITIONS: Pennsylvania Academy of the Fine Arts, Philadelphia, "Annual Exhibition, 1901," no. 226; Childs Gallery, Boston, "Portrait Paintings by Josephine Lewis," 10–22 October 1955; Nassau County Museum of Fine Art, Roslyn Harbor, New York, "One Hundred Years: A Centennial Celebration of the National Association of Women Artists," 16 October–31 December 1988

REFERENCES: Ronald G. Pisano, *One Hundred Years: A Centennial Celebration of the National Association of Women Artists* (Roslyn Harbor, N.Y.: Nassau County Museum of Fine Art, 1988), 7 (illus.); Betsy Fahlman, "Women Art Students at Yale, 1869–1913: Never True Sons of the University," *Woman's Art Journal* 12, no. 1 (Spring/Summer 1991): 18–19, inside front cover (illus.)

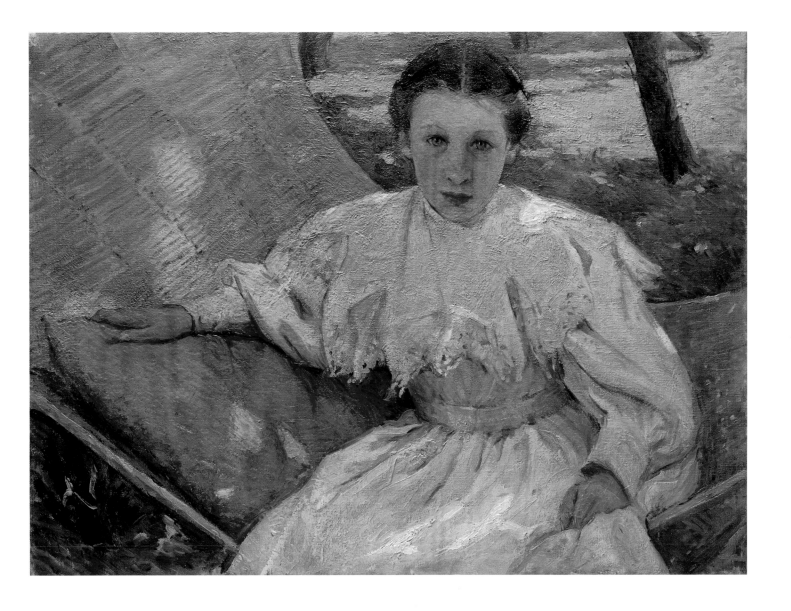

Frank Weston Benson (1862–1951)

34 Laddie, 1908

Oil on canvas, 33¼ x 30

Signed and dated lower right,
"F.W. Benson - 1908"

Gift of John G. Greene, Boston,
57.1073

PROVENANCE: Commissioned by Edwin
Farnham Greene, Esq., 1908; remained
in the Greene family

EXHIBITIONS: St. Botolph Club, Boston,
"Paintings by Frank W. Benson," 10–29
January 1910, no. 1 (as *Portrait of a Boy*);
Farnsworth Art Museum, "Frank W.
Benson: 1862–1951," 6 July–9 September
1973; North Haven Historical Society,
North Haven, Maine, "Frank W. Benson,"
4–5 August 1977, no. 1; Farnsworth Art
Museum, 5 October–28 November 1979,
and Portland Museum of Art, Maine,
18 December 1979–27 January 1980,
"Masters in Maine"; Spanierman Gallery,
New York, "Frank W. Benson: The
Impressionist Years," 11 May–11 June
1988; Colby College Museum of Art,
Waterville, Maine, "Americans and Paris,"
1 August–22 October 1990, no. 14;
Farnsworth Art Museum, "Bellows and
Benson in Maine: Reality and the Dream,"
28 June–8 November 1998

REFERENCES: John W. Wilmerding, Sheila
Dugan, and William Gerdts, *Frank W.
Benson: The Impressionist Years* (New
York: Spanierman Gallery, 1988), 22, 59
(illus.); *Frank W. Benson: A Retrospective*
(New York: Berry-Hill Galleries, 1989),
n.p.; Michael Marlais, *Americans and
Paris* (Waterville, Maine: Colby College
Museum of Art, 1990), 20, 22 (illus.);
Faith Andrews Bedford, *Frank W. Benson,
American Impressionist* (New York:
Rizzoli, 1994), 121, 122; Susan C. Larsen
and Pamela J. Belanger, *Bellows and
Benson in Maine: Reality and the Dream*
(Rockland, Maine: Farnsworth Art
Museum, 1998), n.p. (illus.)

The light of North Haven, the smaller of the two Fox Islands in Penobscot Bay just off the coast of Maine from Rockland, provided the stimulus for Frank Benson's turn to his particular brand of American impressionism in the early years of the twentieth century. North Haven and its companion, Vinalhaven, were elite vacation spots. The summer colony on the Fox Islands had begun in the 1880s and had blossomed by the early decades of this century into an enclave of old establishment families with names like Rockefeller and Cabot. Benson first visited the island in 1900 with his wife, Ellie, and their three children. It was then that they saw the farm of Levi Wooster, on the Thorofare, as the sea passage between North Haven and Vinalhaven is known. They were charmed by the property, which they were eventually able to purchase, and began to summer regularly on North Haven, a pattern that would last virtually the rest of the artist's life.[1] Benson had studied in Paris for two years beginning in 1883, at a time when French impressionism was very much in vogue, but he apparently had little interest in the movement while he was in France. It was not until he moved to North Haven that he made a concerted effort to work out-of-doors, developing a palette and technique designed to capture the brilliant effects of sunlight. *Laddie*, with its vibrant white highlights, is an early example of the style that would make Benson one of the best-known, most widely admired, and, indeed, most successful painters of his generation.

Light and shadow are key to the painting's mood. The clear light of a cool Maine summer day floods across the child's body, illuminating and warming his left side, while leaving the rest of his body in shade. Quick strokes of pure white paint enliven the cotton garment, the smooth, fine, youthful skin, and the towheaded boy's shock of blond hair. Touches of blue on the white fabric serve to increase the glowing effect of sunlight on the young child's de rigueur play outfit of the period. Brownish red tones on the child's nose and freckled face add a note of realism by suggesting another of the sun's effects. Dashing strokes of various green shades indicate island foliage, and a patch of blue at upper left, with a few wispy strokes of white, indicates fog lifting for another perfect day on this island paradise. A portrait to be sure, Benson's *Laddie*, like so many of his paintings done on North Haven, is charged with the atmosphere of the island the artist so loved.

Benson was forty-six when he did this portrait and very much sought after by society people in Boston, where he maintained his studio. He was a founding member of the Ten, the New York–based group that resigned from the Society of American Artists in 1897 to establish their own exhibitions, much as the French impressionists had done twenty-five years earlier. Over the years these exhibitions became the forum for the development of American impressionism and Benson was at the heart of the movement. Along with Edmund Tarbell, he made Boston one of the centers of impressionism. But Benson was also known as a portraitist, and it was with portraiture that he had made a successful career for himself in painting. With *Laddie* Benson combined his interest in portraiture and impressionism in one of his first commissioned plein-air portraits.[2]

The boy pictured in *Laddie* is the fine young son of Benson's North Haven neighbor.[3] The painting was executed at Mullens Inn and took about two weeks to complete. Benson had done many portraits of his own children on North Haven, and he was certainly prepared to work out-of-doors and yet still retain a precise sense of his sitter's identity. Indeed, identity is central to this painting as well as to the portraits of his own children. Benson was a devoted father. His portraits of his children, like *Laddie*, are idealizations of youth itself. It is an image of innocence created in an age of relative innocence. No gritty realist, Benson gives us the healthy, happy American child as symbol of the health and future of the nation. Neither political corruption, corporate excess, nor the plight of the urban poor stains this optimistic painting. None of the symbolism is heavy-handed, yet the implications are there. Established as he was in one of the most sought-after vacation spots on earth, Benson offers up here a hymn to what he saw as the best that America had to offer.

M. M.

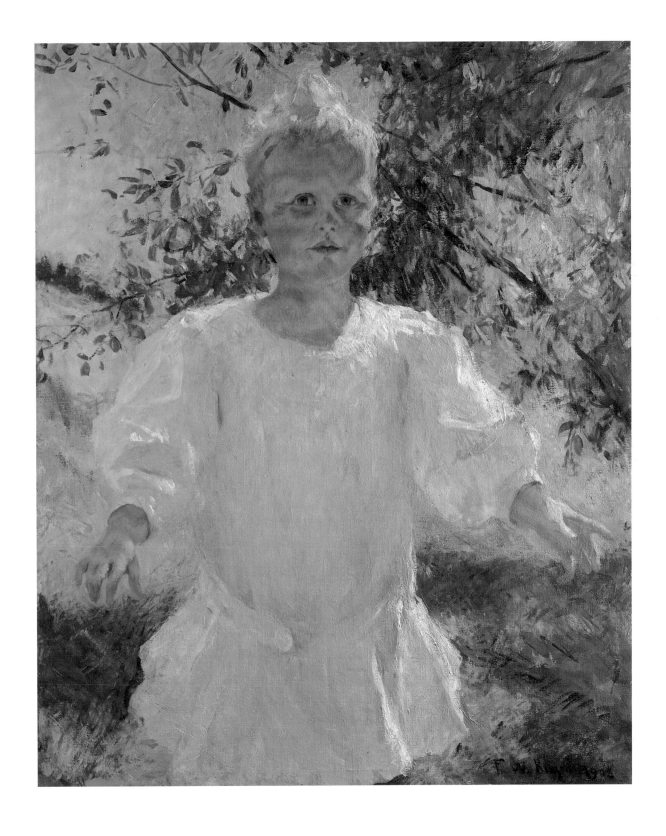

Oil on canvas, 30¼ x 25¼

Signed and dated upper left corner, "F.W. Benson / '22"

Bequest of Mrs. Elizabeth B. Noyce, 97.3.3

PROVENANCE: Gift of the artist to Parker R. Stone, 1922–69; Gilbert C. Laite, Jr. and Stephanie Laite Lanham, 1969–94; Mrs. Elizabeth B. Noyce, 1994–96; Estate of Mrs. Elizabeth B. Noyce, 1996–97

EXHIBITIONS: Museum of Fine Arts, Boston, "Frank W. Benson, Edmund C. Tarbell: Exhibition of Paintings, Drawings and Prints," 16 November–15 December 1938, no. 40; Essex Institute and Peabody Museum, Salem, Massachusetts, "Frank W. Benson, 1862–1951," 6 June–30 September 1956, no. 10; Portland Museum of Art, Maine, "An Eye for Maine," 29 October 1994–22 January 1995; Portland Museum of Art, Maine, 1 October 1997–4 January 1998, "A Legacy for Maine: Masterworks from the Collection of Elizabeth B. Noyce"; Farnsworth Art Museum, "Bellows and Benson in Maine: Reality and the Dream," 28 June–8 November 1998

REFERENCES: Lucien Price, *Frank W. Benson, Edmund C. Tarbell* (Boston: Museum of Fine Arts, 1938), 21, 36 (illus.); Lucien Price, *Frank W. Benson, 1862–1951* (Salem, Mass.: The Essex Institute and the Peabody Museum, 1956), 12; Faith Andrews Bedford, Susan Faxon, and Bruce W. Chambers, *Frank W. Benson: A Retrospective* (New York: Berry-Hill Galleries, 1989), 106 (illus.); Jessica F. Nicoll, *A Legacy for Maine: The November Collection of Elizabeth B. Noyce* (Portland, Maine: Portland Museum of Art, 1997), 42 (illus.), 44; Susan C. Larsen and Pamela J. Belanger, *Bellows and Benson in Maine: Reality and the Dream* (Rockland, Maine: Farnsworth Art Museum, 1998), n.p. (illus.)

Watercolor and graphite on paper,
19 x 29½

Signed and dated lower left,
"F. W. Benson '37"

Museum purchase, 43.62

PROVENANCE: Collection of the artist
1937–43

EXHIBITIONS: Museum of Fine Arts,
Boston, "Frank W. Benson, Edmund
C. Tarbell, Exhibition of Paintings,
Drawings and Prints," 16 November–
15 December 1938, no. 103; Museum
of Fine Arts, Boston, "The Work of
the Guild of Boston Artists Past and
Present," 27 October–29 November
1942; Farnsworth Art Museum,
"Frank W. Benson, 1862–1951," 6 July–
9 September 1973; North Haven
Historical Society, North Haven, Maine,
"Frank W. Benson Exhibition," 4–5
August 1977, no. 3; University Art
Galleries, University of New Hampshire,
Durham, "Two American Impressionists:
Frank W. Benson and Edmund C. Tarbell,"
12 March–21 April 1979

REFERENCES: *The Work of the Guild
of Boston Artists Past and Present*
(Boston: Museum of Fine Arts, 1942),
12; Faith Andrews Bedford, *Frank W.
Benson, American Impressionist* (New
York: Rizzoli, 1994), 222

Walter Lofthouse Dean (1854–1912)

37 On The Deep Sea, 1901

Oil on canvas, 40⅛ x 47¼

Signed and dated lower right, "Copyright 1901 by / Walter L. Dean"

Gift of Mr. and Mrs. John Hill, Boston, 71.1807

EXHIBITIONS: Boston Art Club, 5 January–2 February 1901, no. 54; Department of Art, Louisiana Purchase Exhibition, St. Louis, 1904; The Corcoran Gallery of Art, Washington, D.C., "Biennial Exhibition," February–March 1907, no. 266; Worcester Art Museum, Massachusetts, "Exhibition of Paintings by Walter L. Dean," 22 January–2 February 1908, no. 11; The Fitchburg Museum of Art, Fitchburg, Massachusetts, "The Maine Connection: Paintings and Sculpture from the Farnsworth Art Museum," 21 November 1993–27 March 1994

REFERENCES: Rolf Kristiansen and John Leakey, Jr., *Rediscovering Some New England Artists, 1875–1900* (Dedham, Mass.: Gardiner O'Brien Associates, 1987), 189, 197; Peter Hastings Falk and Andrea Ansell Bien, *The Biennial Exhibition Record of The Corcoran Gallery of Art, 1907–1967* (Madison, Conn.: Sound View Press, 1991), 108

In the 1880s the picturesque scenery around the historic fishing port of Gloucester, Massachusetts, began to attract American painters from Boston and New York. Nostalgic images of an earlier seafaring way of life that was fast disappearing became popular at the same time as the nation was experiencing rapid urban and industrial growth. Well-known American impressionists such as John Twachtman, Willard Leroy Metcalf, and Childe Hassam have long been associated with depictions of the landscape around Gloucester and the important artists' colony that grew up around the old harbor.

Yet in their time there was another group of artists who were prominent members of the Gloucester colony, but who are not well known today. Among them were Walter Lofthouse Dean and Augustus Waldeck Buhler. Dean was in fact one of the earliest members of the colony. In 1885 he outfitted the large sailing yacht *Undine* to serve as a floating studio, and he anchored it in the harbor when he was not cruising in search of maritime subjects. Dean's many paintings of Gloucester harbor and his depiction of the rugged men who fished the Grand Banks achieved popular success for the artist, but only recently have scholars and the public come to appreciate them once again.

Dean's *On The Deep Sea*, painted in 1901, is one of his most powerful illustrations of the heroic life of the deep-sea fishermen that he admired and so often painted. The picture shows two hardy New England fishermen laboring on the Grand Banks, hauling in a huge flounder or codfish as their boat lists dangerously. A somber gray mist envelops the scene. It is relieved only by the brilliant highlights of the artist's painterly rendering of the fish and the agitated water. Dean's mastery of detail in the rendering of the fishermen's rain slickers and traditional sou'wester hats and the peeling paint of their boat is set against a horizonless sky and the gentle swells of the sea. In the distance a white sea bird is glimpsed. Images of men larger than life laboring on the open sea—a theme explored with great success by Winslow Homer and writers such as Jack London—held a deep appeal for turn-of-the-century audiences who could read in them allusions to Darwinian notions of the survival of the fittest and ideals of national character. Dean's idealized representation of two men alone on the open sea practicing their ancient trade were particularly attractive to urban dwellers whose urge to escape their fixed routines and work-a-day life made such pictures popular around the turn of the century. *On the Deep Sea* may also have resonated for Dean's audience with biblical allusions to the tale of Jonah and his epic struggle with a great fish. In retrospect, however, what seems to distinguish Homer's art from that of Dean and others like him is Homer's modern, existential sense of nature unconcerned with human presence and action.

Dean's own life represented something of the struggle to escape the dreariness of industrial labor in the factory cities of New England. He was born of middle-class parents in the industrial town of Lowell, Massachusetts, although the family moved to Boston when he was still a child. On his fifteenth birthday his father gave him a Herreshoff catboat that he named *Fannie*. Dean proved to be an adept sailor, winning many local races, and it was at this time that his enduring love of the sea was born. When he graduated from school, his Lowell relatives provided him with a position to study the business of cotton manufacture in that city, but he soon rejected this in preference for art school. On graduation he taught art briefly at Purdue University in Lafayette, Indiana, but he soon returned to Massachusetts to pursue his love of all things associated with maritime life. In 1882 he traveled to Paris, where he studied at the Académie Julian. Before he returned to Boston he journeyed along the coasts of Brittany, Belgium, Holland, Italy, and England, which provided him with a store of subjects he would often paint in the following years.

In 1885 he moved to Gloucester, where he made a considerable impression with his sailing studio, the *Undine*. He spent a few months crewing as a common seaman on the Grand Banks and filling his notebooks with ideas for pictures. In 1886 he settled into a studio in Boston's Pemberton Square, where he could look out over the waterfront. The next year he had his first major exhibition at the Boston Art Club. The *Boston Herald* noted that "Mr. Dean knows boats as well as a surgeon knows anatomy, and consequently his craft would sail in any weather."[1] In 1893 he contributed another version, *The Open Sea*, to the World's Columbian Exposition in Chicago, but it is now unlocated and known only through photographs. His most famous work was a six-by-nine-foot "allegorical" painting of the Navy's famed *White Squadron*, which he also sent to the fair in Chicago, under the title *Peace*.

Until his death he continued his practice of sketching and painting in Gloucester during the summer and exhibiting in Boston during the winter. He exhibited at Doll and Richards Gallery in Boston, which was for many years the exclusive representative of Winslow Homer, whose work exercised a considerable influence on Dean, as evidenced by the Farnsworth picture. His persistent use of a dark, academic palette and his precise handling of detail set him apart from the American impressionists with their colorful pictures. *On the Deep Sea* expresses Dean's continuing allegiance to a more traditional style of academic realism, which, as taste shifted with the advent of modernism, soon came to be regarded as passé. In 1911 Dean planned a world cruise, and, needing funds to outfit a vessel, he auctioned off practically his whole collection. Over 150 works were sold, but the artist was soon taken ill and died in East Gloucester on 13 March 1912. In 1929 his large painting *Peace* was acquired by Congress for the Capitol in Washington, D.C.

J. G. S.

Augustus Waldeck Buhler (1853–1920)

38 Shipwreck off Cape Ann, 1908

Oil on canvas, 33½ x 55⅝

Signed and dated lower left, "A.W. Buhler / East Gloucester / 1908"

Gift of Miss Dorothy Buhler (artist's daughter), Kittery Point, Maine, 70.1747

PROVENANCE: Commissioned by Frank Howes, Brookline, Massachusetts, 1908; Dorothy Buhler, 1970

EXHIBITIONS: The Fitchburg Art Museum, Fitchburg, Massachusetts, "The Maine Connection: "Paintings and Sculpture from the Farnsworth Art Museum," 21 November 1993–27 March 1994

REFERENCES: Joe Garland, "The Wreck of the *Wilster*: How the Rockport Life Savers Used the Breeches Buoy to Rescue 23 Sailors on a Stormy Night 70 Years Ago," *North Shore*, 26 February 1972, 12, 12 (illus.), 13

Augustus Buhler's painting *Shipwreck off Cape Ann* records the artist's recollections of the grounding of the English tramp steamer *Wilster* and the dramatic rescue of her crew in 1902. According to the artist's daughter, Dorothy, the painting was a commission from the Boston leather merchant Frank Howes, of Brookline, who had a collection of the artist's works. "I remember," Dorothy Buhler wrote to the director of the Farnsworth in 1971, shortly after donating her father's work to the museum, "[Howes] wanted something of a special size for over his fireplace, which accounts for the proportions of the canvas, and I can recall distinctly seeing my father work on it."[1]

The dramatic depiction of a rocky coastline pounded by huge waves and the straining, expectant faces of the anxious crowd captures the people's response to a dreaded shipwreck—an event that was all too familiar to coastal residents around the turn of the century. The dark tonalities and expressive handling of paint suggest the powerful influence of Winslow Homer's work on Buhler. The composition and placement of figures strongly recall the background figures in Homer's etching *Perils of the Sea*, of which Buhler, who exhibited often in Boston, must have been aware. Like Homer and other artists of the Gloucester artists' colony, such as Buhler's contemporary Walter Dean, the artist understood that the market for his pictures of the rugged fisherfolk of the region was a product of rapid cultural change. In 1900, Buhler told a reporter from the *Boston Globe:* "Artists are to a great extent historians. They tell the story of their own times. Who are painting the story of this country? Take the native New England fishermen. . . . This type is rapidly passing away."[2]

The saving of the *Wilster's* crew by the recently established Rockport Gap Head Life Saving Station provided just such a striking opportunity for Buhler to capture the tense moments before the lifesavers could bring in the stranded men.[3] In the distance at far left the lifesavers are glimpsed as they attempt to rig the breeches buoy and run a line out to the imperiled ship on the horizon. Even the faces of the two figures in the foreground at extreme left are probably portraits of individuals Buhler knew were at the scene, although they are unidentified today. The older, bearded man appears in other works by Buhler, who always painted men he knew in the Gloucester community of fishermen. Like Homer in nearby Maine, Buhler understood the darker aspects of the sea. He knew of the hundreds of men who were killed at sea every year, and as *Shipwreck off Cape Ann* vividly suggests, he sympathized with the anxious families who awaited the return of their men after each storm.

Augustus Buhler moved to Cape Ann, near Gloucester, in 1885. He was quickly accepted in the small but thriving Annisquam artists' colony. In 1908 the *Cape Ann Shore* reported, "East Gloucester like Squam is a favorite place for the artists . . . many studios having been erected and many of the fishhouses have been converted into studios for artists. Among these are A.W. Buhler . . . the interior of his studio is fitted with a cabin from an old coaster and various furnishings from fishermen, from side lights and glass net balls."[4] However, Buhler must have felt the need for further training, because in 1888 he went to France to study painting. Like so many other aspiring artists, he enrolled in the Académie Julian and spent his summers sketching in Dordrecht, Holland, and Etamples, France. On his return Buhler opened a studio in Boston, where he worked and exhibited during the winter, and he summered on Cape Ann at Annisquam. By 1901 *The Boston Post* observed that he was known as "a Boston artist of repute and wide reputation . . . particularly noted for his successful sea and coast pictures in which he introduces the hardy and rugged fishermen . . . in their picturesque clothing."[5] Buhler's images of heroic Gloucester fishermen are among his most famous works. One of these was purchased by the Slade-Gorton Company of Gloucester, which used it as their trademark for almost a century. As a historian Buhler was keenly aware that with the coming of mechanization the way of life he painted was rapidly disappearing. Buhler once told a reporter, "These people of New England stock will in the next generation be superseded by other races, mostly Greeks, Italians, and Portuguese. Very few of the young men of New England stock are engaged in the fisheries, preferring other vocations. This picture is a record of vanishing days."[6] Buhler died in 1920. In 1968 Childs Gallery of Boston staged a retrospective exhibition of his work in cooperation with the artist's daughter.

J. G. S.

Samuel Peter Rolt Triscott (1846–1925)

39 Old Dory, Monhegan,
c. 1900–20

Watercolor on paper, 16 x 27
Signed lower left, "S. P. Rolt Triscott"

Gift of Mr. and Mrs. Leo J. Meissner in Memory of Edwin C. and Lora P. Jenney, 66.1536

EXHIBITIONS: Farnsworth Art Museum, "Monhegan: The Artists' Island," 23 April–25 June 1995

Samuel Triscott was one of the first artists to make Monhegan Island, Maine, his home. Born in Gosport, England, the son of a captain in the Royal Navy, Triscott trained as a civil engineer but also studied art at the Royal Institute of Painters in Water Colour in London during the 1860s. He is chiefly known for masterful watercolor landscapes of his native country and New England. According to newspaper accounts at the time of his death, Triscott came to the United States in 1871 and settled in Boston, where he opened a studio at the corner of Winter and Washington Streets.[1] During the 1880s and 1890s he was a member of the Boston Art Club, taught watercolor classes in his studio, and exhibited at the J. Eastman Chase Gallery. His summers were devoted to making landscape watercolors in rural and coastal Massachusetts, Connecticut, New Hampshire, and Maine, and in England. Sears Gallagher, another early Monhegan artist who had a studio in the same building, may have introduced Triscott to the island.

Triscott moved to Monhegan about 1905 and lived there permanently until the end of his life.[2] An avid gardener as well as an artist, he was drawn to the island by the picturesqueness of its natural setting and the simple life of its fishermen. His deep attachment to the island is clearly expressed in *Old Dory, Monhegan*, a sunlit scene of flowers growing up through the planks of an old wooden boat. Unlike his modernist Monhegan contemporaries, including Robert Henri and Rockwell Kent, who painted views of the island's powerful surf and rock formations, Triscott concentrated on quieter scenes of island life. Another Monhegan watercolor, *Fish Houses and Beach*, in the collection of the Farnsworth Museum, also evokes a romantic sense of place and the gentle passage of time. Cluttered with dilapidated fish houses, nets, and lobster traps, this small beach was the nexus of the fishing activities on the island. Triscott centers his composition on a touch of bright red for the shirt of an elderly fisherman, who recedes into the sharp shadows cast by the sunlight. The boldness of Triscott's watercolor technique is most visible in the foreground of this work, where washes of rusts and browns capture tidal drifts of seaweed. To his contemporaries, Triscott's watercolors suggested a nostalgia for a way of life that remained attuned to nature. This was a subject that had great appeal to the island's growing summer tourist trade, drawn increasingly from the urban areas of Boston and New York.

Triscott's detailed watercolor technique, learned at a prestigious English art institution founded in the mid-nineteenth century, also reflects a somewhat old-fashioned approach to the medium, one that maintained a delicate balance between the solid physicality of form and the diffusing effects of light and color. Certain passages of freely applied washes recall the work of his contemporary, John Singer Sargent, a decidedly more abstract watercolorist. Sargent coincidentally died on the same day as Triscott, and their deaths were reported together in the Boston papers.[3] Although today Triscott's name is almost forgotten, during his lifetime his work was popular. In addition to his work in the Farnsworth Museum, there are Triscott watercolors in several private collections and three at the Museum of Fine Arts, Boston, one of which was acquired as early as 1915.[4]

S. D.

39a Fish Houses and Beach,
c. 1900-20

Watercolor on paper, 22½ x 15

Gift of Mr. and Mrs. Leo Meissner, in memory of Edwin C. and Lora P. Jenny, 66.1535

Paul Dougherty (1877–1947)

40 The Crow's Nest, c. 1908

Oil on canvas with wood backing, 26 x 36

Signed lower left, "Paul Dougherty"

Gift of Mrs. Carleton S. Coon, Gloucester, Massachusetts, 79.90

PROVENANCE: Collection of the artist; remained in the family; Mrs. Carleton S. Coon (daughter of the artist), 1979

EXHIBITIONS: Macbeth Gallery, New York, "Exhibition of Paintings by Paul Dougherty, N.A.," 20 January–1 February 1908, no. 10; Portland Museum of Art, Maine, 16 March–9 April 1978, Fitchburg Art Museum, Fitchburg, Massachusetts, 7–31 May 1978, Lyman Allyn Museum, New London, Connecticut, 8 October–12 November, 1978, The New Britain Museum of American Art, New Britain, Connecticut, 17 December–30 December 1978, and The Mead Art Museum, Amherst College, Amherst, Massachusetts, 22 January–20 February 1979, "Paul Dougherty: A Retrospective Exhibition," no. 4; Farnsworth Art Museum, "Monhegan: The Artists' Island," 23 April–25 June 1995

REFERENCES: *Exhibition of Paintings by Paul Dougherty, N.A.* (New York: Macbeth Gallery, 1908), n.p.; *Paul Dougherty: A Retrospective Exhibition* (Portland, Maine: Portland Museum of Art, 1978), 11

Monhegan Island, a small fishing outpost located twelve miles off the middle of Maine's coast, offered Paul Dougherty an opportunity to paint the dramatic juncture between rock and ocean that became the hallmark of his landscape style. By 1900 the island was fast becoming a tourist destination, where summer visitors mingled with lobstermen and artists alike. Unlike other points of interest in Maine, however, Monhegan was not a resort. Rather, it catered to visitors who wished to wander along the cliffs and through the towering pine woods and broad meadow. For a small island (about one by one-and-a-half miles), Monhegan presents an unusually dramatic variety of natural features, especially its headlands and rocky outcroppings. The Crow's Nest, located on the southern end of the island, is a rugged and forbidding ledge that loomed large in Dougherty's imagination.

In the late 1890s Winslow Homer's seascapes of the Maine coast established such scenes as metaphors for the struggle of human existence, and over the years, the best of Paul Dougherty's work was often favorably compared with Homer's. This scene, with its palette of black, brown, russet, and green, its vigorous patchy brushwork, and its sharp contrasts of light and dark, exemplifies Dougherty's especially visceral approach to landscape painting. His work was often described in lyric terms by the critics of his day:

> Rocks of dazzling structure, of bewildering hues,—rocks that look like rotten fruit, others that look like jewels,—rocks that have fallen from the stars, others that have been swept out of the depths of the sea,—rocks half-buried like a sphinx in the sands, others that have risen in granite strata from the bowels of the earth—iron-eaten, moss-covered, rose-tinted, variegated rocks, the artist takes of them all in their isolation as well as their relation to the surf and under the action of waves. . . . It must be fascinating to reconstruct from such data and such impressions a work of art that is as vital and impressive as the work of nature.[1]

The Crow's Nest, first exhibited in 1908 at the Macbeth Gallery in New York,[2] helped establish Dougherty's reputation as an important American marine artist. A contemporary review of the Macbeth exhibition emphasized the weighty sentiment frequently associated with such vigorously painted images of rock and sea: it recalled "the spirit of the mythological Prometheus bound to a rock—the ever-present chafing against the fate that limits and foredooms all human effort."[3]

Born and raised in New York City, Dougherty had studied law and briefly practiced at the bar in the mid-1890s before returning to his early avocation as an artist.[4] Abandoning the legal profession, he traveled to Europe to visit its major cities and museums. Although he had received some early formal training in New York from Constantin Herzberg, Dougherty was essentially a self-taught artist. By 1901, however, his work was accomplished enough to appear in the Paris Salon; in 1905 he was elected a member of the Society of American Artists; and in 1907 he became a member of the National Academy of Design in New York. That same year his marine paintings were featured in a one-person show at the Pennsylvania Academy of the Fine Arts in Philadelphia.

Dougherty's exhibitions at the Macbeth Gallery in 1907 and 1908 launched his long and successful career as marine painter, a career that took him from the coast of Maine to Cornwall, Brittany, California, and the Far East. He lived in Paris from 1920 to 1927, when worsening arthritis forced him to return to the United States. He eventually moved to the West Coast—to the warm climate, dramatic cliffs, and artists' colony of Carmel, California. A prolific painter in both oil and watercolor, his works are represented in several important collections, including the Addison Gallery of American Art, the Carnegie Museum of Art, the Corcoran Gallery of Art, the Metropolitan Museum of Art, and the National Gallery of Art.

S. D.

Robert Henri (1865–1929)

41 Monhegan Island, 1903

Oil on panel, 8 x 10
Signed lower left, "Robert Henri"
Museum purchase, 91.9

PROVENANCE: Maynard Walker, New York; private collection, 1964–91; H. V. Allison & Co., Inc., New York, 1991

EXHIBITIONS: American Academy of Arts and Letters, New York, "Robert Henri (1865–1929) and His Circle," 1965, no. 20; Farnsworth Art Museum, "Monhegan: The Artists' Island," 23 April–25 June 1995, no. 16

Like so many before and after him, Robert Henri was taken with the power of "the mighty surf battering away at the rocks," on the Monhegan headlands.[1] While studying in Paris he had made small pochades, oil sketches, and he found that the loose brushwork and rapid technique of the pochade was perfect for capturing the feel of the pounding surf. In his typically uncomplicated and direct style he wrote to his student and friend John Sloan that he had painted "a whole batch" of these studies during the summer of 1903 and that he felt "pretty good over a lot of them."[2] In its small dimensions and bravado, the Farnsworth study is typical of the work Henri produced on Monhegan in 1903. Such visible brushstrokes in a painting could still cause a stir in New York at the turn of the century, and when Henri organized an exhibition of the work of younger artists, which included some of his Monhegan paintings, for the National Arts Club, the show of the "radical" new "impressionists" caused considerable scandal.[3] There is indeed a radical note to this little painting, and that of course is its charm. Henri's treatment of the surface is vigorous and unrestrained. He rapidly sketched in wet-over-wet, taking advantage of the streaking of the oil paint to achieve the feel of ocean surf as much as its actual appearance. Long, dragging strokes of the brush indicate the rush of the water, while short stabs pick out the features of the headlands. The entire scene is alive with the ruggedness of the place, paint and gesture serving to suggest the roaring sound of the surf, the brisk feel of the wind.

Henri's career and reputation were based on the ruggedness of his technique and the truthfulness of his vision. Both are much in evidence in his Monhegan pochades. He would use the lessons learned in these oil sketches to achieve the stunning effects that made him one of the best portraitists of his time. And he would pass on the doctrine of fresh paint application to a new generation of artists, those Ashcan School painters, who created a dynamic American art in the early years of this century.

An outsider to genteel East Coast society yet inclined toward the arts, Robert Henri was a natural choice as leader of a revolutionary artistic movement. His father moved the family often, first for opportunity and then—when he was accused of murder in the small Nebraska town he had founded—for secrecy. The young Robert always remained faithful to his father, changing his name from Cozad to Henri and acting sometimes as foster son, sometimes nephew, to avoid detection by the law. While his father forced the role of outsider on Henri, his mother resolutely sought to educate him and gave him an abiding interest in culture. She would have pronounced his new name in the French manner, while Robert preferred the more American, less refined "Hen-rye."[4]

Henri's desire for a realist style of art, charged with the excitement and drama of real places and real people, led him to France and Spain, but especially to New York City, where he led the group of artists dubbed the Ashcan School for their insistence on painting the less cultured aspects of city life. That same concern for a "real" experience led him to Maine's Monhegan Island. Henri first visited Monhegan in 1903 while staying with his friend the painter Edward Redfield in Boothbay Harbor. He was so taken with the island that he decided to bring his frail young wife, Linda, out for the air and the atmosphere. "It is a wonderful place to paint," he declared, "so much in so small a place one could hardly believe it."[5] Henri would later purchase a cottage on Horn's Hill and was instrumental in bringing his students Rockwell Kent and George Bellows to the island, just as he inspired them to develop their particular realist styles.

M. M.

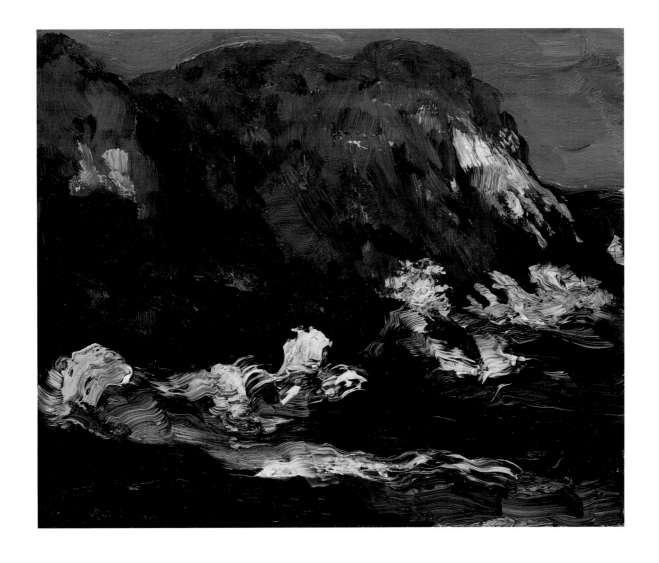

Rockwell Kent (1882–1971)

42 Maine Coast, c. 1907

Oil on canvas, 28⅛ x 38
Bequest of Mrs. Elizabeth B. Noyce,
97.3.25

PROVENANCE: Collection of the artist;
George S. Chappell, New York, 1914;
ACA Galleries, New York; Leslie
Hindman, Auctioneers, New York;
Jordan-Volpe Gallery, New York, 1993;
Vose Galleries, Boston, 1993; Mrs.
Elizabeth B. Noyce, 1993–96; Estate of
Mrs. Elizabeth B. Noyce, 1996–97

EXHIBITIONS: Farnsworth Art Museum,
17 July–18 September 1994, and Portland
Museum of Art, Maine, 29 October
1994–22 January 1995, "An Eye for
Maine: Paintings from a Private
Collection"; Portland Museum of Art,
Maine, "The Allure of the Maine Coast,
Robert Henri and His Circle, 1903–1918,"
29 June–15 October 1995; Portland
Museum of Art, Maine, 1 October
1997–4 January 1998, and Farnsworth
Art Museum 12 April–14 June 1998,
"A Legacy for Maine: Masterworks from
the Collection of Elizabeth B. Noyce"

REFERENCES: *The Magazine Antiques*
143 (April 1993): 503 (illus.); Donelson
Hoopes, *An Eye for Maine* (Rockland,
Maine: Farnsworth Art Museum, 1994),
8 (illus.), 15; Donelson Hoopes, "Two
Centuries of Maine Art," *Island Journal*
11 (1994): 48, 59 (illus.); Jessica F. Nicoll,
*The Allure of the Maine Coast, Robert
Henri and His Circle, 1903–1918*
(Portland, Maine: Portland Museum of
Art, 1995), 11 (illus.); Jessica F. Nicoll,
*A Legacy for Maine: The November
Collection of Elizabeth B. Noyce*
(Portland, Maine: Portland Museum of
Art, 1997), 2 (illus.), 52, 68; Scott R.
Ferris and Ellen Pearce, *Rockwell Kent's
Forgotten Landscapes* (Camden, Maine:
Down East Books, 1998), 77 (illus.)

Propelled by the recommendation of his teacher, Robert Henri, Rockwell Kent began his first extended visit to Monhegan Island in June 1905.[1] During the next five years, Kent would execute a group of paintings depicting the island, including *Maine Coast*, which would bring him critical praise as well as symbolize his growing artistic independence.[2] After his departure in 1910, Kent would not return to Monhegan, except for a brief visit in 1917, for more than thirty-five years. Yet his early experience of the island's dramatic juxtaposition of land and sea would inspire him to embark on a lifetime of far-flung northern adventures, leading to periods of residence in Newfoundland, Alaska, Ireland, and Greenland.

Unlike many contemporary paintings of Monhegan by Kent and other artists, *Maine Coast* does not depict a typical island scene—a view of rocky shoreline, harbor, or fishing community.[3] Instead, the viewer looks across the expanse of a snow-covered field toward a stand of spruce trees, a blanketed headland, and a distant view of the sea.[4] Kent composed the scene around a series of receding diagonal wedges demarcated by the line of grassy stubble in the foreground, the edges of the grove of trees, and the contour of the slope in the left background. Although at first glance the landscape may appear to lack dramatic incident, Kent infused the painting with a palpable sense of vitality. The deep, icy blue shadows and the scumble of clouds in the overcast sky indicate the passage of time, while the striking contrast between the dazzling white snow and the denseness of the evergreens lends the painting a fresh immediacy. Thick brushwork also activates the surface of *Maine Coast*, demonstrating the influence not only of Kent's teachers but also of Winslow Homer's late paintings.[5] Kent would soon abandon the painterly style of *Maine Coast*, distilling its sensuous tactility into simplified, abstracted forms like those found in the Farnsworth's *Lone Rock and Sea* (1950, no. 145).

When Kent arrived on Monhegan, he had recently decided to leave the architectural program at Columbia University to devote himself entirely to his art studies.[6] Having attended William Merritt Chase's summer painting classes at Shinnecock Hills, Long Island, Kent had enrolled at the New York School of Art, whose instructors included Chase, Robert Henri, and Kenneth Hayes Miller. Along with many of his contemporaries, Kent fell under the spell of the charismatic Henri. In fervent tones, Henri encouraged his students to break with academic formulas and reinvigorate American art by investigating the world around them.[7] Unlike those in Henri's circle dubbed the Ashcan School, Kent would find his principal inspiration not in the streets of New York, but in a series of remote locations. A summer spent working as an apprentice to the painter Abbott Thayer in Dublin, New Hampshire, in 1903 helped spark Kent's interest in the rural landscape.

Kent painted *Maine Coast* during one of several winters he spent on Monhegan. Influenced by his growing interest in socialist politics[8] as well as by Henri's belief that an artist's life and work should represent a seamless whole, Kent sought encounters with native islanders during the off-season. In his first experience of manual labor, undertaken to finance his extended stays, he worked as a well driller, carpenter, lobsterman, and general handyman. He also built a house and studio on land he had purchased on Horn's Hill. Looking back on this time in Maine, Kent wrote in 1928:

> Those were days of hard work, with all the excitement of a new and dangerous vocation. I liked the cold. It was stimulating. It became an obsession to me. Have I said I liked it? I question that. It may be that I hated it so that I got a kind of exaltation from the effort of overcoming it.[9]

A painting like *Maine Coast* should therefore be read not only as a sensitive seasonal landscape but also as proof for a New York audience of Kent's stamina in surviving the harsh island winters. It was on Monhegan that Kent began to craft his lasting artistic persona as a rugged individualist.[10]

M. L.

George Wesley Bellows (1882–1925)

George Bellows was deeply attracted to Monhegan Island. He visited the island only three times, in the summer of 1911, the summer and fall of 1913, and the summer of 1914, but he completed well over 150 paintings based on the island and its people. The majority of Bellows's sea paintings, a major subsection of his work, were developed from Monhegan motifs. Themes of loneliness and depression mingle with confident statements of the force of human effort against an uncompromising nature in Bellows's images of the sea, and these are played out in terms of both sturdy composition and daringly vibrant, thick strokes of pigment. Typically powerful in terms of both paint and subject, *Beating Out to Sea* was completed on the island in 1913 during Bellows's most productive stay.[1]

George Bellows was uniquely positioned to produce during the summer of 1913. He had finally convinced his wife, Emma, to go to Monhegan with him, and he settled in happily with her and their two-year-old daughter, Anne. In a letter to his mentor Robert Henri, who first brought Bellows to Monhegan in 1911, he bragged that Anne was "the most popular person on the island."[2] In the same letter he informed Henri that his "financial condition" was "never better." Bellows had already had a one-man show in New York, and in the spring he had become a full academician of the National Academy of Design. While he was still able to benefit from the notoriety of being associated with Henri's Ashcan School, he was also a respected member of New York's art establishment. In short, he could afford to take a risk in his painting. In February 1913 Bellows had worked on the installation of the famous Armory Show, and he was clearly intrigued by the modernist European art he saw there. This, too, may have stimulated him to try something new.

Bellows's sea paintings of 1913 exhibit an increased concern with dramatic brushwork. Built up with thick strokes from a one-inch brush, they make such paintings as those from the 1911 Monhegan series or city subjects such as *Cliff Dwellers* (Los Angeles County Museum of Art), completed just a few months earlier, seem controlled and careful by comparison. Clearly influenced by the seascapes of Winslow Homer, Bellows has gone further than the artist he so admired for his brilliant handling of paint. In *Beating Out to Sea* the rush of water forced back by the land is paralleled in light blue and green paint applied wet over the deep blue of the wave. Rugged strokes of black and white block out features of the headland—possibly Black Head—and come perilously close at times to depicting nothing at all. There is a bravado in such painting, and when Bellows showed a group of twenty-seven works from Monhegan—including *Beating Out to Sea*—at the Montross Gallery in New York[3] he was generally greeted with praise for his virtuoso talent with the brush. For some hostile critics this talent degenerated into mere cleverness, but none denied the bold expressiveness of the Monhegan paintings.[4] Sympathetic critics also pointed out the structure that supported the bold brushwork. In *Beating Out to Sea* one may note, especially in the central section, how often brushstrokes and color areas depicting apparently natural forms are arranged in triangular shapes. This may indeed show, as some have suggested, that Bellows employed the compositional schemes for artists developed by the theorist H. G. Maratta, but such structure clearly serves to balance and stabilize this painting.[5]

Bellows was attracted to the sea, but it also frightened him.[6] In 1911, when he visited Monhegan without Emma, he often wrote to her expressing respect for and fear of the sea. He wrote of contemplating a leap from the precipitous headlands on the eastern side of the island as he stared over the cliffs.[7] *Beating Out to Sea* expresses something of the danger of the rocky coast of Monhegan. The boat, a small commercial fishing schooner called a "pinkie," is performing a tricky and sophisticated sailing maneuver, "beating," or sailing to windward, off the headlands.

Bellows must have had particular affection for this painting. The Montross show of 1914 evidently did not go well, at least in terms of sales, and Bellows's next solo show in New York, an exhibition of thirteen paintings and eight drawings inaugurating the new Whitney-Richards Galleries, represented a return to the figure paintings and city subjects that had made his reputation in the city. Only one painting from Monhegan, *Beating Out to Sea*, was included in the exhibition, sole witness to the artist's profound experiences on the island.[8]

M. D.

43 Beating Out to Sea, 1913

Oil on panel, 14⅝ x 18⅞
Signed lower left, "GEO BELLOWS"
Museum purchase, 45.567

PROVENANCE: Collection of the artist, 1913–25; Estate of the artist, 1925; Emma Bellows, 1925–45; H. V. Allison & Co., Inc., New York, 1945

EXHIBITIONS: Montross Gallery, New York, "George Bellows," 17–31 January 1914; Whitney-Richards Galleries, New York, "George Bellows," December 1915; H. V. Allison & Co., Inc., New York, "Paintings by George Bellows," 7 November–15 December 1945; Farnsworth Art Museum, 5 October–28 November 1979, and Portland Museum of Art, Maine, 18 December 1979–27 January 1980, "Masters in Maine"; Los Angeles County Museum of Art, 16 February–10 May 1992, Whitney Museum of American Art, New York, 5 June–30 August 1992, Columbus Museum of Art, Columbus, Ohio, 11 October 1992–3 January 1993, and Amon Carter Museum, Fort Worth, Texas, 20 February–9 May 1993, "The Paintings of George Bellows"; Farnsworth Art Museum, "Monhegan: The Artists' Island," 23 April–25 June 1995, no. 2

REFERENCES: Emma Louise Bellows, *The Paintings of George Bellows* (New York: Alfred Knopf, 1929), 41 (illus.); *The Index of Twentieth Century Artists*, vol. I, no. 4 (March 1934): 122; *Paintings by George Bellows* (New York: H. V. Allison & Co., Inc., 1945), n.p.; Michael Quick, Jane Myers, Marianne Doezema, and Franklin Kelly, *The Paintings of George Bellows* (New York: Harry N. Abrams, Inc., 1992), 152 (illus.), 155, 253; Jennifer Hardin and Valerie Ann Leeds, *In the American Spirit: Realism and Impressionism from the Lawrence Collection* (St. Petersburg, Fla.: Museum of Fine Arts, 1999), 19 (illus.).

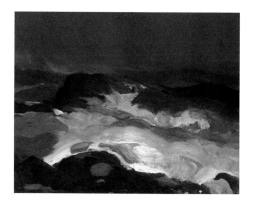

43a Sea in Fog, 1913

Oil on panel, 15½ x 20

Museum purchase, 45.568

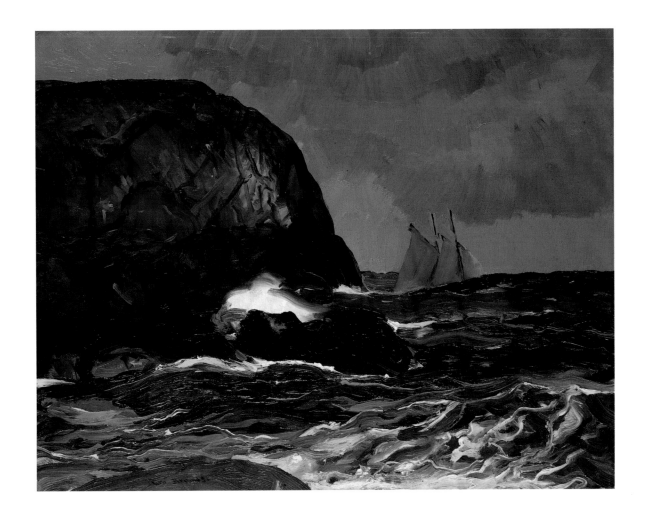

44 Romance of Autumn, 1916

Oil on canvas, 32 x 40⅛

Signed lower right, "GEO BELLOWS / ESB"

Gift of Mr. and Mrs. Charles Shipman Payson, 64.1366

PROVENANCE: Estate of the artist, 1916–25; Emma Bellows, 1925–50s; H. V. Allison & Co., Inc., New York, 1957; Mrs. Charles Shipman Payson, 1957–64

EXHIBITIONS: Farnsworth Art Museum, 5 October–28 November 1979, and Portland Museum of Art, Maine, 18 December 1979–27 January 1980, "Masters in Maine"; Los Angeles County Museum of Art, 16 February–10 May 1992, Whitney Museum of American Art, New York, 5 June–30 August 1992, Columbus Museum of Art, Ohio, 11 October 1992–3 January 1993, and Amon Carter Museum, Fort Worth, Texas, 20 February–9 May 1993; Farnsworth Art Museum, "Bellows and Benson in Maine: Reality and the Dream," 28 June–8 November 1998

REFERENCES: "Criehaven: A Bellows Pastoral," *Bulletin 1977* (The William Benton Museum of Art, University of Connecticut, Storrs), 1, no. 5 (1977), 32 (illus.); Carl Little, *Paintings of Maine* (New York: Clarkson Potter, 1991), frontispiece, 124; Michael Quick, Jane Myers, Marianne Doezema, and Franklin Kelly, *The Paintings of George Bellows* (New York: Harry N. Abrams, Inc., 1992), 58, 60 (illus.), 61, 63, 162, 253; Susan C. Larsen and Pamela J. Belanger, *Bellows and Benson in Maine: Reality and the Dream* (Rockland, Maine: Farnsworth Art Museum, 1998), n.p., cover (illus.)

George Bellows began experimenting with brilliant color during the years following the Armory Show in 1913, but he was never bolder with his colors than in this view of the Maine coast at Camden painted in the fall of 1916. Brilliant reds and golds, almost garish in their intensity, compete with deep purples and vivid blues and greens. Clearly based on the intense hues of autumn in Maine, the painting goes beyond nature to a rich and daring coloristic expressiveness that was unusual in the work of a realist like Bellows. When a group of paintings done at Camden was exhibited at the Milch Gallery in New York the following year, critics noted a pronounced quality of aggressiveness and the "violent beauty and naiveté" of color.[1]

The year 1916 marked Bellows's fifth and final stay in Maine, and he spent the bulk of the summer and fall in Camden. He was especially fond of Camden, because of its scenery, its shipbuilding yards, and its isolation. For Bellows, Camden was an escape from the summer crowds on Monhegan. *Romance of Autumn* presents the view from Sherman's Point, across Sherman's Cove to Mount Battie in the distance. The Camden town center and the boat docks, also a favored setting, are located just to the left of the area represented in the picture. Today the point is dotted with elegant houses, but in 1916 it was still farmland.[2] But Bellows was focusing less on an accurate rendering of this particular rural spot than he was on creating a dramatically composed painting and, as the title indicates, a suggestive composition.

Bellows was very much concerned with compositional structure. Elements are by no means placed haphazardly on the surface of his canvases. For example, the line that articulates the curve of the hill on the far shore just behind the mainsail of the schooner continues the curve established by the jib, foresail, and mainsail. This curve is then repeated by the larger hill to the right and then several times throughout the painting. A large V shape dominates the canvas, opening out to either side from the point where the young boy's ankle touches the bottom edge of the picture. Similarly the color of the young girl's hair is picked up by the top of the tree on the right, reinforcing an upward movement to the right that counteracts the sharp horizontal movement of the sailboat to the left. In all of this the three key elements of the painting are set apart for the viewer's notice. The young couple, the sailboat, and the wondrous landscape are separated like players in a fairy tale, and such this may be.

Bellows and his wife, Emma, celebrated their sixth wedding anniversary that September. They had two children, Anne, born in 1911, and Jean, born in 1915. In his letters to Emma, George was often quite romantic, referring to possible second honeymoons and how deeply he missed her when they were apart. That September they had sent the children back to New York and were alone together for the first time since the children were born. Given this circumstance, it is tempting to interpret *Romance of Autumn* in terms of a rekindled romance. The pair in the foreground suggests the innocence of young love. The path of the boat as it represents movement from left to right through the painting, as well as the autumn setting, connotes the passage of time. The personal reference seems underscored by the striking resemblance between the blond girl in the painting and Bellowses' daughter Anne. The artist was certainly capable of using his family in an allegorical composition. He had earlier completed a painting of himself and Emma and Anne on Monhegan, titled *Fisherman's Family*, (location unknown) that seems to convey an ideal vision of the family unit.[3] Bellows always felt that he had married above himself with Emma, that she was pulling him up to her social level. While he was known on occasion to disparage bourgeois social conventions, he was also intensely pleased with his situation. It is not, perhaps, too far-fetched to see in this brilliant and dynamically colored picture not only a response to the new palette of the modernists, but also a love poem to the artist's wife.

M. D.

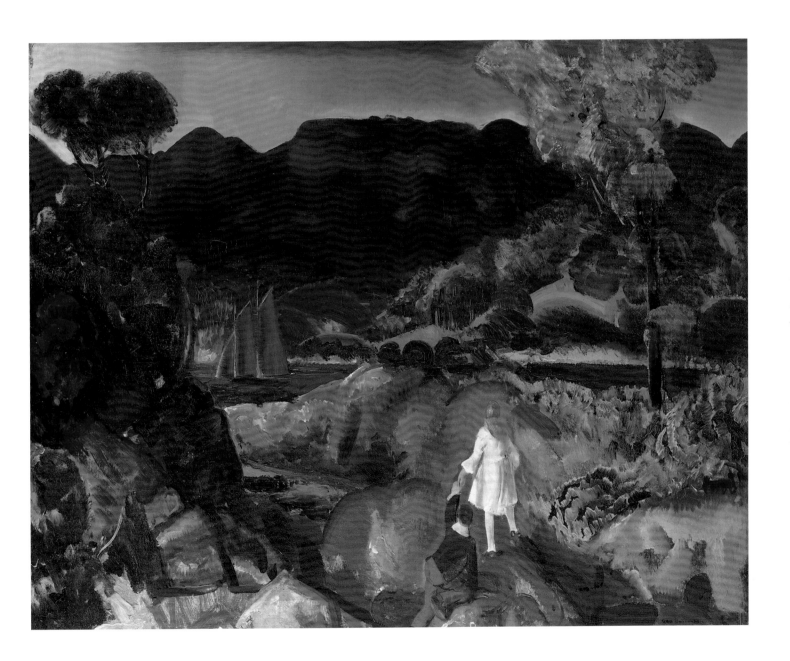

45 The Fish Wharf, Matinicus Island, 1916

Oil on panel, 18 x 22

Signed lower left, "GEO BELLOWS"

Bequest of Mrs. Elizabeth B. Noyce, 97.3.2

PROVENANCE: Collection of the artist, 1916–25; Estate of the artist, 1925; Emma Bellows, 1925–58; Joslyn Art Museum, Omaha, Nebraska; 1958–59; Hirschl and Adler Gallery, New York, 1959; Coe Kerr Gallery, New York, 1959; Norman Woolworth, Northrup, Maine, 1959–70; private collection, New York, 1970–95; Mrs. Elizabeth B. Noyce, 1995–96; Estate of Mrs. Elizabeth B. Noyce, 1996–97

EXHIBITIONS: H. V. Allison & Co. Inc., New York, "Paintings by George Bellows," 1956, no. 4; H. V. Allison & Co. Inc., New York, "George Bellows," 1–31 May 1957, no. 11; Farnsworth Art Museum, "A Legacy for Maine: Masterworks from the Collection of Elizabeth B. Noyce," 12 April–14 June 1998; Farnsworth Art Museum, "Bellows and Benson in Maine: Reality and the Dream," 28 June–8 November 1998

REFERENCES: Jessica F. Nicoll, *A Legacy for Maine: The November Collection of Elizabeth B. Noyce* (Portland, Maine: Portland Museum of Art, 1997), 61; Christopher Crosman, "The Art of Community," *Island Journal* 14 (1997): 32, 33 (illus.); Susan C. Larsen and Pamela J. Belanger, *Bellows and Benson in Maine: Reality and the Dream* (Rockland, Maine: Farnsworth Art Museum, 1998), n.p. (illus.)

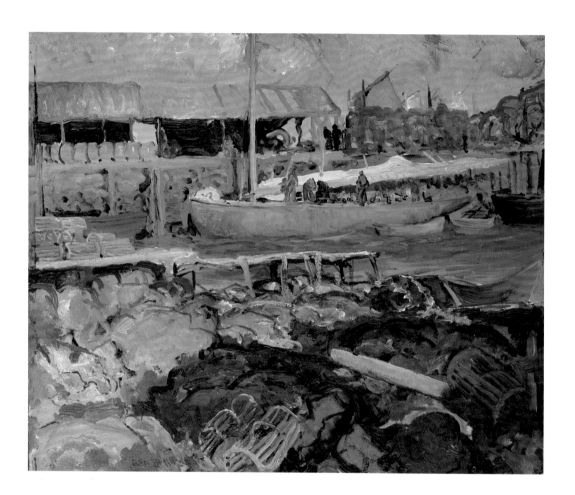

46 The Teamster, 1916

Oil on canvas, 34 x 44

Signed lower right, "GEO BELLOWS"

Bequest of Mrs. Elizabeth B. Noyce, 97.3.1

PROVENANCE: Collection of the artist, 1916–25; Estate of the artist, 1925; Emma Bellows, 1925–64; Mrs. Alex Iselin Henderson, Fairfield, Connecticut; Estate of Priscilla Alden Bartlett Henderson, New York, 1980; private collection, 1980–95; Berry-Hill Galleries, New York, 1995; Shipmasters Gallery, Bath, Maine, 1995; Mrs. Elizabeth B. Noyce, 1995–96; Estate of Mrs. Elizabeth B. Noyce, 1996–97

EXHIBITIONS: The Art Association of Newport, Rhode Island, "Exhibition of Paintings by George Bellows, Arthur B. Davies and W. Glackens," 4–18 September 1917, no. 5; Milch Galleries, New York, "George Bellows," 13–24 March 1918, no. 7; Randolph-Macon Women's College, Lynchburg, Virginia, "Ninth Annual Exhibition, Painting and Sculpture," 6–31 March 1920, no. 14; Milwaukee Art Institute, Wisconsin, "George Bellows," July–August 1923; H.V. Allison & Co., Inc., New York, "Paintings by George Bellows," October–November 1942; H.V. Allison & Co., Inc., New York, "George Bellows," 7–29 May 1964, no. 10; Berry-Hill Galleries, New York, "George Bellows," 2 December 1993–15 January 1994; Berry-Hill Galleries, New York, "American Paintings 1807–1935," 1 December 1994–1 February 1995; Portland Museum of Art, Maine, "The Allure of the Maine Coast: Robert Henri and His Circle, 1903–1918," 29 June–15 October 1995; Farnsworth Art Museum, "One Hundred Years of Maine at Work," 13 July–5 October 1997; Portland Museum of Art, Maine, 1 October 1997–4 January 1998 and Farnsworth Art Museum, 12 April–14 June 1998, "A Legacy for Maine: Masterworks from the Collection of Elizabeth B. Noyce"; Farnsworth Art Museum, "Bellows and Benson in Maine: Reality and the Dream," 28 June–8 November 1998

REFERENCES: George Bellows, "The Big Idea: George Bellows Talks about Patriotism for Beauty," *Touchstone* 1 (July 1917): 273 (illus., as *The Bridge Builder*); Edgar Holger Cahill, "George Bellows," *Shadowland* 6 (July 1922): 61 (as *The Teamster*); Kenneth M. Ellis, "Bellows Best Seen in Lithographs, Oils Are Disappointing, but One Shows Stature of Artist, *The Teamster* Is Best of Current Showing," *Milwaukee Leader*, 6 July 1923; Charles H. Morgan, *George Bellows, Painter of America* (New York: Reyna Company, 1965), 200; Donald Braider, *George Bellows and the Ashcan School of Painting* (Garden City, N.Y.: Doubleday Company, 1971), 105; Bruce Weber, *American Paintings VII* (New York: Berry-Hill Galleries, 1994), 226–27, 227 (illus.); Jessica F. Nicoll, *The Allure of the Maine Coast: Robert Henri and His Circle, 1903–1918* (Portland, Maine: Portland Museum of Art, 1995), 34 (illus.); Christopher Crosman, "The Art of Community," *Island Journal* 14 (1997): 31, 33 (illus.); Susan C. Larsen, *One Hundred Years of Maine at Work* (Rockland, Maine: Farnsworth Art Museum, 1997), cover (illus.), n.p.; Jessica F. Nicoll, *A Legacy for Maine: The November Collection of Elizabeth B. Noyce* (Portland, Maine: Portland Museum of Art, 1997), 18 (illus.), 41, 61; Susan C. Larsen and Pamela J. Belanger, *Bellows and Benson in Maine: Reality and the Dream* (Rockland, Maine: Farnsworth Art Museum, 1998), n.p. (illus.)

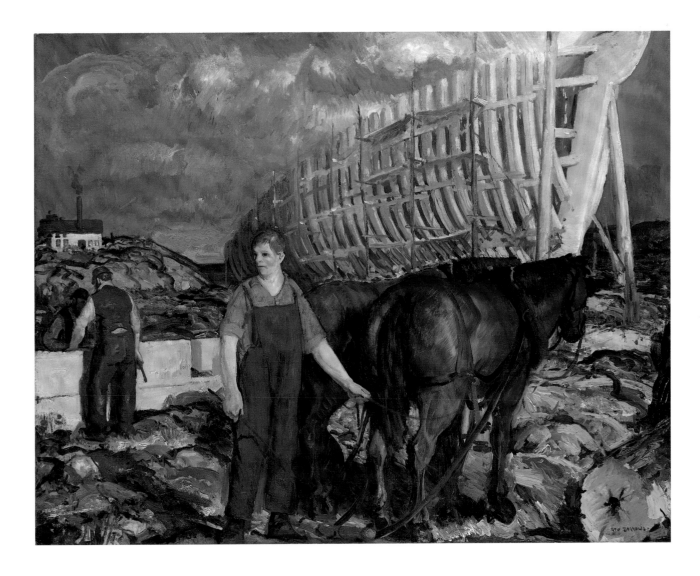

Marsden Hartley (1877–1943)

In 1934 Marsden Hartley returned to New York from Germany to be greeted by poor critical reception and diminishing support from his patron Alfred Stieglitz. The beleaguered painter initially retreated to Gloucester and Bermuda but then traveled to Nova Scotia in September 1935. This province and its inhabitants so fascinated Hartley that he spent that fall and the following summer and fall boarding with the Mason family in the small fishing village Eastern Points Island. Drawn especially to the sons, Alty and Donny,[1] Hartley was overcome with grief when these two young men and their cousin, Allen, drowned on 19 September 1936. Like other personal tragedies, this one found its way into Hartley's art. The artist had painted a "marine fantasy," *Eight Bells' Folly: Memorial to Hart Crane* (1933, Frederick R. Weisman Art Museum, Minneapolis), in homage to his poet friend who had committed suicide by diving off a steamship on his return to the United States from Mexico. Like this seascape, *Stormy Sea No. 2* responded to a specific calamity, yet its function and meaning for Hartley went beyond a memorial to the Mason boys; this work helped the artist negotiate a crucial transformation in his art and career.

Hartley recognized the dangers of the sea as part of the life of the North Atlantic fisherfolk:

They are all home now off the sea & look so grateful that the sea let them come home to their families once more, for they never know. Ten days ago a ship went down off Cape Breton, & after a terrible siege at sea in dories those still alive managed to row into shore. One of them crawled on his hands & knees up to a house, & they rescued those. The others perished & were washed ashore last week. But they dread the sea terribly.[2]

He described this destructive ocean and its "clutch of death" in his late writings: "The sea is wild and black and black / a devil curse is in the dark / of the wind."[3] In *Stormy Sea No. 2*, an expressionistic manner—impastoed and curling brushstrokes, somber blues and grays— picture this dark, dreadful ocean, and the lone schooner describes the way the Mason boys met their end—that is, in a small craft during a sudden gale. In *Fishermen's Last Supper, Nova Scotia* (1938, private collection), this same boat appears in the wall painting in the Mason dining room and was based on a picture belonging to the family.[4] More than a detail in a narrative, however, this boat on the vast sea stands for human frailty in the face of natural forces. Hartley wrote about Albert Pinkham Ryder's portrayal of sea disasters and storm-tossed boats in metaphoric terms; they expressed the "profound spectacle of the soul's despair in conflict with wind and wave."[5] Artists have long used the solitary ship on the sea to signify human struggles, journeys, and mythic resurrections, and Hartley's seascapes were part of this tradition. In *Eight Bells' Folly*, the boat with the mystical number 33 represents Crane, who is engulfed by a shark and rising waves, while symbols of transcendence—clouds, moon, sun, eight-pointed stars—indicate rebirth. *In Give Us This Day* (1938–39, private collection), the schooner, along with the many other symbols, refers to the passage of Alty, Donny, and Allen into the afterlife, as does the vessel in *Stormy Sea No. 2*.[6]

While this seascape began as a memorial to three Nova Scotia fishermen, it also played a part in Hartley's homecoming. *Stormy Sea No. 2* was one of at least six works of identical size and subject matter that the painter made in Nova Scotia after the drowning to serve as preparatory studies for the larger *Northern Seascape, Off the Banks* (1936, Milwaukee Art Museum). This latter painting was originally named *Off the Banks, Nova Scotia*, but Hartley changed the title after its showing at the gallery An American Place to give this work an "American" identity.[7] Along with such seascapes, *Stormy Sea No. 2* played a part in Hartley's efforts to cast himself as a regional and American artist. In his period commentaries, the artist defined an American tradition for his own style—a realism informed with a mystic sensibility—and matched this approach with his own natal region, New England.[8] For Hartley, Ryder's art exemplified this regional aesthetic, and, by emulating this artist's work he associated himself with the mystical New England tradition.[9] Indeed, the image of the solitary storm-tossed boat on the dark ocean pictured in Hartley's *Stormy Sea No. 2* recalls Ryder's many seascapes, such as *Toilers of the Sea* (1915, The Metropolitan Museum of Art).

Stormy Sea No. 2 also takes its cue from another Maine painter, Winslow Homer.[10] This small oil painting served as a study for

47 Stormy Sea No. 2, 1936

Oil on board, 12⅛ x 16
Museum purchase, 1983, 83.2

PROVENANCE: Paul Rosenberg Galleries, New York; Collection of a Gentleman, Springfield, Massachusetts; Barridoff Galleries, Portland, Maine, 1982

EXHIBITIONS: Mount Saint Vincent University Art Gallery, Halifax, Nova Scotia, 1 October 1987–1 January 1988, and Art Gallery of Ontario, Toronto, Canada, 16 January–13 March 1988, "Marsden Hartley and Nova Scotia," no. 6; Schmidt-Bingham Gallery, New York, 28 May–22 June 1991, Lakeview Museum of Arts and Sciences, Peoria, Illinois, 13 July–18 August 1991, and Fresno Art Museum, Fresno, California, 2 September–26 October 1991, "Retrieving the Elemental Form"

REFERENCES: *American and European Art: Public Auction* (Portland, Maine: Barridoff Galleries, 1982), n.p.; Gerald Ferguson, ed., Ronald Paulson and Gail R. Scott, essayists, *Marsden Hartley and Nova Scotia* (Halifax, Nova Scotia: Mount Saint Vincent University Art Gallery, 1987), 12–13, 13 (illus.), 146–49, 147 (illus.)

Northern Seascape, Off the Banks, which has an affinity to Homer's works at Prout's Neck, such as *Weatherbeaten* (1890, Portland Museum of Art) with its dramatic clash between rocky coast and pounding surf. Although Hartley considered Homer less of a dreamer than Ryder, he recognized value in his art: Homer presented the real with "all its personal fullness of appearance" and "gets as near to the sense of immediacy in sea life as one can get." For Hartley, Homer was one of the foremost New England artists, a "fierce Yankee" who painted Maine.[11] By emulating and identifying with both Homer and Ryder, Hartley constructed a regional and American ancestry for his own seascapes.[12]

We can also read this painting in very personal terms for the artist. This image evokes Hartley's own tumultuous journey as an artist, especially in the 1930s. At this time, economic problems, critical disfavor, patronage conflicts, and demands for Americanism in the arts set the stage for an unsettling episode in the painter's career. Hartley had to sell himself as an American artist, and for him, as for many artists of the period, region became the locus of national identity. This turbulent seascape, *Stormy Sea No. 2*, became a vehicle through which Hartley could steady his course as an artist. He transformed a personal tragedy into a professional victory as his seascapes, with their connection to the American artists Ryder and Homer, achieved recognition and financial success at the end of a stormy career.[13]

D. C.

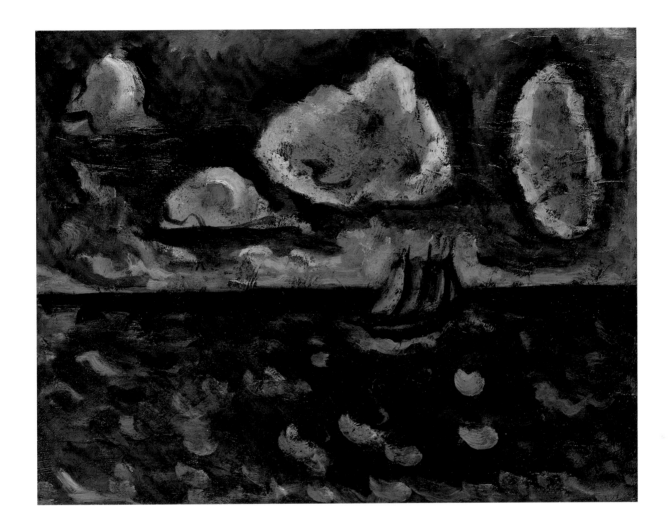

47a Song of Winter No. 6, c. 1908–09
Oil on board, 8⅞ x 11⅞
Gift of Mrs. Elizabeth B. Noyce, 96.13.5

John Marin (1870–1953)

48 Maine Landscape, 1919

Watercolor on paper, 16 3/16 x 19 1/4
Signed and dated lower right,
"Marin 19"
Anonymous gift, 74.1939

PROVENANCE: Collection of Charles Bain
Hoyt; private collection

EXHIBITIONS: Museum of Fine Arts,
Boston, "Ten American Watercolor
Painters," 1939, no. 49; The Monmouth
Museum, Monmouth, New Jersey, "The
Spirit of the Coast," 22 July–23 September
1984, no. 51

REFERENCES: Sheldon Reich, *John Marin:
A Stylistic Analysis and Catalogue
Raisonné* (Tucson: University of Arizona
Press, 1970), 470; Susan B. Morehouse,
The Spirit of the Coast (Lincroft, N.J.:
The Monmouth Museum, 1984), n.p.

In 1919, when John Marin painted *Maine Landscape,* he wrote to Alfred Stieglitz criticizing certain paintings of the state as "Pseudo Romantic Chaldean Persian Grecian Roman Italian French German Combination Vision, an Abstract Concreteness, a monumental memory of other things." In his estimation, his own watercolors were quite different: "A point of view: My eyes. In other words, my Maine or my Berkshires or my Delaware country."[1] For Marin, personal expression, not standardized formula, characterized his "point of view." The artist's outlook, however, was not completely original but was shaped by European modernism and contemporary ways of seeing nature.

Like many of his avant-garde counterparts, Marin made the obligatory journey to Paris. Working there from 1905–1910, he saw the emerging modernists in the galleries and, sparked by the French post-impressionists, already showed a preference for watercolor. A 1907 Cézanne watercolor exhibition at Galerie Bernheim-Jeune and retrospective at the Salon d'Automne defined a new type of watercolor—fragmentary, anti-naturalistic, emotive—and Marin began to formulate a similar vision in his own art.[2] Throughout the teens, he explored varied styles in this medium—futurism in *Movement, Fifth Avenue* (1912, The Art Institute of Chicago) and synthetic cubism in *Abstraction* (1917, National Gallery of Art, Washington, D.C.), for example. In 1919, during his summer stay in the Stonington-Deer Isle area, the artist synthesized contrasting aspects of his early manner. *Maine Landscape* combines the hard-edged abstract shapes of Marin's 1917 paintings and the atmospheric, soft-edged forms from those done the previous year; the color shapes that constitute the landscape recall the geometric structure of synthetic cubism, while the hazy color forms typify the Whistlerian influence in Marin's early works.[3]

Marin talked about painting "disorder under a big order" in his 1919 watercolors.[4] In *Maine Landscape,* horizontal strips defining shore, sea, and sky counterbalance the three vertical forms in the paper's center. Color is evenly weighed out: on the left, pale green and pale violet trees sit on a violet ground; they are equivalent hues to the green tree and solid green ground on the right.[5]

The curved, soft shapes, along with analogous colors, picture a pleasing mood—an image of the coast enticing viewers to contemplation. The shore in *Maine Landscape* is still and serene, absent of the drama in either George Bellows's or Marsden Hartley's seascapes.

Marin spent long periods in Maine beginning in 1914 until his death in 1953, and he looked at this "border of the sea" through many lenses.[6] Whereas Maine appealed to the artist because, like New York, it was an untamed place with big forms and elemental forces, he also treasured its quiet spaces. In this region, Marin could create his own "small, large world," which contrasted with the modern city: "[I]n New York, I had to have, or thought I had to have, my three or four papers a day, . . . [In Small Point, Maine] I don't even want to look at a paper, don't much care, I suppose, what is happening in Europe or Elsewhere. But just here, in and about Casco Bay, what these families and fisher folk do is much more important than what other families are doing."[7] This region was not only an ideal antiurban locale but provided an escape for Marin into his own intimate world—a world pictured in *Maine Landscape.*

The "solemn restful beautiful firs"[8] that dominate this watercolor create this intimacy. Trees served multiple functions for Marin and his colleagues. Hartley considered the Maine pines as "symbols of a deeply haunting past,"[9] while the solitary tree resonates with a mystical and sexual power in Georgia O'Keeffe's *Lawrence Tree* (1929, artist's estate, Abiquiu, New Mexico). Common in Marin's art, trees appeared in groups in early abstractions and as singular forms in later works, often evoking nature's moods and mystery.[10] For the painter, this natural form could be transformed into a religious icon: "A little glade back in my woods I discovered a straight growing little poplar tree—I cleaned up all around it—Now it is my schrine [*sic*]—where I can go pray all day."[11] In *Maine Landscape,* flat, hazy trees seem to float, and their insubstantiality defines them as ethereal, even mystical.

This construct of nature as spiritual had a long history in American art—a history not lost on Marin and his Stieglitz-circle colleagues. In the pages of the journal *Camera Work,* the nineteenth-century triumvirate of Emerson, Thoreau, and Whitman was praised as "supreme irrationalists," "chevaliers of the Divine-Moment," and the "fathers of the cubists and futurists, for they repeated what they felt, not what they saw."[12] American modernists considered these writers their artistic ancestors because they emphasized "felt expression" and an art springing from a connection to place. Marin's approach to nature was frequently associated with these Transcendentalists' work, and this affinity helped to constitute his art as "American."[13] In the years surrounding World War I, as critics, patrons, and viewers demanded that artists be "American," Marin and his patron Stieglitz downplayed the painter's indebtedness to European modernism and packaged his style and subject matter as native products. The critic Paul Rosenfeld, for example, wrote of Marin's art: "None but one American-born could have rubbed this pigment. . . . The nervousness of Marin's picture is deeply American, deeply Yank. . . . There is something Walt Whitmanish."[14] Although Marin contended in 1919 that he had arrived at his own "point of view" in paintings like *Maine Landscape,* he "framed" nature much like earlier American literary figures and his contemporary European counterparts.

D. C.

Watercolor and graphite on paper, 13½ x 13⅛

Signed and dated lower right, "Marin 33"

Bequest of Mrs. Elizabeth B. Noyce, 97.3.33

PROVENANCE: Nicholas J. Mininourch, Rosemont, New York, 1970; private collection, New England; Mrs. Elizabeth B. Noyce, 1994–96; Estate of Mrs. Elizabeth B. Noyce, 1996–97

EXHIBITIONS: An American Place, New York, "John Marin: A Recent Work," 3 November–1 December 1934

REFERENCES: Sheldon Reich, *John Marin: A Stylistic Analysis and Catalogue Raisonné* (Tucson: University of Arizona Press, 1970), 653

50 On the Road to Addison, Maine, No. 2, 1946

Oil on canvas, 23 x 29¼

Signed and dated lower right, "Marin 46"

Museum purchase in memory of Thomas Gardiner, 95.4

PROVENANCE: Estate of the artist; Kennedy Gallery, New York, 1981; private collection, Gloversville, New York; Barridoff Galleries, Portland, Maine, 1995

EXHIBITIONS: An American Place, New York, "John Marin," 1 April–2 May 1947, no. 19; New Jersey State Museum, Trenton, "John Marin," 3 December 1950–21 January 1951, no. 32; M.H. de Young Memorial Museum, San Francisco, 15 February–22 March 1949; Santa Barbara Museum of Art, 1–30 April 1949, and Los Angeles County Museum of Art, 12 May–12 June 1949, "John Marin," no. 14; Cape Split Place, Addison, Maine, 1 August–1 October 1978, "John Marin"; Dartmouth College Museum and Galleries, Hanover, New Hampshire, 13 October–19 November 1978, Worcester Art Museum, Worcester, Massachusetts, 12 December 1978–28 January 1979 and New Jersey State Museum, Trenton, 24 March–24 June 1979, "John Marin," no. 29

REFERENCES: Sheldon Reich, *John Marin: A Stylistic Analysis and Catalogue Raisonné* (Tucson: University of Arizona Press, 1970), 747 (illus.)

Charles Demuth (1883–1935)

51 Cluster, 1922

Watercolor on paper, 13¾ x 11¾

Signed and dated lower center,
"C. Demuth / 1922"

Bequest of Mrs. Elizabeth B. Noyce,
97.3.8

PROVENANCE: Alfred Stieglitz collection,
New York; The Downtown Gallery,
New York; Hirschl and Adler Galleries,
New York, 1967; IBM International
Foundation, 1967–95; Mrs. Elizabeth B.
Noyce, 1995–96; Estate of Mrs. Elizabeth
B. Noyce, 1996–97

EXHIBITIONS: The Downtown Gallery,
New York, "Charles Demuth: Oils and
Watercolors," 6–28 July 1950, no. 2;
Forth Worth Art Association, Fort Worth,
Texas, 1951, no. 2; The Downtown
Gallery, "Demuth: Watercolor Retrospec-
tive," 6 April–1 May 1954; IBM Gallery
of Science and Art, New York,
"Watercolors from the IBM Collection,"
July–September 1967, no. 9; IBM
Gallery of Science and Art, New York,
"American Images: Selections from the
IBM Collection," May–June 1984;
Portland Museum of Art, Maine, 8 June–
2 September 1996, and Farnsworth Art
Museum, 16 February–20 April 1997,
"A Brush with Greatness: American
Watercolors from the November
Collection"; Portland Museum of Art,
Maine, 1 October 1997–4 January 1998,
and Farnsworth Art Museum, 12 April–
14 June 1998, "A Legacy for Maine:
Masterworks from the Collection of
Elizabeth B. Noyce"

REFERENCES: Emily Farnham, "Charles
Demuth: His Life, Psychology and Works,"
Ph.D. diss., Ohio State University, 1959,
vol. 2, 577, no. 420 (W 1023); Sotheby's
catalogue no. 6713, 23 May 1995 (New
York: Sotheby's, 1995), (illus., no. 87),
n.p.; Jessica F. Nicoll, *A Brush with
Greatness: American Watercolors from
the November Collection* (Portland,
Maine: Portland Museum of Art, 1996),
5, 5 (illus.); Jessica F. Nicoll, *A Legacy
for Maine: The November Collection of
Elizabeth B. Noyce* (Portland, Maine:
Portland Museum of Art, 1997), 56, 62

When Charles Demuth painted *Cluster* in 1922, he had recently returned from Paris. Although he cut short this particular trip, he did manage to see his friends Marsden Hartley and Gertrude Stein. Late in September 1921 he had been hospitalized in Paris, where he learned that he was seriously ill with diabetes, yet he had been able to continue painting. Demuth's doctor wrote: "Upon his return to this country Demuth was in bad shape. That, I think, was when I first saw his mother. She was a horse of a woman, a strange mother for such a wisp of a man."[1] He now needed his mother, whom he sometimes referred to as "Augusta the Iron-Clad," to care for him.[2] She was a strong woman and a tremendous reassurance for him as he struggled with diabetes. Demuth suffered from *diabetes mellitus*, an ailment that mani-fests itself in the form of emaciation and chronic hunger and thirst and is often fatal. Fortunately, a sanatorium designed specifically for the treat-ment of this disease had just been established at Morristown, New Jersey. The artist became one of its first patients and was also one of the first to receive experimental insulin injections, which allayed the symptoms enough to allow Demuth to live for fifteen more years.

Because he had so little energy from 1922 to 1930, Demuth restricted himself mostly to painting in watercolor on small-format papers. The artist spent part of 1922 at the sanatorium in Morristown, where he completed several watercolor still lifes, and *Cluster* was painted there or shortly after his return home to Lancaster, Pennsylvania, that year. Demuth's draftsmanship is remarkable, and in *Cluster*, as in many of the artist's still lifes, the design was conceived in pencil and then the tones of water-color are blotted and overlapped, all carefully controlled. The spray of flowers moves upward to form an oval; making full use of the white paper, Demuth left many areas in pencil only. Each form is considered separately, yet each is essential to the whole composition. There is an ephemeral quality in the various gradations from dark to light that informs the shape of the flowers and the important space around them.

Demuth's refined and subtle watercolor still lifes like *Cluster* were enhanced by their feeling of remove. Forbes Watson wrote in 1923, "Between himself and his spectators," Demuth "likes to maintain a barrier of aloofness."[3] The artist's works do not shed light on the particular subject, yet they recommend to the viewer a sensibility that leads to the understanding of art. The point of reference is not life but art, which erases the suggestion of a concrete object. The total detachment Demuth brought to his work was praised, especially in the 1920s.[4]

A leading member of the precisionists, along with Charles Sheeler and Niles Spencer, Demuth painted industrial and urban scenes as well as views of his hometown of Lancaster ren-dered in his own interpretation of the cubist idiom. Lancaster was accessible to the sophisti-cated art world in Philadelphia and New York City that inspired his intellectual and artistic development as well as satisfied his taste for the urbane, but isolated enough to serve as the refuge he needed because of his delicate health. Encouraged early on by his family to pursue his artistic interests, in 1901, Demuth entered the Philadelphia School of Industrial Art and then the Pennsylvania Academy of the Fine Arts, where he studied with William M. Chase and Thomas P. Anchutz. He also made several trips to Paris and studied at the Académie Colarossi and Académie Julian. He was close to Alfred Stieglitz and a member of the Gallery 291 cir-cle, an intimate of the avant-garde Arensberg salon, and in addition to Marsden Hartley and Gertrude and Leo Stein, counted among his friends Marcel Duchamp, William Carlos Williams, and Ezra Pound.

P. J. B.

Edward Hopper (1882–1967)

52 Haunted House, 1926

Watercolor on paper, 14 x 20
Signed lower right, "Edward Hopper /
Rockland, Me."

Museum purchase, 71.1775

PROVENANCE: The artist to Leslie G.
Sheaffer, 1927–48; Rehn Galleries,
New York, 1948–50; Fred L. Palmer,
New Jersey 1950–71

EXHIBITIONS: Farnsworth Art Museum,
9 July–5 September 1971, no. 21, and
Pennsylvania Academy of the Fine Arts,
Philadelphia, 24 September–28 November
1971, no. 5, "Edward Hopper, 1882–1967,
Oils, Watercolors, Etchings"; Farnsworth
Art Museum, 5 October–28 November
1979, and Portland Museum of Art,
Maine, 18 December 1979–27 January
1980, "Masters in Maine"; Jane Voorhees
Zimmerli Art Museum, Rutgers, The
State University of New Jersey, New
Brunswick, "Edward Hopper's Places,"
8 September–3 November 16 1985;
Ogunquit Museum of American Art,
Ogunquit, Maine, "'From the Collection
of' Exhibition," 1 July–4 September 1989,
no. D-20

REFERENCES: *Edward Hopper, 1882–1967*
(Rockland, Maine: Farnsworth Art
Museum, 1971), cover; Gail Levin,
Edward Hopper: The Art and the Artist
(New York: W.W. Norton & Co., 1980),
176 (illus.); Gail Levin, *Hopper's Places*
(New York: Alfred A. Knopf, 1985),
7 (illus.), 8; "*From the Collection of*"
Exhibition (Ogunquit, Maine: Ogunquit
Museum of American Art, 1989), 16
(illus.), 19; Carl Little, *Edward Hopper's
New England* (San Francisco: Pomegranate
Art Books, 1993), 12, (illus., no. 15);
Gail Levin, *Edward Hopper: A Catalogue
Raisonné* Vol. II (New York: Whitney
Museum of American Art in association
with W.W. Norton & Co., 1995), 108;
Gail Levin, *Edward Hopper: An Intimate
Biography* (New York: Alfred A. Knopf,
1995), 198

One of the most respected American painters of the twentieth century, Edward Hopper created works that reveal his regard for the power of abstract form and his interest in recording scenes of unvarnished everyday life that were heralded by both representational and modernist artists and critics alike. Hopper first visited Maine to spend the summer of 1914 at Ogunquit. Two years later he went to Monhegan Island, probably after the place was enthusiastically described to him by Robert Henri, the artist's favorite teacher, and Hopper returned there for the next three summers. In 1926 Hopper and his wife, Jo, traveled by train from New York, arriving first in Eastport. He wrote to his dealer, Frank Rehn, from Rockland about his trip: "We did not like Eastport at all. It has very little of the character of a New England coast town, so we left after three days and went to Bangor by sail and then by boat to this town [Rockland], a very fine old place with lots of good-looking houses but not much shipping."[1]

This was a particularly happy time for Hopper, he was very much in love with his new wife and they enjoyed traveling together. They spent seven weeks in Rockland, and Hopper completed over twenty-five watercolors, including the four works in the Farnsworth collection, *Haunted House*; *Railroad Crossing, Rockland, Maine*; *Lime Rock Quarry, No. 1*; and *Schooner's Bowsprit*.[2] The Hopper scholar Gail Levin believes that in the Rockland works the artist sought out "subjects from the past, favoring images evocative of bygone epochs and lost values, like this *Haunted House*, which serves as a metaphor for the role that the past came to play in his present."[3] *Haunted House* is an image of a deserted nineteenth-century boarding house at 5 South Street, in Rockland, near the shipyard. Hopper was probably drawn to the building because of its boarded-up windows and its abandoned state. This otherwise ordinary structure is turned by Hopper into a highly evocative image, suggesting unseen and even mysterious past events.

Hopper completed works of several trawlers in the shipyard, including *Schooner's Bowsprit*, an image of a derelict vessel. He also found and recorded one of his favorite themes in Rockland—*Railroad Crossing, Rockland, Maine*. Indeed, railroad tracks held special appeal for Hopper, symbolizing he said the "interest, curiosity, and fear" one encounters arriving in a new place.[4] Further, Hopper imbued these works with a sense of modern life—lonely, precarious, on the move, and the declining importance of small towns and rural areas. As a boy he was fascinated by trains, creating numerous drawings of them, and later was attracted to train stations, the interior of individual cars, and the experience of a train ride, with its fleeting images of the countryside.

Two of Hopper's contemporaries wrote eloquently about the artist's stark depictions of ordinary life filled with complex psychological overtones and his need for structural clarity, which distinguished him from other artists of the American scene with whom he is usually associated. Guy Pène du Bois contributed an essay for the Hopper exhibition at the Whitney Museum:

He has turned the Puritan in him into a purist, turned moral rigours into stylistic precisions. . . . He has never stopped, to use an example of very minor importance, preferring to portray houses and steam engines to men. He has perhaps erred a little in his terrific desire to simplify, for, with him, it becomes a simplification of the already rudimentarily simple. . . . He bought a lace collar from his wife, she told me, so that she would no longer wear it. . . . His hatred of the purely decorative is notorious. And yet he will, as in the painting of that Victorian house by the railroad track, not belie existing fact. His work in this sense is in no way subjective. He is an interpreter and not an inventor of forms. Can any one be?[5]

Two years later, in 1933, Charles Burchfield wrote the following for the Museum of Modern Art's Hopper retrospective:

Hopper's viewpoint is essentially classic; he presents his subjects without sentiment, or propaganda, or theatrics. He is the pure painter, interested in his material for its own sake, and in the exploitation of his idea of form, color, and space division. In spite of his restraint, however, he achieves such a complete verity that you can read into his interpretations of houses and conceptions of New York life any human implications you wish; and in his landscapes there is an old primeval Earth feeling that bespeaks a strong emotion felt, even if held in abeyance.[6]

P. J. B.

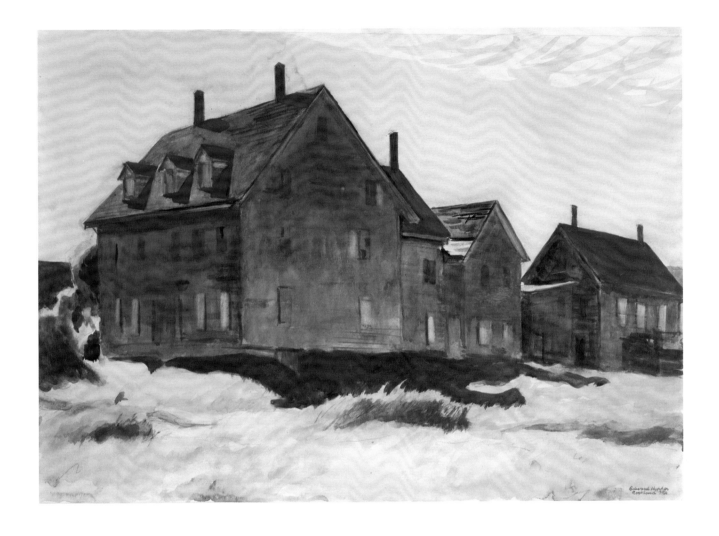

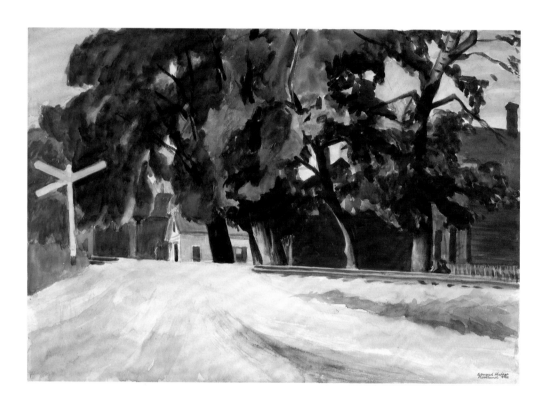

53 Railroad Crossing, Rockland, Maine, 1926

Watercolor on paper, 13½ x 19¼

Signed lower right, "Edward Hopper / Rockland, Me."

Bequest of Mrs. Elizabeth B. Noyce, 97.3.21

PROVENANCE: The artist to Rehn Gallery, New York, 1926; Mr. and Mrs. Herbert A. Goldstone, 1959–93; Kennedy Galleries, New York 1993–95; Mrs. Elizabeth B. Noyce, 1995–96; Estate of Mrs. Elizabeth B. Noyce, 1996–97

EXHIBITIONS: Currier Gallery of Art, Manchester, New Hampshire, 8 October–15 November 1959, Museum of Art, Rhode Island School of Design, Providence, 2–27 December 1959, and Wadsworth Atheneum, Hartford, Connecticut, 6 January–7 February 1960, "Watercolors by Edward Hopper with a Selection of His Etchings," no. 8; Portland Museum of Art, Maine 8 June–2 September 1996, and Farnsworth Art Museum, 16 February–20 April 1997, "A Brush with Greatness: American Watercolors from the November Collection"; Farnsworth Art Museum, "One Hundred Years of Maine at Work," 13 July–5 October 1997; Portland Museum of Art, Maine, 1 October 1997–4 January 1998, and Farnsworth Art Museum, 12 April–14 June 1998, "A Legacy for Maine: Masterworks from the Collection of Elizabeth B. Noyce"

REFERENCES: Charles E. Buckley, *Edward Hopper* (Manchester, N.H.: Currier Gallery of Art, 1959), n.p.; Gertrud A. Mellon and Elizabeth F. Wilder, eds., *Maine and Its Role in American Art: 1740–1963* (New York: Viking Press, 1963), 134 (illus.); Lloyd Goodrich, *Edward Hopper* (New York: Whitney Museum of American Art, 1964), 66; Gail Levin, *Edward Hopper: The Art and the Artist* (New York: W. W. Norton & Co., 1980), 47, 201 (illus.); Gail Levin, *Edward Hopper* (New York: Crown Publishers, 1984), 31 (illus.); Robert Hobbs, *Edward Hopper* (New York: Harry N. Abrams, 1987), 94 (illus.), 95; Lloyd Goodrich, *Edward Hopper* (New York: Harry N. Abrams, 1989), 190 (illus.); *The Magazine Antiques* 144, no. 4 (October 1993): 399 (illus.); Gail Levin, *Edward Hopper: A Catalogue Raisonné* Vol. II (New York: Whitney Museum of American Art in association with W. W. Norton & Co., 1995), 115; Jessica F. Nicoll, *A Legacy for Maine: The November Collection of Elizabeth B. Noyce* (Portland, Maine: Portland Museum of Art, 1997), 19 (illus.), 68

54 Lime Rock Quarry No. 1, 1926

Watercolor on paper, 12¼ x 19½

Signed lower right, "Edward Hopper / Rockland, Me."

Bequest of Mrs. Elizabeth B. Noyce, 97.3.20

PROVENANCE: The artist to Rehn Gallery, New York, 1926; Charles E. Buckley, 1957–94; Mrs. Elizabeth B. Noyce, 1994–96; Estate of Mrs. Elizabeth B. Noyce, 1996–97

EXHIBITIONS: Currier Gallery of Art, Manchester, New Hampshire, 8 October–15 November 1959, Museum of Art, Rhode Island School of Design, Providence, 2–27 December 1959, and Wadsworth Atheneum, Hartford, Connecticut, 6 January–7 February 1960, "Watercolors by Edward Hopper with a Selection of His Etchings," no. 7; University of Arizona Art Gallery, Tucson, "A Retrospective Exhibition of Oils and Watercolors by Edward Hopper," 20 April–19 May 1963, no. 9; Edward W. Root Art Center, Hamilton College, Clinton, New York, "Edward Hopper: Oils, Watercolors, Prints," 10 May–7 June 1964, no. 18; City Art Museum of St. Louis, Missouri, "Paintings, Watercolors and Drawings Privately Owned," 22 October–30 November 1969; Currier Gallery of Art, Manchester, New Hampshire, "New Hampshire Collects Paintings and Sculpture," 19 October–30 November 1980; Hirschl and Adler Galleries, New York, "Edward Hopper: Light Years," 1 October–12 November 1988, no. 12; Portland Museum of Art, Maine, 8 June–2 September 1996, and Farnsworth Art Museum, 16 February–20 April 1997, "A Brush with Greatness: American Watercolors from the November Collection"; Farnsworth Art Museum, "One Hundred Years of Maine at Work," 13 July–5 October 1997; Portland Museum of Art, Maine, 1 October 1997–4 January 1998, and Farnsworth Art Museum, 12 April–14 June 1998, "A Legacy for Maine: Masterworks from the Collection of Elizabeth B. Noyce"

REFERENCES: Charles E. Buckley, Watercolors by Edward Hopper (Manchester, N.H.: Currier Gallery of Art, 1959), n.p.; Joseph S. Trovato, Edward Hopper (Utica, N.Y.: Munson-Williams-Proctor Institute, 1964), n.p.; Peter Schjeldahl, Edward Hopper: Light Years (New York: Hirschl and Adler Galleries, 1988), 22, 24 (illus.); Gail Levin, Edward Hopper: A Catalogue Raisonné Vol. II (New York: Whitney Museum of American Art in association with W.W. Norton & Co., 1995), 110; Gail Levin, Edward Hopper: An Intimate Biography (New York: Alfred A. Knopf, 1995), 198; Jessica F. Nicoll, A Brush with Greatness: American Watercolors from the November Collection (Portland, Maine: Portland Museum of Art, 1996), 6 (illus.); Jessica F. Nicoll, A Legacy for Maine: The November Collection of Elizabeth B. Noyce (Portland, Maine: Portland Museum of Art, 1997), 68

55 Schooner's Bowsprit, 1926

Watercolor on paper, 14 x 20

Signed lower left, "Edward Hopper / Rockland, Me."

Anonymous gift, 65.1453

PROVENANCE: The artist to Mr. C. B. Hoyt, Boston, 1927; Private collection, 1953-65

EXHIBITIONS: Farnsworth Art Museum, 9 July–5 September 1971, no. 20 and, Pennsylvania Academy of the Fine Arts, Philadelphia, 24 September–31 October 1971, "Edward Hopper 1882–1967"

REFERENCES: Jay Hanna, "Edward Hopper, 1882–1967: A Maine Memorium," Maine Digest (Summer 1967): 70 (illus.); Edward Hopper 1882–1967 (Rockland, Maine: Farnsworth Art Museum, 1971), n.p.; Gail Levin, Edward Hopper: A Catalogue Raisonné Vol. II (New York: Whitney Museum of American Art in association with W.W. Norton & Co., 1995), 126

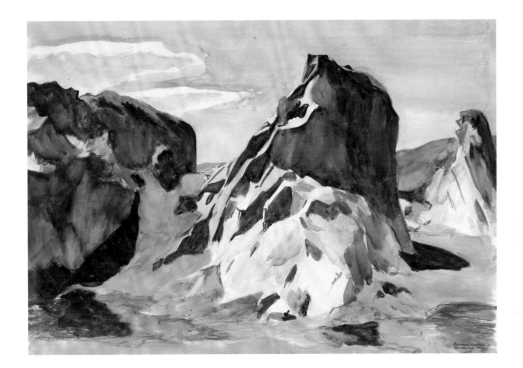

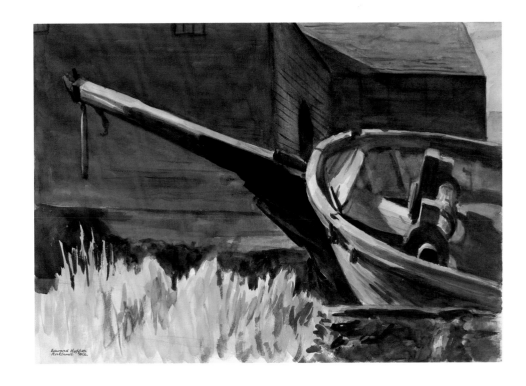

Marguerite Zorach (1887–1968)

Like many of their contemporaries, Marguerite Thompson and William Zorach were drawn to the city for artistic community yet desired to work close to nature. Accordingly, they agreed early in their marriage to spend summers away from New York. From the teens through the early twenties, the two artists stayed in New Hampshire, Cape Cod, and Maine, before buying a farmhouse in Robinhood Cove, near Georgetown, Maine, in 1923.[1] This connection to New England shaped Marguerite Zorach's *Land and Development of New England*.

By the 1930s Zorach had settled on the descriptive, modernist-derived style evident in this painting. The two-dimensional, densely packed surface with a high horizon and schematic landscape are witness to the influence of both European modernism and American folk art,[2] while the chiseled figures recall William Zorach's sculpture as well as cubist and primitive art. In this mural-sized canvas, Zorach also combines figures and motifs from her own earlier works—tree hieroglyphs from *Autumn Woods* (1917, collection of Charles Ipcar), mill and stream from *The Deserted Mill* (1917, collection of Robert Foley), horses and father and child from *A New England Family* (1917–18, oil, private collection, and linoleum cut, Currier Gallery of Art, Manchester, New Hampshire), and background architecture along with the mother and child from the wall hanging *The Family of Ralph Jonas* (1926–27, collection of the Jonas family).[3] *Land and Development of New England* reworks this earlier tapestry with its family group set against a New England coastal community. This work with its multiple themes—family, regional history, the folk—had a private face that related to the artist's domestic life and a public face that intersected with the cultural needs of the 1930s.

Struggling with managing home and children while still making her art, Zorach picked up techniques such as embroidery so that she could work in short intervals between household tasks. This domestic world figured into her imagery.[4] In *Land and Development of New England*, four figures—father holding infant, mother tending to toddler—form a family unit paralleling Zorach's own family in 1917–18 (William, Marguerite, and Tessim and Dahlov as young children). The identity of the standing female is more puzzling: she could be another

daughter or, perhaps, an allegory of New England.[5] By portraying her family as a New England family, Zorach fashioned an identity as a regional and American painter. Living in Maine was a homecoming of sorts, because her mother's family claimed a New England ancestry back to the Massachusetts settlers—an ancestry mined by contemporary critics.[6] Zorach's paintings of domestic life were associated with her American-ness; when they were shown in 1934 at the Downtown Gallery, one reviewer characterized them as "the 'American Scene and the American People,' for [Zorach] has chosen those subjects which are close to her daily life, the people of New England, her family, and the Maine landscape."[7]

Land and Development of New England relates not only to Zorach's personal history but also to broader cultural concerns with family and regional history. In the 1930s artists, writers, and filmmakers reconstructed history, legends, myths, and heroes as part of a widespread effort to mold national identity in this unstable time. The federal government took an active role in this reconstruction. The Treasury Department's Section of Painting and Sculpture murals dealt with recurrent themes—family, pioneer, common man, farmer, worker—that built community and a shared past. For 1930s audiences, this past related to the present: murals of local history and economic activity "affirmed the importance of 'the people,' a sense of renewal, and the continuity of prosperity."[8]

Although not a Section mural, *Land and Development of New England* shares subjects commonly found in these projects.[9] Zorach not only presents the patriarch as a pioneer cultivating nature but describes this land as a rich resource. She paints an idealized rural New England at the same time that inadequate technology, poor management, and the Depression were eroding agriculture, especially in Maine, and that the region's textile, shoe, and paper industries were on the decline.[10] This image offered an alternative to present conditions—a well-ordered, productive region, full of resources. In addition, like many Section murals, *Land and Development of New England* emphasizes the "fruits of family labor." As the cultural historian Barbara Melosh has pointed out, numerous Section murals depicted the farm family, with husband

and wife as partners working together—an icon of an ideal community.[11]

Regional folk, in particular, represented traditional gender identities. As historians have argued, early-twentieth-century social changes from the sexual revolution to the feminization of service jobs challenged established notions of gender, and the Depression deepened this "gender crisis" by disempowering the male breadwinner.[12] In this context, region was mythologized as a masculine domain and a place where traditional gender identities could be recovered. The regionalist painter Thomas Hart Benton announced in a 1935 interview that he was moving to Missouri because New York had "lost its masculinity."[13] He portrayed the Midwest as a "man's world": males populate his murals as the movers and shakers in politics, industry, agriculture, and history, while women are largely left to domestic chores, as in *A Social History of Missouri* (1936, Missouri State Museum, Jefferson City). Similarly, *Land and Development of New England* maps out gender-specific spaces. The region's settlement is presented as a masculine endeavor in which only men clear forests, plow the land, and dam the rivers. Family relations evoke an imagined nineteenth-century rural society. Dressed in L. L. Bean hunting boots and flannel shirt, the patriarch proclaims through his gestures—one hand supporting the infant, the other petting the hound—his role as protector and provider. With his broad chest and erect posture, he dominates the landscape as well as the mother and child. The mother, in contrast, plays the role of family nurturer and is excluded from the background landscape and its activities. While Zorach herself was able to negotiate between public and private in her own life and career, she marked out clearer boundaries between genders for her viewers just as many of her contemporaries did.

D. C.

56 Land and Development of New England, c. 1935

Oil on canvas, 96 x 78

Signed lower right, "Marguerite Zorach"

Museum purchase, 91.17

PROVENANCE: Estate of the artist, 1968; Ann Johnston, Vermont, 1968–91; Barridoff Galleries, Portland, Maine, 1991

EXHIBITIONS: Farnsworth Art Museum, 11 July–28 September 1980, Colby College Museum of Art, Waterville, Maine, 26 October–14 December 1980, and Worcester Art Museum, Worcester, Massachusetts, 29 May–2 August 1981, "William and Marguerite Zorach: The Maine Years," no. 18; Williams College Museum of Art, Williamstown, Massachusetts, 13 July–29 September 1991, and Farnsworth Art Museum, 3 November 1991–5 January 1992, "Companions in Art: William and Marguerite Zorach," no. 51; Farnsworth Art Museum, "One Hundred Years of Maine at Work," 17 June–5 October 1997

REFERENCES: William Zorach, *Art Is My Life* (New York: The World Publishing Co., 1967), n.p. (illus.); *Marguerite Zorach* (Waterville, Maine: Colby College Art Museum, 1968), frontispiece (illus.); Roberta K. Tarbell, *William and Marguerite Zorach: The Maine Years* (Rockland, Maine: Farnsworth Art Museum, 1980), 53; *Public Auction: American and European Art* (Portland, Maine: Barridoff Galleries, 1991), cover, (illus., no. 35); Vivian Patterson, *Companions in Art: William and Marguerite Zorach* (Rockland, Maine: Farnsworth Art Museum, 1991), n.p.; Susan C. Larsen, *One Hundred Years of Maine at Work* (Rockland, Maine: Farnsworth Art Museum, 1997), n.p., back cover (illus.)

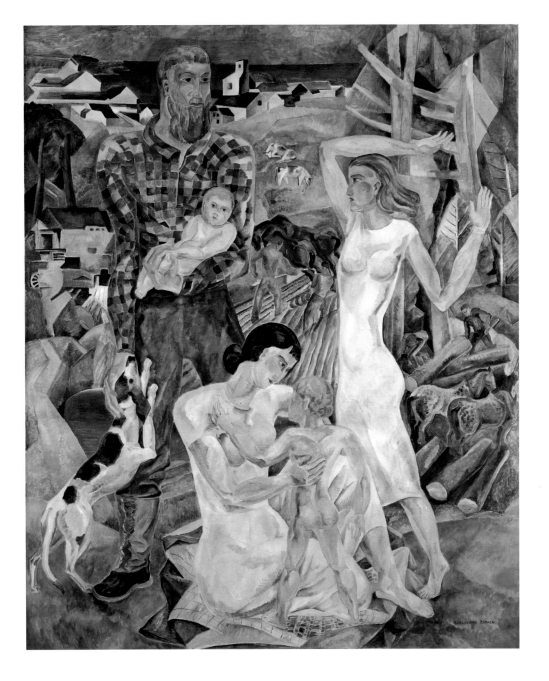

William Zorach (1889–1966)

57 Fall, Homestead Pasture,
c.1928–1932

Watercolor and gouache on paper,
15⅝ x 22⅛
Signed lower right, "William Zorach"
Gift of Mr. and Mrs. Bert Thome,
Brookfield, Connecticut, 80.36.2

PROVENANCE: Collection of the artist,
purchased by Bert Thome, Brookfield,
Connecticut, 1958; remained in the
Thome family

EXHIBITIONS: The Fitchburg Art Museum,
Fitchburg, Massachusetts, "The Maine
Connection: Paintings and Sculpture
from the Farnsworth Art Museum," 21
November 1993–27 March 1994

The 1907 exhibitions of Paul Cézanne's water-colors at Paris's Galerie Bernheim-Jeune and Salon d'Automne and their subsequent showing at Alfred Stieglitz's Photo-Secession Gallery, or 291, in New York (1911) inspired a new water-color manner. In the hands of the first-generation American modernists, this medium moved away from realistic description to evanescent washes and sketchy, suggestive forms.[1] Involved in avant-garde circles in Paris and New York, William Zorach had ample opportunity to study this fresh approach to the medium. The young painter journeyed to Paris in 1909, where he attended the informal art school La Palette, and the expressionism that he studied there and evolved in his own work placed him among the experimental artists when he returned to New York. In his watercolors of the 1910s, Zorach displayed diverse styles modeled after European and American modernists, from the organic, Matisse-like *Farm in the Hills* (1915, collections of the Zorach children) to the geometric, Marin-like *Boats in the Early Morning—Stonington, Maine* (1919, collections of the Zorach children).[2]

Like his modernist colleagues, Zorach adopted watercolor because it allowed him to work spontaneously and express immediate emotions. He wrote about his paintings during his 1919 summer in Stonington, Maine: "I felt that I was digging down into my inner soul . . . My development took an inner, mystical turn; I felt that I had to express something beyond surface reality. I knew there was a deeper reality which I must put into my work."[3] When Zorach later turned to sculpture as his primary medium, he continued to use watercolor because it served needs that his sculpture could not:

> There are things one does for the pure love of form and color, in the easy abandonment to the moods and fancies of the moment. These are my watercolors. Then there are the visions imprisoned in the rock and the visions deep in one's soul. . . . This is my sculpture. All these things have their place and value.[4]

Fall, Homestead Pasture displays the lessons that the artist had learned from Cézanne and the post-impressionists. Applying pigments with large brushstrokes, he built a decorative surface of curving, interweaving lines and shapes reminiscent of Vincent van Gogh's paintings. He placed these strokes onto wet paper to create brilliant color and allowed these colors to melt together. Autumnal hues construct spatial tension: greens on the right and left of the composition recede, while the central pasture and trees with their reds and oranges move forward.[5] Round forms communicate a soothing mood consonant with the subject, while contrasting colors, jagged lines, and staccato daubs of paint energize the landscape.

Like his American colleagues, Zorach put modernist styles to the service of a romantic naturalism.[6] *Fall, Homestead Pasture* shows nature controlled and ordered by humans—a view very different from the destructive nature in Marsden Hartley's *Stormy Sea No. 2* (see no. 47). Soft-edged forms, brilliant color, and curving strokes all make this scene comfortable for the viewer and artist; it was, after all, a site near the Zorach home in Robinhood Cove, near Georgetown, Maine.[7] This domesticated landscape, with horses grazing in a fenced-in pasture surrounded by the lush New England autumnal woods, replicates a common nineteenth-century landscape formula: with the trees framing the scene and a cleared pasture in the center, it recalls pastoral views like Thomas Cole's *Cattle and Distant Mountain* (see no. 3).

Like most of Zorach's watercolors, *Fall, Homestead Pasture* was painted in Maine and records familiar spots around Robinhood Cove. Ambivalent about modernization, many early-twentieth-century artists, including the Zorachs, settled in, and, in a sense, colonized regions valued as primitive or antimodern. In the rapidly urbanizing United States, people imagined that an ideal rural past survived in Maine. For Zorach, "Artists like to live and work in a place that has a special beauty—preferably an unspoiled and uncommercialized beauty—where there is real life among the people and the activities of work and living."[8] *Fall, Homestead Pasture* defines the region as a place where the balance between humans and nature was preserved; it describes the domesticated space near the Zorach home and resonates a nineteenth-century image of this harmonious landscape. Zorach adopted the ideal modernist technique—watercolor—to paint this ideal anti-modern locale.

D. C.

Allen Erskine Philbrick (1879–1964)

Allen Erskine Philbrick is known for his landscapes of Michigan and Maine, where he summered, and because he was an important and influential teacher at the Art Institute of Chicago. Born in Utica, New York, Philbrick lived in Winnetka, Illinois. He began his art studies at the Art Institute of Chicago, then went to Paris to study at the Académie Julian and Académie Colarossi, and traveled extensively throughout Europe. Philbrick exhibited at the Art Institute of Chicago, the National Academy of Design, and the Paris Salon. He was a teacher for nearly fifty years at the Art Institute of Chicago, and because of his demanding teaching schedule, summers were the only opportunity he had to devote fully to his painting. During the years 1908 to 1918 and again 1932 to 1960, Philbrick and his family spent summers in Damariscotta, Maine, where he painted the local scenery and the places and towns where people gathered.

Main Street, Damariscotta, Maine depicts this small town on a sunny but hazy day, at a particularly difficult time—during the Great Depression. The depression in Maine hurt most those areas that were already poor, especially in the already hard-pressed areas, including the midcoast region. In September 1933 a reporter and confidant of Eleanor Roosevelt, Lorena Hickok, spent nine days in Maine, doing field investigation for the Federal Emergency Relief Administration. Her detailed report included the observation—that thousands of families should be getting federally funded relief but were not, because a "Maine-ite . . . would almost starve rather than ask for help." It was considered a "disgrace in Maine to be 'on the town.'" Maine people did not embrace Franklin Roosevelt's New Deal, and instead of receiving aid towns like Damariscotta preferred to cut town expenses. FERA attempted to do what they could for the area, but, as Hickok wrote, "their ideas simply do not fit in with ours, that's all."[1]

Although the popular tourist resort community of Boothbay Harbor was only ten miles south and would have helped the economy of Damariscotta during the summer of 1936, for the people in town and those on the outskirts life was difficult. At first glance, Philbrick's painting of the town including the Damariscotta River flowing underneath the bridge on a lovely summer day appears peaceful and even cheerful. However, Philbrick has included in *Maine Street, Damariscotta, Maine* subtle hints of the depressed condition of the community just below the surface of the brightly colored buildings. There is little commercial activity on the street, and although several parked cars line the street, none are depicted moving. Of the few figures in the townscape, three are on the bridge and have stopped to look down at the rushing water of the Damariscotta River below.

P .J. B.

58 Main Street, Damariscotta, Maine, 1936

Oil on canvas, 30 3/16 x 40⅛
Signed lower right, "Allen Philbrick"
Bequest of Mrs. Elizabeth B. Noyce, 97.3.41

PROVENANCE: Collection of the artist; Jane Philbrick Kofler (the artist's daughter) 1964–92; Mrs. Elizabeth B. Noyce, 1993–96; Estate of Mrs. Elizabeth B. Noyce 1996–97

EXHIBITIONS: Farnsworth Art Museum, "Allen E. Philbrick: American Impressionist," 5 October–4 December 1980; Adams Davidson Galleries, Washington, D.C., "Allen Philbrick Rediscovered: An Exhibition of Paintings and Etchings from 1905 to 1936," 11 November–30 December 1988, no. 22

REFERENCES: *Allen Philbrick Rediscovered: An Exhibition of Paintings and Etchings from 1905 to 1936* (Washington, D.C.: Adams Davidson Galleries, 1988), cover; Jessica F. Nicoll, *A Legacy for Maine: The November Collection of Elizabeth B. Noyce* (Portland, Maine: Portland Museum of Art, 1997), 72

Andrew Winter (1893–1958)

Seguin Island at the mouth of the Kennebec River is one of the foggiest locations in Maine and the site of one of the earliest lighthouses in the United States. Its first tower, constructed in 1795 during the presidency of George Washington, was replaced in the late nineteenth century by one that reached 188 feet above sea level, making it the highest lighthouse on the coast of Maine.[1] An experienced sailor as well as an artist, Andrew Winter must have felt a special affinity for such an important symbol of navigation. Born in Estonia, Winter went to sea in 1913, sailing first on square riggers and later serving as a mate on British and American steamships.

After becoming an American citizen in 1921, Winter entered art school at the National Academy of Design in New York. There figure drawing and a traditional approach to painting remained at the core of the curriculum. He returned to Europe on a traveling fellowship in 1925 to study in Rome and Paris. In the 1930s and 1940s his seascapes and landscapes from the Caribbean to the coast of Maine garnered critical recognition and prizes at exhibitions at the National Academy, the Pennsylvania Academy of the Fine Arts, and New York's prestigious Salmagundi Club.[2] A description of the artist that appeared in a 1937 Philadelphia newspaper vividly conveys this roving mariner's recent success: "Winter's arms, heavily tattooed with mermaids, geisha girls, dragons, sea-horses, tropical birds and bathing beauties of all climes and races, have not interfered with his strenuous rise to artistic fame."[3]

Seguin Island Light, with its muted palette of browns, grays, blacks, and whites, is characteristic of his understated, but forcefully rendered painting style. The simple geometry of the principal architectural features is given shape by sharp contrasts of dark and light, while the paint surface is animated by vigorous brushwork. The strong effects of lighting and the lack of human presence recall the work of Edward Hopper, another artist of this generation who had great affection for the loneliness of coastal scenes. Winter emphasizes the geographic isolation of the lighthouse in the unadorned character of the lightkeeper's house, the black void of its windows, and the barrenness of the rocky outcropping on which it stands. In addition to Seguin, Winter painted lighthouses at Little Harbor and Eastern Point in Maine and Montauk Light on Long Island. The potentially destructive power of the sea implied in these lighthouse scenes is fully realized in paintings such as his *Wreck at Lobster Cove,* which won the Edwin Palmer Memorial Prize for the best marine painting at the National Academy of Design in 1940.

Andrew Winter personally identified with lonely landscapes. He and his wife, Mary, who was also an artist, eventually settled as year-round residents on Monhegan Island, Maine. In a clever pun on his own name, his *Self-Portrait at Below Zero, Lobster Cove* of 1936, also in the collection of the Farnsworth Museum, shows the artist holding a paintbrush and bundled up against the rigors of an island winter. The colors of his palette and the strong brushwork in this forceful portrait are similar to those of his landscapes. He painted Monhegan in all seasons, frequently rowing around the island in the worst of weather to capture scenes of the harshest seas and the most dramatic views of the cliffs and rocks. His involvement with the natural and human life of the island was complete: he fished with the local lobstermen, collected ducks for still life studies, and built ship's models.

Despite the geographic seclusion of Monhegan, Winter was no recluse. He maintained ties to several academically oriented institutions, including the Allied Artists of America, the National Academy of Design, and the Louis Comfort Tiffany Foundation. A prolific watercolorist, he was also a member of the American Watercolor Society. During his lifetime, he exhibited at a number of important museums and commercial galleries, among them the Corcoran Gallery of Art in Washington, D.C.; the Currier Gallery of Art in Manchester, New Hampshire; the Memorial Art Gallery in Rochester, New York; the Cranbrook Academy of Art in Bloomfield Hills, Michigan; and in New York City at the Babcock and Grand Central Art galleries.

S. D.

59 Seguin Island Light, 1940

Oil on canvas, 16 x 20

Signed and dated lower right, "A WINTER - 40"

Gift of Mr. and Mrs. Leo Meissner, 71.1795.76

EXHIBITIONS: Farnsworth Art Museum, "The Paintings of Andrew Winter (1893–1958)," 3 January–28 February 1982; The Fitchburg Art Museum, Fitchburg, Massachusetts, "The Maine Connection: Paintings and Scultpure from the Farnsworth Art Museum," 21 November 1993–27 March 1994

59a Self Portrait at Below Zero, Lobster Cove, 1936

Oil on canvas, 22 x 28

Gift of Mr. J. J. Taylor, Palm Desert, California, 80.32

Jan Marinus Domela (1896–1973)

60 **Monhegan Island**, 1938

Oil on canvas, 30 x 40
Signed lower right, "J. Domela"
Bequest of Mrs. Elizabeth B. Noyce,
1997, 97.3.9

PROVENANCE: Jan Derk Domela (artist's
son) 1973–92; Montgomery Gallery,
San Francisco, 1991–92; Mrs. Elizabeth B.
Noyce, 1992–1996; Estate of Mrs.
Elizabeth B. Noyce, 1996–97

EXHIBITIONS: Montgomery Gallery, San
Francisco, "Jan Domela," 1992, no. 6;
Farnsworth Art Museum, 17 July–18
September 1994 and Portland Museum
of Art, Maine, 29 October 1994– 22
January 1995, "An Eye for Maine";
Portland Museum of Art, Maine,
"A Legacy for Maine: The November
Collection of Elizabeth B. Noyce,"
1 October 1997–4 January 1998

REFERENCES: Donelson Hoopes, *An Eye
for Maine* (Rockland, Maine: Farnsworth
Art Museum, 1994), 14, 37 (illus.);
Donelson Hoopes, "Two Centuries of
Maine Art," *Island Journal* 11 (1994),
60 (illus.); Neil Rolde and Charles C.
Calhoun, *An Illustrated History of Maine*
(Augusta, Maine: Friends of the State
Museum, 1995), 181 (illus.); Jessica F.
Nicoll, *A Legacy for Maine: The
November Collection of Elizabeth B.
Noyce* (Portland, Maine: Portland
Museum of Art, 1997), 62

The dramatic and rugged landscape of isolated Monhegan Island provided the stimulus for Jan Marinus Domela to paint this light-filled view of the village, harbor, and Manana Island in the distance. Nearly twelve miles from Port Clyde, at the tip of the St. George Peninsula, and accessible by the mailboat, Monhegan had been popular as an artist's retreat since the end of the nineteenth century—visited by Samuel P. R. Triscott, W. W. Norton, Robert Henri, George Bellows, Rockwell Kent, Ernest Albert, and numerous others. Domela met resident artist Jay Hall Connaway during his visit in 1938, and they became close friends. They shared much in common—similar ideas and approach to art—and sketched and painted together. *Monhegan Island* was painted at this time and it is a depiction of village, harbor, and Manana in the later afternoon, when the bright sunlight on the landscape heightens the sharp contrasts with areas in shadow that add to the drama of this remote and isolated island.

Born in Amsterdam in 1896, Domela first developed an interest in art while he was at a boarding school in Switzerland. At the early of age of nineteen he journeyed to the United States to visit his sister in Fresno, California, and soon began his formal study at the Los Angeles School of Illustration and Painting and the Mark Hopkins Art Institute. He returned to Holland in 1925, and studied at the Rijks Academy in Amsterdam and then to Paris at the Académie Julian. In 1928, Domela returned to California and became chief matte painter at Paramount Studios. He exhibited his work at the Young Painters Club in Los Angeles, where he met artists Paul Sample and Millard Sheets. He also exhibited at the Los Angeles County Museum's "Ninth Annual Exhibition of Painters and Sculptors" winning honorable mention, and competing against artists like Robert Henri, Charles Reiffel, and Alson Clark.

Point Lobos on the Monterey Peninsula was a favorite place for Domela's plein air paintings, as well as the European Alps and the California Sierras. The artist remained at Paramount Studios as chief artist in the special effects department until his retirement in 1968. During these years, Domela created landscapes for nearly every film the studio produced from 1928-1960, receiving several academy awards including one for his work on "The Ten Commandments."

P. J. B.

Henriette Wyeth (Hurd) (1907–1997)

61 Death and the Child, 1935

Oil on canvas, 47½ x 43¾

Gift of Mr. and Mrs. Andrew Wyeth
in memory of "B. J." Stuart, 91.55

PROVENANCE: Collection of the artist;
Collection of Mr. and Mrs. Andrew Wyeth

EXHIBITIONS: Brandywine River Museum,
Chadds Ford, Pennsylvania, "Henriette
Wyeth," 6 September–23 November 1980;
Museum of Fine Arts, Museum of New
Mexico, Santa Fe, 19 November 1994–
5 February 1995, Museum of Texas
Technical University, Lubbock, 1 May–
30 June 1995, R. W. Norton Art Gallery,
Shreveport, Louisiana, 1 August–
30 September 1995, Greenville County
Museum of Art, South Carolina,
1 November 1995–30 January 1996,
Henderson Fine Arts Center, San Juan
College, Farmington, New Mexico,
1 March–30 April 1996, Museum of the
Southwest, Midland, Texas, 1 September–
30 October 1996, "Henriette Wyeth:
A Personal View," no. 11

REFERENCES: Paul Horgan, *Henriette Wyeth*
(Chadds Ford, Pa.: Brandywine River
Museum, 1980), 24, 25 (illus.), 54;
Richard Meryman, "The Wyeth Family:
American Visions," *National Geographic*
180, no. 1 (July 1991): 96 (illus.); Paul
Horgan, *The Artifice of Henriette
Wyeth: Blue Light* (Santa Fe: Museum of
New Mexico Press, 1994), 42, 45 (illus.)

From the perspective of sixty-five years hindsight and even in the context of its time, Henriette Wyeth Hurd's painting *Death and the Child* is a startlingly original work with few precedents and no contemporary equivalents in an age that has been described in terms of complaint and cynicism. It remains a strangely moving and provocative image both because of and in spite of its obvious and deeply felt sentiment.

Death and the Child, 1935, is the final work in a series of Henriette Wyeth's "fantasy paintings."[1] This fantasy, however, was a real and emotionally charged subject for a family haunted by the accidental deaths of children over four generations. According to David Michaelis in his recently published biography of N. C. Wyeth, the infant brother of N.C.'s mother, Henriette or "Hattie" Zirngeibel, died under mysterious, if not suspicious, circumstances in a drowning accident. It was a suppressed family tragedy that seems to have deeply affected N.C.'s mother and perhaps contributed to her emotional instability and near obsessive concern for her own children, especially her firstborn, N. C. Henriette was named for Hattie Zirngeibel. Whether such dark family secrets were ever shared with Henriette is unknown. Before the introduction of modern antibiotics and vaccines, infant and early childhood fatalities from polio, pneumonia, smallpox, and asthma were tragic but widely experienced occurrences among families as late as the first half of the twentieth century. At age three, Henriette contracted polio, which left her right hand withered, an undoubtedly terrifying experience for any young parents, but especially traumatic for N.C., who carried at least some of his mother's obsessive fear of separation from his own offspring.[2]

Henriette was N. C.'s firstborn and his first artistic protégé, literally his "golden child" with her blond hair, fine features, and precocious talent, oft proclaimed and nurtured by her father who rigorously emphasized basic drawing fundamentals—endless drafting exercises with cubes, cones, and spheres. From early on, N.C. also emphasized the autobiographical and emotional content that he believed to be at the wellspring of all great art. Later in life, when her principal subject was portraiture, Henriette remarked, "My relationship with people, my awareness of them, my trying to become them, projecting myself into them, are entirely autobiographical."[3]

It is also possible that, consciously or not, the painting refers to Henriette's marriage to Wyeth's former student Peter Hurd and their move in 1929 from Chadds Ford to Hurd's native New Mexico. Henriette was the first and only child of N.C. to move away from Chadds Ford permanently, and the change deeply affected both N. C. and his daughter. Indeed, Henriette returned to Chadds Ford to have her first child and returned "home" each year for lengthy visits through most of her life.

If we sense in Henriette's painting muted echoes of loss, separation, and change, they are part of a family mind-set that dwelled to an unusual degree on such matters. It is also likely that the exotic environs of southern New Mexico and nearby Mexico affected her work at this time. The mystical manifestations of Native American culture seamlessly interwoven for centuries with Catholic ritual, no less than the desert ochers and sun-bleached adobe, the piercing, clear air, and form-dissolving light of the Southwest, are increasingly present in Wyeth's work from the early 1930s, evidenced by her earth-toned, palette and referenced more overtly in her late paintings such as *The Black Saint*, 1980. The only "modern" artist that Henriette ever acknowledged admiration for was Georgia O'Keeffe, whose work she first encountered in New York before Wyeth's marriage. There is no direct evidence that her reclusive, northern New Mexico neighbor O'Keeffe was an influence on Wyeth.

Equally speculative but a promising avenue for further research is how, if at all, Henriette Wyeth might have found inspiration in the strange romantic realism of the English Pre-Raphaelites. A superb collection of these works, formed by Samuel Bancroft, Jr., of Wilmington and now housed at the Delaware Art Museum, would surely have fascinated an impressionable young artist predisposed to fantasy that also coincided with her delicate, ethereal sensibility. Another nearby parallel for the subject and handling of *Death and the Child* can be found in the Swedenborgian faith, well known to, if not deeply understood by, her father through his teacher, Howard Pyle, whose family had converted to Swedenborgianism. Followers of the eighteenth-century Swedish theologian and philosopher Emmanuel Swedenborg believe in links between this life and the hereafter, and, interestingly, the faith posits the possibility of a feminine divine, an idea Henriette might have found especially compelling during this "unmaterial" and rebellious phase of her life.[4] Concerning the subject of *Death and the Child*, Wyeth stated, "This child is being saved from all the loathsome disappointments and corruptions of life. It's a saving grace. There are worse things than death."[5] Both the Pre-Raphaelites and Swedenborgians would have found her description consistent with their own precepts.

The artist's brother Andrew considers *Death and the Child* among Henriette's most important paintings, possibly recognizing its associations with family history and experience, including the tragic death of N.C. and his toddler grandson in an automobile accident in 1945, a defining moment in Andrew's own life. In 1991 the painting was given to the Farnsworth Museum by Andrew and Betsy Wyeth "in memory of 'B. J.' Stuart," the young son of the Wyeths' caretakers, who died in an accident near the Wyeth family home in Cushing, Maine.

C. B. C.

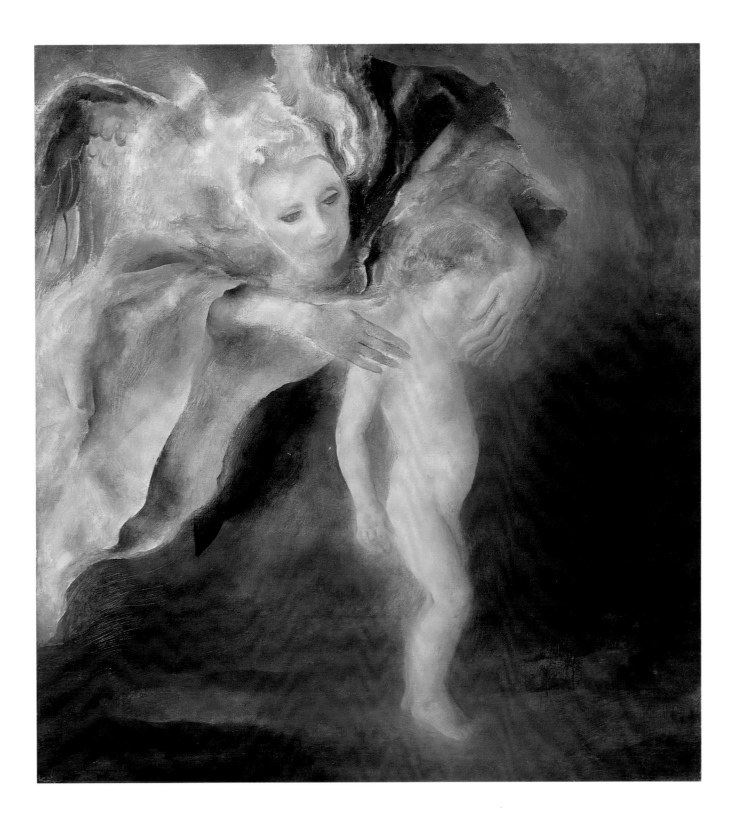

Newell Convers Wyeth (1882–1945)

Newell Convers, or N. C., Wyeth first brought his young family to Maine in the summer of 1920, when they rented quarters in the Wawenok Hotel in the small fishing community of Port Clyde. By the early 1930s he had completed renovations on a former sea captain's cottage located just outside the village and overlooking the harbor. He named the house Eight Bells, possibly in honor of Winslow Homer's well-known painting and print of the same title (Addison Gallery of American Art, Andover, Mass.). For N. C., Maine offered a degree of escape from the demands of commissioned illustrations and a place that looked and felt very different from Chadds Ford and the Brandywine Valley in Pennsylvania or even his native Needham, Massachussets. Wyeth seems to have tuned his palette, technique, and paint handling to very different keys, depending on whether he was painting in Maine or Chadds Ford. As might be expected, the Maine works tend toward deeply saturated greens, cobalt blues, and higher keyed grays and yellows. His Maine works also exhibit a looser, more open, and fluid handling of paint, with darker shadows played against glaring sunlight that erases detail. Nature predominates in his Maine work, even when figures and buildings are present. Instead of the stippled surface handling and suffused but broken light of the Italian neo-Impressionist, Giovanni Segantini, and American impressionists admired by N. C., the Maine work exhibits a renewed interest on the part of N. C. in the work of Winslow Homer.

The Maine coast, with its treacherous ledges and pounding surf, especially along the aptly named Cannibal Shore near Martinsville and Mosquito Island, a few miles from Port Clyde, was for N. C. a natural extension for his fictional illustrations of adventure, danger, and powerful forces beyond human control and understanding. Such paintings as *Portrait of a Young Artist* depicting a young Andrew Wyeth painting before a crashing wave clearly echo illustrations of mythical knights and legendary heroes facing down, literally, in this instance, elemental menace. *Sounding Sea* presents the towering headlands

of Monhegan Island and this time places us, the viewer, in an even more precarious position, about to be hurled against the precipice—a device perfected by Wyeth early in his career for his most important illustrations, such as those for *Treasure Island* and *Kidnapped*, where we witness the action from within the scene. As the critic Robert Hughes observed with regard to Homer, the sea is a metaphor for the belief that "the moment you step from the social path, whose security is an illusion, all becomes wild and strange," a view that Wyeth seems to have shared.[1]

The Morris House, Port Clyde and *Bright and Fair—Eight Bells* are less dramatic in conception but no less personal and convey a sincere warmth and affection for Port Clyde and its people who Wyeth believed represented the last vestiges of Yankee invention, practicality, and fortitude. *Bright and Fair—Eight Bells* is a loving depiction of the Wyeths' summer residence and is among the most soaring, joyful expressions of personal contentment in the artist's vast body of work. A remarkable photograph showing N. C. with *Bright and Fair* on his easel confirms the artist's concern for painting based on fact and physical (or meteorological) accuracy. Lifting the painting to another more poetic level was the challenge Wyeth set for himself. From his home in Chadds Ford, he wrote to Andrew and his daughter-in-law Betsy:

> One of my great and blessed relaxations is to concentrate upon any chance detail associated with remote Port Clyde and the sublime sea that bathes its shores—even the imagined sight of a small ordinary wave, glass-clear and jewel-green, gliding over the the smoothed surface of a gently shelving shore. . . . I feel desperate at times to be there with it and with you both, and to feel the air moan in the hollows of my face.[2]

Images of home, whether in Chadds Ford, Needham, or Eight Bells, are central to N. C.'s personna; such paintings are self-portraits and house everything that was of value to the artist— treasured memories of his youth and dreams for an idealized present and what can only be described as an obsessive devotion to family.[3] Painted in 1936, the year before his son Andrew's debut with a sell-out show at the Macbeth Gallery

in New York, *Bright and Fair* reflects a spirit of optimism, expansiveness, and family pride.

N. C. Wyeth is universally acknowledged to be the finest American illustrator of his generation. Although the qualitative, pejorative distinction that the artist himself placed on illustration is becoming less of an issue in contemporary criticism, N. C. wished to achieve recognition simply as an artist.[4] It was in Maine that he found the time and peace to pursue his personal vision and interests and where he produced some of his finest paintings.

C. B. C.

62 Sounding Sea, 1934

Oil on canvas, 48¼ x 52¼
Signed lower left, "N.C.Wyeth"
Bequest of Mrs. Elizabeth B. Noyce,
97.3.59

PROVENANCE: Mrs. N. C. Wyeth (estate of the artist) 1945–46; private collection, 1947–95; Somerville Manning Gallery, Greenville, Delaware, 1995; Mrs. Elizabeth B. Noyce, 1995–96; Estate of Mrs. Elizabeth B. Noyce, 1996–97

EXHIBITIONS: The Pennsylvania Academy of the Fine Arts, Philadelphia, "One Hundred Thirtieth Annual Exhibition," 27 January–3 March 1935, no. 132

REFERENCES: *Catalogue of the Hundredth and Thirtieth Annual Exhibition* (Philadelphia: The Pennsylvania Academy of the Fine Arts, 2nd edition, 1935), 17; Douglas Allen and Douglas Allen, Jr., *N. C. Wyeth: The Collected Paintings, Illustrations, and Murals* (New York: Crown Publishers, 1972), 179 (illus.); Carl Little, *Art of the Maine Islands* (Camden, Maine: Down East Books, 1997), 11, 42 (illus.)

62a Portrait of a Young Artist,
c. 1930
Oil on canvas, 32 x 40¼
Museum purchase, 63.1285

63 The Morris House, Port Clyde, c. 1935

Oil on canvas, 34 x 52
Signed lower right, "N.C.Wyeth"
Bequest of Mrs. Elizabeth B. Noyce, 97.3.60

PROVENANCE: Gift of Andrew and Carolyn Wyeth to Vanguard School, 1969; private collection; Mr. Jack Dell; Somerville Manning Gallery, Greenville, Delaware, 1995; Mrs. Elizabeth B. Noyce, 1995–96; Estate of Mrs. Elizabeth B. Noyce, 1996–97

EXHIBITIONS: Portland Museum of Art, Maine, 1 October 1997–4 January 1998, and Farnsworth Art Museum, 12 April–14 June 1998, "A Legacy for Maine: Masterworks from the Collection of Elizabeth B. Noyce"

REFERENCES: Christopher Crosman, "The Art of Community," *Island Journal* 14 (1979): 30 (illus.), 35

64 Bright and Fair—Eight Bells,
1936

Oil on canvas, 42⅜ x 52¼
Signed lower right, "N.C.Wyeth"
Museum Purchase, 89.13

PROVENANCE: Mrs. N. C. Wyeth (estate
of the artist), 1945; Carolyn Wyeth to
Somerville Manning Gallery, Greenville,
Delaware, 1989

EXHIBITIONS: Wilmington Society of the
Fine Arts, Delaware, "Twenty-Fourth
Annual Exhibition of Delaware Artists,
Members of the Society and Pupils of
Howard Pyle," 1–27 November 1937,
no. 20; Chester County Art Association,
West Chester, Pennsylvania, "Seventh
Annual Exhibition," 28 May–12 June

1938, no. 38; Farnsworth Art Museum,
"An Exhibition of Paintings from the
World of N.C. Wyeth," 2 July–4
September 1966, no. 75; Brandywine
River Museum, Chadds Ford,
Pennsylvania, 1978, no. 104

REFERENCES: Betsy James Wyeth, ed.,
*The Wyeths: The Letters of N.C. Wyeth,
1901–1945* (Boston: Gambit, 1971),
755; David Michaelis, *N.C.Wyeth: A
Biography* (New York: Alfred A. Knopf,
1998), between 372 and 373 (illus.)

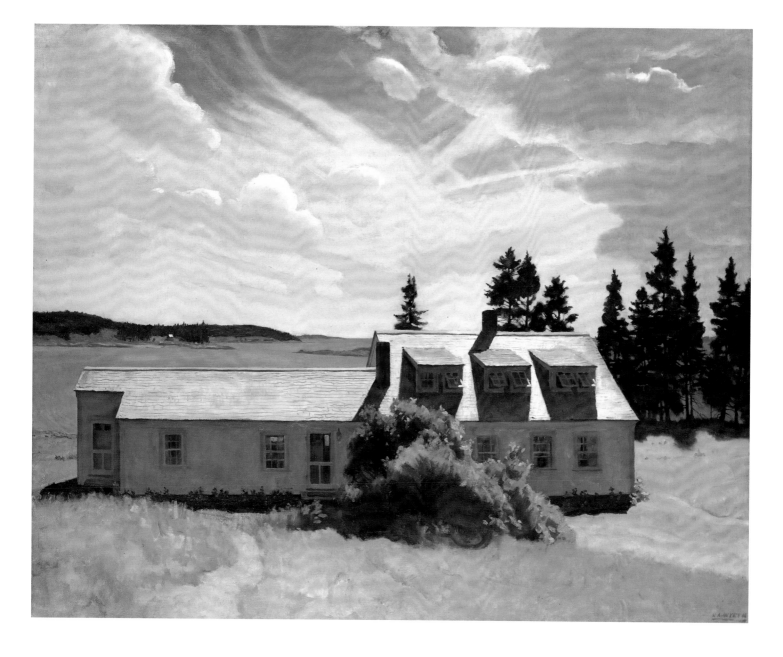

Andrew Newell Wyeth (b. 1917)

65 Turkey Pond, 1944

Tempera on panel, 32¼ x 40¼
Signed lower left, "Andrew Wyeth"
Gift of Mr. and Mrs. Andrew Wyeth
in memory of Walter Anderson, 95.2

PROVENANCE: Hyde Cox, Manchester,
Massachusetts; Collection of Mr. and
Mrs. Andrew Wyeth

EXHIBITIONS: Doll and Richards, Boston,
"Watercolors by Andrew Wyeth," 4–23
December 1944, no. 19; Portraits, Inc.,
New York, "The Wyeth Family," 22
October–9 November 1946; Currier
Gallery of Art, Manchester, New
Hampshire, 7 July–4 August 1951, and
Farnsworth Art Museum, 10 August–
8 September 1951, "Paintings and
Drawings by Andrew Wyeth," no. 4; M.
Knoedler & Co., New York, "Exhibition
of Paintings by Andrew Wyeth," 26
October–14 November 1953, no. 7;
Farnsworth Art Museum, "By Land and
Sea," 30 May–27 September 1992, no. 38

REFERENCES: *Watercolors by Andrew
Wyeth* (Boston: Doll and Richards,
1944), n.p.; Samuel M. Green, *Paintings
and Drawings by Andrew Wyeth*
(Rockland, Maine: Farnsworth Art
Museum, 1951), 15

A child of the interwar years, Andrew Wyeth came of age during the 1930s at the height of regionalism and the emergence of American modernism with its emphasis on abstract principles of structure and formal handling. High-spirited, intelligent, and artistically precocious from an early age, the youngest child of N. C. and Carolyn Bockius Wyeth, Andrew was schooled at home and received his only art training from his father, who was America's best-known illustrator. He rapidly developed under his father's guidance and achieved nearly instant celebrity as a young artist when his first New York show in 1937 at the Macbeth Gallery sold out.[1]

Although Andrew absorbed many important qualities from his father, not least a prodigious work ethic, N. C.'s own style—the emphasis on action, epic scale, and bold use of color and paint handling—was something for the young artist to react against. Unlike his father's preference for oil, Andrew has worked in tempera since first experimenting with the medium in the mid-1930s under the guidance of another of his father's students, Peter Hurd, who later married Andrew's sister, Henriette.[2] Andrew was also attracted to watercolor, another medium in which N. C. showed little interest.

Turkey Pond is among Wyeth's first mature tempera paintings. Earlier works, such as *Soaring* (1942, finished in 1950) and *Winter Fields* (1942), make use of dramatic points of view—looking down from above or flat on the ground looking up—and serve to disorient the viewer. *Turkey Pond*, in contrast, is devoid of special effects and concentrates attention on a quotidian emptiness, a lone figure striding across a field. The figure, with back turned to the viewer, is anonymous, the sky is an allover, cool gray with a suffused light, and the landscape is relatively flat and uniform, save the nearby pond. Andrew's father suggested that *Turkey Pond* was a failure, that it needed more visual interest such as a dog to accompany the figure or a hunting rifle.[3] With this major painting, among Andrew's largest temperas up to this time, the young artist began to assert his independence from his father's direct influence. In part, his new approach in the tempera medium, characterized by technical and stylistic precision and the suggestiveness of absence, can be attributed to the artist's new young wife, Betsy, who encouraged Andrew to develop his own quiet, introspective, and poetic sensibilities that were so different from his father's.[4]

The painting, a gift to the museum in 1995 by Andrew and Betsy Wyeth in memory of Walter Anderson, depicts Andrew's friend from boyhood and, beginning in late adolescence, his frequent model. Compositionally and, to some extent thematically, *Turkey Pond* stands as an important precursor to Wyeth's most famous work, *Christina's World*, 1948 (The Museum of Modern Art, New York). In both paintings, lone figures with backs turned to the viewer are positioned in the foregrounds of empty fields with dry, wild grasses rising to high horizon lines placed in the upper third of the paintings. In 1987 Wyeth described *Turkey Pond*: "I was very pleased with it because it had an authority in the feeling of his striding with blond hair but only the back of his showing." The subject, according to Wyeth, "was the silence of those fall mornings in Maine I'd seen so many times."[5] With the death of N. C. Wyeth the following fall (1945) in a tragic train accident, Andrew's work would change even more profoundly, and the relatively optimistic images of youthful vigor and bright promise, such as *Turkey Pond*, would give way to darker meditations on life's quiddity.

C. B. C.

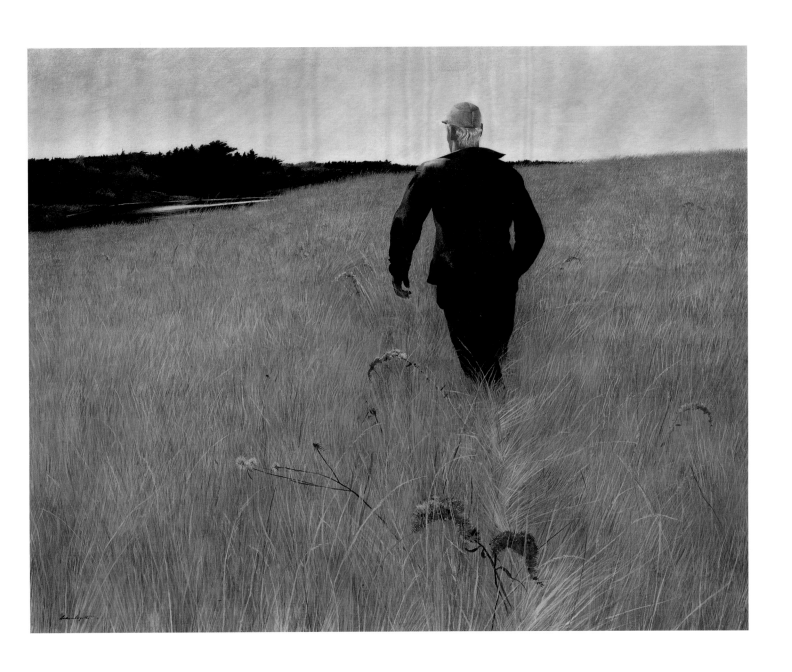

66 The Wood Stove, 1962

Drybrush watercolor on paper,
13⅜ x 26¼

Signed lower right, "Andrew Wyeth"

Museum purchase, 62.1266

PROVENANCE: Collection of the artist

EXHIBITIONS: Pennsylvania Academy of
the Fine Arts, Philadelphia, 8 October–
27 November 1966, Baltimore Museum
of Art, 11 December 1966–22 January
1967, Whitney Museum of American
Art, New York, 6 February–12 April
1967, and The Art Institute of Chicago,
21 April–4 June 1967, "Andrew Wyeth,"
no. 185; Museum of Fine Arts, Boston,
"Andrew Wyeth," 16 July–6 September
1970; The National Museum of Modern
Art, Tokyo, 6 April–19 May 1974, and
The National Museum of Modern Art,
Kyoto, 25 May–7 July 1974, "Andrew
Wyeth," no. 44; The Metropolitan
Museum of Art, New York, "Two Worlds
of Andrew Wyeth: Kuerners and Olsons,"
16 October 1976–6 February 1977, no.
143; Royal Academy of Arts, London,
"Andrew Wyeth," 7 June–31 August
1980, no. 23; The Currier Gallery of Art,
Manchester, New Hampshire, "Master-
works by Artists of New England," 3
April–16 May 1982; The Canton Art
Institute, Canton, Ohio, "Andrew Wyeth:
From Public and Private Collections," 15
September–3 November 1985; Arnot Art
Museum, Elmira, New York, "The Wyeths:
Three Generations of American Painters,"
7 December 1985–23 February 1986;
Heckscher Museum of Art, Huntington,
New York, "The Wyeth Legacy: A Family

The Wood Stove and *Alvaro and Christina*, along with *Hayrack* (1958) in the Farnsworth collection, belong to Wyeth's Olson series of over three hundred drawings, watercolors, and temperas related to Christina Olson and her brother, Alvaro, their deteriorating saltwater homestead and barn, and various objects and furnishings found therein. The Olson works span three decades, from Wyeth's first encounter with the saltwater farm in 1939 and continuing until after the death of Alvaro on Christmas Eve 1967, followed by Christina's less than a month later in January 1968.

Wyeth's special relationship with the Olson house and its inhabitants was through his future wife, Betsy James, a Cushing neighbor who had known the reclusive Olsons since childhood.[1] Initially struck by the spare beauty of the house and its setting on a hill looking to the mouth of the river and the island-dotted Muscongus Bay, Wyeth soon became an intimate friend of Christina and Alvaro and was allowed free access to the house and environs. Over the years the house and its inhabitants became interchangeable, the subject of a sustained meditation on Maine and the human condition.

Both *Alvaro and Christina* and *The Wood Stove*, like many of Wyeth's most important watercolors, evolved from numerous rapidly executed drawings that succinctly emphasize a process of shifting ideas and isolating key objects and compositional schemes. The final watercolors are executed in a technique the artist calls drybrush: nearly dry pigment laid down with finely bristled brushes to achieve delicate lines, sharp edges, and precisely rendered textures. In practice, drybrush paintings are always a mixture of wet and dry painting techniques that nevertheless stand as a unique bridge between Wyeth's more freely painted "pure" watercolors and the more precisely detailed tempera paintings.

The prosaically titled *The Wood Stove* includes Christina Olson seated with her back to the viewer at a small table looking toward the field behind the house. In the opposite window are her favorite geraniums. The chair on the right is where Alvaro usually sat, the large Glenwood wood-burning stove dominating the left center of the painting. Betsy Wyeth has described the kitchen:

Behind the stove are two doors that open into the woodshed. One of Christina's cats sleeps on the floor next to the wood box. If the fire was low and Alvaro was away, she would hitch her chair across the room, put a couple of logs in her lap, and hitch back to the stove. The only hot water in the house came from the teakettle or the storage tank on the right side of the stove.[2]

Although Christina's face is not seen and Alvaro is absent, the room is a portrait of both by association. In a closely related work, *Geraniums*, where the view is of this same south-facing window but from the outside looking in, we see only a faint silhouette of Christina. The geraniums, however, in their gnarled, twisting stems suggest Christina's own body, ravaged by untreated disease, but also her strength and endurance. The red blossoms, played against the shadowy interior, carry her vital spirit and warmth—plain, ordinary, in a botanical sense, but with heightened brilliance in a world of dark and weathered wear, as Wyeth had come to know Christina. Alvaro would sit for only one portrait (*Oil Lamp*, 1945) but the many surrogate portraits, including the empty rocking chair in the right corner of *Woodstove*, describe his lanky physique, simple strength, resilience, and retiring nature as surely and certainly more accurately than any photographic likeness would be able to do. The black, soot-encrusted stove, central to the room, is also Christina, warming the well-used teakettle, a small note of grace and gentility in a harsh but somehow comfortable setting. Wyeth seemed to sense that his longtime models and friends were slipping away. Within five years both would be gone.

One of two posthumous portraits, painted after the deaths of Christina and Alvaro during the winter of 1967–68, *Alvaro and Christina* is among Wyeth's most haunting images.[3] The two doors seen from the attached woodshed lead back into the kitchen. Alvaro would usually use the door on the left, which was closest to the wood pile, in his ceaseless and largely futile attempt to keep warmth in the house (the woodstove provided the only heat in the house until, in the Olsons' final years, neighbors gave them a kerosene heater). Christina would "hitch" herself through the blue door on the right on her way to the primitive four-holer at the far end of the shed. The artist later spoke of the painting in an interview with Thomas Hoving:

I conceived it as a portrait of the whole Olson environment and I painted it the summer after Christina and her brother Alvaro had both died. I went in there and suddenly the contents of that room seemed to express those two people, the basket, the buckets and the beautiful blue door with all the bizarre scratches on it that the dog had made. They were all gone, but powerfully there, nonetheless.[4]

Memory, presence in absence, time, mortality, and the strangely affecting attention to the commonplace are constant themes in Wyeth's work, themes that coincide with and are reinforced by the textured, layered, complex technical and mental processes that give these works such originality and emotional resonance. In 1991 the museum acquired the Olson house itself, a gift from John and Lee Adams Sculley, and now a satellite facility open to the public from Memorial Day through Columbus Day. The house, left largely unfurnished and remarkably preserved as Wyeth painted it, is listed on the National Register of Historic Places, the only such historic structure so-designated by reason of its status as the "model" for works of art by a living artist.

C. B. C.

of Artists," 14 January–19 February 1989; ACA Galleries, New York, "Andrew Wyeth," 14 January–27 February 1993; Aichi Prefectural Museum of Art, Nagoya, 3 February–2 April 1995, The Bunkamura Museum of Art, Tokyo, 15 April–4 June 1995, Fukushima Prefectural Museum of Art, Fukushima, 10 June–30 July 1995, and The Nelson-Atkins Museum of Art, Kansas City, Missouri, 24 September–26 November 1995, "Andrew Wyeth Retrospective," no. 46

REFERENCES: *Andrew Wyeth* (Philadelphia: Pennsylvania Academy of the Fine Arts, 1966), 88; Richard Meryman, *Andrew Wyeth* (Boston: Houghton Mifflin Co., 1968), 145 (illus.), 174; Wanda M. Corn, *The Art of Andrew Wyeth* (Greenwich, Conn.: New York Graphic Society, Ltd., 1973), 33; *Works of Andrew Wyeth* (Tokyo: The National Museum of Modern Art, 1974), n.p.; *Two Worlds of Andrew Wyeth: Kuerners and Olsons* (New York: The Metropolitan Museum of Art, 1976), 142, 143 (illus.); *Andrew Wyeth* (London: Royal Academy of Arts, 1980), 48 (illus.), 77; Betsy James Wyeth, *Christina's World* (Boston: Houghton Mifflin Co., 1982), 153 (illus.), 279; Robert M. Doty, *Masterworks by Artists of New England* (Manchester, N.H.: The Currier Gallery of Art, 1982), n.p.; *Andrew Wyeth: From Public and Private Collections* (Canton, Ohio: The Canton Art Institute 1985), 49; *Three Generations of Wyeths* (Elmira, N.Y.: Arnot Art Museum, 1985), 19 (illus.), 20, 29; *Contemporary Great Masters* (Tokyo: Kodansha, Ltd., 1993), n.p. (illus. no. 24); Kate F. Jennings, *American Watercolors* (New York: Crescent Books, 1995), 56, 77 (illus.); *Andrew Wyeth Retrospective* (Nagoya: Aichi Arts Center, 1995), 82 (illus.), 239; *Andrew Wyeth: Autobiography* (Boston: Little Brown and Company in association with The Nelson-Atkins Museum of Art, Kansas City, 1995), 68, 68 (illus.); Caskie Stinnett, "The Olson House," *Diversion Magazine* (July 1996): 98

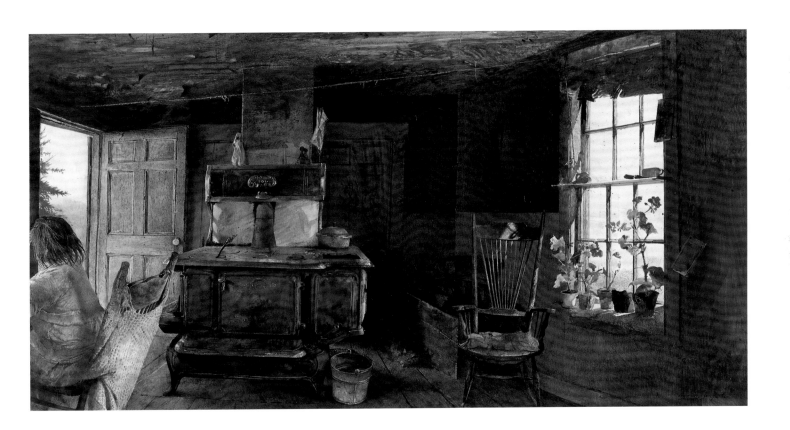

67 Alvaro and Christina, 1968

Watercolor on paper, 22^{13}/$_{16}$ x 28^{3}/$_{4}$
Signed lower right, "Andrew Wyeth"
Museum purchase, 69.1646

PROVENANCE: Collection of the artist

EXHIBITIONS: Museum of Fine Arts, Boston, "Andrew Wyeth," 16 July–6 September 1970; M. H. de Young Memorial Museum, The Fine Arts Museums of San Francisco, "The Art of Andrew Wyeth," 16 June–3 September 1973, no. 78; The National Museum of Modern Art, Tokyo, 6 April–19 May 1974, and The National Museum of Modern Art, Kyoto, 25 May–30 June 1974, "Works of Andrew Wyeth," no. 66; The Metropolitan Museum of Art, New York, "Two Worlds of Andrew Wyeth: Olsons and Kuerners," 16 October 1976–6 February 1977, no. 153; Whitney Museum of American Art at Champion, Stamford, Connecticut, "Four American Families: A Tradition of Artistic Pursuit," 11 November 1983–11 January 1984; Arnot Art Museum, Elmira, New York, "Three Generations of Wyeths," 7 December 1985–23 February 1986; The Heckscher Museum of Art, Huntington, New York, "The Wyeth Legacy: A Family of Artists," 14 January–19 February 1989; ACA Galleries, New York, "Andrew Wyeth," 14 January–27 February 1993; Aichi Prefectural Museum of Art, Nagoya, 3 February–2 April 1995, Bunkamura Museum of Art, Tokyo, 15 April–4 June 1995, Fukushima Prefectural Museum of Art, Fukushima, 10 June–30 July 1995, and The Nelson-Atkins Museum of Art, Kansas City, Missouri, 24 September–29 November 1995, "Andrew Wyeth Retrospective," no. 63; Farnsworth Art Museum, "One Hundred Years of Maine at Work," 13 July–5 October 1997

REFERENCES: Wanda M. Corn, *The Art of Andrew Wyeth* (Greenwich, Conn.: New York Graphic Society, Ltd., 1973), 42 (illus.); *Works of Andrew Wyeth* (Tokyo: The National Museum of Modern Art, 1974), n.p. (illus., no. 66); Tamon Miki, "Andrew Wyeth: A Japanese Viewpoint," *American Art Review* 1, no. 4 (May–June 1974): 88 (illus.); *Two Worlds of Andrew Wyeth: Kuerners and Olsons* (New York: The Metropolitan Museum of Art, 1976), 148, 149 (illus.); Betsy James Wyeth, *Christina's World* (Boston: Houghton Mifflin Co., 1982), 260, 261 (illus.); Wilfried Von Wiegand, "Andrew Wyeth Malt Christinas Welt," *Frankfurter Allgemeine Magazin* 22 April 1983, cover; *Three Generations of Wyeths* (Elmira, N.Y.: Arnot Art Museum, 1985), 21 (illus.), 29; Christopher Finch, *Twentieth-Century Watercolors* (New York: Abbeville Press, Inc., 1988), 291 (illus.); *Contemporary Great Masters: Andrew Wyeth* (Tokyo: Kodansha, Ltd., 1993), 31 (illus.); Kate F. Jennings, *American Watercolors* (New York: Crescent Books, 1995), 78 (illus.); *Andrew Wyeth Retrospective* (Nagoya: Aichi Arts Center, 1995), 99 (illus.), 241; *Andrew Wyeth: Autobiography* (Boston: Little Brown and Company in association with The Nelson-Atkins Museum of Art, Kansas City, 1995), 78, 78 (illus.); Cindy Anderson, "New England Scene," *Yankee* (July 1996): 48 (illus.); Martha Severens and Ken Wilber, *Andrew Wyeth: America's Painter* (New York: Hudson Hills Press, 1996), 33, 34, 45; Susan C. Larsen, *One Hundred Years of Maine at Work* (Rockland, Maine: Farnsworth Art Museum, 1997), back cover (illus.)

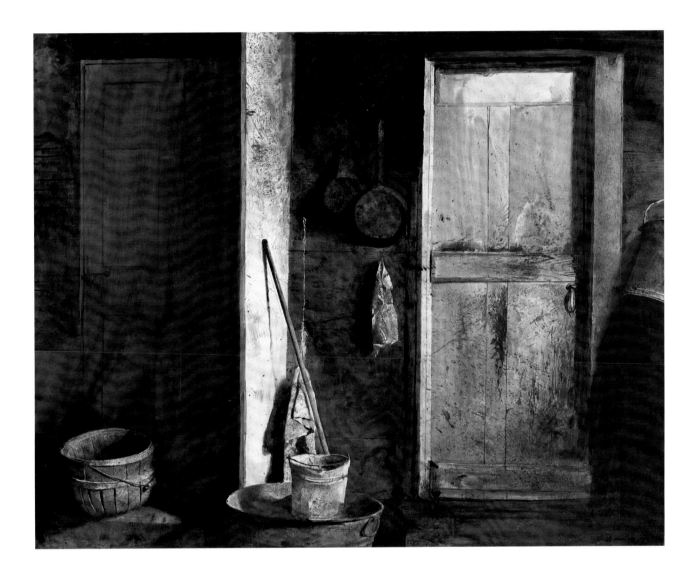

Tempera on Masonite, 24¼ x 48
Signed upper right, "Andrew Wyeth"
Museum purchase, 64.1313

PROVENANCE: Collection of the artist

EXHIBITIONS: 1964 World's Fair, New York, "Day of the State of Maine," 28 May 1964; Pennsylvania Academy of the Fine Arts, Philadelphia, 5 October–27 November 1966, Baltimore Museum of Art, 11 December 1966–22 January 1967, Whitney Museum of American Art at Champion, Stamford, Connecticut, 6 February–12 April 1967, and The Art Institute of Chicago, 21 April–4 June 1967, "Andrew Wyeth: Temperas, Watercolors, Dry Brush, and Drawings, 1938–1966," no. 196; Farnsworth Art Museum, "Maine Paintings by Andrew Wyeth," 9 July–1 September 1968; Museum of Fine Arts, Boston, "Andrew Wyeth," 17 July–6 September 1970; M. H. de Young Memorial Museum, The Fine Arts Museums of San Francisco, "The Art of Andrew Wyeth," 16 June–3

Andrew Wyeth has long favored spare interior settings of old houses in Maine and the Brandywine Valley of Pennsylvania for many of his most haunting works. In many of Wyeth's empty interiors there is a suggestion of flickering movement and foreboding, of an event that has just occurred or is about to happen. The choppy, wind-whipped sea on a rising tide is almost pulled into *Her Room*. A strange half-light plays across the room, coming from all directions at once. The perspective, despite its apparent precision, is slightly off. There is almost a dollhouse quality to the interior with its oversize furnishings and too-perfect arrangement.

Originally titled *Eclipse*, the painting was inspired by a solar eclipse and thoughts of Wyeth's young son Nicholas, who spent many hours alone on the upper reaches of the tidal St. George River. The painting is named for the artist's wife, Betsy, whose family's summer home and farm on Broad Cove in Cushing became the Wyeths' permanent Maine residence following their marriage. Speaking of the mood that the artist was seeking for this picture, Wyeth's biographer and close friend, Richard Meryman, observed, "Wyeth was alone in the house on the day of an eclipse of the sun. Suddenly the front door blew open. The air rushing into the stillness of the room swung the window curtains with it. There was an eerie eclipse light on the water, roughened by a momentary squall. He worried suddenly about his son Nicholas, who was off in a boat; seeing the wooden chest on the floor, he remembered a corpse in a coffin that had once been 'rousted upriver' in a dory."[1] He later changed the title to *Her Room* because, according to Wyeth, "It is a picture of the aloneness of a New England home. The new title is very personal and, I think, gives the thing more warmth." The strange mood of the picture arises from contrasting elements: a gridlike compositional scheme and even the mathematically precise arrangement of the seashells are seen against the natural randomness of storm-blown water and shifting, illogical lighting effects.[2] Wyeth has also hinted at private "secrets" in the painting, including the possibility of a tiny self-portrait in the brass doorknob (a reference to Jan Van Eyck's *Arnolfini Wedding*, perhaps) and the suggestion of a cat peering into the room from the far right window, camouflaged by foliage.

The faded pink window coverings possibly refer to Christina Olson's pink dress and the painting that established Wyeth's national reputation, *Christina's World*, 1948. Such personal and self-referential associations are commonplace throughout Wyeth's oeuvre spanning more than six decades.

Her Room is the result of at least sixteen preliminary studies, including drawings and relatively finished watercolors.[3] It was begun in the summer of 1963 and completed over a course of three and a half months. Like most of Wyeth's temperas, *Her Room*, with its meticulous, nearly hyper-real detail and finish, began with a quick pencil drawing of just a few lines to indicate the basic composition. Subsequent drawings and watercolors, sometimes with written notations as to color, light, and placement of forms, suggest a furious, experimental pace of execution. Most are loosely rendered—including fingerprints, scrapes, and smudges—with additions, subtractions, and numerous changes visible as evidence of a process that is intuitive and often far removed from the original idea. Many of the studies verge on near total abstraction, and Wyeth has admitted, "half the time I don't even know what I am doing," in a frenzy of creative energy linking him, in attitude if not final intention, with abstract expressionism of the preceding decade.[4]

Her Room can be considered among the Farnsworth's most important acquisitions from this period. It reinforced a long relationship with the artist that extends to the creation of the Center for the Wyeth Family in Maine, which opened at the Farnsworth in 1998, and to the present. Moreover, *Her Room* is among those paintings created when the artist was at midcareer and had perfected his mastery of the tempera medium, which reaffirmed his national prominence. With this painting Wyeth can be said to have extended a tradition of American realism stemming from Homer's sea paintings and their innate pessimism, to Hopper's evocation of American isolation and introspection, to contemporary art's renewed interest in a sense of place and edgy dreams on the brink of the millennium.[5]

C. B. C.

September 1973, no. 58; The National Museum of Modern Art, Tokyo, 6 April–19 May 1974, and The National Museum of Modern Art, Kyoto, 25 May–30 June 1974, "Works of Andrew Wyeth," no. 45; Royal Academy of Arts, London, "Andrew Wyeth," 7 June–31 August 1980, no. 25; Portland Museum of Art, Maine, "Maine Light: Temperas by Andrew Wyeth," 14 May–4 September 1983; The Heckscher Museum of Art, Huntington, New York, "The Wyeth Legacy: A Family of Artists," 14 January–19 February 1989; Farnsworth Art Museum, "A Century of the Wyeths," 29 May–17 October 1999

REFERENCES: Edgar J. Driscoll, Jr., "$65,000 for a Wyeth," *Boston Globe,* 12 October 1963, 4 (illus.); Brian O'Doherty, "A New Wyeth Painting Brings $65,000," *New York Times,* 12 October 1963; "The Wyeth Capital of the World," *The Sunday Bulletin Magazine,* Philadelphia, 24 November 1963, cover (illus.); "Painter: Andrew Wyeth," *Time* 82, no. 26 (27 December 1963): 45 (illus.); *Our American Nation,* reprint (Columbus, Ohio: Charles E. Merrill Books, Inc., 1968), 436 (illus.); Richard Meryman, *Andrew Wyeth* (Boston: Houghton Mifflin Co., 1968), 130, 131 (illus.); Wanda M. Corn, *The Art of Andrew Wyeth* (Greenwich, Conn.: New York Graphic Society, Ltd., 1973), 4 (illus.); Wanda M. Corn, "Andrew Wyeth: The Man, His Art, and His Audience," Ph.D. diss., New York University, 1974, 142, 70 (Vol. 2, illus., no. 158); *Works of Andrew Wyeth* (Tokyo: The National Museum of Modern Art, 1974), 45 (illus.); *Andrew Wyeth* (London: Royal Academy of Arts, 1980), 50 (illus.); George R. French, "Main Event at Farnsworth Is Intimate Wyeth Exhibit," *Worcester Telegram,* 27 August 1988, 26, 27 (illus.); Margaret Moorman, "Creativity among the Wyeths," *Newsday,* 20 January 1989, 21 (illus.); Richard Meryman, *First Impressions: Andrew Wyeth* (New York: Harry N. Abrams, Inc., 1991), 10–11 (illus.); *Contemporary Great Masters* (Tokyo: Kodansha, Lts., 1993), 25 (illus.)

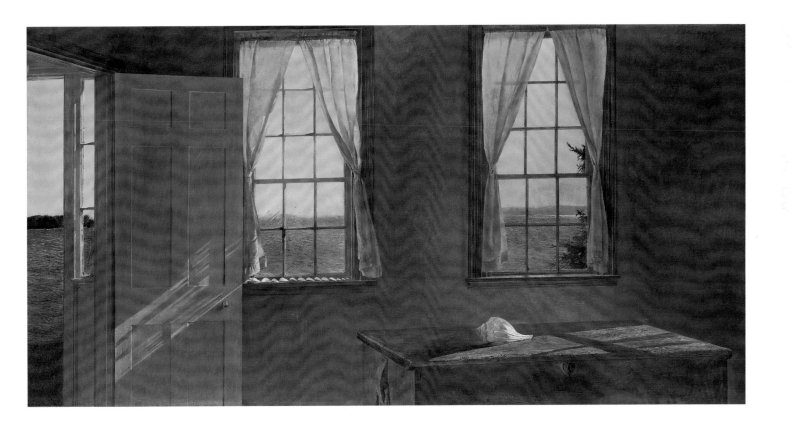

James Browning Wyeth (b. 1946)

Jamie Wyeth's early works, including *The Capstan* (1963), painted when the artist was only seventeen years old, and *Bronze Age (1967)*, reflect the technical skill that might be expected from a member of the Wyeth family. Already, however, the youngest Wyeth's technique and style demonstrate a personal approach that has become increasingly clear with his more recent paintings such as *Portrait of Orca Bates (1989)* and *Screen Door to the Sea* (1994). In the earlier paintings there is little narrative content, and the paintings reflect almost anatomical studies of the richly patinated surfaces on the capstan and bronze bell—nostalgic, perhaps, but undeniably real in the context of Monhegan Island, a place that was and still is redolent of nineteenth-century traditions and the sea. Yet beneath these surfaces and bravura handling is the suggestion of time, tradition, and transition, themes that the young artist would consistently return to and develop in a remarkable series of paintings describing aspects of youthful passage and cultural change and transformation.

James Browning Wyeth, or Jamie Wyeth, as he now signs most of his works, is the youngest son of Andrew and Betsy Wyeth. As was the case with his father, his formal schooling ended shortly after grade school when he announced his intention to pursue art. Wyeth's first teacher was his aunt, Carolyn Wyeth. Carolyn was a demanding teacher who insisted on a classical grounding in draftsmanship. Later, when Andrew carried on Carolyn's foundation work with Jamie, the father recognized in his son an artist whose training needed only to be supplemented with a sense of purpose and belief in his own vision. Although both Jamie and his father devote considerable attention to drawing and watercolor, Jamie paints exclusively in oil, just as his father has only worked in tempera (since the late 1930s). For the younger Wyeth, oil offers heavy, pliable physicality and a range of brilliant color possibilities that suit his own sensibility. It should be noted that Jamie uses an unusual technique of spot glazing to highlight key areas, which often gives the paintings a sense of shifting, complex light sources. In addition to his youthful apprenticeships under his aunt and father, Wyeth ventured to New York, where he studied anatomy in a hospital morgue. In most ways, his training was grounded in classical models dating to the Renaissance, very much in contrast to formal art school education of the late 1960s and early 1970s that emphasized experimental and avant-garde approaches, heavily influenced by then current critical theory.[1]

Portrait of Orca Bates and *Screen Door to the Sea* belong to the series that Wyeth began in 1989 depicting a youthful Monhegan islander on the verge of adulthood. In *Portrait of Orca Bates* we meet a teenager who is about to go "off-island" to finish his schooling.[2] He holds his pet, a black back seagull, and stands against a fluorescing sea played against an equally fluorescent Hard Rock Cafe tee shirt. Wyeth's subject, then, is the collision of natural and cultural phenomena. Monhegan's remoteness (twelve miles from the mainland) and isolation throw such dislocations into even sharper relief than can be found in more urban settings. It is an island rooted in old ways where the small fishing community is still governed by weather and tides, unpredictable and certain, all at once. Here Wyeth finds a world where MTV and seagulls coexist in a timeless, ineffable moment on a vast, wondrous sea of change.

If adolescence is an invention of the twentieth century, then Jamie Wyeth is among the first contemporary artists to recognize its emergence as a subject of increasing social importance. *Screen Door to the Sea* compares Orca Bates to a grandfather clock. The clock hands are set a few minutes before midday, and the intense light through the door suggests high summer. Orca wears a military-style tunic and stands just inside the doorway. Whether he is arriving or about to leave is an open question. The dual electric light switches are positioned up and down, affirming our present, conflicted century. Orca, caught between light and dark, inside and outside, change and stasis, strangeness and familiarity, tradition and invention, is also, perhaps, a portrait of the artist, Maine, and American art and culture at the end of the millennium.

C. B. C.

69 Bronze Age, 1967

Oil on canvas, 24¼ x 36¼

Signed lower right, "James Wyeth"

Museum purchase, (Katherine Haines Fund), 67.1576

PROVENANCE: Collection of the artist

EXHIBITIONS: Farnsworth Art Museum, "Oils, Watercolors, Drawings by James Wyeth," 11 July–8 September 1969, no. 16; Brandywine River Museum, Chadds Ford, Pennsylvania, "The Brandywine Heritage," 1971, no. 137; Joslyn Art Museum, Omaha, Nebraska, "James Wyeth," 16 November 1975–18 January 1976, no. 45; Hollywood Art Museum, Hollywood, Florida, 23 February–15 March 1976; Brandywine River Museum, Chadds Ford, Pennsylvania, "Sights of the Sea," 9 September–19 November 1978; Pennsylvania Academy of the Fine Arts, Philadelphia, 18 September–14 December 1980, Greenville County Museum of Art, Greenville, South Carolina, 17 January–29 March 1981, and The Amon Carter Museum of Western Art, Forth Worth, Texas, 23 April–7 June 1981, "Jamie Wyeth," no. 117; Whitney Museum of American Art at Champion, Stamford, Connecticut, "Four American Families: A Tradition of Artistic Pursuit," 11 November 1983–11 January 1984; Heckscher Museum of Art, Huntington, New York, "The Wyeth Legacy: A Family of Artists," 15 January–19 February 1989; Farnsworth Art Museum, "Monhegan: The Artists' Island," 23 April–25 June 1995, no. 29

REFERENCES: William Pahlman, "In an Era of Pop and Op, Why Is Andrew Wyeth a Hit?" *Highlights of Maine Digest* (Summer 1968): 75; Richard McLanathan, *The Brandywine Heritage* (Chadds Ford, Pa.: The Brandywine River Museum, 1971), 102 (illus.); "James Wyeth" (Omaha: Joslyn Art Museum, 1975), n.p. (illus., no. 45); Frank Goodyear, Jr., *Jamie Wyeth* (Philadelphia: Pennsylvania Academy of the Fine Arts, 1980), 117; *Four American Families: A Tradition of Artistic Pursuit* (New York: Whitney Museum of American Art, 1983), n.p.; Carl Little, *Paintings of Maine* (New York: Clarkson Potter/Publishers, 1991), 102 (illus.); Edgar Allen Beem, "The Art of Island Maine," *Island Journal* 10 (1993): 73 (illus.)

69a The Capstan, 1963

Watercolor on paper, 21½ x 17½

Gift of Dorothy Addams Brown,
Boston, Massachusetts, 63.1302

70 **Portrait of Orca Bates**, 1989

Oil on panel, 50 x 40

Signed lower right: "Orca Bates / Jamie Wyeth"

Gift of Mrs. John S. Ames, by exchange, 94.10

PROVENANCE: Collection of the artist; Gerald Peters Gallery, Sante Fe, 1994

EXHIBITIONS: The Hubbard Museum, Ruidoso Downs, New Mexico, 2 June–3 September 1990; Central House of Artists, Moscow, 1 October–4 November 1990, and Amerika Haus, Berlin, 14 November–15 December 1990; Farnsworth Art Museum, "Jamie Wyeth: Islands," 27 June–22 August 1993, no. 31; Farnsworth Art Museum, "Monhegan: The Artists' Island," 23 April–25 June 1995, no. 30; Arnot Art Museum, Elmira, New York, "Re-presenting Representation III," 10 October 1997–11 January 1998

REFERENCES: Richard McLanathan, *Jamie Wyeth of Monhegan* (Rockland, Maine: Island Institute, 1991), 8; Edgar Allen Beem, "The Art of Island Maine," *Island Journal* 10 (1993): 74; Cindy Anderson, "Portrait of Orca Bates," *Yankee Magazine* (September 1996): 56 (illus.), 124

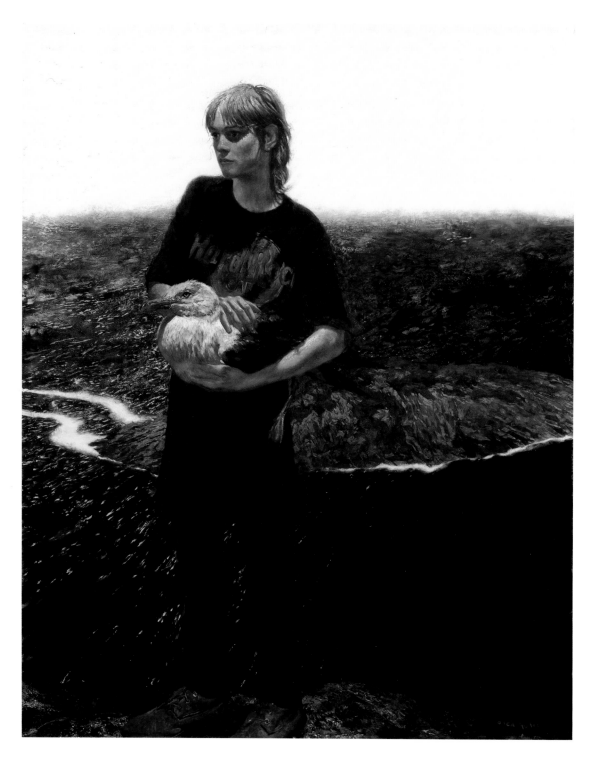

Oil on panel, 36 x 30

Signed lower right, "J. Wyeth"

Anonymous gift, 96.10

PROVENANCE: Private collection

EXHIBITIONS: Arnot Art Museum, Elmira, New York, "Re-presenting Representation III," 10 October 1997–11 January 1998; Farnsworth Art Museum, 21 June–8 November 1998, and Delaware Art Museum, Wilmington, 10 December 1998–21 February 1999, "Wondrous Strange: The Wyeth Tradition"

REFERENCES: Cindy Anderson, "A Portrait of Orca Bates" *Yankee Magazine* (September 1996): 56 (illus.); *Re-presenting Representation III* (Elmira, N.Y.: Arnot Art Museum, 1997), 48; David Michaelis, Susan C. Larsen, Stephen T. Bruni, Betsy James Wyeth, Theodore F. Wolff, and Christopher Crosman, *Wondrous Strange: The Wyeth Tradition* (Boston: Little, Brown and Co., 1998), 134 (illus.), 167

Walt Kuhn (1877–1949)

72 A Stream in the Woods, 1935

Oil on canvas, 30 x 25

Signed and dated lower left,
"Walt Kuhn / 1935"

Museum purchase, 88.2

PROVENANCE: Estate of the artist,
Salander-O'Reilly Galleries, Inc., New
York, 1988

EXHIBITIONS: Ogunquit Museum of
American Art, Ogunquit, Maine, "Walt
Kuhn: American Master," 1 July–15
September 1992; The Fitchburg Art
Museum, Fitchburg, Massachusetts,
"The Maine Connection: Paintings and
Sculpture from the Farnsworth Art
Museum," 21 November 1993–27
March 1994

REFERENCES: Lawrence B. Salander, *Walt
Kuhn (1877–1949): The Landscapes*
(New York: Salander-O'Reilly Galleries,
Inc., 1987), n.p. (illus., no. 8)

One of the defining times in Walt Kuhn's career as an artist must have come in the relatively brief period from 30 September to 19 November 1912, when, as the secretary of the newly formed Association of American Painters and Sculptors, he traveled to Europe to meet with artists and dealers in the Netherlands, Germany, and France to select works for *the International Exhibition of Modern Art,* better known today as the Armory Show. The effect of this experience on Kuhn's art was profound. The influence of the European artists Paul Cézanne, Vincent van Gogh, Paul Gauguin, Pablo Picasso, Georges Braque, and Henri Matisse can be clearly discerned in his still life, figure, and landscape work from this time onward.[1] Kuhn said of the exhibition, which opened 17 February 1913, "Two things produced the Armory Show: A burning desire by everyone to be informed of the slightly known activities abroad and the need of breaking down the stifling and smug condition of local art affairs as applied to the ambition of American painters and sculptors."[2] Though he is best remembered for his figure, still life, and portrait work, Kuhn also painted landscapes throughout his career. Few early examples survive, but one work, *Nocturnal Landscape,* 1905 (Currier Gallery of Art, New Hampshire), with its dark tones and muddy color, reveals the effect of his years of training at the Royal Academy in Munich.[3]

Born of German immigrant parents in Brooklyn, New York, Kuhn's formal art training did not start until 1901 when he traveled to Paris, where he studied at the Académie Colarossi for several months. He then traveled to Munich, where he enrolled at the Royal Academy. Kuhn remained in Europe until 1903, when he returned to New York and over the next decade put his drawing skills to use producing pen-and-ink illustrations for such publications as *Life, Puck, Judge, New York World,* and the *New York Sunday Sun.*[4] His association with Maine began as early as 1911, when he visited Ogunquit for the first time with his brother-in-law.[5] He was to visit Ogunquit and other places in Maine during the summers from this time onward. Beginning in 1915 the artist, his wife, Vera, and daughter, Brenda, spent several summers on Grand Manan, a Canadian island off Eastport.[6] In 1920, following a successful one-man show at Marius de Zayas's Gallery in New York, Kuhn bought a cottage in Ogunquit, where the artist and his family were to summer until the year before his death in 1949.[7]

In Maine Kuhn began to produce a group of landscapes of which *A Stream in the Woods* is one of his most powerful. It is strongly influenced by his experience of Cézanne, and by the cubists Picasso and Braque. This painting is one of the most simplified, abstract, and striking of all Kuhn's Maine works. A waterfall tumbles from upper left to lower right over a rocky ledge. A thin strip of forest and a glimpse of cobalt blue sky define the distance. The rest of the painting is all foreground—a fall of bright white water tumbles in stark contrast over dark violet, blue, and brown rocks. No middle ground provides a transition to the background. One is immediately in the scene. Another painting by Kuhn, *Old Wharf, Cape Neddick River,* 1944, is based on a far more conventional composition, with a more comfortable movement from foreground to background. Similarly, the foreground elements in *Old Wharf, Cape Neddick River,* appear to be almost sculpted in a thick impasto of paint in which the marks of the brush can be clearly discerned.

There is, at this time, a strong stylistic similarity between many of Kuhn's landscapes and those by his friend and contemporary Marsden Hartley, whose painting, *Kinsman Falls, Profile Road, New Hampshire,* 1930 (private collection), is notably close in both subject and style to *A Stream in the Woods.*[8] This work and many others among Kuhn's landscapes display a stylistic freedom and willingness to experiment that is less evident in his more studied figure paintings and portraits. In this group of landscapes the viewer is very much aware of the process that made the painting. The thick impasto of paint and the evident brushstrokes suggest the energy with which the painting was executed. This, together with the emphasis on bold, simplified form and composition, gives the works the same strong feeling of dynamism and immediacy that seem to have characterized the man. His friend the sculptor Robert Laurent, interviewed in 1987, said, "Kuhn was very frank. If he didn't like someone he'd tell them right away. He would never compromise, and he had a one track mind—art."[9]

H. A. F.

72a Old Wharf, Cape Neddick River, 1944

Oil on canvas, 24 x 20

Gift of Brenda Kuhn, 84.1

Raphael Soyer (1899–1987)

Soyer is best remembered as a painter of people, one of the group of social realists who were active in New York during the 1920s, 1930s, and 1940s, whose number included Edward Hopper, Reginald Marsh, Philip Evergood, Milton Avery, Jack Levine, and others.[1] However, from 1957 until his death in 1987, Soyer (when he was not traveling in Europe) usually spent at least a part of his summer on Vinalhaven.[2] Here he produced a series of landscapes that were very different in subject and style from the work that he made in New York. While his urban scenes and figure and portrait work were often suffused with a warm, golden tonality—a Rembrandtesque glow—his landscapes from Vinalhaven took on a cool blue-gray hue.[3] And his drawing, often quite loose and expressive in his New York paintings, was generally tighter and more carefully considered in his Vinalhaven landscapes. He was aware of the difference. He said, "the entire landscape gradually turns gray even if it started on a sunny day since gray days predominate on the Island."[4]

The *Boatyard, Vinalhaven*, painted during one of his summer sojourns on the island, has this characteristic cool gray cast. The overall subdued quality of the color is relieved only by the vivid green of a stand of tall grass growing in the hull of an old boat in the foreground. The bulky shape of a half-built (or half-destroyed) lobster boat occupies the entire middle ground. The lower two-thirds of the painting is composed of carefully drawn and juxtaposed forms. A narrow strip of water, wharf, and sky defines the horizon line. Similarly, in *At the Shore, Maine*, the fore- and middle grounds are composed of an architecture of carefully rendered forms—lobster pots, boats, wharves, and buildings—obstacles to be scaled to gain entry to the scene. Soyer himself likened these paintings to still lifes. He said, "I start out with the idea of making a landscape, but invariably it becomes still-life-like."[5]

It is evident that the Vinalhaven landscapes were quite different from the work produced in New York. What sets them apart primarily is the handling of light, and it was light that seemed to trouble him most about these paintings: "The aspect of these canvases, then, is such that they could well have been painted in a studio, under a skylight. Intrinsically I am not really interested in light effects, but in foreground perspectives, in the shape and texture of rocks, in the architecture of piled up traps, in the depth of bushes, and in the contour of leaves when they enter into the landscape."[6] This statement suggests that Soyer was more comfortable painting in his studio in New York than in the out-of-doors in Maine and that for each visit to Vinalhaven he had to make a somewhat difficult adjustment to deal with the very different light of the outdoors.

In *The Boatyard, Vinalhaven*, the combination of narrow tonal range, subdued color, and absence of dark shadows flattens the light and conveys the feeling of a chill, damp Maine island day. Certainly form and perspective anchor the painting, but no less important in creating the atmosphere is Soyer's skillful handling of the subtleties of light and shade. In *At the Shore, Maine*, higher-keyed tones and brighter color, particularly in the sky, suggest a different, more blustery type of Maine weather. The atmosphere, again, is dependent on Soyer's innate ability to observe and reproduce the subtle tonal variations of a gray Maine day.

Over the span of his long career, Soyer's work remained rooted in realism even though he lived at a time when preconceptions about art were being tested and overturned.[9] He recounted the story of being accosted on a train to Long Island by Jackson Pollock who rudely demanded to know why he still painted the way he did. "There are planes flying and you still paint realistically. You don't belong to our time," said Pollock. In his characteristically shy and understated fashion Soyer simply replied quietly that he painted the way he liked to.[10]

H. A. F.

73 The Boatyard, Vinalhaven, c. 1950

Oil on canvas, 20⅛ x 16³⁄₁₆
Signed lower left, "Raphael Soyer"
Gift of Mrs. Elizabeth B. Noyce, 96.13.7

PROVENANCE: Collection of the artist; Rebecca Soyer Beagle (sister of the artist), 1987–93; Mrs. Elizabeth B. Noyce, 1993-96

EXHIBITIONS: Farnsworth Art Museum, 17 July–18 September 1994, and Portland Museum of Art, Maine, 29 October 1994–22 January 1995, "An Eye for Maine"; Farnsworth Art Museum, "One Hundred Years of Maine at Work," 13 July–5 October 1997; Portland Museum of Art, Maine, "A Legacy for Maine: Masterworks from the Collection of Elizabeth B. Noyce," 1 October 1997–4 January 1998

REFERENCES: Donelson Hoopes, *An Eye for Maine* (Rockland, Maine: Farnsworth Art Museum, 1994), 9, 17; Jessica F. Nicoll, *A Legacy for Maine: The November Collection of Elizabeth B. Noyce* (Portland, Maine: Portland Museum of Art, 1997), 76; Carl Little, *Art of the Maine Islands* (Camden, Maine: Down East Books, 1997), 60

73a At the Shore, Maine, 1965
Oil on canvas, 20⅛ x 24¼
Gift of Mary Soyer, 88.14

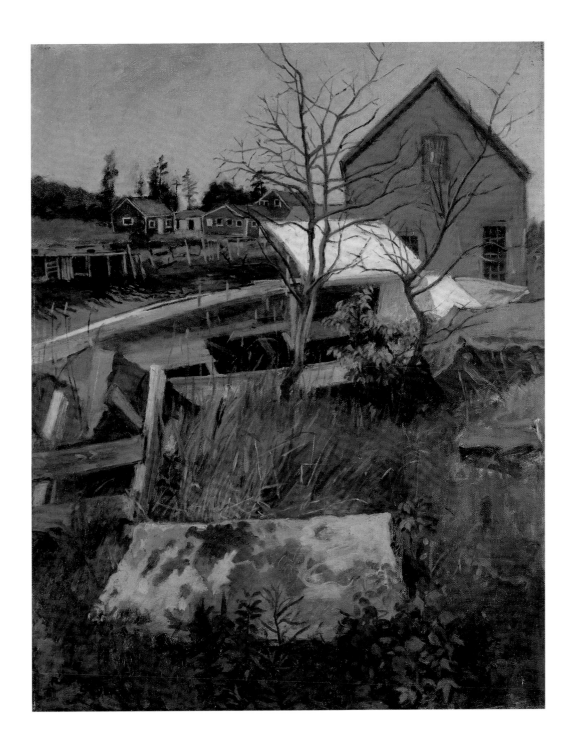

Carl Sprinchorn (1887–1971)

74 Loggers' Cabin by the Stream,
c. 1948

Oil on canvas, 28 x 34
Museum purchase, 94.5

PROVENANCE: Estate of the artist, 1971–94

EXHIBITIONS: Tom Veilleux Gallery, Farmington, Maine, "An Exhibition and Sale of Over Fifty Paintings from the Estate of Carl Sprinchorn (1887–1971)," 16 July–16 August 1994, no. 12

REFERENCES: *An Exhibition and Sale of over Fifty Paintings from the Estate of Carl Sprinchorn (1887–1971)* (Farmington, Maine: Tom Veilleux Gallery, 1994), n.p.; Daniel Doan, *Indian Stream Republic* (Hanover, N.H.: University Press of New England, 1997), cover

When Carl Sprinchorn[1] painted *Loggers' Cabin by the Stream*, he had been living in the Maine woods, except for occasional trips to such cities as New York and Philadelphia, for eleven years.[2] That fact may not seem extraordinary, given the popularity of Maine as a painting locale for such noted contemporaries as John Marin, Marsden Hartley, Marguerite and William Zorach, George Bellows, and a host of others before and after, most of whom stuck to the more picturesque seacoast. But no artist had done what Sprinchorn did: live exclusively *in* the Maine backwoods and *among* Maine backwoodsmen for such an extended period of time.

Sprinchorn's experience in the Maine woods was unique and daring. It began in 1911 when he first ventured into the region, searching for relatives said to be living in the Swedish colony at Monson. He returned to that area off and on from 1919 to 1921, spending time in the lumber camps with the woods crews. In a technique learned from his teacher, Robert Henri, Sprinchorn executed numerous quick-sketch drawings of loggers and rivermen at work, capturing their rapid, muscular gestures with vivid accuracy.

After living and working in a variety of places, the call of the Maine north woods came again in 1937. Wanting to get as close as possible to Mount Katahdin, Sprinchorn took the train north, finally landing in Patten, where he found his way to the doorstep of Caleb Scribner, a game warden with, fortuitously, a love of art and some talent for watercolor.[3] Later, Sprinchorn moved to Shin Pond, living for the most part at the Lumberman's Hotel and Boardinghouse, on a rise between Lower and Upper Shin Pond at the foot of Mount Chase.

One gets a sense of the ruggedness of Sprinchorn's experience during these years by understanding that historically, and even now (it has changed little over the years), Shin Pond is the last outpost before one enters the Katahdin forest wilderness; what was known as the Matagamon Road began there and ended in the woods not too many miles west. For loggers and hunters going into or coming out of the lumber camps, it was an important way-stop for provisions, gas, telephone, and conversation. For Sprinchorn it was a perfect location for his intended occupation: to render the landscape of the northern Maine woods and the lives and work of its lumbermen, hunters, and hermits. From his cabin at Shin Pond he could set up an easel to paint Mount Chase, walk down a path to the outlet between Upper and Lower Shin Pond, or hike over the hill to Crommet's Farm or Whetstone.

Loggers' Cabin by the Stream represents this very juncture of landscape and lumbering. It is one of three versions of roughly the same scene, depicting a rushing stream with the spring pulp drive in the foreground; bare trees as focal points; low-lying lumber camp buildings in the middle ground; and a conical mountain dominating all. The other two versions have been reproduced or exhibited under various titles: *April Showers*[4] for one version; for the other, either *April Showers (Lumber Camp, Black Brook)*[5] or *Lumber Camps and Pulp Wood, Trout Brook.*[6] In both variants the focus is more on the foreground pulpwood and camp buildings, the scene is more compacted, and the mountain is less emphasized as a compositional element than in the Farnsworth painting.

While the specific site is identified in the titles as either Black Brook or Trout Brook, both are in the Matagamon headwaters of the east branch of the Penobscot River where many lumbering camps in the twentieth century were located.[7] The Folger Library Special Collections at the University of Maine has a small sketchbook by Sprinchorn with a dedicatory inscription to Richard Sprague, Sprinchorn's longtime friend and supporter, which confirms the place and date of this series. The inscription reads, "sketches for several versions of *April Showers* April 8/48 South Branch of Trout Stream Camp McCarthy? Camp back of McCarthy Dam." Sprinchorn's question mark indicates his uncertainty about the spelling of the camp, which is, in fact, McCarty, just south of Burnt Mountain.

The eight pencil sketches are rough, but with the artist's notations, they offer important clues about Sprinchorn's working process. On the first sketch he tells himself for later reference: "2 things—must be absolutely dramatic—must be 'fresh' from under & in the gleam [of] April Shower" with "fogs & clouds," and there must be "a very long expanse" with "full play of detail." Further-more, his notes tell him that "to get rainy effect have tops of wood refl[ect] sky."

He wanted to depict ragged edges of the roof of the tar paper camp buildings with blue smoke from the chimneys and piles of reddish old pulpwood and new yellow logs. The sketches were executed close to the scene, while the painting was done later done in his "studio" (probably a corner of his rented room) at Shin Pond.

The Farnsworth painting is probably a third stage in the artist's rendering of this theme. The sketches and at least one of the paintings, which is more like an oil sketch, appear likely to have been executed in situ, while the Farnsworth version, with its more studied composition, achieves what Sprinchorn assigned himself to do: give the dramatic effect by depicting a broad expansive sweep of the scene. To do this the artist added a Cézannesque repoussir of two trees hugging the left frontal picture plane and leading the eye from left to right, across the river swollen with winter runoff and loaded with new pulpwood, into the middle ground with the two skeletal trees, and on into the background of camp buildings with the mountain as backdrop to it all.

In his autobiographical notes, Sprinchorn records that, rather than slavishly copying nature, he preferred to "select and interpret nature, after living close to the sources of nature."[8] Commenting on another painting, he admitted to creating an "invented vantage point" moving "one lake and one mountain into a proper focus."[9] Like Cézanne, Hartley, and other artists who immersed themselves in a particular natural locale, Sprinchorn so thoroughly understood his subject that he could construct a composition partially through invention while simultaneously remaining true to the spirit of the place. Such is the genius manifest in *Loggers' Cabin by the Stream*.

G. S.

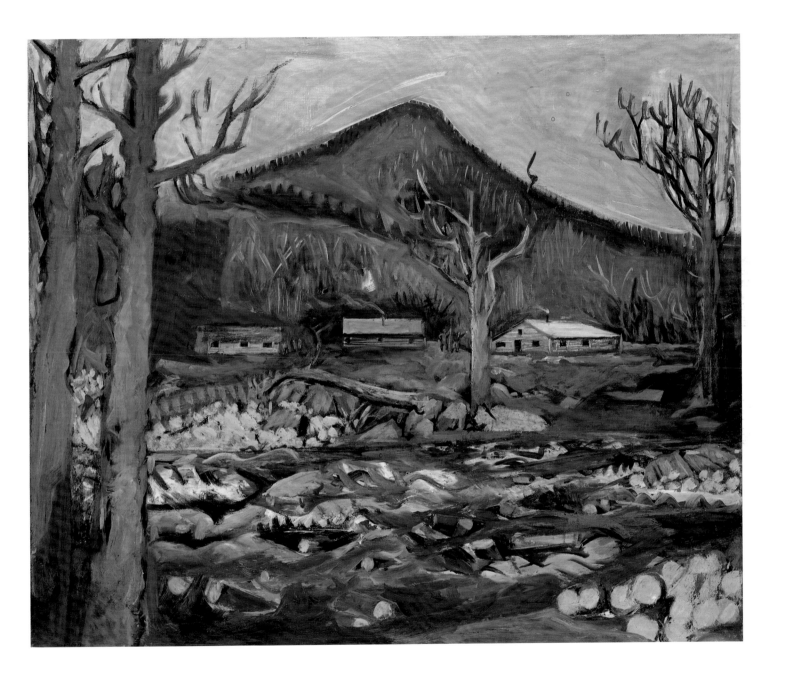

Louise Nevelson (1899–1988)

75 Maine Meadows, Old County
Road, c. 1931

Oil on board, 29½ x 35½

Signed lower left, "Nevelson"

Bequest of Nathan Berliawsky,
80.35.20

PROVENANCE: Collection of the artist;
Nathan Berliawsky (artist's brother)

EXHIBITIONS: Ogunquit Museum of
American Art, Ogunquit, Maine, "Maine-
scapes: Women Artists, 1900–1995,"
5–30 September 1995; Farnsworth Art
Museum, "Louise Nevelson: The
Farnsworth Collection," 18 June–30
October 1994, no. 4

REFERENCES: Carl Little, *Paintings of Maine*
(New York: Clarkson Potter/Publishers,
1991), 79 (illus.), 129; Suzette Lane
McAvoy, *Louise Nevelson: The
Farnsworth Collection* (Rockland,
Maine: Farnsworth Art Museum, 1994),
cover; Suzette Lane McAvoy, "Louise
Nevelson: The Farnsworth Collection,"
American Art Review 6, no. 5 (1994):
170 (illus.); Carl Little, "Louise Nevelson
at the Farnsworth Museum," *Art in
America* (December 1994): 110

Decades before she was to become known as "the doyenne of American sculpture,"[1] Louise Nevelson believed in her talent as an artist. With great self-determination she pursued her belief and rose to the top ranks of American art. In 1954 Harold Weston, president of the Federation of Modern Painters and Sculptors, wrote Wendall Hadlock, then director of the Farnsworth Museum: "She may be the one living artist with a national reputation who, although born elsewhere, considers Rockland as her place of origin."[2] Born in tsarist Russia in the autumn of 1899, Nevelson immigrated to Rockland with her family in 1905.[3] At an early age, she received recognition from her school-teachers as "the artist." She later stated, "From the first day in school until the day I graduated, everyone gave me 100 plus in art. Well, where do you go in life? You go to the place where you get 100 plus."[4]

In *Maine Meadows, Old County Road*, an early painting probably dating from 1931, Nevelson depicts the landscape outside her adopted hometown. Undulating green hills sur-round a group of white frame houses, red barns, and patches of tilled earth, all rapidly painted in thin brushstrokes that reveal the golden brown of the composition board used as support. The road of the title, Old County Road, curves up from the foreground, encir-cling the scene in a strong embrace. Despite her later statements to the contrary,[5] at this moment in her life, Nevelson's affection for the town in which she grew up is manifest. Very likely painted on the eve of her departure to Munich to study with the influential teacher Hans Hofmann, *Maine Meadows, Old County Road* gives testament to her happiness at the prospect. As if to suggest her newfound confi-dence as an artist, she has filled the narrow band of pale blue sky with colorful stars.[6] In

1977 Nevelson said, "[the star] could be a crown, five points, I've always felt like a star."[7]

Filled with exuberance and youthful energy, *Maine Meadows, Old County Road* is one of Nevelson's most successful paintings from the early years of her career. Although undated, it relates closely to another, less finished work in the Farnsworth collection, *View of Rockland Meadows*, which bears the date 1931. Prior to her departure for Germany in the fall of that year, Nevelson accompanied her young son Mike back to Rockland, where her family had agreed to look after him in her absence.[8] It may be that Nevelson painted *Maine Meadows, Old County Road* and *View of Rockland Meadows* during this short visit. By that time, she had had three years of serious art instruction under Kenneth Hayes Miller and Kimon Nicolaides at the Art Students League in New York and was resolved to pursue a career in art. "I knew I had it," she said, "and I felt that through this spe-cial perception I could live a meaningful life."[9] Her subsequent studies with Hofmann in Munich, and afterward in New York, marked a turning point in her life and art. She later cred-ited him with introducing her to cubism and the "push and pull" of negative and positive space, concepts that were critical to the development of her mature work.

In 1933 Nevelson began studying with Chaim Gross, a young artist who was gaining recogni-tion as one of the new generation of sculptors interested in a return to direct carving. From this point forward, sculpture began to dominate Nevelson's artistic interests, and although she continued to paint into the early 1950s, it was never with the same lighthearted spirit evident in *Maine Meadows, Old County Road*.

S. L. M.

The 1940s were difficult years for Louise Nevelson. She suffered the deaths of both her parents during this decade as well as that of her strongest supporter, the art dealer Karl Nierendorf.[1] And despite receiving mostly positive response to her early exhibitions at the prestigious Nierendorf Gallery, she was still struggling to establish herself as a serious artist.[2]

Throughout this time she continued to create both two- and three-dimensional work, the most interesting of which foreshadow her mature style, such as the painting *Woman, Child and Cats*, 1946. As with the majority of her paintings from this period, the surface of *Woman, Child and Cats* is heavily impasted, with thick layers of paint worked sculpturally with the palette knife.[3] Making little distinction between sculpture and painting, Nevelson declared, "I don't see much difference between one medium or another."[4] And in a revealing statement from 1953, written in her personal abbreviated style, she notes: "Artists speak of t 2 dimensional flat surface: there is no flat surface, t very depths between strokes seems like infinite space."[5]

The female figure in this work bears a strong resemblance to the artist, and many of her paintings from this period feature herself, family, or friends as subjects. Most interestingly, the background behind the figures in this work is composed of a grid of interlocking rectangles, one of which contains an orderly grouping of six round forms. A similar background treatment appears in another painting in the Farnsworth collection, *Figure in a Blue Shirt*, 1952, foretelling the wall constructions that she began to make in the next decade.

The primitive rendering of the figures and the totem of cats' heads in *Woman, Child and Cats* reflect Nevelson's long-held interest in tribal arts. As early as the 1930s, totemic figures and references to tribal sculpture begin appearing in her work,[6] and it has been suggested that this interest may lead as far back as her childhood in Rockland, where American Indian artifacts were sold in antique shops catering to summer tourists.[7] Most surely, her exposure to museum collections in New York and Paris, her acquaintance with Wolfgang Paalen and his writings on primitive art in the Surrealist magazine *Dyn*, and her apprenticeship with the Mexican muralist Diego Rivera all helped to strengthen her early attraction to African, pre-Columbian, and Indian art.

Such was her interest that in the spring of 1950 and the winter of 1951 she and her sister Anita traveled to Mexico and Guatemala to visit the Mayan ruins firsthand. The experience had a profound effect on her: "This was a world of forms," she said, "that at once I felt I could identify with, . . . a world of geometry and magic."[8] On her return, she produced a number of sculptures and two-dimensional works that recall the forms and atmosphere of the ancient sites.[9] Assimilating both primitive art and cubism, *Bronze Bird*, from 1952, with its sinuous, simplified form, is one of her most fully realized sculptures from this period.[10] Nevelson herself must have shared this opinion, for it is one of the few works to be cast in bronze; most others remain in terra cotta or tattistone, a self-hardening material she used frequently at the time.[11]

As difficult as the 1940s were for Nevelson, the 1950s proved rewarding. After years of struggle, she found her mature voice as an artist and in a series of highly acclaimed exhibitions rapidly ascended to the heights of American art. While intimating aspects of the work to come, pieces such as *Woman, Child and Cats* and *Bronze Bird* are reminders of a formative period that by the late 1950s she surpasses.

S. L. M.

76 Woman, Child and Cats, 1946

Oil on canvas, 33⅛ x 39⅜

Signed and dated upper left, "Nevelson 1946"

Gift of Nathan Berliawsky, 77.36

PROVENANCE: Collection of the artist; Nathan Berliawsky (artist's brother)

EXHIBITIONS: Farnsworth Art Museum, 13 July–30 September 1979, Norton Gallery and School of Art, West Palm Beach, Florida, 8 November 1979–6 January 1980, Jacksonville Art Museum, Florida, 17 January–15 March 1980, and Scottsdale Center for the Arts, Arizona, 28 March–30 April 1980, "The Art of Louise Nevelson"; Farnsworth Art Museum, "Louise Nevelson: The Farnsworth Collection," 18 June–30 October 1994, no. 7

REFERENCES: Jan Ernst Adlmann, *The Art of Louise Nevelson* (Rockland, Maine: Farnsworth Art Museum, 1979), 19, 66 (illus.); Suzette Lane McAvoy, "Louise Nevelson: The Farnsworth Collection," *American Art Review* 6, no. 5 (1994): 146, 147 (illus.)

76a Bronze Bird, 1952

Bronze, 6¼ x 9¼ x 7½

Gift of the Federation of Modern Painters and Sculptors, Inc., with funds provided by Anita Berliawsky, 55.911

For her 1958 exhibition *Moon Garden + One* at Graham Central Moderns gallery, Louise Nevelson created a totally black environment that included her first great wall construction, *Sky Cathedral*, a monumental piece composed of nearly sixty stacked boxes. The show garnered unstinted critical acclaim; the art critic Hilton Kramer described the works as "appalling and marvelous, utterly shocking in the way they violate our received ideas on the limits of sculpture . . . yet profoundly exhilarating in the way they open an entire realm of possibility."[1]

The show also "made a sensational impression" on Dorothy Miller, curator of painting and sculpture at the Museum of Modern Art, and the following year she asked Nevelson to participate in an exhibition she was organizing called *Sixteen Americans*.[2] This would be Nevelson's first major museum show and she was anxious to respond with innovative work. Miller recounts: "She confided that she would surprise her public with something new at the Museum. For several months she worked in a secret location outside her studio. She created another sensation when, on opening day, we unveiled *Dawn's Wedding Feast*, a great gallery full of her first white sculpture."[3] Nevelson's use of virginal white, after years of using black, stunned her audience. She later explained that the show represented a new beginning for her, "a kind of wish fulfillment, a transition to marriage with the world."[4]

The slender, vertical construction, *Dawn Column I*, represents one of the "witnesses" to the symbolic wedding ceremony that was the theme of the installation.[5] It stood on the farthest end of a long, narrow platform, the first in a grouping of ten similar columns, flanking the nuptial altar. Although it was Nevelson's wish to keep the installation intact, this proved impossible, and over the years, individual pieces were sold to museums and private collectors.[6] In 1980 the Whitney Museum reunited a major portion of the installation, including the Farnsworth's *Dawn Column I*, for its exhibition

Atmospheres and Environments. In the course of installing the show, it was discovered that the Farnsworth column had been altered from its original configuration; accordingly, it was reassembled correctly at that time.[7]

Over the next decade, Nevelson continued to be an innovator; she experimented with new materials such as aluminum, translucent plastic, and Cor-ten steel, and added gold to her palette of black and white.[8] The structure of her classic black walls also changed. *The Endless Column*, 1969 and 1985, shows the transition in her work. Rather than an assemblage of irregularly shaped pieces of found wood, the boxes of *The Endless Column* are composed in a rhythmic pattern of machine-made shapes. In his catalogue essay for the 1985 exhibition of Nevelson's work at the Farnsworth Museum, Willy Eisenhart described the piece as "stately and dignified, musical in its harmonies of lines and shadows, defined by a fugue of repeating forms."[9] Nevelson added the top two rows of boxes and the flanking sentinel-like constructions at the time of the 1985 exhibition to "better hold the space of the alcove" in which it was displayed.[10]

Also included in this exhibition were *Gold Throne I* and *Gold Throne II* (no. 168), created by the artist in 1984 for the St. Louis Opera Theatre's production of Gluck's *Orfeo and Euridice*. For Nevelson, this first opportunity to design for the stage was the consummation of a lifelong interest in theater. In the late 1920s she had studied at the innovative American Laboratory Theatre in New York, established by the actress Princess Norina Matchabelli and the set designer Frederick Kiesler.[11] Although she dropped her theatrical studies in 1929 in favor of the visual arts, her love for the stage continued to find expression in her dramatic public persona and in the theatrical presentation of her work.

S. L. M.

77 The Endless Column, 1969 and 1985

Wood, center panel, 130¼ x 59 x 11; right panel, 115 x 22 x 6; left panel, 110 x 22 x 10

Bequest of Nathan Berliawsky, 80.35.30; Gift of the artist, 1985

PROVENANCE: Center pieces, Collection of the artist; Nathan Berliawsky (artist's brother), 1970–80; Right and left additions, Collection of the artist, 1985

EXHIBITIONS: Farnsworth Art Museum, 13 July–30 September 1979, Norton Gallery and School of Art, West Palm Beach, Florida, 8 November 1979–6 January 1980, Jacksonville Art Museum, Florida, 17 January 1980–15 March 1980, and Scottsdale Center for the Arts, Arizona, 28 March–30 April 1980, "The Art of Louise Nevelson"; Farnsworth Art Museum, "The Art of Louise Nevelson at the Farnsworth," 22 September–17 November 1985; Farnsworth Art Museum, "Louise Nevelson: The Farnsworth Collection," 18 June–30 October 1994, no. 29

REFERENCES: Jan Ernst Adlmann, *The Art of Louise Nevelson* (Rockland, Maine: Farnsworth Art Museum, 1979), 16 (illus.), 57; Willy Eisenhart, *The Art of Louise Nevelson at the Farnsworth* (Rockland, Maine: Farnsworth Art Museum, 1985), n.p.

77a Dawn Column I, 1959

92 x 10½ x 10

Museum purchase, 79.81

Milton Avery (1885–1965)

78 The Typist, 1952

Oil with charcoal under drawing on canvas, 42 x 31½

Signed and dated lower left, "Milton Avery 1952"

Gift of Mrs. Mary Louise Meyer in memory of Norman Meyer, 97.6

PROVENANCE: Estate of the artist, 1965; Alpha Gallery, Boston; Mr. and Mrs. Norman Meyer, 1966–97

EXHIBITIONS: Baltimore Museum of Art, 9 December 1952–18 January 1953, The Phillips Collection, Washington, D.C., 1 February–22 February 1953, Wadsworth Atheneum, Hartford, Connecticut, 1 March–31 March 1953, Lowe Gallery, Coral Gables, Florida, 15 April–15 May 1953, The Institute of Contemporary Art, Boston, 1 September–1 October 1953, "Milton Avery," no. 84

REFERENCES: Frederick S. Wight, *Milton Avery* (Baltimore: Baltimore Museum of Art, 1952), 19

The Typist, 1952, is an important, representative work from the beginning of Milton Avery's mature style and was created at the moment when Avery, at age sixty-seven, having attained modest success and critical attention during the 1940s, was now eclipsed by the emergence of abstract expressionism. Ironically, for an artist whose work was castigated and neglected during the thirties and early forties for being too abstract, it was now considered too "realistic." Although Avery was a direct influence on the color field abstractions of his longtime friends and colleagues Mark Rothko, Adolph Gottlieb, and Barnett Newman, his own work was grounded in the earlier modernist tradition of Georgia O'Keeffe, Marsden Hartley, and Arthur Dove, who never completely divorced representational imagery from works that sometimes verged on pure abstraction.

In 1949 Avery suffered a major heart attack from which he never fully recovered, suffering throughout his remaining fifteen years from fatigue and angina that required daily doses of nitroglycerin. His paintings from the early 1950s such as *The Typist* reflect significant but subtle shifts from his work of the 1940s and perhaps a period of deeper introspection as a result of his illness. Instead of the opaque surfaces and hard outlines of his earlier works, Avery moved to softer, thinned oil paints applied so they look like watercolor washes. Never a fussy draftsman, he allowed edges to soften and bleed into surrounding forms while still clearly defining them. Often Avery would rub down his canvases with rags to even out the colors and allow undertones to show through. In general, the colors are more complex and difficult to "name," and their juxtaposition becomes more daring; forms are larger and more compact, backgrounds and interior detail are all but eliminated. *The Typist* exhibits many of these refinements, differentiating it from his work of the preceding decade and predicting an increasingly abstract vocabulary that is already apparent in his landscapes of this period.

Avery's only visit to Europe in 1952 might have been an opportunity to reinforce his artistic kinship with European modernism and to see works by Picasso, Matisse, and other School of Paris artists with whom he was already intimately familiar through his longtime associations with the Valentine and Paul Rosenberg &

Company galleries in New York (galleries that were the principal U. S. venues for Picasso, Matisse and other School of Paris Masters). Unfortunately, his weakened condition precluded visits to European galleries and museums. Avery spent most of the summer sketching from his hotel rooms in Paris, the French Riviera, and London. Although the artist rejected frequent comparisons between his work and that of Matisse, they seemed to share a similar sensibility—painting as a "comfortable armchair" in the familiar words of Matisse.[1] But the ease and charm of Avery's painting belies a serious, thoughtful, and compulsively hard-working artist. In 1951 he wrote, "I try to construct a picture in which shapes, spaces, colors, form a set of unique relationships, independent of any subject matter."[2] As Robert Hughes observed, "the idea of a painting as a field of color starts with him."[3]

In Avery's handling of the face in *The Typist*, divided in symmetrical halves by abutting a deep red against a slightly less saturated value of the same red, it is difficult not to see the influence of Matisse's early fauve *Madame Matisse with a Green Stripe* (1905, Statens Museum, Copenhagen). It has been suggested that Avery "permitted himself the pleasure of flexing muscles with the fauvist master after touring Europe for the first time in 1952."[4]

The device of a featureless face, composed of pure color like a medieval heraldic shield, appears several years earlier in Avery's *Seated Girl with Dog* (1944, collection of Mr. and Mrs. Roy R. Neuberger, New York), a work that is closely related to *The Typist* in composition and color. The differences, however, point to Avery's steady development toward more simplified, looser form, softer transitions, and richer color harmonies. By the end of 1952 *The Typist* was featured in a major retrospective exhibition that was organized by the Baltimore Museum of Art and traveled to the Phillips Collection, Washington, D.C.; the Wadsworth Atheneum, Hartford, Connecticut; the Lowe Gallery, Coral Gables, Florida; and the Institute of Contemporary Art, Boston. While widespread public recognition would elude Avery for another decade or more, *The Typist* marks an important, transitional phase in the artist's development.

C. B. C.

William Kienbusch (1914–1980)

The Maine coast provided William Kienbusch with one of the major themes that distinguishes his mature work. As a young painter searching for his artistic identity amid the ferment of the New York art world in the heyday of abstract expressionism, Kienbusch very early in his career was attracted to Maine, which became his second home.[1] Toward the end of his life, he could recall with precision that it was the summer of 1946, while in Trevett, that he not only achieved a sense of his own style but also recognized an affinity with the casein medium that would remain the preferred vehicle for his artistic expression.[2]

While an undergraduate at Princeton University in the mid-1930s, Kienbusch had developed an intense appreciation for the history and traditions of American painting.[3] Although his first tentative efforts at painting were couched in a conservative figurative mode, by the early 1940s he had begun to move in the direction of modernism. One of his earliest mentors was Stuart Davis with whom he studied art at the New York School of Social Research. Subsequent meetings with Marsden Hartley and John Marin provided further impetus for Kienbusch to adopt a style of painting and drawing that intertwined the aesthetics of cubism and expressionism, to which the American art world had been formally introduced in 1913.[4]

By 1950 abstract expressionism was firmly established as the dominant progressive force in American art, and its impact on the international art scene served to proclaim that New York had assumed the mantle of leadership, displacing Paris. The movement took on many guises, from the "action painting" of Jackson Pollock to the more restrained "color field" idiom of Mark Rothko. One of the leading critics of the time offered a concise appraisal of this new school: "[Such] painting . . . is inseparable from the biography of the artist. The painting itself is a 'moment' in the adulterated mixture of his life—whether 'moment' means the actual minutes taken up with spotting the [painting] or the entire duration of a lucid drama conducted in sign language. [It] is of the same metaphysical substance as the artist's existence."[5] While Kienbusch pursued a path quite separate from the polarities seen in Pollock's and Rothko's art, the results of his inner probing reveal the same quality of the "metaphysical." For him, the dialogue between his personal tensions and his art required the kind of physical isolation that he found in Maine, rather than among the gregarious milieu of New York's Greenwich Village.

Kienbusch found his dominant thematic material in nature, but his paintings are not concerned with transcribing appearances; rather, they are, as he was often heard to say, "equivalents" of nature. He expressed his approach as "a translation, a language to communicate a world . . . of many things I love: Maine islands, trees, the sea, fences, gong buoys, churches, roses, mountains. I betray these if I copy."[6] Although his paintings were sometimes conceived in a strictly limited color range—some employing only black and white with mediating grays—they consistently reveal his love of lyrical tonality. Spareness is also a characteristic partner in this lyricism; but rather than producing the effect of immediate visual satisfaction or gratification, even the most elemental of Kienbusch's paintings invite prolonged contemplation.

But what most distinguishes his work is a profound sense of "place." As a bibliophile, with a predilection for modern American literature, Kienbusch preferred the kind of pungent economy of phrase that also characterized the work of one of his favorite poets, Wallace Stevens. That directness of approach, with its openness, its freedom from mannerism or artifice, seems to invest a particularly American quality in Kienbusch's art. *Sea Gate and Goldenrod*, with its elemental composition and color range, is typical of the artist's conception of his paintings as "equivalents" of nature. As with many of his compositions, Kienbusch here is deliberately equivocal, as sea and flora merge into and out of each other in an expression of the inherent unity of all nature, a concept that is reinforced through the suggestion of the traditional yin/yang symbol in the overall design.[7]

D. H.

79 Sea Gate and Goldenrod, 1963

Casein on paper, 32¼ x 45¼

Signed and dated lower right, "Kienbusch 63"

Museum purchase, 94.9

PROVENANCE: Estate of the artist; Kraushaar Galleries, New York

EXHIBITIONS: Kraushaar Galleries, New York, "William Kienbusch, 1914–1980: Memorial Exhibition," 12 January– 5 February 1983, no. 12; Farnsworth Art Museum, "William Kienbusch: A Retrospective Exhibition," 1946–1979," 14 July–8 September 1996, no. 11

REFERENCES: *William Kienbusch, 1914– 1980: Memorial Exhibition* (New York: Kraushaar Galleries, 1983), n.p. (illus.); Pamela J. Belanger, ed., Donelson Hoopes, Susan C. Larsen, and Carl Little, essayists, *William Kienbusch: A Retrospective Exhibition, 1946–1979* (Rockland, Maine: Farnsworth Art Museum, 1996), 37, 56 (illus.), 66

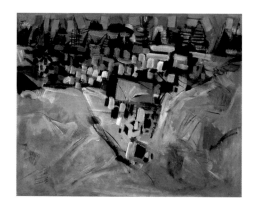

79a Quarry Hill, Hurricane Island, 1955

Casein on paper, 21½ x 27⅛

Bequest of Mrs. Elizabeth B. Noyce, 97.3.26

Fairfield Porter (1907–1975)

80 The Dock, 1974–75

Oil on canvas, 20⅟₁₆ x 36

Signed and dated upper right, "Fairfield Porter 74–75"

Gift of Mrs. Anne Porter, 79.55

PROVENANCE: Estate of the artist to Mrs. Anne Porter (the artist's wife), Southampton, New York, 1975–79

EXHIBITIONS: Hirschl and Adler Galleries, Inc., New York, "Fairfield Porter: His Last Works, 1974–75," 4–28 May 1976, no. 19; The Monmouth Museum, Monmouth, New Jersey, "The Spirit of the Coast," 24 July–23 September 1984, no. 62; The Parrish Art Museum, Southampton, New York, 27 June–12 September 1993, Mead Art Museum, Amherst College, Amherst, Massachusetts, 29 October–24 December 1993, The Snite Museum of Art, University of Notre Dame, Notre Dame, Indiana, 20 January–20 March 1994, Albright-Knox Art Gallery, Buffalo, New York, 14 May–3 July 1994, and Colby College Museum of Art, Waterville, Maine, 20 July–21 September 1994, "Fairfield Porter: An American Painter," no. 60

REFERENCES: Prescott D. Schutz, *Fairfield Porter: His Last Works* (New York: Hirschl and Adler Galleries, 1976), n.p.; Carl Little, *Paintings of Maine* (New York: Clarkson Potter/Publishers, 1991), 100–01 (illus.), 126; Edgar Allen Beem, "The Art of Island Maine," *Island Journal* 10 (1993): 79 (illus.); William C. Agee, Malama Maron-Bersin, Michelle White, and Peter Blank, *Fairfield Porter: An American Painter* (Southampton, N.Y.: The Parrish Art Museum, 1993), 73 (illus.)

Fairfield Porter was at the zenith of his career when he painted *The Dock* in 1974–75. It was a scene that he knew intimately: the dock at Great Spruce Head Island, his beloved summer home of sixty-one years. Porter first went to the island at the age of six and in later years described his childhood summers there as golden days. He had painted this scene before, yet *The Dock* and a second version, *The Harbor-Great Spruce Head*, 1974,[1] reflect the technical bravura and optimistic confidence of Porter's late painting style.

When Porter left for Great Spruce Head Island in the summer of 1974 he was in high spirits. His second exhibition at the Hirschl and Adler Galleries that spring was a great success.[2] New York critics praised his recent work and sales were numerous. In 1974 Porter was already renowned for his art criticism (in *Art News* and *The Nation*), as a poet, and as a guest lecturer at several universities. That summer Porter was also invited to be a visiting artist at the Skowhegan School of Painting and Sculpture in Maine. In the New York art world he was, in his own words, "now better known." Preparations were underway for a major retrospective of sixty of his paintings spanning his entire career at the Heckscher Museum (shared with the Queens Museum and the Montclair Museum). Poignantly, however, the summer of 1974 was also the last time Porter was to produce major oils on Great Spruce Head Island.[3]

When Porter set up his portable easel to paint *The Dock* it was, perhaps unknowingly then, a moment that came full-circle in his life and painting. The immediacy and spontaneity that Porter achieves in this painting is clearly both a tribute to the influences and sensuousness of the French Nabi painters and, in its confident, broad, abstract paint handling, to his long friendship with Willem de Kooning. The energy and dazzling sunlight, which permeate the painting, convey a midsummer's heat at noontime. The dock juts straight out from the foreground of the painting into the water, serving as the transition and passageway, both literally and metaphorically, from land to sea to the distant shore. On Great Spruce Head Island all communication with the outside world came by boat and inevitably passed over the dock. The boats moored in the harbor in this painting were the single means of transportation to the mainland. The dock then becomes the passage from private to public space.

The intense colors in *The Dock* are a study in harmonies: its mauve sand contrasts with its sea of vibrant blue, which draws the eye to the horizontal band of flickering light and dark greens of the Barred Islands on the opposite shore of the protected harbor. White light dances off the lobster boat and the sails of the sailboat anchored in the harbor. The oil tank, which dominates the left foreground, reaffirms the practical needs of this island community. The daring frontal perspective and whitish light of the dock lead the viewer's eye from the island's shore to the vibrant blue of the distant mainland. One also senses in the sensuousness of his paint Porter's sheer pleasure and delight in the natural beauty of this familiar vista.

Two pencil sketches for *The Dock* are found in undated sketchbooks in the Fairfield Porter Papers (1997 addition) and present two very different ideas for the painting's composition. In the first undated sketch[4] one sees Porter's rapid line drawing, a visual shorthand study, which is the actual design for *The Harbor-Great Spruce Head* and *The Dock*. The second sketch is annotated by Anne Channing Porter, *Study for "The Dock" GSHI*, and is a radical departure from Porter's final design.[5]

In contrast to *The Dock's* wide, open vista, Porter's painting *Beach Flowers No. 2*, 1972, is a fine example of his Maine "trail" paintings. As early as the mid-1950s Porter began experimenting with a small format of close-up images, details of the Maine landscape. Just as one would focus a camera for a close-up shot, so in this painting Porter minutely examines the wild roses, primroses, and daisies on the beach's edge and the sea's debris of mussel shells and driftwood on the rocks covered with lichen. Despite the closely cropped focus, its paint application is broad and abstract, rapidly executed in rich daubs of vibrant color. Here nature has its own cycle of wholeness—from the fullness of blossoming primroses to its discards of broken mussel shells and withered rose petals.

During the summer of 1972, David and Lindsay Shapiro, a poet and his wife, visited the Porters on Great Spruce Head Island.[6] In a letter from the island dated 25 July Porter wrote to the Shapiros, "I tried to paint (two versions) some terrific flowers on the shore: evening primroses of uniquely beautiful yellow, and field roses of an equally unique pink, with the colors of lichens on the rocks, gray-green and orange. . . . They were much harder to paint than people."[7] It is likely that Porter is referring to *Beach Flowers No. 2* in this letter or, if not, certainly to a variation on this theme. Porter's acute sense of color harmonies and direct study of nature in this painting highlight the hidden, often overlooked wonders of nature.

"I've been to Maine almost every summer since I was six. It's the place where most of all I feel myself to belong."[8] Porter's overwhelming sense of belonging and his joyous revelry in his island home are clearly felt in both *The Dock* and *Beach Flowers No. 2*.

L. M. A.

80a Beach Flowers No. 2, 1972

Oil on canvas, 24¼ x 20⅛

Bequest of Mrs. Elizabeth B. Noyce,
97.3.42

Lois Dodd (b. 1927)

Along the upper left edge of *The Painted Room* is a light bulb suspended from a narrow sliver of ceiling. Lois Dodd provides us this small visual clue so as not to deceive us about what we are viewing. For she is as forthright in painting as she is in person, and she wants us to know that, "Yes, you really are inside a room; otherwise it would be totally surreal, without that little piece of ceiling and the light bulb there."[1] We are viewing a wall in Dodd's Cushing, Maine, farmhouse on which she has painted a scene from the woods across the road. In the middle of this wall is a window, framed in brilliant yellow curtains, that filter the strong summer light, which is the true source of the painting's illumination, not the artificial light of the light bulb above. Through the opened window, whose double-hung sashes create a grid of intersecting rectangles, we see the sun-struck leaves of the trees beyond.

The *Painted Room* originated in the following way: Dodd was fixing the plaster on the walls of the bedroom when she realized that the patches looked like clouds. So, deciding to "have some fun with it," she put a little blue sky in and then, since she was working on a series of paintings of the woods at the time, kept right on painting until the room was covered with trees. The decision to make a painting of the wall with the window in it came later, but it seemed natural because she had by then been making paintings of windows off and on for more than ten years.[2]

Windows are among Dodd's most often recurring subjects. She began painting them in the late 1960s when she changed her summer home from inland Maine to the coast. At the time she had been painting landscapes with farm animals in them, presented close to the picture plane. But with her move to Cushing, she recalls, "Cow pastures were no longer on every hand and my interest had turned to the fascinating reflections and visions composed in the window frames of vacant houses and other buildings that I saw when out walking or driving."[3]

The basic geometric structure of windows appeals to Dodd's aesthetic. For even when painting landscape, which she does frequently and on site, she seeks "to clarify all that confusion."[4] The art critic Hilton Kramer has called her "a gentle, discreet, undogmatic modernist."[5] And as an admirer of Mondrian and cubism, she is drawn to elements that reaffirm the flatness of the picture plane. "I always search out the underlying geometric configuration or shapes as I begin a painting," she said in an interview in 1992. "I also look for flatness and elements that will maintain the flatness of the picture plane. In painting windows, I do not want to give the viewer a very deep space to move into and would prefer to move some of the elements forward into the space of the viewer."[6]

A native of Montclair, New Jersey, Dodd studied art at Cooper Union during the late 1940s. One of the founding members of the Tanager Gallery, which spurred the thriving Tenth Street scene in New York City during the 1950s, Dodd is of the generation that "came of age aesthetically . . . during the heyday of second generation Abstract Expressionism."[7] Yet she never swerved far from the path of realism. "What I find in nature is infinitely more exciting than anything I could invent," she has said. "Therefore I go to nature."[8]

Although she does not invent what is not there, in many of her works, as in *The Painted Room,* Dodd often chooses to exploit the ambiguity present in her subjects. Milton Brown notes that "Lois Dodd seems to favor the enigmatic. . . . Her paintings are full of devices of ambiguity—reflections in mirrors and windows, creating spatial discontinuity or inversion; forms that are interrupted; shadows that become forms; and light that deforms. . . . Outdoors and indoors become interchangeable. It is a quest to discover the mysterious in the commonplace."[9]

S. L. M.

81 The Painted Room, 1982

Oil on linen, 60 x 50

Gift of the American Academy and Institute of Arts and Letters, New York: Hassam, Speicher, Betts and Symons Funds, 91.7

PROVENANCE: Collection of the artist; American Academy and Institute of Arts and Letters

EXHIBITIONS: American Academy and Institute of Arts and Letters, New York, "Forty-Second Annual Purchase Exhibition: Hassam, Speicher, Betts and Symons Funds," 12 November–9 December 1990, no. 1; Montclair Art Museum, Montclair, New Jersey, 11 February–12 May 1996, Farnsworth Art Museum, 19 May–7 July 1996, and Trenton City Museum, Trenton, New Jersey, 12 October 1996–5 January 1997, "Lois Dodd: Twenty-five Years of Painting," no. 12

REFERENCES: Mona Hadler, *Lois Dodd: Twenty-five Years of Painting* (Rockland, Maine: Farnsworth Art Museum, 1996, cover

Beverly Hallam (b. 1923)

82 Orange Prince, 1985

Acrylic on linen, 72 x 72

Gift of the Beverly Hallam, 91.48

EXHIBITIONS: University of Southern Maine Art Gallery, Gorham, Maine, "Contemporary Works from Maine," 19 January–13 February 1986; Barn Gallery, Ogunquit, Maine, "Ogunquit Art Association, Group Exhibition, 1986; Midtown Galleries, New York, 13 April–21 May 1988, Francesca Anderson Gallery, Boston, 4–26 June 1988, and Hobe Sound Galleries, North Portland, Maine, 28 June–23 July 1988, "Beverly Hallam: The Floral Image"; Evansville Museum of Arts and Science, Evansville, Indiana, 22 April–27 May 1990, Sheldon Swope Art Museum, Terre Haute, Indiana, 9 June–15 July 1990, Art Museum of Southwest Texas, Beaumont, Texas, 8 September–21 October 1990, Bergen Museum of Art and Science, Paramus, New Jersey, 4 November–16 December 1990, and Polk Museum of Art, Lakeland, Florida, 11 January–3 March 1991, "The Flower Paintings"; Farnsworth Art Museum, "Beverly Hallam: Forty Years of Flowers," 18 January–5 April 1998

REFERENCES: *Beverly Hallam: The Floral Image* (New York: Midtown Galleries, 1988), 11 (illus.), 32; John Whitney Payson, *The Flower Paintings* (Evansville, Ind.: Evansville Museum of Arts and Science, 1990), 15; Carl Little, *Beverly Hallam: An Odyssey in Art* (Washington, D.C.: Whalesback Books, 1998), 100, 103 (illus.), 105

Hallam's startling, illusionistic flower paintings, such as *Orange Prince*, 1985, owe as much to their monumental scale (*Orange Prince* is six feet square) as to their exacting realism for their undeniable presence and impact. Indeed, Hallam subverts the notion of realism, enlarging her subjects to the point of disbelief.

The orange prince flowers, blown up to the scale of an exotic, tropical species and presented with the boldness of a seventeenth-century, Dutch monarch, are actually small, wilted pansies combined with lily of the valley leaves arranged in four tiny bud bases on a mirrored pedestal that is only eleven inches in diameter. The mirror, although appearing to be a large glass table, actually sits on another "normal"-size table. This kind of perceptual confusion, the antithesis of how one normally perceives photographic "reality," lies at the heart of Hallam's thoroughly contemporary vision. It is the visual equivalent of pulling a cloth from beneath a complete table setting without disturbing the assembled glasses, plates, and silverware. More than just a "neat trick," it raises questions about illusion and reality and the artist's mediating role between the two, a subject that has long occupied painters as diverse as Diego Velazquez, William Harnett, and Malcolm Morley. Moreover, mirrors that distort reality have been a trope of twentieth-century art since Pablo Picasso and Marcel Duchamp.

Hallam's apparently sudden and decisive shift in the early 1980s from her earlier, densely worked, painterly abstractions to immaculate, hyper-realistic flower paintings is in point of fact consistent with her long-standing interests in nature and technical processes. Hallam was among the first, and probably the first woman, artist to work with polyvinyl acetates, more commonly known as acrylics, while still in graduate school at Syracuse University in 1953.[1] Her use of the new medium was itself highly experimental. Combining acrylic with nearly every traditional and nontraditional material at hand, from gold leaf to conte crayon and pastel and, by the late 1970s, mica chips, Hallam created a vast body of semiabstract mixed-media works. She was also among the first contemporary artists to experiment with monotype printmaking, a little-used and virtually forgotten medium, although once favored in the late-nineteenth and early-twentieth-century by such artists as Edgar Degas,

Maurice Prendergast, James McNeill Whistler, and Henri Matisse. Throughout her years of technical experimentation and increasingly abstract paintings, prints, and collages, nature, most often based on floral still lifes, was a constant theme.[2]

Hallam's move to representation sprang both from a sense that she had exhausted the possibilities for monotype, which she had been producing for nearly two decades, and from a desire to explore what she called the "mysterious quality" in her work, a quality that she believed resided in shadows. Her immediate inspiration came from shadows cast by an arrangement of flowers on a table, which she quickly photographed.[3] The intersection of life-long interests in photography, flowers, and, now, the expressive possibilities of natural light animating both, led, if not inevitably then logically, to the artist's first experiments with airbrushed, photography-based painting. That Hallam had to teach herself the demanding technique of airbrush painting was likely an added delight for an artist who, at age fifty-seven, turned away from a successful career and work that had provided critical recognition, awards, and museum purchases over the previous three decades.

According to Hallam's meticulous notes on her working method, *Orange Prince* was begun in the heat of late August and completed five months later in January 1986.[4] The technical process is far too laborious and complex to describe here but involves painstakingly cut stencils and much trial and error to arrive at the finished painting. The time-consuming process is the antithesis of her earlier, spontaneous abstract paintings and monotypes, although the slow revelation of forms as the stencils are continuously placed and removed keeps the paintings in a lengthy state of abstraction that pleased Hallam.

Relatively speaking, *Orange Prince* is less complex, quieter, and more contemplative than many of her other large-scale flower paintings, which often tend toward baroque plays of light and shadow. The overall design simplicity and clarity of *Orange Prince* lends the painting a quality of monumentality quite aside from physical size. Late afternoon shadows are mostly screened by the vertical blinds, which march in linear regularity against the background window-wall, providing a geometric foil to the

organic flowers and leaves. The curves of the table and glass pedestal rhyme with the contours of the small bud vases that in turn play off the organic curving outlines and cupping forms of leaves and wilting flower petals. The glass pedestal casts a deep, mysteriously abstract shadow while the adjacent shadow is an almost perfect parallelogram. Curiously, the stems and leaves of the floral arrangement do not cast shadows, although the backlighting is intense enough to enable us to see the silhouettes of green leaves through the orange flowers. Overall, the painting is a study in balance and contradiction, geometry and nature, alluding to the carefully controlled and measured technical means that magically enable us to experience the accidental and ephemeral nature of creativity and life itself.

C. B. C.

Will Barnet (b. 1911)

83 Woman and Tall Trees, 1977

Oil on canvas, 71 x 39⅝

Signed and dated lower right, "c Will Barnet '77"

Gift of Will and Elena Barnet, 91.4

EXHIBITIONS: National Academy of Design, New York, "Annual Exhibition," 1977; Pensacola Museum of Art, Pensacola, Florida, "Americans and the Sea," 10 September–31 October 1982; Harmon-Meek Gallery, Naples, Florida, 11–23 March 1990, and Midwest Museum of American Art, Elkhart, Indiana, 31 August–14 October 1990, "Will Barnet: Retrospective 1931– 1987"; Arnot Art Museum, Elmira, New York, "Kingdom of the Sea," 21 June–8 September 1991; Farnsworth Art Museum, 12 January–3 March 1991, "Will Barnet: Paintings 1943–90"; The Fitchburg Art Museum, Fitchburg, Massachusetts, "The Maine Connection: Paintings and Sculpture from the Farnsworth Art Museum," 21 November 1993–27 March 1994

REFERENCES: Frank Getlein, *Will Barnet: Retrospective 1931–1987* (Naples, Fla.: Harmon-Meek Gallery, 1990), 7 (illus.).

Woman and Tall Trees, 1977, belongs to the series *Women and the Sea*, which Will Barnet began in the early 1970s. While not a radical departure from the artist's earlier figurative paintings of the 1960s, this series is characterized by increasing spareness, simplification of forms, and subtle tonal modulation among closely keyed colors. While this reductivist aesthetic can be compared with minimalist painting of the period and anticipates a renewed interest in figure-ground relationships, as seen in the work of Susan Rothenberg and others during the 1970s, Barnet's work derives largely from his own past art and a vast catalogue of art historical and literary interests. Indeed, Barnet is among the most visually allusive artists on the contemporary scene.

A partial list of references for the *Women and the Sea* series would include Egyptian wall painting; Greek friezes and vase painting; Japanese prints (especially those by Utamaro); American folk art; Native American art of the Pacific Northwest; luminist paintings by Martin Johnson Heade, Fitz Hugh Lane, and John Frederick Kensett; Georges Seurat; Henri de Toulouse-Lautrec; Mark Rothko; and Adolph Gottlieb, to name only a few that have been cited by critics and the artist himself.[1] Barnet's own abstract work from the late 1940s and 1950s is also of primary importance. In an essay for a 1957 publication on abstract painting, Barnet wrote: "Man's physical symmetry is a source of inspiration to the artist. . . . It becomes the structure of the picture, and the structure of the picture becomes the human form. There are no voids, there is no atmosphere, except in the drama and the purity which the painter gives the canvas its life."[2] Every Saturday, in what has become a lifelong ritual, the octogenarian artist haunts lower Manhattan galleries and New York's great museums looking at art, past and present. Unlike "appropriation" artists of recent vintage and postmodern ironists, Barnet looks for and selectively reforms that which resonates with and accommodates his own needs and sensibility.

The *Women and the Sea* paintings represent a successful effort not only to marry representation and abstraction but to distill universal content from personal experience and to fuse humanism with late modernism. The direct impetus for the series was a desire to work on subject matter that spoke to his New England heritage. Born in the coastal town of Beverly, Massachusetts, Barnet was educated at the Museum School of the Museum of Fine Arts, Boston. After moving to New York in 1930, he enrolled at the Art Students League, where he later taught, off and on, from 1936 through 1980. His entire career, with the exception of occasional teaching stints at various colleges and universities, has been centered on New York.

In 1971, seeking a respite from the oppressive Manhattan summer and his increasingly demanding teaching schedule, Barnet rented a shorefront cottage in New Harbor, Maine. One evening, around dusk, he glimpsed his wife, Elena, standing on the porch with a shawl wrapped around her shoulders, her silhouette etched against the sea and sky. The image resonated with associations from his youth in Beverly, a small seaside community on Boston's North Shore. The remnants of Beverly's proud seafaring traditions lingered in stately oceanfront mansions, the former homes of shipmasters and merchants who had made their fortunes in whaling and trade with Europe and the Far East. Wandering along the shorefront, Barnet recalled "beautiful ladies strolling through gardens adorned with statuary."[3] The son of Eastern European immigrants, part of Beverly's immigrant population that exploded during the late-nineteenth and early-twentieth-centuries, Barnet was deeply affected by the social discontinuities of his youth, and as early as the mid-1940s the artist expressed his desire to "capture the suicidal dust of the North Shore."[4]

On a personal, autobiographical level *Woman and Tall Trees*, and the entire series, can be seen as a container for complex and conflicted emotions and childhood memories of wonder and alienation, closeness and distance, tradition and newness, shadow and clarity. The seamless scrim of poetic and formal content found in these paintings is best explained by the artist: "I was involved with trying to deal with the sky, ocean and great distances. I felt the need to come to grips with the radiant light found in the atmosphere without being realistic or literary. I want to dissociate from normal human activity the relationship between the figure and nature, and to deal instead with the mysterious poetry between the two. I want to give the sense of great distances yet keep the paintings two-dimensional."[5]

C. B. C.

Neil Welliver (b. 1929)

84 Prospect Ice Flow, 1976

Oil on linen on wooden support, 71⅞ x 95¹³⁄₁₆

Signed lower right, "Welliver"

Bequest of Mrs. Elizabeth B. Noyce, 97.3.51

PROVENANCE: Lewis and Susan Cabot; O'Farrell Gallery, Brunswick, Maine, 1989–90; Mrs. Elizabeth B. Noyce, 1990–96; Estate of Mrs. Elizabeth B. Noyce, 1996–97

EXHIBITIONS: Portland Museum of Art, Maine, 1 October 1997–4 January 1998, and Farnsworth Art Museum, 12 April–14 June 1998, "A Legacy for Maine: Masterworks from the Collection of Elizabeth B. Noyce"

REFERENCES: Jessica F. Nicoll, *A Legacy for Maine: The November Collection of Elizabeth B. Noyce* (Portland, Maine: Portland Museum of Art, 1997), 77, 79 (illus.)

Prospect Ice Flow, completed in 1976, is among Welliver's most powerful, majestic images of the period and represents the beginning of the artist's exclusive focus on landscape painting. It is no accident that Welliver chose to settle in Lincolnville, which sits precisely on the line where climatologists say that northern Maine begins. *Prospect Ice Flow* precisely, brutally captures not only the look of winter in Maine but the kinesthetic feel of the stabbing pain of coldness before flesh, teared eyes, and running nostrils begin to freeze and death sets in. The freeze, thaw, refreeze cruelty and fickleness of shifting temperature, wind, and currents are set against the implacable stillness and immobility of the mountainside as the flowing ice pauses before lunging into the viewer's very lap.

Welliver, however, is neither an expressionist painter nor do his landscapes have much to do with the romantic tradition of his Hudson River School and later forebears seeking the transcendental, sublime theater of nature. A native of the rural northern Pennsylvania town of Millville, Welliver received his B.F.A. degree from the Philadelphia Museum College of Art, in 1953. He received his M.F.A. degree from the Yale School of Art in 1955, where he studied with Josef Albers, Burgoyne Diller, and James Brooks, and himself later taught at Yale between 1955 and 1965. Beginning in 1966 and continuing until his retirement in 1989, Welliver taught at the University of Pennsylvania, commuting throughout the 1970s twice monthly from his home in Maine. Welliver's early figurative work clearly indicates the influence of painterly abstract expressionism and his interest in such artists as Willem de Kooning and Arshile Gorky, among others. When, in the mid-1970s, Welliver eliminated the human figure, his paintings took on an allover quality; if you squint, you have Jackson Pollock, the pulsating energy of rhythmic brushstrokes and flickering color. There is also the legacy, which continues to the present, of strictly balanced and limited color harmonies and structural clarity derived, in part, from Piet Mondrian, Albers, and other abstract, geometric artists. This structural clarity and integrity is what the poet Mark Strand refers to as Welliver's ability to paint landscapes that appear "perfectly coherent, perfectly poised."[1] Welliver's nearly universal critical acclaim is grounded in the artist's unique method of synthesizing a convincing realism with abstract, formalist concerns, especially flatness, gesture, and a painting's essential, self-referential existence as an object rather than a depiction of something else.[2] Welliver has remarked that he wants to have "his cake and eat it too"—alluding to his paradoxical goal of effecting perfect equilibrium between illusionistic fact and abstract form.

This synthesis of realism and abstraction has much to do with Welliver's working method. Most of his large paintings begin with a relatively small (one or two foot) canvas executed directly from nature, often supplemented by detailed drawings that enable him to clarify certain difficult passages. Welliver refers to these studies but draws freehand on large sheets of paper, which he then adheres to his sized canvas. Using a tailor's serrated wheel to prick the outlines of the drawing, he pats the perforated paper with a small sack of chalk dust. Once the drawing is transferred to the canvas (which he frequently alters once the paper is removed) Welliver begins to paint. His most unusual practice, probably unique to Welliver, is to work from the upper left corner down to the bottom right corner. The painting rolls down like a window shade with the landscape revealed over the course of its execution from top to bottom. His palette is also idiosyncratic and unusually restricted for a "realist" painter, using only eight colors: two blues, two yellows, a red, a green, black, and white.[3] Welliver's technique suggests a high degree of analytical decision-making and emotional detachment. Yet the artist, like his painting, is full of contradictions and paradoxes.

The year 1976 marked a tragic period in the artist's life. The year before, Welliver's studio burned to the ground, taking with it nearly his entire life's work up that point, including most of his figure paintings. In 1976 his one-year-old daughter, Ashley, died of sudden infant death syndrome. Six months later, in October, his wife, Polly, died of complications from a strep infection. After her death, Welliver stopped painting female nudes and focused exclusively on landscapes. In this context, the enfolding, tree-studded banks of the shoreline in *Prospect Ice Flow* can almost be read as the natural equivalent to a keening Greek chorus. But if we are tempted to see the massive chunks of ice as the scattered white coffins of the artist's "landscape of loss," as Edgar Allen Been suggests in his penetrating essay of the same title, Welliver himself is not so sure. Asked whether his personal misfortunes can be found in his work he said, "Of course it's affecting me. How? The bottom line is I don't know you see."[4] But whatever is personal in Welliver's work is presented matter-of-factly, without sentiment or self-pity. It is simply there, like the meandering brook in *Rock Barrier—East Twin*, also in the Farnsworth collection, making its way through the cluttered, random newness of nature, obdurate and cleansing all at once.

C. B. C.

84a Rock Barrier—East Twin, 1990

Oil on canvas, 72 x 72

Museum purchase in memory of James Carpenter and his daughter, Jane Poliquin, 92.10

Checklist of Additional Works

PAMELA J. BELANGER

Checklist of Additional Works

ERNEST ALBERT (BROWN)
(1857–1946)

Born Brooklyn, New York; died New Canaan, Connecticut. Dropped his surname in 1879. Worked as a theatrical and scenic designer in New York, St. Louis, and Chicago. 1892, involved in creating color schemes and ornamental design for building interiors at the World's Columbian Exposition. Studied at the Brooklyn Art School. Beginning 1905, focused on landscape painting in the area of Old Lyme, Connecticut. 1914, instrumental in forming the Allied Artists of America and was the group's first president. 1922, associate member of NAD. From 1915 to 1925 summered on Monhegan Island, Maine.

Sunset Spray—Monhegan Island, c. 1920

Oil on canvas, 30⅛ x 32⅛

Signed lower right, "Ernest Albert A.N.A."

Gift of Mrs. Dorothy D. Woodyear, 86.26

CHARLES CURTIS ALLEN
(1886–1950)

Born Leominster, Massachusetts; died Chestnut Hill, Massachusetts. Studied at the school of Worcester Art Museum with Philip Hale and Hermann Dudley Murphy and later taught watercolor at the school. Received numerous prizes and membership to several art organizations including Salmagundi Club, the Rockport Art Association, the Ogunquit Art Association, the Boston Society of Watercolor Painters, the Philadelphia Watercolor Club, the American Watercolor Society, and the Guild of Boston Artists. 1933, elected associate member of NAD.

Lobsterman's Shack, Cape Porpoise, Maine, n.d.

Oil on canvas board, 12 x 16

Signed lower right, "Chas Curtis Allen A.N.A."

Museum purchase, 73.1878

Cape Porpoise, c. 1944

Watercolor on paper, 17¼ x 22⅞

Signed lower right, "Chas Curtis Allen"

Museum purchase, 45.495

Apple Trees and Cabbages, c. 1943–44

Watercolor on paper, 15¼ x 22½

Signed lower right, "Chas Curtis Allen"

Museum purchase, 44.163

Kennebunk, Maine Coast, n.d.

Watercolor on paper, 10½ x 12¹¹⁄₁₆

Signed lower right, "Chas Curtis Allen"

Museum purchase, 45.521

FREDERICK WARREN ALLEN
(1888–1961)

Born North Attleboro, Massachusetts; died Maine. Pupil of Bela Pratt, Paul Landowski, and Paul Bartlett. Sculptor and teacher; taught at the MFA,B School and was head of the sculpture department for over thirty years. Member of the Boston Guild of Artists, Boston Sculpture Society, Concord Art Association. Summered at North Haven, Maine.

Portrait of Carl Norwood Van Ness, c. 1920

Bronze, mounted on driftwood block, 15½ x 7⅞ x 9

Signed lower back edge, "F. W. Allen sc"

Gift of Sylvia V. N. Martin and Mary Van Ness Crocker, 84.33

The Wave, n.d.

Bronze, mounted on marble base, 11 x 6 x 5

Signed center right "F. Warren"

Gift of Mrs. Fredrick Allen, Wellesley, Massachusetts and North Haven, Maine, 71.1759

85 **Ernest Albert (Brown)** Sunset Spray—Monhegan Island

MILTON AVERY
(1885–1965)

Colonial Gas, 1934

Gouache on paper, 18 x 12

Signed lower left, "Milton Avery"

Gift of The Avery Family, 92.2

JAMES GARDNER BABBIDGE
(1844–1919)

Born in Rockland, Maine; died Togus, Maine. 1864–65, during the Civil War served in U.S. Navy and assigned to the U.S. steamship *Supply*. 1868, listed as a seaman and painter of ships. 1875, opened studio in Rockland; for over thirty years his portraits of ships were in great demand by local sea captains.

Bark "Hattie G. Hall," 1878

Oil on canvas, 18⅝ x 29¹⁵⁄₁₆

Signed and dated lower right, "J.G. Babbidge Jan. 1878," lower left, "No. 12," and lower center, "Hattie G. Hall of Boston, Capt. M.H. Fisk"

Gift of Kathleen Fisk Gove, Henry H. Gove, Fiske R. Gove, In memory of Louise Geddes Fisk, 62.1245

Ship "Alice A. Hall," 1881

Oil on canvas, 20 x 29¹⁵⁄₁₆

Signed and dated lower left, "J.G.B. 1881"

Museum purchase, 55.1128

HENRY BACON
(1839–1912)

Born Haverhill, Massachusetts; died Cairo, Egypt. During Civil War, field artist for *Leslie's Weekly*. 1864, one of the first Americans to study at newly reformed Ecole des Beaux-Arts with Alexandre Cabanel and Jean-Léon Gérôme; and 1866–67, at Ecouen, France, with Edouard Frère. 1868–96, in Paris and following year began extensive travel in Egypt, Greece, Ceylon, Sicily, and Italy. 1895, turned to painting exclusively watercolors. About 1900 settled in London and wintered in Egypt. Exhibited at Boston Athenaeum, NAD, PAFA, and the Paris Salon.

Sketch of Gondola, 1890

Oil on canvas, 10⅛ x 14¼

Signed and dated lower left, "Henry Bacon—1890"

Museum purchase, 43.60

JOHN HALEY BELLAMY
(1836–1914)

Born Kittery Point, Maine; died Portsmouth, New Hampshire. Wood-carver, amateur poet, and inventor. Apprentice wood carver at Boston and Portsmouth Navy Yards. Best known for his carvings of American eagles but also did decorative work for public buildings and private homes. Maintained studio in the Sir William Pepperrell Mansion at Kittery Point.

The Flying Dragon, c. 1842

Watercolor on paper, 7⅛ x 9⅛

Gift of Mr. and Mrs. Andrew Wyeth, 74.1949.4

86 **Milton Avery** Colonial Gas

87 **James Gardner Babbidge** Bark "Hattie G. Hall"

FRANK WESTON BENSON
(1862–1951)

Portrait of Charles Lewis Fox, 1885

Oil on canvas, 12⅞ x 9¹¹⁄₁₆

Signed and dated upper right, "To My Friend Charlie Fox. / Paris 1885 Frank W. Benson."

Gift from the Estate of Charles Lewis Fox, 60.1171.1

Blue Jays, 1942

Watercolor on paper, 8 x 14

Signed and dated lower left, "F. W. Benson '42"

Museum purchase, 44.419

Three Geese, 1939

Watercolor on paper, 19 x 26

Signed and dated lower left, "F. W. Benson '39"

Museum purchase, 44.420

Landscape, c. 1944

Watercolor on paper, 6½ x 12½

Signed lower left, "Cush. F. W. Benson"

Museum purchase, 45.461

Rescue, c. 1890s

Gouache and charcoal on card, 7⅞ x 12⅛

Signed lower left, "FWB"

Gift of Mrs. Elizabeth B. Noyce, 97.3.4

CARROLL THAYER BERRY
(1886–1978)

Born New Gloucester, Maine; died Rockport, Maine. 1909, B.S. Engineering, University of Michigan. Studied art in Boston and at PAFA. Commissioned by the U.S. government to execute a series of large murals commemorating the engineering achievement of the Panama Canal. Just prior to World War II, commissioned again by the U.S. government to document the naval construction at Bath Iron Works. 1945, settled in Rockport, Maine, and began working with woodcuts, wood engraving, and linocuts. 1959, collaborated on book with James Moore and Kosti Rauhomaa, *Maine Coastal Portrait.* Recognized today as one of the country's leading printmakers of Maine coast and coastal vessels.

Bath Iron Works, World War II, 1941

Oil on canvas, 32¼ x 36⅛

Signed and dated lower left, "Carroll Thayer Berry 41"

Museum purchase (Elmer C. and Alice L. Davis Fund), 72.1847

Robinson House, Head Tide, Maine, n.d.

Oil on canvas, 26¼ x 30⅛

Signed lower right, "Carroll Thayer Berry"

Museum purchase, 46.598

DWIGHT BLANEY
(1865–1944)

Born Brookline, Massachusetts; died Boston. 1892, traveled to Europe to study and sketch. 1895, began exhibiting at PAFA, and in 1897 at NAD. In Boston, exhibited at St. Botolph Club, Doll and Richards, the Guild of Boston Artists, and Boston Water Color Club. 1915, awarded bronze medal at the PPIE in San Francisco, also on advisory committee for the exposition along with Edmund Tarbell, Frank Benson, Joseph DeCamp, and Hermann Dudley Murphy.

Maine Landscape, 1907

Oil on canvas, 22⅛ x 26

Signed and dated lower right, "Dwight Blaney '07"

Gift of Mrs. Jonathan Comeau, 81.52

Shore Scene at Ironbound Island, 1926

Watercolor on paper, 14 x 20

Signed and dated lower left, "'26 Dwight Blaney"

Museum purchase, 43.24

The Jeanette, 1901

Oil on canvas, 22½ x 26⅛

Signed and dated lower left, "Dwight Blaney—1901"

Gift of Elizabeth B. Noyce, 96.13.1

ABRAHAM JACOBI BOGDANOVE
(1886–1946)

Born Minsk, Russia; died Dunbarton, New Hampshire. Studied at NAD under George Maynard and F. C. Jones. Member of the Society of Independent Artists and Allied Artists of America. Exhibited at NAD, PAFA, MMA, Corcoran, Carnegie. 1918, set up studio at Monhegan Island, Maine, and painted there every summer until his death.

Turtle Rock, 1940

Oil on canvas, 25 x 30

Signed and dated lower right, "A. J. Bogdanove / 1940"

Gift of Mrs. Abraham Jacobi Bogdanove, 58.1119

88 Frank Weston Benson
Portrait of Charles Lewis Fox

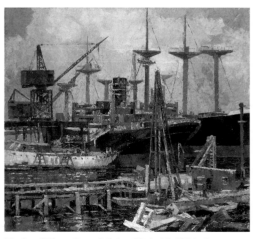

89 Carroll Thayer Berry Bath Iron Works, World War II

WILLIAM DARLEY BOIT
(1840–1915)

Born Boston; died Rome. 1863, graduated Harvard Law School. 1871–74, studied in Rome with Frederick Crowninshield and later with Thomas Couture and François-Louis Français in Paris. 1876–86, exhibited at Paris Salon. Exhibited at Doll and Richards and St. Botolph Club in Boston, and at Knoedler's in New York. Lifelong friendship with John Singer Sargent, who inspired Boit's work in watercolor and with whom he later held several joint watercolor exhibitions in Boston and New York.

Study of Old Oak, 1880

Watercolor on paper, 10 x 14

Signed and dated lower left, "Boit Copt Hall 12 July '80"

Museum purchase, 44.127

Trees and Shore, 1887

Oil on canvas, 13 x 18⅛

Signed and dated lower right, "Boit 16 August '87"

Museum purchase, 44.126

FREDERICK ANDREW BOSLEY
(1881–1942)

Born Lebanon, New Hampshire; died Boston. 1900–06, studied at MFA,B, School under Frank Benson and Edmund Tarbell. Exhibited at the Guild of Boston Artists, NAD, and PAFA. Taught at several private schools before succeeding Tarbell as director of Museum School in 1913. 1915, awarded bronze medal, PPIE, San Francisco; 1925, gold medal, Locust Club, PAFA. 1920, began summering in Harpswell, Maine.

Dark Interior, 1920

Oil on canvas, 38⅛ x 35

Signed and dated lower right, "F. Bosley / 1920"

Gift of Natalie Winslow, 53.873

ELIZABETH JANE GARDNER BOUGUEREAU
(1837–1922)

Born Exeter, New Hampshire; died Saint-Cloud, France. Studied Académie Julian with Jules-Joseph Lefebvre and William Bouguereau, whom she married in 1896. 1868–96 exhibited at the Paris Salon (first woman to exhibit at the Salon and receive a gold medal). 1889, awarded bronze medal, Exposition Universelle, Paris. 1893, two works included in the World's Columbian Exposition, Chicago. Also exhibited at PAFA and Philadelphia Centennial.

Psyche, 1870

Oil on wood panel, 13⅞ x 10⅛

Signed lower right, "E. J. Gardner. d'Curzon," dated lower left, "Paris 1870"

Gift of Mrs. Mary Boudreau, 59.1137

JAMES BROOKS
(1906–1992)

Born St. Louis, Missouri; died Bellport, New York. 1923–25, studied at Southern Methodist University, Dallas; 1925–26, Dallas Art Institute with Martha Simkins; and 1927–31, ASL with Kim Nicolaides and Boardman Robinson. 1938–42, muralist with WPA's Federal Art Project, at which time did a 12 x 235 foot mural at LaGuardia Airport which was restored in 1980; 1942–45 in Army. Taught, 1947–48, Columbia; 1947–59, Pratt Institute; 1955–60, Yale; 1963, artist-in-residence, American Academy, Rome; 1971–72, University of Pennsylvania; and 1975, Cooper Union. One-man exhibitions: 1952, Peridot Gallery, New York City; 1963, Whitney; 1966, Philadelphia Art Alliance; 1972, Dallas Museum of Fine Arts; 1983, Portland Museum of Art, Maine. Group exhibits at Guggenheim, AIC, Whitney, MOMA, Corcoran, PAFA, as well as the Tate Gallery, London. Awards: 1952, Carnegie Institute, Fifth Prize; 1957, AIC, The Mr. & Mrs. Frank G. Logan Medal; 1961, AIC, Norman Wait Harris Silver Medal and Prize; 1967, Guggenheim Foundation Fellowship; 1973, National Endowment for the Arts. 1948, summer spent with his wife, artist Charlotte Park, on Spruce Head Island, South Thomaston, Maine.

Ithaca, 1976

Acrylic on canvas, 46 x 41⅞

Signed lower right, "J. Brooks"

Gift of Mrs. Charlotte Brooks, 98.35

90 William Darley Boit Study of Old Oak

91 James Brooks Ithaca

HARRISON BIRD BROWN
(1831–1915)

Born Portland, Maine; died London. Started his career as a house and ship painter. By twenty-one he had his own banner and sign painting business, then turned to painting full time. No formal art training. Between 1861 and 1875 exhibited at the NAD; 1860 and 1863 at Boston Athenaeum; 1862 and 1863 at PAFA. Maintained a studio on Cushing Island in Casco Bay off Portland. 1892 moved to London to live with his daughter. Was a founder of the Portland Society of Art and its president in 1892. Works can be found in Portland Museum of Art, Maine, Bowdoin College Museum of Art, Colby College Museum of Art, Peabody Essex Museum, Salem, Massachusetts, and St. Louis Art Museum.

Seascape, n.d.

Oil on canvas, 9 x 18⅛

Signed lower left, "HBB"

Gift of the Estate of Ruby Smith, 62.1274

Lake Country, n.d.

Oil on canvas, 21⅞ x 36¹⁄₁₆

Gift of Mr. Gifford Cochran, 64.1323

Norlands Homestead, Livermore, Maine, c. 1883

Oil on canvas, 30 x 58

Signed lower left, "H B Brown"

Museum purchase, 83.8

JOHN GEORGE BROWN
(1831–1913)

Born Durham, England; died New York City. Studied art in England and Scotland before coming to America in 1853. 1857–59, attended NAD, began exhibiting there from 1858, and nearly every year until his death. 1862, elected associate member of NAD, and 1863, full member. 1893, several works included at World's Columbian Exposition, Chicago. Also exhibited at Boston Athenaeum, BAC, Brooklyn Art Association, and PAFA.

Shoeshine Boy, 1876

Oil on canvas, 16⅛ x 12⅛

Signed and dated lower right, "J.G. Brown. N.A. / 1876"

Gift of Mrs. John Clapperton Kerr, 49.706.1

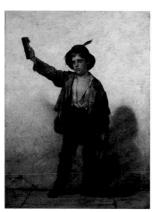

93 John George Brown Shoeshine Boy

CONSTANTINO BRUMIDI
(1805–1880)

Born Rome; died Washington, D.C. Studied in Rome, Academy of Arts. 1852, immigrated to America after successful career in Italy. 1855–80, worked on frescoes at the United States Capitol, most notably in the canopy of the dome and around the rotunda's 300-foot-long frieze, as well as decorating many rooms and corridors. With recent restoration of the rotunda Brumidi stands revealed as one of the first major American muralists.

Portrait of Moses Titcomb, 1858

Oil on canvas, 30³⁄₁₆ x 25⅛

Signed lower right, "C. Brumidi. Artist"

Gift of Wilbur Chapin Searle, 59.1145

AUGUSTUS WALDECK BUHLER
(1853–1920)

The Marsh, East Gloucester, 1916

Oil on canvas, 17⅜ x 24¼

Signed and dated lower right, "A.W. Buhler 1914"

Gift of Dorothy Buhler, 73.1902

Seascape, c. 1916

Oil on wood panel, 9 x 11¾

Signed lower right, "A.W. Buhler"

Gift of Mr. Edward F. McKeen and Miss Elinor Curwin, 69.1641

Meditation, 1916

Oil on canvas, 24¼ x 35

Signed and dated lower left, "A.W. Buhler 1916"

Gift of Miss Dorothy Buhler, 76.1945.8

94 William Partridge Burpee The Picnic

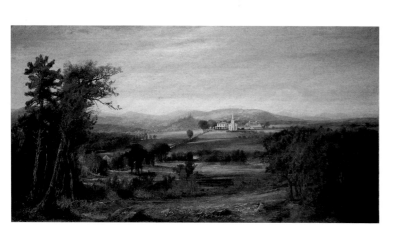

92 Harrison Bird Brown Norlands Homestead, Livermore, Maine

CHARLES EDWIN BURCHFIELD
(1893–1967)

Born Ashtabula Harbor, Ohio; died West Seneca, New York. 1912–16 studied at Cleveland Institute of Art with Henry G. Keller; briefly at NAD. From 1929 on, painted full-time. Exhibited regularly at AIC, PAFA, Whitney annuals and biennials, and Rehn Galleries. 1927 and 1948, NAD; 1986, AIC, MOMA, Carnegie Institute, and Whitney. Work found in collections at AIC, MOMA, Brooklyn Museum, Cleveland Museum, Phillips Collection, Washington D.C., and MFA,B. 1921 and 1958, won numerous awards. Member American Academy of Arts and Sciences, National Institute of Art Letters, NAD.

Gray Day, 1916

Watercolor and opaque watercolor and pencil, 13⅞ x 19¼

Signed lower right, "CHAS BURCH-FIELD"

Museum purchase, 98.2

WILLIAM PARTRIDGE BURPEE
(1846–1940)

Born and died Rockland, Maine. 1864, left Rockland for Boston and established a studio. While in Boston traveled frequently to Gloucester area to sketch and paint. 1897, traveled and studied in Europe and visited museums in Italy, Spain, France, Germany, and England. On returning studied art in New York with William Bradford. 1890–1905, exhibited at BAC, and 1902–10, at PAFA. 1904, bronze medal at Louisiana Purchase Exhibition, St. Louis. 1913, returned to Rockland.

Landscape with River, 1868

Oil on canvas, 20 x 32

Gift of Maynard Ingraham, 77.41

Lowell, Massachusetts, mid-1870s

Oil on cardboard, 5¼ x 8½

Gift of Edwin Sylvester, 49.944.2

Shore View, Swampscott, c. 1888

Oil on canvas, 10³⁄₁₆ x 16⁵⁄₁₆

Gift of Edwin Sylvester, 49.944.17

At the Beach, c. 1890

Oil on canvas, 8 x 11¹⁄₁₆

Gift of Edwin Sylvester, 49.1486

The Picnic, c. 1896–97

Oil on canvas, 10 x 14⅛

Gift of Edwin Sylvester, 49.944.5

Rockland Coastline, 1902

Watercolor and graphite on prepared board, 15¾ x 12½

Signed lower right, "W. P. Burpee / 02"

Gift of William G. Butman, 58.1122

Monhegan, the Head, mid-1920s

Oil on canvas, 20 x 24⅛

Museum purchase, 46.653

Beach with Two Dories, n.d.

Oil on canvas, 18 x 24

Museum purchase, 46.654

Beached, n.d.

Oil on canvas, 10⁵⁄₁₆ x 15

Gift of Edwin Sylvester, 49.944.8

Spanish Monastery, n.d.

Watercolor on paper, 20⅛ x 14¹⁄₁₆

Signed lower left, "W. P. Burpee"

Gift of Miss Eleanor M. Bird, in memory of her parents Mr. and Mrs. Henry B. Bird, 76.1993

JAMES EDWARD BUTTERSWORTH
(1817–1894)

Racing off Boston Light, c. 1870

Oil on board, 7¹⁄₁₆ x 10⁷⁄₁₆

Signed lower right, "J E Buttersworth"

Gift of Angeline T. Ferris, 97.4

95 William Partridge Burpee Monhegan, the Head

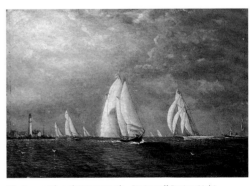

96 James Edward Buttersworth Racing off Boston Light

KENNETH CALLAHAN
(1905–1986)

Born Spokane, Washington; died Seattle. 1925, attended University of Washington. Largely self-taught in art. 1926–28, traveled and studied in England, Italy, France, and Mexico. 1933–53, curator and assistant director, Seattle Art Museum. 1954, awarded Guggenheim Fellowship. 1959, 1963, and 1966, artist-in-residence at Skowhegan School of Painting and Sculpture, Maine. 1975, elected member NAD.

Casual Wave, c. 1982

Acrylic on board, 31⅛ x 39

Signed lower right, "Kenneth Callahan"

Gift of Beth Callahan in memory of Kenneth Callahan, 92.31

GEORGE CATLIN
(1796–1872)

Born Wilkes-Barre, Pennsylvania; died Jersey City, New Jersey. 1818–23, studied and practiced law in Litchfield, Connecticut, and Luzerne County, Pennsylvania. Self-taught painter and portrait miniaturist. 1820–25, portrait miniaturist in Philadelphia. 1824, elected to PAFA, and 1826, member of NAD. 1832–38, painted first comprehensive record of American Indian tribes of the trans-Mississippi West. 1841, wrote and illustrated *Letter and Notes on the Manners, Customs and Conditions of the North American Indians*. 1837–51, traveled with his "Indian Gallery" and troupe of Indians in Central and South America, England, and continental Europe. 1851, closed Indian Gallery in London and sold it to a Philadelphian. 1879, gallery donated to Smithsonian Institution.

Plains Indians, n.d.

Oil on board, 8⅞ x 14

Signed lower right, "Geo Catlin"

Gift of Mr. Gifford Cochran, 63.1298

SIDNEY MARSH CHASE
(1877–1957)

Born and died Haverhill, Massachusetts. Studied with Charles Woodbury and Edmund Tarbell in Boston, and Howard Pyle in Delaware. Classmate and lifelong friend of N.C. Wyeth. Illustrator for *Scribner's, Harper's Monthly, Saturday Evening Post*, and *Collier's*. 1915, turned to painting rather than illustration and focused on coastal subjects at Matinicus, Port Clyde, and Tenants Harbor, Maine. Exhibited at Doll and Richards in Boston and PAFA. Member of Salmagundi Club and NAD.

Schooner off Monhegan, c. 1945

Oil on canvas, 25⅛ x 32

Signed lower right, "S. M. Chase"

Gift of Mrs. Sidney Marsh Chase, 71.1768

After the Storm, n.d.

Watercolor on paper, 19½ x 25½

Signed lower left, "S. M. Chase"

Gift of Mrs. Sidney Marsh Chase, 66.1512

Port Clyde, Maine, n.d.

Watercolor on cardboard, 15 x 20⅛

Signed lower right, "S. M. Chase"

Gift of Mrs. Sidney Marsh Chase, 66.1511

CLARENCE KERR CHATTERTON
(1880–1973)

Born Newburgh, New York; died New Paltz, New York. 1900, studied New York School of Art with William Merritt Chase and Robert Henri. 1915, first artist-in-residence at Vassar College. 1948, retired from Vassar as professor emeritus. 1918, journeyed for the first time to New England, stopping at Ogunquit and visiting Monhegan Island with his friend, Edward Hopper. 1918–48, summered every year at Ogunquit.

Surf, c. 1922

Oil on canvas, 24 x 30¼

Signed lower right, "C. K. Chatterton"

Gift of John M. Van De Water, in memory of his wife, Julia Chatterton Van De Water, daughter of C. K. Chatterton, 92.24

97 Sidney Marsh Chase Schooner off Monhegan

98 J. Foxcroft Cole Landscape with Sheep

CALVERT COGGESHALL
(1907–1990)

Born Whitesboro, New York; died Newcastle, Maine. 1925–29, attended School of Art and Architecture at the University of Pennsylvania. 1949, worked with Bradley Walker Tomlin. Had studios in New York City, where he worked as designer, and in Newcastle, Maine. He was one of the first artists to show at Betty Parsons's gallery in New York City and had ten solo shows there. He also exhibited at MOMA, Whitney, Carnegie, and Los Angeles County Museum of Art.

New London—August, 1950

Oil on canvas, 24 x 36

Signed lower left, "50 Coggeshall"

Gift of Mr. Arthur Wiesenberger, 52.704

Untitled, 1989

Oil on canvas, 55 x 50

Signed upper right, "C. Coggeshall / 1989"

Gift of Mrs. Susanna Coggeshall, 91.47

J. FOXCROFT COLE
(1837–1892)

Born Jay, Maine; died Winchester, Massachusetts. Along with Winslow Homer apprenticed with John H. Bufford in Boston. 1860–63, studied painting in Paris under Emile C. Lambinet and at Ecole des Beaux-Arts. 1864, established studio in Boston, next door to William Morris Hunt, John La Farge, and Elihu Vedder. 1865, Hunt advised him to go to Paris to study under Charles Jacques of the Barbizon School. 1866–75, exhibited at the Paris Salon and frequently at the Royal Academy in London, as well as the Boston Athenaeum, NAD, and PAFA. Cole along with Hunt were responsible for introducing the Barbizon School to American landscape painters.

Landscape with Sheep, c. 1890

Oil on canvas, 13 x 20⅛

Signed lower right, "J. Foxcroft Cole"

Museum purchase, 44.391

Off the North Shore, n.d.

Oil on cardboard panel, 8⅛ x 10¹¹⁄₁₆

Signed lower left, "J. Foxcroft Cole"

Museum purchase, 45.458

JAY HALL CONNAWAY
(1893–1970)

Born Liberty, Indiana; died Green Valley, Arizona. 1910–11 studied at John Herron Art Institute, Indianapolis; 1911–13, ASL with George Bridgman and William Merritt Chase, and 1912, also at NAD. 1920, studied at Académie Julian in Paris under Jean-Paul Laurens, and 1921, Ecole des Beaux-Arts. 1922, discovered by Macbeth Gallery. 1926, awarded NAD's Hallgarten prize. 1929–31, lived and painted on coast of Brittany, France. 1931–47, lived year-round on Monhegan Island, Maine, painting and operating the Connaway Art School during the summer. 1947, moved studio and school to Dorset, Vermont. Exhibited at NAD, PAFA, and in France at Salon d'Automne. 1943, elected to NAD.

The Tripod, c. 1930

Oil on panel, 20⅛ x 23¹⁵⁄₁₆

Signed lower left, "Connaway" and lower right, "Near Dead Man's Cove, Monhegan"

Gift of Louise B. Connaway, 88.11

Harry and Doug's Monhegan Store, c. 1938

Oil on canvas, 14³⁄₁₆ x 24¹⁄₁₆

Signed lower right, "Connaway"

Gift of Louise B. Connaway, 80.27.2

Rocks, Monhegan, 1940

Oil on board, 19¼ x 29¹⁵⁄₁₆

Signed and dated lower right, "Connaway 40," dated lower left, "Sept-4-1940"

Gift from the Textile Arts Foundation (Nancy Hemenway and Robert Barton), 96.15.3

Rocks, Monhegan, 1942

Oil on cardboard, 15⅛ x 20¼

Signed and dated lower right, "Connaway 4-42 / Rocks Monhegan Maine"

Museum purchase, 44.187

100 **Jay Hall Connaway** Harry and Doug's Monhegan Store

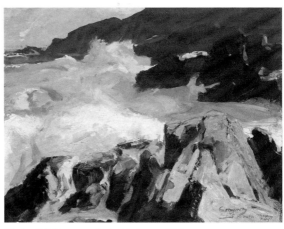

99 **Jay Hall Connaway** Rocks, Monhegan, 1940

CHARLES COPELAND
(1858–1945)

Born Thomaston, Maine; died Newton Centre, Massachusetts. 1877, studied at Lowell Institute, Boston. Apprenticed with designer Abner Crossman. Illustration work published in *Harper's* and Trent's edition of *Robinson Crusoe*. 1919, began working exclusively in landscape and marine watercolors. Maintained studio in Boston and later Newton Centre, Massachusetts, but summered in Thomaston every year. Exhibited at PAFA, Society of American Artists, BAC, and Boston Society of Water Color Painters. Charter member and president for many years of BAC.

Haying, 1889

Watercolor on board, 15¼ x 21⅞

Signed and dated lower right, "Copeland 89"

Anonymous Gift, 60.1474

Gray Day, Criehaven, Maine, 1910

Watercolor on paper, 10⁵⁄₁₆ x 14¼

Signed lower right, "Charles Copeland"

Museum purchase, 46.587

Montpelier, 1914

Watercolor on paper, 17³⁄₁₆ x 26

Signed lower left, "Charles Copeland"

Gift of Mrs. Charles Copeland, 50.711

Mt. Kineo, n.d.

Watercolor on paper, 17 x 21¹⁄₁₆

Signed lower left, "Charles Copeland"

Museum purchase, 46.585

The Fox, n.d.

Watercolor on paper, 10¼ x 14⁹⁄₁₆

Signed lower left, "Charles Copeland"

Museum purchase, 46.586

Criehaven, n.d.

Watercolor on paper, 22¹⁄₁₆ x 34½

Signed lower right, "Charles Copeland"

Gift of Mrs. W.B.D. Gray and Mrs. James Creighton, 73.1883

(ROBERT) BRUCE CRANE
(1857–1937)

Born New York City; died Bronxville, New York. 1878 and 1882, studied at ASL; 1879, with Alexander H. Wyant; and 1882, Grez-sur-Loing, France, with Stanislas-Jean-Charles Cazin. 1897, elected associate member of NAD; 1901, full academician. Several awards including 1897, awarded Webb prize at Society of American Artists; 1900, bronze medal at Paris Exposition Universelle; 1901, George Inness gold medal at NAD; and 1904, gold medal at St. Louis Exposition. 1900, paints along coast of Maine. After 1904, worked mostly in Connecticut, summers at Old Lyme. 1915, established exhibiting organization, Twelve Landscape Painters, with Emil Carlsen, J. Alden Weir, and Charles H. Davis.

The Golden Tree, c. 1910–20

Oil on canvas, 30¼ x 32⅛

Signed lower left, "Bruce Crane N.A."

Gift of Edward C. Sargent, 77.7

ELEANOR PARKE CUSTIS
(1897–1983)

Born Washington D.C.; died Gloucester, Massachusetts. 1915–18 studied at and graduated from Corcoran Art School; continued to study there through 1925. 1924–25, spent summers in Boothbay Harbor, Maine, studying under Henry Snell. Also well known as a photographer, illustrator of children's books and magazines. Author of books on photography. Traveled extensively in Europe, Egypt, Mediterranean, Central and South America. 1960, settled permanently in Gloucester, Massachusetts. Exhibited at Vose Galleries, Boston; National Association of Women Painters and Sculptors; Grand Central Art Galleries; New York Watercolor Club; Arts Club of Washington; Washington Water Color Club; American Watercolor Society. Member of Washington Water Color Club; Society of Washington Artists; BAC; Arts Club of Washington; North Shore Art Association.

Damariscove Houses, 1924

Gouache on paper, 13⅛ x 15½

Signed lower right, "Eleanor Parke Custis"

Bequest of Mrs. Elizabeth B. Noyce, 97.3.5

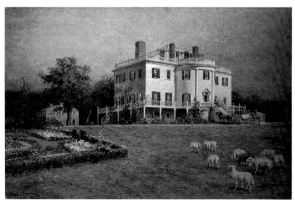

101 Charles Copeland Montpelier

102 (Robert) Bruce Crane The Golden Tree

CARL GORDON CUTLER
(1873–1945)

Born and died Newtonville, Massachusetts. Studied MFA,B, School and at Académie Julian with Benjamin Constant and Jean-Paul Laurens. Exhibited at Paris Salon, AIC, Whitney, Corcoran, Brooklyn Museum, and PAFA. One of the Four Boston Painters along with Maurice Prendergast, Charles Hovey Pepper, and E. Ambrose Webster. Member of BAC and Copley Society. For nearly twenty-five years beginning about 1920 he spent summers in South Brooksville, Maine.

Wood Interior, Brooksville, Maine, n.d.
Watercolor on paper, 16 x 24
Gift of Mr. Robert C. Vose, Jr., 91.38

Pond Island and Camden Hills,
c. 1920
Watercolor on paper, 16⅞ x 24
Signed lower right, "Carl G. Cutler"
Bequest of Elizabeth B. Noyce, 97.3.6

Cape Rosier, Looking Southwest, n.d.
Watercolor and pencil on paper, 25 x 20
Signed lower left, "Carl G. Cutler"
Gift of Peter G. Lisle, 97.17.1

Caterpillar Ridge, n.d.
Watercolor and pencil on paper, 17 x 25
Signed lower right, "Carl G. Cutler"
Gift of Peter G. Lisle, 97.17.4

Sinuous Tree, n.d.
Watercolor and pencil on paper, 25 x 20
Signed lower left, "Carl G. Cutler"
Gift of Peter G. Lisle, 97.17.5

Foliage Patterns, n.d.
Watercolor and pencil on paper, 20 x 25
Signed lower right, "Carl G. Cutler"
Gift of Peter G. Lisle, 97.17.12

Eggemogin Reach, n.d.
Watercolor and pencil on paper, 17 x 25
Signed lower right, "Carl G. Cutler"
Gift of Peter G. Lisle, 97.17.13

South Brooksville, Looking North, n.d.
Watercolor and pencil on paper, 20 x 25
Signed lower right, "Carl G. Cutler"
Gift of Peter G. Lisle, 97.17.17

Eggemogin Reach and Little Deer Isle, n.d.
Watercolor and pencil on paper, 17 x 25
Signed lower left, "Carl G. Cutler"
Gift of Peter G. Lisle, 97.17.18

Early Autumn, n.d.
Watercolor and pencil on paper, 17 x 25
Signed lower right, "Carl G. Cutler"
Gift of Peter G. Lisle, 97.17.23

Quarried Hillside, n.d.
Watercolor and pencil on paper, 17 x 25
Signed lower left, "Carl G. Cutler"
Gift of Peter G. Lisle, 97.17.25

RANDALL DAVEY
(1887–1964)

Born East Orange, New Jersey; died California. Studied liberal arts and architecture at Cornell, and 1910–11, under Robert Henri, at the ASL, becoming his assistant teacher in 1912. A fellow student was George Bellows. 1920 taught at AIC; 1921–24 Kansas City Art Institute; 1945–46 at University of New Mexico. Member of NAD, National Association of Mural Painters, National Association of Portrait Painters, Taos Society of Artists, Society of Independent Artists, Painter-Gravers Society. Exhibited for many years at NAD beginning in 1914 and winning the Hallgarten Prize in 1915. Also exhibited at PAFA; Armory Show of 1913; and Grand Central Art Association, winning a prize in 1939. Worked for WPA as a muralist. 1911 made first trip to Monhegan Island with his former teacher, Robert Henri. Made another trip to island in 1914.

A Blow at Monhegan, c. 1915
Oil on board, 18 x 22
Museum purchase, 95.6

View from White Head, Monhegan,
1911
Oil on board, 11¾ x 15
Signed lower left, "Randall Davey"
Bequest of Mrs. Elizabeth B. Noyce, 97.3.7

Untitled, n.d.
Oil on board, 7⁵⁄₁₆ x 9¼
Signed lower left, "Randall Davey"
Museum purchase, 98.23.4

104 Randall Davey A Blow at Monhegan

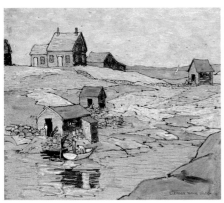

103 Eleanor Parke Custis Damariscove Houses

ARTHUR BOWEN DAVIES
(1862–1928)

Born Utica, New York; died Florence, Italy. 1877, studied with Dwight Williams. 1879, moved to Chicago, where he attended Chicago Academy of Design. 1883, studied at AIC. 1886, moved to New York City, enrolling at ASL. Until 1888, when he began exhibiting regularly, did illustrations for *Century Magazine* and *Saint Nicholas*. 1893 and 1897, first and second trips to Italy under sponsorship of William Macbeth. 1894, exhibition at Macbeth Galleries of his first Italian works won him instant recognition. 1908, exhibited with The Eight at Macbeth. 1913, president Association of American Painters and Sculptors and in association with Walt Kuhn and Walter Pach organized the *International Exhibition of Modern Art*, better known as the Armory Show. Member of NAD, PAFA, and BAC. 1901, awarded silver medal, Pan-American Exposition, Buffalo. 1930, memorial exhibition, MMA.

Orvieto on Hill, c. 1928
Watercolor and crayon on blue wove paper, 9½ x 12½
Signed lower left, "A.B. Davies"
Gift of Mr. and Mrs. Niles Davies, Sr., 65.1389

Green Hills, c. 1924–28
Watercolor and gouache on gray paper, 9⅞ x 12⅞
Lower right, signature stamp
Museum purchase, 98.13

WILL ROWLAND DAVIS
(1879–1944)

Born and died Boston. Studied at Cowles Art School with Joseph R. DeCamp, and at MFA, B School with Edmund Tarbell and Frank W. Benson. Member of the Copley Society, North Shore Arts Association, and American Federation of Arts.

The Builders, c. 1920s
Oil on canvas, 47 x 55
Signed lower right, "Will Davis"
Gift of Aline Davis Hulbert, the artist's niece, 93.20

Captain Smith, n.d.
Oil on canvas, 34¼ x 40
Signed upper right, "W. R. Davis"
Gift of Mrs. Will R. Davis, 53.871

JOSEPH B. DAVOL
(1864–1923)

Born Chicago, Illinois; died Ogunquit, Maine. Studied at Académie Julian with Benjamin Constant and Jean-Paul Laurens in Paris. Member of PAFA and Salmagundi Club. 1915, exhibited at PPIE, San Francisco.

York Beach, 1913
Oil on canvas, 29 x 36
Signed lower right, "Davol"
Gift of Mr. Ralph Booth, 66.1503

Sand Dunes, c. 1906
Oil on canvas, 17 x 21
Signed lower left, "Davol"
Gift of Mr. Ralph Booth, 66.1504

WALTER LOFTHOUSE DEAN
(1854–1912)

Schooner "Polly," 1894
Oil on canvas, 13¹⁵⁄₁₆ x 20⅛
Signed lower center, "Walter L. Dean / MD"; upper right, "Polly / 1894"
Gift of Bradbury M. Prescott, 72.1862.1

106 **Will Rowland Davis** The Builders

107 **Joseph B. Davol** York Beach

105 **Arthur Bowen Davies** Orvieto on Hill

JOSEPH RODEFER DECAMP
(1858–1923)

Portrait of Albert H. Chatfield, Sr., 1905

Oil on canvas; 30 x 25⅛

Signed lower right, "JOSEPH-DE-CAMP"

Gift of Albert H. Chatfield, Jr., 90.16

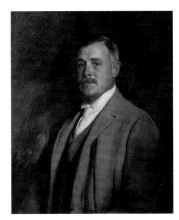

108 Joseph Rodefer DeCamp Portrait of Albert H. Chatfield, Sr.

JOSEPH DE MARTINI
(1896–1984)

Born Mobile, Alabama; died Boston. 1930, first trip to Monhegan Island; 1945, established studio at Fish Beach on the island, returning nearly every summer until his death. 1935–40, painted in the Federal Art Project in New York. 1950, studied with Leon Kroll, ASL, New York City. 1951, awarded Guggenheim Fellowship. Exhibited at MOMA, Whitney, AIC, and PAFA.

Monhegan Cliffs, 1945

Oil on canvas, 18¼ x 24

Signed lower right, "Joseph De Martini"

Museum purchase, 46.603

Gray Sands, n.d.

Oil on canvas, 14 x 24 1/16

Signed lower right, "De Martini"

Bequest of Nathan Berliawsky, 80.35.6

Surf, n.d.

Oil on canvas, 20⅛ x 24 1/16

Signed lower right, "Joseph De Martini"

Bequest of Nathan Berliawsky, 80.35.7

109 Joseph De Martini Monhegan Cliffs

FREDERICK KNECHT DETWILLER
(1882–1953)

Born Easton, Pennsylvania. Studied art, architecture, and painting at Columbia University, the Ecole des Beaux-Arts, Paris, ASL, Istituto di Belle Arti, Florence, and Ecole Américaine des Beaux-Arts, Fontainebleau, France. Member and director (1925–34) of the Society of Independent Artists, and 1939 elected Associate Academician, NAD. Exhibited at Paris Salon, NAD, AIC, and PAFA. An original member of the Pemaquid Group, from early 1930s until his death regularly spent summers in New Harbor and Pemaquid, Maine.

Isle Mt. Desert, c. 1944

Watercolor on paper, 12½ x 18

Signed lower left, "F. K. Detwiller"

Museum purchase, 44.207

EDWIN DICKINSON
(1891–1978)

Born Seneca Falls, New York; died Wellfleet, Massachusetts. 1910–11, studied Pratt Institute. 1911–12 studied with William Merritt Chase and Frank Vincent DuMond at the ASL. 1912–13, studied at NAD and Buffalo Fine Arts Academy. 1912–13 summers, studied with Charles W. Hawthorne, his most influential teacher, at Provincetown. 1917, began exhibiting at PAFA, and 1918 at NAD. 1938–39, taught Buffalo Academy of Fine Arts; 1922–23, 1945–66, ASL; 1949–57, Brooklyn Museum Art School; and 1956–58, Skowhegan School of Painting and Sculpture. 1929, 1957, won NAD's Second Benjamin Altman Prize, and 1949 awarded the academy's Evelyn Clair Lockman Prize. 1948, elected associate member of NAD, and full status in 1950. Numerous one-man shows, including, 1927, Albright Art Gallery, Buffalo; 1965, retrospective exhibition at Whitney; 1979, memorial exhibition, American Academy of Arts and Letters, New York; 1982, traveling show, "Edwin Dickinson: Draftsman/Painter" at NAD.

The Glen, Brook, 1930

Oil on board, 29⅞ x 24⅞

Signed and dated lower left, "E. W. Dickinson / Sheldrake / 2 Jan 1930 / 25 years"

Bequest through Will of Ruth Chapin Sutter, 84.21

110 Edwin Dickinson The Glen, Brook

PAUL DOUGHERTY
(1877–1947)

Farm Land U.S.A., c. 1901

Oil on academy board, 6⅛ x 9⅛

Bequest of Lisa D. Coon Estate, 90.27.11

Country Road through Trees, 1905

Oil on canvas, 25¼ x 30

Signed and dated lower left, "Copy right 1905 / Paul Dougherty"

Bequest of Lisa D. Coon Estate. 90.27.3

Rock Beach under the Cliff, Cornwall, c. 1909

Oil on panel, 12¾ x 16

Bequest of Lisa D. Coon Estate, 90.27.8

Low Tide, 1910

Oil on panel, 21 x 26

Signed lower right, "Paul Dougherty"

Bequest of Lisa D. Coon Estate, 90.27.2

Alps, Sunset, and Snowy Mountains, c. 1912–13

Oil on canvas, 26 x 36

Bequest of Lisa D. Coon Estate, 90.27.1

Monterey Pines, after 1930

Watercolor on paper, 13½ x 19¼

Signed lower left, "Paul Dougherty"

Bequest of Lisa D. Coon, 90.27.4

FRANK DUVENECK
(1848–1919)

Born Covington, Kentucky; died Cincinnati. 1870, studied at the Royal Academy, Munich, with Wilhelm von Diez. 1875, first critically successful exhibition of portraits at BAC. That year returned to Munich with John H. Twachtman and Henry Farny. 1878, organized class of American students in Munich known as the Duveneck Boys. 1879, moved his school to Italy. 1888, returned to Cincinnati and in 1890 began teaching painting classes at Cincinnati Art Museum. 1900, joined faculty of the Cincinnati Art Academy and from 1904 until his death was director of the Academy. 1905, elected associate member of NAD, and full status the following year. 1915, special Medal of Honor at PPIE, San Francisco. From 1899 to 1919, summered regularly at Gloucester, Massachusetts.

Folly Cove, c. 1905

Oil on board, 16¼ x 22¼

Signed lower left, "FD"

Museum purchase, 43.59

Portrait of Mrs. Philip Hinkle, c. 1906–07

Oil on canvas, 67 x 42½

Gift of Mr. Joseph H. G. Hinkle, 69.1706

Smith's Cove, Gloucester, Massachusetts, n.d.

Oil on canvas, 20⅛ x 25 1/16

Gift of Miss Dorothy Buhler, 75.1063

THOMAS EAKINS
(1844–1916)

Composition for Rush Carving Allegorical Figure, c. 1876

Oil on paper, 10¼ x 8½

Gift of Mr. Gifford Cochran, 64.1322

CHARLES EBERT
(1873–1959)

Born Milwaukee, Wisconsin; died Old Lyme, Connecticut. 1892–93, studied at Cincinnati Art Academy, then ASL. 1894–96, at Académie Julian, Paris, with Benjamin Constant and Jean-Paul Laurens. 1896, opened studio in New York City. Around 1900, moved to Greenwich, Connecticut, and studied with John Twachtman and introduced to J. Alden Weir and Childe Hassam. 1910, awarded bronze medal from Buenos Aires Exposition. 1915, silver medal from the PPIE, San Francisco. From 1909 on, spent summers on Monhegan Island, Maine. Exhibited at NAD, AIC, and PAFA.

Fishing Boats—Monhegan, after 1909

Oil on canvas, 30 x 36

Signed lower left, "Ebert"

Gift of Peter H. Davidson, 81.55

Crowded Beach—Monhegan, Maine, c. 1930s

Oil on board, 13¼ x 17¾

Signed lower right, "Ebert"

Gift of Miss Elizabeth R. Ebert, 71.1808

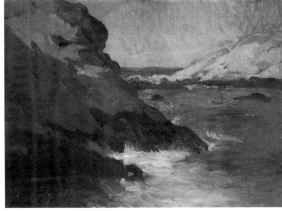

112 **Frank Duveneck** Folly Cove

111 **Paul Dougherty** Alps, Sunset, and Snowy Mountains

LOUIS M. EILSHEMIUS
(1864–1941)

Born near Arlington, New Jersey; died New York City. 1884–86, studied at ASL. 1886–87, studied with William Bouguereau at Académie Julian, Paris, and that summer with landscapist Joseph van Luppen in Antwerp. 1888, returned to New York City. From that time to early 1900s traveled widely to California, Europe, North Africa, Hawaii, and South Seas. 1917, discovered by Marcel Duchamp at the *First Annual Exhibition of the Society of Independent Artists*. 1920, first one-man show at the Société Anonyme organized by Duchamp. 1921, stopped painting, focused on musical compositions, inventions, and writing.

Bathers, c. 1920

Oil on paper, 14 x 25⅞

Signed lower left, "Eilshemius"

Gift of Gifford Cochran, 64.1324

Two Men Climbing a Ladder, n.d.

Oil on board, 22⁷⁄₁₆ x 25½

Gift of Louise Nevelson, 84.23.7

DOROTHY EISNER
(1906–1984)

Born New York City; died Greenwich Village. 1925–29, studied ASL with Boardman Robinson and Kenneth Hayes Miller. 1927–29, three trips to France, studied briefly at Grande Chaumière, Paris. 1930 and 1946, summered on Monhegan Island. 1933–36, board member of the Society of Independent Artists. 1933, exhibiting member of National Association of Women Painters and Sculptors. 1940, founding member of Federation of Modern Painters and Sculptors. 1960–83, summered on Cranberry Island off Mount Desert Island, Maine. Prizes include 1937, Edith Penman Memorial Prize, and 1976, Hassam Fund Purchase Award from the American Academy of Arts and Letters.

Fourth of July, 1976

Oil on canvas, 35 x 40

Signed and dated lower right, "Dorothy Eisner / 1976"

Gift of John McDonald, husband of the artist, 92.13

STEPHEN ETNIER
(1903–1984)

Born York, Pennsylvania; died South Harpswell, Maine. Attended Yale School of Fine Arts and PAFA. 1928, private apprenticeship arrangement with Rockwell Kent. 1929, studied with John Carroll and together that summer they sailed and painted the Maine coast. 1932–66, exhibited at Milch Galleries in New York City, and 1966–80, at Midtown Gallery. 1953, elected member of NAD, receiving several academy prizes including Samuel F. B. Morse Gold Medal, Benjamin Altman Prize, and Slatus Gold Medal. As a child summered in South Harpswell and from 1926 made it his permanent residence.

Day's End, 1950

Oil on canvas, 17¹⁄₁₆ x 31¹⁄₁₆

Signed and dated lower left, "Stephen Etnier 50"

Museum purchase, 44.186

Mid-Channel Bell, 1954

Oil on canvas, 11 x 24³⁄₁₆

Signed and dated lower left, "Stephen Etnier 54"

Gift of Gifford A. Cochran, 65.1446

Willows, 1965

Oil on canvas, 14¹⁄₁₆ x 30⅛

Signed and dated lower center left, "Stephen Etnier 65"

Anonymous Gift, 65.1442

Study for Sailmaker, Nassau, 1970

Oil on Masonite, 16 x 24

Signed and dated lower right, "Stephen Etnier 70"

Anonymous Gift, 81.7.5

ALVAN FISHER
(1792–1863)

The Falls of Niagara, c. 1820

Oil on canvas, 34 x 48¼

Museum purchase, 89.14

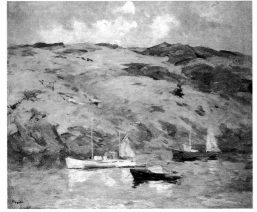

113 **Charles Ebert** Fishing Boats—Monhegan

114 **Stephen Etnier** Mid-Channel Bell

JONATHAN FISHER
(1768–1847)

Dedham, Massachusetts, 1790

Oil on canvas, 19½ x 26½

Museum purchase, 65.1465.132

The Latter Harvest, 1804

Oil on canvas, 20 x 26½

Museum purchase, 65.1465.136

Calvary, n.d.

Oil on canvas, 21¾ x 27¼ framed

Signed lower left, "Calvary"

Museum purchase, 65.1465.137

Gethsemane, 1838

Oil on cardboard, 22⅛ x 19½

Museum purchase, 65.1465.146

Hollis, Harvard and Massachusetts Halls, n.d.

Oil on canvas, 19½ x 26½

Museum purchase, 65.1465.147

Massachusetts Hall at Harvard, 1790

Watercolor on paper, 10¹/₁₆ x 13¼

Museum purchase, 65.1465.133

GERTRUDE HORSFORD FISKE
(1878–1961)

Born Boston; died Weston, Massachusetts. 1912, graduated MFA,B, School, studying with Edmund Tarbell, Frank Benson, and Philip Hale. Summered in Ogunquit, Maine, studying with Charles H. Woodbury, thereafter returning nearly every summer. 1922, elected associate of NAD, and academician in 1930. 1915, silver medal PPIE, San Francisco. Several awards from NAD: Julia A. Shaw Prize in 1922 and 1935; Thomas B. Clarke Prize in 1922 (for *The Carpenter*) and 1925; Thomas R. Proctor Prize in 1929 and 1930. Also exhibited in important annuals at PAFA and Corcoran. Founding member of the Guild of Boston Artists, co-founder of the Concord and Ogunquit Art Associations, and member of seven other art organizations. 1929, first woman named to Massachusetts State Art Commission.

The Carpenter, c. 1922

Oil on canvas, 54¼ x 40⅛

Signed lower right, "Gertrude Fiske"

Gift of the Estate of Miss Gertrude Fiske, 66.1529

The Pilgrim, 1925

Oil on canvas, 36 x 30⅛

Signed and dated lower right, "Gertrude Fiske 1925"

Gift of the Estate of Miss Gertrude Fiske, 66.1532

Grandmother, 1926

Oil on canvas, 40½ x 42½

Signed and dated lower left, "Gertrude Fiske 1926"

Gift of the Estate of Miss Gertrude Fiske, 66.1530

Taxes, c. 1939

Oil on canvas, 34⅛ x 42⅛

Signed lower left, "Gertrude Fiske"

Gift of the Estate of Miss Gertrude Fiske, 66.1531

JAMES FITZGERALD
(1899–1971)

Born Boston; died Isle of Arran, Ireland. 1919–23, studied at Massachusetts School of Art with Ernest Lee Major and Wilbur Dean Hamilton, and 1923–24 at the MFA,B, School under Edmund Tarbell, Philip Hale, and Leslie Thompson. 1928–43, painted in Monterey, California. 1925, first trip to Monhegan Island. Continued to paint some summers on Monhegan and after 1943 permanent resident until his death. Exhibited in New York at Milch Gallery and Ferargil Gallery, and in Boston at Doll and Richards, Vose Galleries, and the Boston Society of Watercolor Painters.

Torchin', Monhegan, Maine, c. 1960

Oil on canvas, 34¼ x 44⅛

Signed lower right, "James Fitzgerald"

Gift of Edgar and Anne Hubert, 83.7

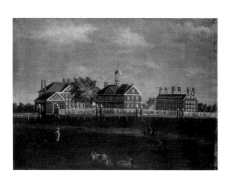

115 Jonathan Fisher Hollis, Harvard and Massachusetts Halls

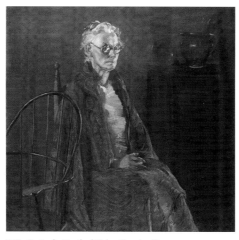

116 Gertrude Horsford Fiske Grandmother

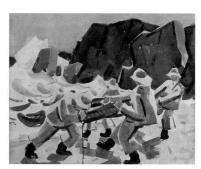

117 James Fitzgerald Fishermen

121 Charles Lewis Fox The Ferry

Fishermen, c. 1938

Watercolor on paper, 19⁷/₁₆ x 25⅛

Signed lower left, "James Fitzgerald"

Museum purchase, 44.338

Plowing, c. 1943

Watercolor on paper, 19⅞ x 25¹³/₁₆

Signed lower right, "James Fitzgerald"

Museum purchase, 45.466

Gulls of Maine, c. 1943

Watercolor on paper, 18⅞ x 23⁹/₁₆

Signed lower right, "James Fitzgerald"

Museum purchase, 45.467

Mountain Mist, c. mid-1930s

Watercolor on paper, 23⅛ x 17⅛

Signed lower left, "James Fitzgerald"

Gift of Mr. and Mrs. Edgar Hubert, 84.25

JOHN FOLINSBEE
(1892–1972)

Born Buffalo, New York; died New Hope, Pennsylvania. 1906, stricken with polio and confined to wheelchair. 1912 and next few summers, studied painting at the ASL summer school in Woodstock, New York, under Birge Harrison and John Carlson. 1914, attended ASL under Frank DeMond and John C. Johansen. 1916, moved to New Hope, Pennsylvania. 1919, elected associate at NAD; 1928 became full member. Awards include: 1916, Third Hallgarten Prize, NAD; 1921, Carnegie Prize, NAD; 1923, First Hallgarten, NAD; 1926, bronze medal, Sesquicentennial International Exposition, Philadelphia; 1931, Sesnan Gold Medal, PAFA; 1941 and 1950, First Altman Prize, NAD. Mid-1930s, began summering on Montsweag Bay near Wiscasset and Boothbay, Maine, and visited there by Andrew Wyeth, William Thon, and William Zorach.

Lopaus Point, 1957

Oil on canvas, 26¼ x 40

Signed lower left, "John Folinsbee"

Gift of Mrs. John Folinsbee, 83.27

CHARLES LEWIS FOX
(1854–1927)

Born and died Portland, Maine. 1872, studied architecture at Massachusetts Institute of Technology for only a year. Studied painting in Paris for six years, with Léon Bonnat and Alexandre Cabanel and apprenticed as a weaver in the Gobelin ateliers. He met and befriended Frank W. Benson who was also studying in Paris. Returned to Portland and established a cooperative school of art on Congress Street, and a summer art colony at North Bridgton, Maine. Marsden Hartley was invited and went to the colony in July 1901. Gained prominence as a painter of Indians and lived several seasons among tribes in the West. Beginning about 1920 he lived for short periods with the Penobscot Indians at Old Town, Maine, and painted numerous portraits of individuals at the reservation. He was known to them as "Gwerksus," which means "The Fox."

The Gleaner, 1885

Oil on canvas, 24¹/₁₆ x 15⁹/₁₆

Signed and dated lower left, "Charles L. Fox / Dordrecht 1885"

Gift of the Estate of Charles L. Fox, 60.1171.52

Spilled Milk, 1886

Oil on canvas, 25⅞ x 19⅜

Signed and dated lower left, "Charles L. Fox Holland 1886"

Gift of the Estate of Charles L. Fox, 60.1171.51

Pride, 1892

Oil on canvas, 21¼ x 27¾

Signed and dated lower left, "To Students of Art / Charles L. Fox 1892"

Gift of the Estate of Charles L. Fox, 60.1171.3

Portrait of a Woman, 1908

Oil on canvas, 31¹³/₁₆ x 35¹³/₁₆

Signed and dated lower right, "C. L. Fox 1908"

Gift of the Estate of Charles L. Fox, 60.1171.53

Portrait of Elizabeth Andrews (Indian Girl, Larbet), 1920

Oil on board, 21¾ x 17¾

Signed and dated lower right, "Gwerksus 1920"

Gift of the Estate of Charles L. Fox, 60.1171

An Indian Child, Julia, 1926

Oil on board, 16 x 20⁵/₁₆

Signed and dated lower right, "Gwerksus 1926"

Gift of the Estate of Charles L. Fox, 60.1171.7

The Ferry, 1926

Oil on cardboard, 17¼ x 21¼

Signed and dated lower left, "Gwerksus / 1926"

Gift of the Estate of Charles L. Fox, 60.1171.37

118 John Folinsbee Lopaus Point

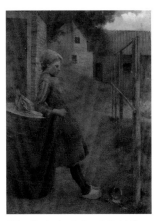

119 Charles Lewis Fox Spilled Milk

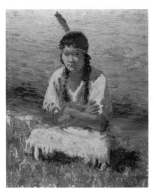

120 Charles Lewis Fox Portrait of Elizabeth Andrews (Indian Girl, Larbet)

THOMAS ADRIAN FRANSIOLI
(1906–1997)

Born Seattle, Washington; died Danvers, Massachusetts. 1930, graduated from University of Pennsylvania with a degree in architecture, also studied at ASL. 1930–43, practicing architect in New York and Virginia; 1943–46, in Army in Guam, Philippines, and Japan. 1946, started painting full time. First exhibition, Margaret Brown Gallery, Boston, 1948. Other exhibitions, 1948–52 and 1958, Whitney; 1949 and 1952, Carnegie; 1950, MMA; 1963, Colby College, Waterville, Maine. Painted murals in Aetna Life Building, Hartford, Connecticut; Princeton Club, New York; Brevoort Hotel, New York. Work included in Whitney; Seattle Art Museum; Dallas Museum of Arts; MFA,B; Boston Public Library. Represented in Boston from 1946 by the Margaret Brown Gallery.

South End, Boston, 1948

Oil on board, 19 x 24⅛

Signed and dated lower right, "T. F. 1948"

Gift of Boston Society of Independent Artists, 50.699

GEORGE FULLER
(1822–1884)

Born Deerfield, Massachusetts; died Brookline, Massachusetts. 1841, began painting after accompanying his brother Augustus on painting tour. 1842–47, studied and worked at Boston Artists Association. 1847–59, studied at NAD and painted portraits. 1860, traveled in Europe and influenced by Barbizon School. 1861–75, farmed the family property in Deerfield. 1875–84, painted full time in Boston and became successful. 1852, elected associate member of NAD, and an original member of the Society of American Artists. Exhibited at NAD, PAFA, American Art-Union, Boston Athenaeum, Doll and Richards, and BAC.

Landscape, n.d.

Oil on canvas, 7 x 9¹⁄₁₆

Signed lower center, "G. F."

Gift of Dr. William Hekking, 58.1094

SEARS GALLAGHER
(1869–1955)

Born West Roxbury, Massachusetts; died Boston. Studied with Samuel P. R. Triscott and Tomasso Juglaris in Boston and Jean-Paul Laurens and Benjamin Constant in Paris. Exhibited at Paris Salon, BAC, PAFA, Boston Society of Water Color Painters, Doll and Richards, Boston Society of Etchers, and Brooklyn Society of Etchers. 1922, awarded Logan Prize for etching, AIC. Accompanied by his teacher, Triscott, Gallagher first visited Monhegan in 1892 and made the island one of his favorite sites for his work in watercolor and etching.

Maine Coast, c. 1923

Watercolor on paper, 9¾ x 13¾

Signed lower left, "Sears Gallagher"

Museum purchase, 44.165

Heavy Sea, c. 1939

Watercolor on paper, 13½ x 19

Signed lower left, "Sears Gallagher"

Museum purchase, 44.116

HENRY MARTIN GASSER
(1909–1981)

Born Newark, New Jersey; died South Orange, New Jersey. Studied at Newark School of Fine and Industrial Art, Grand Central School of Art, ASL with Robert Brackman, and privately with John R. Grabach. Received over 100 awards including: 1943, The Hallgarten Prize, NAD; 1945, Philadelphia Watercolor Club Prize; 1969, American Watercolor Society. Member NAD, American Watercolor Society, Salmagundi Club, and Philadelphia Watercolor Club. 1950, elected academician NAD. 1946–54, director of Newark School of Fine and Industrial Art. 1964–70, taught at ASL.

Old Shaft Road, c. 1950

Casein on paper, 21¼ x 29½

Signed lower right, "H. Gasser"

Gift of Henry Gasser, 68.1603

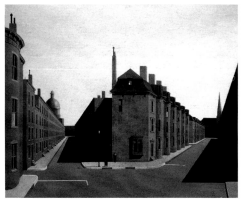

122 Thomas Adrian Fransioli South End, Boston

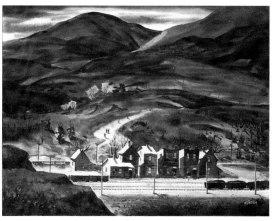

123 Henry Martin Gasser Old Shaft Road

CHARLES DANA GIBSON
(1867–1944)

Born Roxbury, Massachusetts; died New York City. 1883–84, studied ASL with Kenyon Cox and Thomas Eakins; 1889, Académie Julian, Paris. Exhibited at Paris Salon, PAFA, NAD. Illustrated for *Life*, *Harper's Monthly*, *Scribner's*, *Century*, and *Collier's*. Creator of the "Gibson Girl," the beautiful young socialite who epitomized the modern woman of the late-nineteenth and early-twentieth century. 1904–44, spent summers at his estate on Seven Hundred Acre Island, off Islesboro, Maine.

Lady in Red with Cigarette, c. 1939

Oil on canvas, 45½ x 36⅛

Signed lower left, "C. D. Gibson"

Gift of Mrs. John Magro, 84.18

ROBERT SWAIN GIFFORD
(1840–1905)

Born on Naushan Island, Massachusetts; died New York City. Began career as marine painter in New Bedford, Massachusetts, studying with Dutch artist Albert van Beest. 1864, moved to Boston and established studio. Mid-1860s, moved to New York and began to exhibit scenes of sailing vessels at NAD. 1869, took a sketching tour of Oregon and California. 1870, traveled throughout Europe. 1874, voyaged to Algiers and Egypt. 1878, elected associate member NAD. Member of National Arts Club, Royal Society of Painters and Etchers, Society of American Artists, and Society of London Painters.

October Day, 1879

Watercolor on paper, 11¹¹⁄₁₆ x 18⅜

Signed and dated lower left, "R. Swain Gifford 79"

Museum purchase, 95.18

The Roc's Egg, 1874

Watercolor and gouache on paper, 14¹¹⁄₁₆ x 10¾

Signed and dated lower left, "R. Swain Gifford / 74"

Gift of Mrs. Dorothy Hayes, 59.1176

WILLIAM WALLACE GILCHRIST, JR.
(1879–1926)

Born and died Brunswick, Maine. Studied at PAFA and in Munich, Paris, and London. Member of Salmagundi Club, Art Club of Philadelphia, and Philadelphia Water Color Club. 1908, awarded Third Hallgarten Prize, NAD. Summered at Prout's Neck, Maine, and studied with his friend Winslow Homer.

Catnap, 1924

Oil on panel, 10 x 14

Signed and dated lower right, "Gilchrist 24"

Gift of Peter and Carol Stratton Remembering Jean Greig LaHaye, 89.5

ABBOTT FULLER GRAVES
(1859–1936)

Born Weymouth, Massachusetts; died Kennebunkport, Maine. Attended Massachusetts Institute of Technology. 1884, studied under flower painter Georges Jeannin in Paris and roomed with Edmund Tarbell. 1887–90, studied in Paris with flower painter Georges Jeannin. 1885–87, taught at Cowles Art School in Boston along with close friend Childe Hassam. 1891, opened art school in Boston and later moved it to Kennebunk. Member BAC, Boston Water Color Society, Copley Society, Allied American Artists, NAD (elected associate, 1926), PAFA, and Salmagundi Club.

Flowers in a Blue and White Vase, n.d.

Watercolor on paper, 20 x 14

Signed lower left, "Abbott Graves"

Museum purchase, Charles L. Fox Fund with gift of Mr. and Mrs. Kennedy Crane III, 86.8

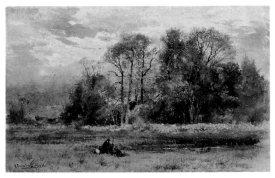

124 **Robert Swain Gifford** October Day

125 **Abbott Fuller Graves** Flowers In a Blue and White Vase

WALTER P. S. GRIFFIN
(1861–1935)

Born Portland, Maine; died Stroudwater, Maine. 1877–81, studied at MFA,B, School. 1882, enrolled at NAD and became friends with William M. Chase, Willard Metcalf, and Childe Hassam. 1887, studied in Paris with Raphael Collin and at Ecole des Beaux-Arts with Jean-Paul Laurens. 1898, in Hartford, Connecticut, as director and instructor at Art Society of Hartford. 1907–11, lived in Old Lyme, Connecticut, and member of art colony there. 1908, summered on Monhegan Island, Maine. 1912, elected associate member of NAD and 1922 full academician status. Exhibited BAC, PAFA, Allied Artists of America, Salmagundi Club, and Paris Salon. 1915, awarded Medal of Honor, PPIE, San Francisco. 1924, Sesnan Gold Medal, PAFA.

July Morning: Contes Alpes Maritimes, 1927

Oil on canvas, 24 x 30

Signed lower right, "Griffin"

Gift of Mrs. George J. Johnson, 78.71

MAURICE GROSSER
(1903–1986)

Born Huntsville, Alabama; died New York City. 1924, graduated with honors in mathematics from Harvard University. Studied at ASL. Author of four books on painting. Librettist for two operas by Virgil Thompson and Gertrude Stein, *Four Saints in Three Acts* (1934) and *The Mother of Us All* (1947). Exhibited at High Museum, Houston Museum of Fine Arts, Boston Athenaeum, NAD, and several New York City galleries. 1956–67, art critic for the *Nation*. 1969–70, visiting professor of art at University of Ife, Nigeria. 1981, elected associate of NAD.

Moroccan Boat, 1958

Oil on canvas, 16⁵⁄₁₆ x 25½

Signed and dated lower right, "Grosser '58"

Gift of the American Academy of Arts and Letters "Childe Hassam Fund," 59.1147

Still Life with Nolid and Polylink, 1979

Oil on canvas, 12¼ x 16⅝

Signed and dated lower right, "M.G. 79"

Gift of Ms. A. Aladar Marberger, Mr. Lawrence L. DiCarlo and Mrs. Beverly Zagor, 86.23.1

ANNA ELIZA HARDY
(1839–1934)

Born Bangor, Maine; died South Orrington, Maine. Studied with her father, artist Jeremiah Hardy, Georges Jeannin in Paris, and Abbott Thayer in Dublin, New Hampshire. Aunt was miniaturist, Mary Ann Hardy. Known for her floral paintings as well as still lifes and portraits. Exhibited for many years at the BAC; 1876 and 1877, NAD; Doll and Richards in Boston; 1881, the Joan Whitney Payson Gallery of Art, Portland, Maine; and 1892, the Bangor Historical Society.

Blackberries, n.d.

Oil on canvas, 16 x 12

Gift of Mrs. Elizabeth B. Noyce, 96.13.3

Pansies, n.d.

Oil on canvas, 11³⁄₁₆ x 27

Signed lower left, "Anna E. Hardy"

Gift of Mrs. Elizabeth B. Noyce, 96.13.10

JEREMIAH PEARSON HARDY
(1800–1888)

Born Pelham, New Hampshire; died Bangor, Maine. Moved to the Bangor, Maine, area in 1811. Studied in Boston with David Brown and later in New York with Samuel F. B. Morse. About 1827, returned permanently to Bangor. Made over 200 portraits as well as genre paintings and still lifes. Traveled to Camden, Bath, Skowhegan on portrait commissions. 1830–50, his productive years. 1830 and 1858 exhibited at the Boston Athenaeum. Works can be found in the MFA,B. Brother of painter Mary Ann Hardy and father of painter Anna Eliza Hardy.

The Trapper, 1823

Oil on cardboard, 9¹⁵⁄₁₆ x 7¹¹⁄₁₆

Signed and dated on back, "P. Hardy 1823"

Museum purchase, 63.1289

Mr. and Mrs. Albert Livingston Kelley of Frankfort, 1862

Oil on canvas, 53½ x 52½

Gift of Waldo Pierce, 58.1114

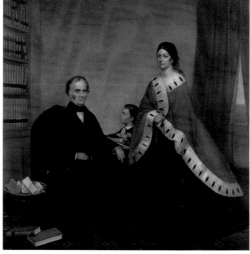

128 **Jeremiah Pearson Hardy** Mr. and Mrs. Albert Livingston Kelley of Frankfort

126 **Walter P. S. Griffin** July Morning: Contes Alpes Maritimes

127 **Anna Eliza Hardy** Blackberries

Young Girl, c. 1870

Oil on canvas, 20¼ x 24

Gift of Miss Charlotte Hardy, 63.1281

The Smelt Seller, c. 1870–80

Oil on canvas, 30⅛ x 24½

Signed lower right, "J. P. Hardy"

Gift from the Estate of Harriet W. St. Clair, 66.1489

Cyrus Brewer, n.d.

Oil on canvas mounted on wood panel, 34¼ x 27¼

Museum purchase, 44.172

Mrs. Cyrus Brewer, n.d.

Oil on canvas, 40¼ x 27

Museum purchase, 44.173

Portrait of Mr. Walter Brown of Bangor, 1847–48

Oil on canvas, 46⅝ x 37

Gift of Mrs. Donald C. Stanley, 67.1548

Portrait of Mrs. Walter Brown of Bangor, 1847–48

Oil on canvas, 46½ x 37¾

Gift of Mrs. Sally Ann Haven Holmes, 67.1549

Camden, n.d.

Oil on cardboard, 11½ x 15½

Gift of Charles D. Childs, 63.1278

GEORGE WAINWRIGHT HARVEY
(1855–1930)

Born East Gloucester, Massachusetts; died Gloucester, Massachusetts. Largely self-taught. Studied in Philadelphia under W. H. Weisman. From 1884 on, had many solo exhibitions at J. Eastman Chase's Gallery in Boston. 1886, traveled to Europe and spent time in Holland. Exhibited 1884, 1894, 1897–99 at the BAC.

Straddle on the Annisquam Marshes, n.d.

Oil on board, 10¼ x 12½

Signed lower right, "GWH"

Gift of Mrs. Dorothy Buhler, 77.48.1

Lighthouse Beach, c. 1898

Watercolor on paper, 8¾ x 12¾

Signed lower left, "George W. Harvey"

Gift of Mrs. Dorothy Buhler, 76.1945.10

Coffin's Beach, c. 1890

Watercolor on paper, 18½ x 25½

Signed lower left, "G. W. Harvey"

Gift of Mrs. Dorothy Buhler, 77.32

WILLIAM STANLEY HASELTINE
(1835–1900)

Born Philadelphia; died Rome, Italy. 1850, studied with German painter Paul Weber in Philadelphia. 1854, graduated Harvard University, then followed Weber to Düsseldorf to study there. 1856–58, sketching trips through Germany, Switzerland, and Italy accompanied by Emanuel Leutze, Worthington Whittredge, and Albert Bierstadt. 1858–70, maintained studio at New York's Tenth Street Studios Building. 1869, moved permanently to Rome, making occasional trips to America. 1859, first trip to Mount Desert, Maine, and during 1860s, painted along the New England coastline. 1860, elected associate member NAD and following year full academician. Exhibited NAD, PAFA, Boston Athenaeum. Co-founder of American School of Architecture, which became the American Academy in Rome in 1897.

Villa of Mme. de Stael, Coppet Lake of Geneva, 1880

Watercolor on paper, 15 x 21½

Signed and dated lower left, "W.S.H. Sept. 20 '80"

Gift of Mrs. Helen Haseltine Plowden, 61.1211

CHARLES EMILE HEIL
(1870–1950)

Born and died Boston. Studied in Boston and Paris. Influenced by John R. DeCamp, Ernest Lee Major, Thomas Courtois, and Filippo Colarossi. 1915, won gold medal for watercolor at PPIE, San Francisco. Member of Boston Water Color Club, Society of Independent Artists, Boston Society of Water Color Painters, Chicago Society of Etchers, Brooklyn Society of Etchers. Exhibited 1896, 1900, 1901–03 and 1906–09, BAC, and 1903, PAFA. Works can be found in Worcester Art Museum, Worcester, Massachusetts; Malden Public Library, Malden, Massachusetts; Concord Art Association.

Circus Horse, n.d.

Watercolor on paper, 10 x 7½

Signed lower left, "Charles E. Heil"

Museum purchase, 46.664

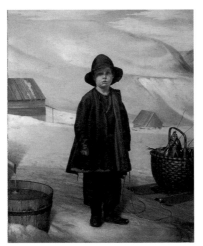

129 Jeremiah Pearson Hardy The Smelt Seller

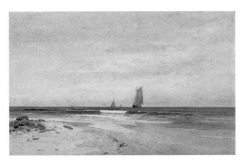

130 George Wainwright Harvey Coffin's Beach

131 William Stanley Hazeltine Villa of Mme. de Stael, Coppet Lake of Geneva

WILLIAM MATHEWS HEKKING
(1885–1970)

Born Chelsea, Wisconsin; died Woolwich, Maine. 1908, graduated Syracuse University. 1908–10, studied with Howard Pyle, also at ASL and Académie Julian in Paris. 1922, awarded gold medal, Kansas City Art Institute, and 1926, Huntington Prize, Columbus Society of Artists. Exhibited at PAFA. Early 1920s, started painting on Monhegan Island, Maine. 1924–31, director of the Albright Art Gallery in Buffalo, New York. 1930, joined expedition of International Ice Patrol to Arctic. Later traveled to Labrador, Greenland, and Iceland. 1954, exhibited at Doll and Richards, Boston, scenes of Eskimo settlements and portraits painted at Grenfel Mission in Labrador.

Black Head, Monhegan, in December, c. 1950s

Oil on Masonite, 24 x 36

Signed lower left, "Wm. M. Hekking"

Gift of Mr. Virgil H. Wedge in memory of Sarah Marion Swayne Hekking, 55.938

Heavy Seas—"Station Alpha," 1962

Oil on Masonite, 24 x 48

Gift of Dr. William M. Hekking, 62.1264

Attika—Eskimo Grand Dame, 1950

Watercolor on paper, 24 x 18

Signed lower right, "Wm. M. Hekking / Attika"

Gift of Mr. Donald A. Hekking, 73.1872

Semigak—Eskimo Patriarch, 1950

Watercolor on paper, 20¼ x 16¼

Signed lower right, "Nutak / Eskimo—Semigak / Labrador / Wm. M. Hekking"

Museum purchase, 68.1615

ROBERT HENRI
(1865–1929)

In the Woods, c. 1890

Oil on canvas, 10½ x 14⁵⁄₁₆

Museum purchase, 81.26

AMASA HEWINS
(1795–1855)

Born Sharon, Massachusetts; died Florence, Italy. 1821, worked as merchant in West India Goods in Boston. 1827, in Washington, D.C., painting portraits. 1830–33, studied in Europe and traveled throughout France, Italy, and Spain. In Italy met Thomas Cole, Samuel F. B. Morse, and Horatio Greenough. 1833–38, 1841–47, painted portraits at his studio in Boston. 1841–42, second trip to Italy. 1852, moved to Italy where he stayed until he died. Exhibited Boston Athenaeum, NAD, and Apollo Association.

Portrait of General Jedediah Herrick, c. 1844

Oil on canvas, 29³⁄₁₆ x 24 1/8

Gift of Mr. W. Herrick Brown, 56.982

ALDRO THOMPSON HIBBARD
(1886–1972)

Born Falmouth, Massachusetts; died Rockport, Massachusetts. 1910–13, Studied MFA,B School with Edmund Tarbell and Frank W. Benson. 1920, awarded first prize, Duxbury Art Association; 1922, First Hallgarten Prize, NAD; 1923, Jennie Sesnan Gold Medal, PAFA; 1928, William Stotesbury Prize, PAFA. 1924, elected associate member NAD and 1934 full academician status. Member BAC, St. Botolph Club, Guild of Boston Artists, Copley Society, Salmagundi Club, NAD, Allied Artists of America, North Shore Arts Association, Rockport Art Association. 1921–48, founder and director Rockport Summer School of Drawing and Painting (later the Hibbard School) in Massachusetts.

After the Blizzard, c. 1940–45

Oil on canvas, 17¾ x 23½

Signed lower right, "A.T. Hibbard"

Museum purchase, 45.465

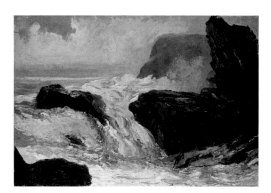

132 William Mathews Hekking Black Head, Monhegan, in December

133 Aldro Thompson Hibbard After the Blizzard

EMIL EUGEN HOLZHAUER
(1887–1986)

Born Schwabisch Gmund, Germany;
died New York. 1909–12, joined
Henri School of Art, New York,
studying with Robert Henri and
Homer Boss. 1930, awarded Logan
Medal and Purchase Prize at
International Water Color Exhibition,
AIC. Exhibited at AIC, Corcoran,
Brooklyn Museum, Whitney, NAD,
PAFA, and Society of Independent
Artists. 1942–46, professor of art,
Wesleyan College. 1914, began paint-
ing on Monhegan Island, Maine,
through the mid-1950s.

Mending Nets, 1928

Oil on canvas, 30¼ x 40¼

Signed and dated lower right,
"Holzhauer / 1928"

Gift of Mr. and Mrs. Emil Holzhauer,
83.12

JAMES HOPE
(1818/19–1892)

Born at Drygrange, Roxboroughshire,
Scotland; died Watkins Glen, New
York. Taken to Canada as a child.
Attended Castleton Seminary in
Vermont in 1842, then took up portrait
painting in West Rutland, Vermont,
in 1843. Worked in Montreal between
1844 and 1846 then returned to
Vermont to paint landscapes and teach
at Castleton Seminary. Fought in the
Civil War and made many sketches,
which he later developed into a series
of large battle paintings that were
exhibited throughout the country.
Exhibited at NAD, American Academy,
American Art-Union, and PAFA.

**Battle of Antietam, September 17,
1862, 7th Maine Attacking over the
Sunken Road through the Piper
Cornfield,** c. 1862

Oil on canvas, 18⅞ x 35⅞

Gift of Alice Bingham Gorman, 97.16

THOMAS HIRAM HOTCHKISS
(c. 1834–1869)

Born Coxsackie, New York, near
Hudson, New York; died Taormina,
Sicily. 1856, began exhibiting at
NAD. 1859, became close friend and
sketching companion of Asher B.
Durand. 1860, traveled in Italy and
settled in Rome and remained there
until his early death from tuberculo-
sis. 1868, visited America. On his
many Italian travels often accompa-
nied by Elihu Vedder. Very little is
known about Hotchkiss's life.
However, reminiscences by Vedder in
his *Digressions of V.,* 1910, provide
many of the known details.

**Cypresses and Convent of San
Miniato,** 1864

Oil on canvas, 14⅝ x 9¼

Gift of Mrs. Dorothy Hayes, 59.1177

ERIC HUDSON
(1864–1932)

Born Boston; died Rockport,
Massachusetts. Studied at MFA,B
School. Studied at Académie Julian.
1926, elected associate member NAD.
1926, awarded silver medal, Sesqui-
centennial Exposition, Philadelphia.
Member of North Shore Artists
Association, Allied Artists of America,
and Salmagundi Club. 1897, began
summering on Monhegan Island.

An Island Harbor, c. 1926

Oil on canvas, 28½ x 34

Signed lower left, "Eric Hudson"

Given in Memory of Eric and
Gertrude Dunton Hudson, 94.12.1

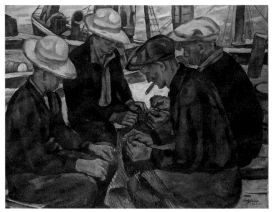

134 **Emil Eugen Holzhauer** Mending Nets

135 **Thomas Hiram Hotchkiss**
Cypresses and Convent of San
Miniato

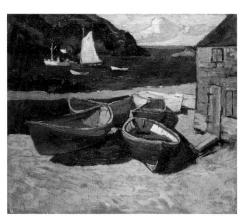

136 **Eric Hudson** An Island Harbor

JOHN BRADLEY HUDSON
(1832–1903)

Born Portland, Maine; died Weston, Massachusetts. Apprentice to his father decorating furniture. 1853, began studies with Charles Octavius Cole in Portland. 1858–late-1890s, active painter in Portland. Later, moved to Weston, Massachusetts. Exhibited Boston Athenaeum, BAC.

Old County Hall, Portland, Maine, 1875–88

Oil on wood panel, 10⅛ x 12⅜

Signed lower left, "J. B. Hudson" and dated lower right, "1875–1888"

Museum purchase, 64.1338

The Auburn-Lewiston Bridge, 1875

Oil on canvas, 12⅝ x 16⅞

Signed lower left, "J. B. Hudson" and dated lower right, "1875"

Museum purchase, 69.1636

JURGAN FREDERICK HUGE
(1809–1878)

Born Hamburg, Germany; died Bridgeport, Connecticut. Biographical information on Huge is scant. As a young man immigrated to America and settled in Bridgeport. 1832, first known painting. 1862, Bridgeport directories listed as grocer. 1869–72 directories listed as landscape and marine artist, and later teacher in drawing and painting, landscape and marine artist.

Clipper Schooner, Hardscrabble, 1872

Watercolor and gouache on paper, 29¼ x 39¼

Signed and dated lower right, "J. F. Huge, Bridgeport, Conn. 12/72"

Gift of Mr. Goodwin Wiseman, 66.1480

ANTONIO NICOLO GASPARO JACOBSEN
(1850–1921)

Born Copenhagen, Denmark; died New York City. Received art training at Royal Academy, Copenhagen. 1871, immigrated to New York City shortly after outbreak of Franco-Prussian War. Employed by Old Dominion Steamship Company to paint ships owned by the firm. 1880, moved to West Hoboken, New Jersey, set up a studio and continued to specialize in steamship portraits. Jacobsen became very successful and his works were often commissioned from European sea captains and owners. Known to be the most prolific of American marine painters.

Schooner Marion N. Cobb, 1909

Oil on board, 21⅞ x 35¾

Signed and dated lower right, "Antonio Jacobsen 1909"

Museum purchase, 58.1103

MERLE P. JAMES
(1890–1963)

Born Farmsville Station, New York; died Cushing, Maine. Graduated from Syracuse University School of Fine Arts with a Bachelor of Painting. Employed as a bookbinder with Roy Crofters Book Binders in East Aurora, New York, and later as director of Rotogravure and art editor of the Buffalo *Courier-Express*. Summers were spent in Cushing, Maine. 1946, retired to Cushing. Chairman of the Members Advisory Council of the Albright Art Gallery for six years.

Olson's, 1944

Watercolor on paper, 14⅛ x 20

Signed and dated center left, "Merle P. James '44"

Gift of Mrs. Louise Rockwell, Mrs. Betsy Wyeth, and Mrs. Gwendolyn Cook, 78.91

137 John Bradley Hudson Old County Hall, Portland, Maine

138 Antonio Nicolo Gasparo Jacobsen Schooner Marion N. Cobb

139 Merle P. James Olson's

WILLIAM JAMES
(1882–1962)

Born Cambridge, Massachusetts; died Chocorua, New Hampshire. Son of William James, the philosopher and psychologist, and nephew of Henry James, the writer. Attended Harvard Medical School, but never practiced. 1904–05, studied with Frank Benson and Edmund Tarbell at MFA,B School. 1905–06, at Académie Julian. Briefly shared a studio in Boston with brother Alexander. 1915, awarded silver medal at PPIE, San Francisco, and 1925, Beck Gold Medal, PAFA. Member of Guild of Boston Artists and American Academy of Arts and Sciences. Friend of Isabella Stewart Gardner. 1913–26, teacher and trustee at MFA,B School and 1936–38, acting director.

Portrait of William A. Farnsworth, 1947

Oil on canvas, 40 x 30

Signed upper right, "W. James"

Museum purchase, 47.698

WILLIAM JENNYS
(active 1793–1807)

Very little is known about the artist, but the distinctive portrait paintings reveal much about his professional career. Mid-1790s, painted portraits in New Milford, Connecticut area, and later spent two years in New York City. 1800–07, traveled the Connecticut River Valley, Massachusetts, and Vermont. Many of his works survive, usually half-length portraits in three-quarter view. Often enclosed in a painted oval spandrel, his sitters are rigidly posed, clearly delineated, and captured intently staring toward the viewer. His strong pictorial style influenced a number of Connecticut Valley artists.

Young Lady, c. 1800

Oil on canvas, 20⅛ x 16¼

Gift of Mrs. Charlotte Hardy, 60.1155

DAVID JOHNSON
(1827–1908)

Born New York City; died Walden, New York. 1845–47, studied at Antique School of the NAD and in 1850, studied briefly with Jasper F. Cropsey. 1849, first exhibited at the NAD and American Art-Union. 1859, elected associate member NAD, and 1861 received academician status. 1876, awarded prize at the Philadelphia Centennial Exposition. One of the founders of the Artists' Fund Society. A second-generation Hudson River School painter, Johnson made many sketching trips to New England, often accompanied by Benjamin Champney, John F. Kensett, and John W. Casilear. Summered in the Catskills and in the White Mountains at North Conway, New Hampshire, and made a few visits to Maine. Remained in New York City until 1904, then moved to Walden, where he died four years later.

Landscape, 1875

Oil on wood panel, 4¹⁵⁄₁₆ x 7¾

Signed and dated lower left, "DJ 75"

Museum purchase, 89.2

(JONATHAN) EASTMAN JOHNSON
(1824–1906)

Young Girl, c. 1880s

Oil on canvas, 27 x 21¼

Signed lower left, "E. J."

Gift of Mr. Gifford Cochran, Lamoine, Maine, 63.1299

Portrait of Counsellor Pruyn, c. 1883

Oil on board, 22¼ x 14⁵⁄₁₆

Signed lower left, "E. J."

Gift of Mr. Gifford Cochran, Lamoine, Maine, 66.1477

140 William James Portrait of William A. Farnsworth

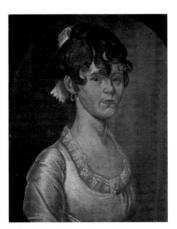

141 William Jennys Young Lady

142 (Jonathan) Eastman Johnson Young Girl

BERNARD KARFIOL
(1886–1952)

Born Budapest, Hungary; died Irvington-on-Hudson, New York. 1900, studied at NAD. 1901, studied in Paris at Académie Julian with Jean-Paul Laurens and later at Ecole des Beaux-Arts. Traveled throughout Mexico, Europe, West Indies. 1906, returned to U.S. from Europe and became a studio painter of still lifes and nudes. 1913, included in the Armory Show. 1925, won prize at PPIE, Los Angeles. 1928, awarded Corcoran Gold Medal and the first William A. Clark Prize. Numerous exhibitions; in Paris at the Grand Salon and Salon d'Automne, in New York at NAD, Downtown Gallery, and the Forum Gallery, and Philadelphia at PAFA. 1914 on, summered at Ogunquit, Maine.

Josias River, Perkins Cove, 1917

Oil on canvas, 19¹⁵⁄₁₆ x 25

Signed lower left, "B. Karfiol"

Gift of George R. Karfiol, 83.15

WILLIAM JURIAN KAULA
(1871–1953)

Born and died Boston. 1887–91, studied in Boston at Massachusetts Normal Art School, 1891–96 at Cowles Art School and privately with Edmund Tarbell. Attended Académie Colarossi and Académie Julian in Paris. Member of BAC, St. Botolph Club, Copley Society, Boston Water Color Club, Guild of Boston Artists, and Boston Society of Watercolor Painters, and American Artists Association of Paris. Also exhibited at Paris Salon and PAFA. 1915, awarded bronze medal at PPIE, San Francisco. Maintained studio in Boston and summered in New Ipswich, New Hampshire.

Pine Valley, n.d.

Watercolor on paper, 17¾ x 22

Signed lower left, "W. J. Kaula"

Museum purchase, 44.166

WILLIAM KEITH
(1838/39–1911)

Born Aberdeenshire, Scotland; died Berkeley, California. 1850, immigrated to U.S. and apprenticed as engraver for *Harper's* magazine in New York City until 1859. 1868, commissioned by Oregon Navigation and Railroad Company to complete a number of landscape paintings and watercolors. For this commission Keith made a four-month sketching trip along the Columbia River. 1869–70, studied in Europe and on his return to America painted for some time in Maine. 1871, opened studio with Wilhelm Hahn in Boston. 1872, settled in San Francisco and was an important member of the Rocky Mountain School. Exhibited at NAD, BAC, and PAFA.

Artist Monks Fishing, c. 1870s

Oil on canvas, 20 x 30¹⁄₁₆

Gift of Edwin Beckwith, 61.1200

JOHN FREDERICK KENSETT
(1816–1872)

Born Cheshire, Connecticut; died New York City. About 1828, studied engraving with his father, Thomas Kensett, and his uncle, Alfred Daggett in New Haven. 1840–48, sailed to Europe with Asher B. Durand, John W. Casilear, and Thomas P. Rossiter and studied landscape painting in England, France, Italy, and Germany. He shared a studio with Benjamin Champney in Paris and Thomas Hicks in Rome. On his return to America he opened a studio in New York and met with almost instant success. 1848, elected associate member of NAD, and following year full status. 1870, member of first board of trustees of the MMA. 1841–72, made sketching tours every summer, variously in Newport, Rhode Island, several sites in New York State, the Berkshires, the White Mountains, Ohio, New Jersey, and Maine.

The Meadow, n.d.

Oil on canvas, 10½ x 14⅜

Gift of Mr. Gifford A. Cochran, 65.1443

143 Bernard Karfiol Josias River, Perkins Cove

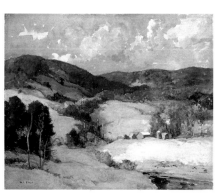

144 William Jurian Kaula Pine Valley

ROCKWELL KENT
(1882–1971)

Lone Rock and Sea, 1950

Oil on canvas, 28 x 44

Museum purchase, 77.35

WILLIAM KIENBUSH
(1914–1980)

To the Sea—Jutland (Jay Sunderland's Studio), 1959

Casein on paper, 27⁷⁄₁₆ x 39½ (sight)

Signed and dated lower left, "Kienbush 59"

Gift of Bruce Brown, 97.12

Rowboat to Island #2, 1973

Casein on paper, 32¼ x 40½

Signed and dated lower right corner, "Kienbush 73"

Museum purchase, 96.11

CHARLES F. KIMBALL
(1831–1903)

Born Monmouth, Maine; died Portland, Maine. 1857, studied painting briefly with Charles Octavius Cole and opened studio on Congress Street in Portland. Exhibited with John Bradley Hudson, who also studied with Cole. During Civil War stopped painting professionally and became a cabinetmaker. A founder of the Portland Society of Art.

Portland from South Portland, 1860

Oil on canvas, 10 x 18

Signed and dated lower right, "C. F. K. 1860"

Gift of the Estate of Charles L. Fox, 60.1273

PAUL KING
(1867–1947)

Born Buffalo, New York; died Stony Brook, Long Island, New York. Studied 1901–04 at ASL with H. Siddons Mowbray; 1905–06 in Holland with Willy Sluiter, Evert Pieters, and Bernard Bloomers. 1908–21 board member, vice president, and acting president of the Philadelphia School of Design for Women. 1918, associate and 1933 academician of NAD. Exhibited regularly at PAFA between 1903 and 1938; BAC 1907 and 1909; NAD 1902–1948. Member of Salmagundi Club, awarded Shaw Prize and Inness Prize in 1906. Member Allied Artists of America; American Federation of the Arts; Art Club of Philadelphia; Artist's Aid Society; Artists' Fund Society; International Society of Arts and Letters; fellowship, PAFA. 1915, awarded silver medal PPIE, San Francisco; 1923, first Altman Prize, NAD.

Quarry, Rockland, Maine, c. 1921

Oil on canvas, 32¼ x 40⅛

Signed lower right, "Paul King"

Museum purchase, 74.1924

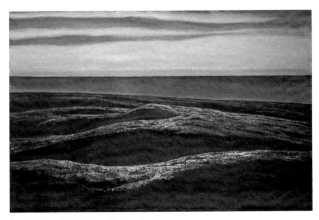

145 **Rockwell Kent** Lone Rock and Sea

146 **Paul King** Quarry, Rockland, Maine

DANIEL RIDGWAY KNIGHT
(1840–1924)

Born Philadelphia, Pennsylvania; died Paris, France. 1858–61, studied at PAFA. 1861–63, studied at Ecole des Beaux-Arts and at Atelier Gleyre, where he became friends with Auguste Renoir and Alfred Sisley. 1863–65, served in Union Army. 1871, moved to Paris, then Poissy as permanent home. Exhibited Paris Salon nearly every year from 1873–99. 1888, third gold medal, Paris Salon. 1889, silver medal, Munich Exhibition. 1893, medal at World's Columbian Exposition, Chicago. 1896, Grand Medal of Honor, PAFA.

Man on Wall Smoking Pipe, n.d.

Watercolor on paper, 15 x 10¹¹⁄₁₆

Signed lower left, "D. Ridgway Knight"

Gift of Mrs. Edward Browning, Sr., 56.974

LEON KROLL
(1884–1974)

Born New York City; died Gloucester, Massachusetts. 1901, studied at ASL with John H. Twachtman; 1906–08 at Académie Julian, Paris, with Jean-Paul Laurens. Taught at NAD, Maryland Institute of Art, AIC, ASL. 1920, associate and 1927 academician NAD. Friend and traveling companion of George Bellows, Robert Henri, Maurice Prendergast, and Marc Chagall. 1916 and 1929, came to Maine. 1910, first solo exhibition at NAD. Awarded over thirty prizes: among them AIC Frank C. Logan Prize, 1919; NAD Benjamin Altman Prize, 1923, 1932, 1935; AIC Potter Palmer Gold Medal, 1924; PAFA Joseph E. Temple Gold Medal, 1927; Carnegie First Prize, 1936. Member National Arts Club; New Society of Artists; Philadelphia Art Club; BAC; Salmagundi Club; American Society of Printers, Sculptors and Engravers, president 1931–35. Exhibited regularly 1911–66 at PAFA; 1906–50, NAD, AIC. As member WPA Federal Art Project, painted murals in Justice Department Building in Washington, D.C.

Lowering Day, Camden, 1916

Oil on canvas, 26¾ x 32⅛

Bequest of Mrs. Elizabeth B. Noyce, 97.3.28

Crashing Waves, Ogunquit, 1915

Oil on panel, 4⅛ x 4¹⁵⁄₁₆

Bequest of Mrs. Elizabeth B. Noyce, 97.3.28

MAX KUEHNE
(1880–1968)

Born Halle, Germany; died New York City. Family immigrated to U.S., settling in Flushing, New York. 1907, studied painting with William Merritt Chase and Kenneth Hayes Miller. 1909, joined night class run by Robert Henri. 1910, traveled to Europe to study old masters. On returning to U.S. painted in New York City, Gloucester and Rockport, Massachusetts. 1914, traveled to Spain where he lived and worked until 1917. Spent 1922, 1924, and 1929 in Spain. 1919 and 1921 in Maine. 1912–14 exhibited work at Charles Daniel Gallery, New York; 1917 and 1918, Whitney Studio Club; 1926 and 1927, Rehn Gallery, New York; 1926, 1933, 1936, and 1937, Carnegie International Exhibitions, winning honorable mention in 1926; 1931, NAD; 1932, AIC; 1933, Whitney; 1936, solo exhibition at Kleeman Galleries, New York. Member Rockport Art Association.

Rockport Harbor, Maine, 1919

Oil on canvas, 31 x 36⅛

Signed and dated lower left, "Kuehne 19"

Bequest of Mrs. Elizabeth B. Noyce, 97.3.29

YASOU KUNIYOSHI
(1893–1953)

Born Okayama, Japan; died New York City. 1906, came to the United States. 1908–10, studied at Los Angeles School of Art and Design; later studied at NAD; 1914–16 at Independent Artist's School; 1916–20 with Kenneth Hayes Miller at the ASL; 1935 Guggenheim Fellowship to Mexico. 1933–53 taught at ASL and 1936–53 at New School for Social Research, New York. 1948, retrospective exhibition at Whitney; 1952, represented at Venice Biennale. Member Brooklyn Modern Artists, National Institute of Arts and Letters, Artist's Equity Association (president). Among awards: 1934, Los Angeles Museum of Art; 1939, Golden Gate Expo, San Francisco; 1939 and 1944, Carnegie Institute; 1950, second prize MMA.

Fishing Scene, Maine, 1922

Watercolor and graphite on paper, 11⁵⁄₁₆ x 8⅜

Signed and dated lower left, "Kuniyoshi 22"

Museum purchase, 96.3

147 Daniel Ridgway Knight
Man on Wall Smoking Pipe

149 Max Kuehne Rockport Harbor, Maine

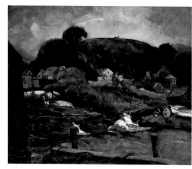

148 Leon Kroll Lowering Day, Camden

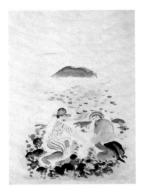

150 **Yasou Kuniyoshi** Fishing Scene, Maine

151 **John La Farge** Japanese Fisherman, Study of Sunlight

JOHN LA FARGE
(1835–1910)

Born New York City; died Providence, Rhode Island. 1856, studied painting in Paris with Thomas Couture. 1859, returned to U.S., studied with William Morris Hunt in Newport for a year. 1876, artistic shift from flower studies and landscapes to stained glass and murals, received commission to decorate H. H. Richardson's Trinity Church in Boston. At the fore of the American Arts and Crafts movement, joined with architects McKim, Mead and White, and sculptor Augustus Saint-Gaudens in revival of Renaissance techniques. One of the first American artists to admire Japanese art. 1886 and 1890, accompanied by writer Henry Adams traveled to Japan and the South Seas, producing some of his best watercolors. 1901, awarded gold medal, PPIE, Buffalo. Member American Academy of Arts and Letters, American Institute of Architects.

Japanese Fisherman, Study of Sunlight, c. 1888–89

Watercolor on paper, 6⅛ x 5¹⁄₁₆

Museum purchase, 44.360

FITZ HUGH LANE
(1804–1865)

Pretty Marsh, Mt. Desert Island, mid-1860s

Oil on canvas, 10⅝ x 15¼

Gift of Mr. and Mrs. S. Morton Vose, 60.1168

Penobscot Bay from the Southwest Chamber Window, 1851

Oil on canvas, 11 x 17

On back, "F. H. Lane and J. J. Stevens"

Museum purchase, 60.1203

154 **Bernard Langlais** Summer Music

BERNARD LANGLAIS
(1921–1977)

Born Old Town, Maine; died Portland, Maine. Studied Corcoran School with Ben Shahn; 1949–51, Skowhegan School with Henry Varnum Poor; 1949, Brooklyn Museum School with Max Beckmann; Académie de La Grande Chaumière, Paris; Academy of Art, Oslo. Exhibited: Leo Castelli, Inc., New York City; 1962, Allan Stone Gallery, New York City; 1962, San Francisco Museum of Art; 1966, Makler Gallery, Philadelphia; Portland Museum of Art, Maine; AIC annuals; Whitney annuals; Houston Museum of Fine Arts; MOMA; Carnegie, and others. Among awards: scholarship, Corcoran; Fulbright Fellowship (Norway); 1969, Purchase Award, National Academy of Arts and Letters; 1972, Guggenheim Fellowship; Ford Foundation.

Summer Music, n.d.

Oil on board, 16 x 20

Signed lower left, "Bernard Langlais"

Gift of Mrs. Elizabeth B. Noyce, 96.13.2

Seagulls, 1977

Mixed media on canvas, 24¹⁄₁₆ x 30⅛

Signed lower right, "Bernard Langlais"

Bequest of Mrs. Elizabeth B. Noyce, 97.3.32

Elephant, n.d.

Painted plywood, 11 x 20½

Gift of Maine State Museum on behalf of the State of Maine, 80.16

Eagle, c. 1975

Wood sculpture on pressed board, 17⁷⁄₁₆ x 34⅝

Die-stamped letters lower left of frame, "Bernard Langlais"

Gift of Dr. and Mrs. Robert B. Stewart, 91.18

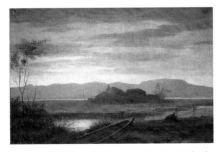

152 **Fitz Hugh Lane** Pretty Marsh, Mt. Desert Island

153 **Fitz Hugh Lane** Penobscot Bay from the Southwest Chamber Window

ERNEST LAWSON
(1873–1939)

Born Halifax, Nova Scotia; died Miami Beach, Florida. 1888, studied at Kansas City Art School. 1891, moved to New York City, enrolled at ASL and studied with John H. Twachtman. 1892–93, transferred to art school at Cos Cob, Connecticut, opened by Twachtman and J. Alden Weir. 1893, studied at Académie Julian. 1895, returned to U.S., settling in Washington Heights, the upper end of Manhattan. 1908, elected associate member of NAD, receiving full academician status 1917. Received many awards including 1904, silver medal, St. Louis Universal Exposition; 1907, Sesnan Medal, PAFA; 1908, First Hallgarten Prize, NAD; 1915, gold medal, PPIE, San Francisco; 1916, Altman Prize, NAD; 1917, Inness Gold Medal, NAD; and 1920, Temple Gold Medal, PAFA.

Peggy's Cove, c. 1924

Oil on panel, 16 x 20

Museum purchase, 45.441

WILLIAM ROBINSON LEIGH
(1866–1955)

Born near Falling Waters, Berkeley County, West Virginia; died New York City. 1880–83, studied with Hugh Newell at Maryland Institute, Baltimore. Next twelve years studied in Germany, and 1883–87 and 1891–92 at Royal Academy, Munich. 1896, settled permanently in New York City. Painted portraits, cycloramas at the Natural History Museum, and illustrations for *Scribner's*, *Natural History*, and *Collier's*. 1906, traveled to Wyoming, New Mexico, and Arizona. 1955, elected member NAD. Also member of Allied Artists of America, Salmagundi Club, and American Watercolor Society. Awarded medals by Royal Academy, Munich, and Paris Salon.

Arizona Sunset, 1917

Oil on panel, 13 x 16⅝

Signed and dated lower right, "W. R. Leigh 1917"

Gift of Mr. Gifford Cochran, 64.1326

WILLIAM HENRY LIPPINCOTT
(1849–1920)

Born Philadelphia; died New York City. Began art training at PAFA, and in 1874 left for Paris and studied with Léon Bonnat. Remained in Paris for eight years, returned in 1882 and opened studio in New York. 1885, elected associate member NAD, full academician status in 1897. Also member of Century Association, American Watercolor Society, Society of American Etchers, and New York Etching Club. Later became professor of painting at NAD. Exhibited at Paris Salon, PAFA, NAD, and awarded honorable mention at 1901 Pan-American Exposition, Buffalo.

Man Reading the Kennebec Journal, 1891

Oil on canvas, 21⅛ x 25¹⁵⁄₁₆

Signed and dated lower left, "Copyright Wm. H. Lippincott 1891"

Museum purchase, 63.1276

PHILIP LITTLE
(1857–1942)

Born, Swampscott, Massachusetts; died Salem, Massachusetts. 1875–77, studied Massachusetts Institute of Technology and Lowell Institute and 1881–82, MFA,B School. Worked for his father in the Pacific Mills factory in Lawrence and at Forbes Lithograph Company in Boston. Was curator of fine arts at the Salem Institute in Salem, Massachusetts. He shared a studio with Frank Benson in Salem. 1907, first solo exhibition at Rowlands Galleries in Boston; also exhibitions at Rhode Island School of Design, Providence; Library and Art Museum, Utica, New York; Worcester Art Museum, Worcester, Massachusetts; and St. Louis City Art Museum. Group exhibitions: 1881, BAC; 1911–22, NAD; 1914–30, PAFA. Awards include, 1912, Paris Salon and AIC; 1915, silver medal, PPIE, San Francisco.

The Glory of October, 1909

Oil on canvas, 36 x 36¼

Museum purchase, 91.8

The Weirs, n.d.

Oil on canvas, 30⅛ x 25⅛

Signed lower left, "Philip Little"

Gift of Mrs. Talbot Aldrich, 54.1060

An August Day, c. 1918

Oil on canvas, 30⅛ x 25

Signed lower left, "Philip Little"

Gift of Mrs. Marguerite Little Young, 54.1068

155 William Henry Lippincott Man Reading the Kennebec Journal

156 Philip Little The Glory of October

MICHAEL LOEW
(1907–1985)

Born and died New York City. 1926–29, studied ASL with Richard Lahey and Boardman Robinson; 1930, Académie Scandinave, Paris; 1947–49, Hofmann School, New York City; 1950, Atelier Fernand Léger, Paris. Traveled to France, Germany, Italy, Africa, Mexico, Central America, Spain, England. 1956–57 taught at Portland Museum School, Oregon; 1958–85, School of Visual Arts, New York City. Member American Abstract Artists and Federation of Modern Painters and Sculptors. 1976, Guggenheim Foundation Fellowship. Exhibited at Portland Art Museum, Oregon; various galleries in New York City; Salon des Réalités Nouvelles; Federation of Modern Painters and Sculptors; AIC; Colby College Museum of Art; PAFA; Portland Museum of Art, Maine; Whitney; MMA. 1949, first trip to Monhegan Island.

Green, Purple, Orange on Ochre, 1976–1977

Acrylic on canvas, 66 x 60

Gift of Mrs. Mildred C. Loew, 97.20

Monhegan Harbor 3, 1949

Watercolor on paper, 15¼ x 19⅛

Signed and dated lower right, "M. Loew '49"

Gift of Maurine and Robert Rothschild, 94.20

GEORGE BENJAMIN LUKS
(1867–1933)

Born Williamsport, Pennsylvania; died New York City. 1884, studied PAFA, and later in academies in London, Paris, Düsseldorf, and Munich. 1894, joined art staff at *Philadelphia Press.* 1894–95 attended Robert Henri classes and formed friendships with Everett Shinn, John Sloan, and William Glackens, who together formed the core group of The Eight, later known as the Ashcan School or the New York Realists. Member National Association of Portrait Painters, New York Watercolor Club, and American Painters and Sculptors. 1916, awarded William A. Clark Prize and Honorable Mention, Corcoran. 1918, Temple Gold Medal, PAFA. 1920 and 1926, Logan Medal, AIC. 1932, William A. Clark Prize and Gold Medal, Corcoran.

Children at Play, n.d.

Watercolor and gouache on paper, 5¹¹⁄₁₆ x 8

Signed lower right, "G Luks"

Museum purchase, 44.190

In the Park, n.d.

Watercolor and gouache on paper, 5¾ x 8½

Signed lower left, "G Luks"

Museum purchase, 44.189

DODGE MACKNIGHT
(1860–1950)

Born Providence, Rhode Island; died East Sandwich, Massachusetts. Apprenticed to theatrical scene designer, in 1878 worked at Taber Art Company of New Bedford, Massachusetts, making reproductions of paintings and photographs. 1883, studied in Paris with Fernand Cormon. 1886–87, traveled to England, southern France, Spain, and Algeria. 1890, exhibited work in John Singer Sargent's London studio. Beginning 1888 and almost annually throughout his career, exhibited in Boston at Doll and Richards. 1897, returned to U.S., settling East Sandwich, Cape Cod. 1901, Isabella Stewart Gardner became a friend and patron. 1921, works exhibited with Winslow Homer and Sargent at BAC, and during the twenties acclaimed as a great watercolorist. Also exhibited at Paris Salon, PAFA, and St. Botolph Club, Boston.

The Land of the Olive and Fig, 1885

Watercolor on paper, 11¼ x 18½

Signed lower left, "W. Dodge MacKnight" and dated lower right, "Aubenas, France 1885"

Gift of Miss Anna A. Kloss, 69.1631.1

ETHEL MAGAFAN
(1916–1993)

Born Chicago; died Woodstock, New York. Studied Colorado Fine Arts Center and with Frank Mechau, Boardman Robinson, and Peppino Mangravite. 1951, Fulbright Fellowship. Awards include 1951, 1956, 1964, 1967, NAD; 1955, 1962, American Watercolor Society, Pomona, California; 1962, Albany Institute of History and Art; 1966, Connecticut Academy of Fine Arts. Exhibited MMA; Carnegie; AIC; NAD; Audubon Artists; PAFA; Corcoran; San Francisco Museum of Art; Whitney; MFA,B; and others.

Snow above the Meadow, n.d.

Tempera on Masonite, 20½ x 27¼

Signed lower left, "Ethel Magafan"

Gift of Mr. James T. Wallis, 70.1755A

160 Dodge MacKnight The Land of the Olive and Fig

159 George Benjamin Luks Children at Play

157 Michael Loew Green, Purple, Orange on Ochre

158 Michael Loew Monhegan Harbor 3

PAUL HOWARD MANSHIP
(1885–1966)

Born St. Paul, Minnesota; died New York City. 1892–1903, studied St. Paul Institute School of Art. 1905, enrolled at ASL, became assistant to sculptor Solon Borglum. 1906–08, classes at PAFA with Charles Grafly. 1909–12, awarded Prix de Rome and studied at American Academy, Rome. 1912, returned to America and received high praise for work abroad influenced by archaic Greek sculpture. 1914, elected associate member NAD, 1916, full-member status. Member National Sculpture Society (president 1939–42), (Federal) Commission of Fine Arts (president 1937–41), and Century Association (president 1950–54). Awarded numerous prizes including: 1913, Helen Foster Barnett Prize, NAD; 1914, George D. Widener Memorial Gold Medal, PAFA; 1915, gold medal, PPIE, San Francisco; 1921, gold medal, American Institute of Architects; 1925, Saltus Gold Medal for Merit, NAD; 1937, Diplome d'Honneur, Paris World's Fair; and 1945, major retrospective and gold medal, National Institute of Arts and Letters.

Europa and the Bull, 1924

Bronze on marble, 10½ x 12⅞ x 7⅞

Signed, dated, and inscribed on back, "P. MANSHIP / copyright 1924"

Museum purchase, 45.443

161 **Paul Howard Manship** Europa and the Bull

FRANK C. MATHEWSON
(1862–1941)

Born and died Barrington, Rhode Island. Studied with Jean-Paul Laurens in Paris and at National School of Decorative Arts in Paris. Member of New York Watercolor Society, American Watercolor Society, Providence Art Club, North Shore Art Club, and honorary president of South County Art Society. Spent winters in Providence and summers in South Kingston, Rhode Island.

Ogunquit, Maine, 1903

Oil on canvas, 24 x 20

Signed and dated lower left, "F. C. Mathewson 1903" and inscribed lower right, "Ogunquit, Me."

Gift of Mr. Robert Van Winter, 84.29

162 **Frank C. Mathewson** Ogunquit, Maine

JOHN W. MCCOY
(1910–1989)

Born Pinole, California; died Chadd's Ford, Pennsylvania. Early education at Wilmington Friend's School; 1929–33, Cornell University, Ithaca, New York; 1931–32, summer courses at Beaux-Arts School, Fontainebleau, France, under Jean Despujos, André Strauss, and Gaston Baland; 1934, PAFA; 1934, begins study with N. C. Wyeth. 1946–61 instructor at PAFA. 1938, first solo exhibition at Vose Gallery in Boston. Solo exhibitions: 1942, Munson-Williams-Proctor Institute, Utica, New York; 1942, Babcock Gallery, New York; Knoedler's Gallery, New York; Coe Kerr Gallery, New York; 1945, Currier Gallery, Manchester, New Hampshire; Schenectady Museum, Schenectady, New York; 1955, William A. Farnsworth Library and Art Museum, Rockland, Maine; 1959, Delaware Art Museum, Wilmington, Delaware. Awarded Whitmer Memorial, American Watercolor Society; Philadelphia Watercolor Club Prize; Obrig Prize, NAD; Dana Medal, PAFA; Samuel F. B. Morse Medal, NAD. Member of NAD; Audubon Artists; Philadelphia Watercolor Club; American Watercolor Society; PAFA; 1944–45 director, Wilmington Society of Fine Arts.

Wawenock Hotel, 1944

Tempera on panel, 25 x 30

Gift of Anna B. McCoy in memory of John W. McCoy, 55.912

Witch Corner, 1976

Oil, watercolor, and acrylic on paper, 28¹³⁄₁₆ x 20⅞

Signed lower left, "John W. McCoy"

Gift of anonymous donor in memory of Wendell Hadlock, 79.54

163 **John W. McCoy** Witch Corner

LEO JOHN MEISSNER
(1895–1977)

Born Detroit, Michigan; died Yonkers, New York. Studied at Detroit School of Fine Arts under John Wicker. Enrolled at ASL studying with Guy Pène du Bois and George Luks. Art editor for *Charm* and *Motor Boating* magazines for twenty-five years. 1950, retired and focused on painting and printmaking. 1923 on, maintained home and studio on Monhegan Island. Awarded several prizes: 1923, Mary Smith Prize, PAFA; Pennell Purchase Prize at the Library of Congress; Best Print Prize, Michigan Artist; 1964, second Cannon Prize, NAD. 1969, elected academician NAD. Member Audubon Artists, Society of American Graphic Artists, Albany Print Club, Boston Print Makers, Michigan Academy of Science, Arts and Letters; the Prairie Print Makers; and Old Bergen Art Guild.

Cathedral Woods, 1967

Oil on academy board, 30 x 22

Signed lower left, "Leo / Meissner"

Gift of Mr. and Mrs. Leo J. Meissner, 67.1541

Fiddlers Ledge Awash, n.d.

Oil on canvas board, 22 x 28

Signed lower right, "Leo Meissner"

Gift of the Estate of Mrs. Leo Meissner, 78.63.2

Squeaker Cove, n.d.

Oil on panel, 24 x 17¹⁵⁄₁₆

Signed lower left, "Leo Meissner"

Gift of the Estate of Leo Meissner, 78.63.6

HERBERT W. MEYER
(1882–1960)

Born and died New York City. Studied at ASL with John H. Twachtman. Member of Salmagundi Club, New York Architectural League, Allied Artists of America, New York Watercolor Club, American Watercolor Society, and NAD. Exhibited at NAD and PAFA.

View of Haystack, c. 1938

Oil on canvas, 24 x 36

Signed lower right, "Herbert Meyer"

Gift of Mr. and Mrs. Edward W. Freeman, 67.1542

THOMAS MORAN
(1837–1926)

Born Bolton, Lancashire, England; died Santa Barbara, California. 1844, immigrated to America. 1853–56, apprenticed to engraving firm in Philadelphia, and 1856 began sharing studio with his brother Edward (1829–1901). 1871, joined U.S. Geological Survey with F. V. Hayden to Yellowstone region. 1873, accompanied Major John Wesley Powell's Grand Canyon Expedition, and 1874, again with Hayden, traveled to Mountain of the Holy Cross, Colorado. One of the first artists to see and paint largely unknown western scenery, Moran is considered "the father of the [United States National] park system." 1876, awarded medal Centennial Exposition, Philadelphia. 1878, first visited Long Island, New York. 1884, built studio in East Hampton. 1881, elected associate member NAD and three years later received full academician status. 1922, moved permanently to Santa Barbara.

Attributed to Thomas Moran

Alpine Landscape, c. 1880s

Oil on wood panel, 18 x 24⅞

Signed lower right, "Moran"

Gift of Mrs. Stuart Symington, 91.26

WILLIAM HORACE MUIR
(1902–1964)

Born Hunter, North Dakota; died Stonington, Maine. Studied at Minneapolis School of Arts under Charles S. Wells and Richard Lahey; 1923–24 at ASL with Leo Lentilli and Robert Laurent. Materials used included tropical woods and hardwoods, a variety of stones including granite, and bronze. Also made watercolors, pastels, charcoal drawings, window displays, and dioramas. 1939, moved to Deer Isle, Maine, with his artist wife, Emily Muir. Exhibited sculpture in 1934 at NAD; 1958 and 1964, PAFA. Numerous other exhibitions at Sculpture Center, New York; Portland Museum of Art, Maine; University of Maine; MMA; Brooklyn Museum, and 1931 International Watercolor Exhibition at the Brooklyn Museum.

Fish Packing Plant, 1945

Watercolor on paper, 14⅛ x 19⅝

Signed and dated upper left, "Bill Muir 45"

Bequest of Mrs. Elizabeth B. Noyce, 97.3.40

164 Leo John Meissner Cathedral Woods

165 William Horace Muir
Fish Packing Plant

169 William Edward Norton Lost in the Fog

LOUISE NEVELSON
(1899–1988)

York Avenue, New York City, 1934

Oil on board, 35¾ x 23⅞

Signed and dated lower center, "Nevelson 1934"

Bequest of Nathan Berliawsky, 80.35.21

Child, c. 1946–51

Terra-cotta, 11 x 9 x 7½

Bequest of Nathan Berliawsky, 81.11.11

Mother and Child II, c. 1946–51

Terra-cotta 14½ x 8½ x 6½

Gift of the artist, 81.11.9

Martha Graham, c. 1950

Cast bronze with black patina, 8½ x 17¾ x 9½

Signed along base of figure's left leg, "Nevelson"

Gift of the artist, 84.23.8

Figure in a Blue Shirt, 1952

Oil on canvas, 42 x 24¹⁄₁₆

Signed and dated lower right, "Nevelson 1952"

Bequest of Nathan Berliawsky, 80.35.25

Orfeo: Gold Throne I, 1984

Gold leaf on wood, 63 x 28 x 18

Gift of the artist, 85.23.29

Orfeo: Gold Throne II, 1984

Gold leaf on wood, 36¾ x 35 x 17

Gift of the artist, 85.23.3

166 Louise Nevelson Child

167 Louise Nevelson Mother and Child II

WILLIAM EDWARD NORTON
(1843–1916)

Born Boston; died New York City. Went to sea in his teens. Attended art and science classes at Lowell Institute and Harvard Medical School. Studied with George Inness, and in Paris with Antoine Vollon and Jacquesson de la Chevreuse. Lived in Europe for twenty-five years, London, Paris, and Italy. 1878–1901, exhibited at Royal Academy in London. 1895–98, exhibited at Paris Salon, receiving honorable mention in 1895. 1902, returned to America, and exhibited in New York at NAD and Salmagundi Club, and in Boston at BAC. Also exhibited at the Philadelphia, Chicago, and St. Louis Expositions.

Lost in the Fog, 1872

Oil on canvas, 28³⁄₁₆ x 48³⁄₁₆

Signed and dated lower left, "Norton 1872"

Gift of the Estate of Mrs. Arthur Williston, 71.1758

WALDO PEIRCE
(1884–1970)

Born Bangor, Maine; died Newburyport, Massachusetts. Studied at Phillips Academy. 1908, A.B., Harvard University. 1910–11, Académie Julian, Paris. Traveled through Europe, North Africa, and Spain with former heavyweight champion Jack Johnson, and again with close friend Ernest Hemingway. WPA artist, executed murals for several U.S. post offices. 1944, first honorable mention, Carnegie. 1950, retrospective at Farnsworth Art Museum. Settled in Bangor, Maine, after his return to the U.S. in 1930, and summered in Searsport, Maine.

Nude in an Upholstered Chair, 1921

Oil on canvas, 36⅜ x 25⅞

Signed and dated lower right, "for Jim Brown / WP / 21"

Gift of Mr. and Mrs. James M. Brown, 80.20

Fire at East Orrington, 1940

Oil on canvas, 27 x 40¹⁄₁₆

Signed and dated lower right, "W. P. '40"

Museum purchase, 50.708

The Devil and Three Virgins, 1941

Oil on canvas, 25 x 34¼

Signed and dated lower right, "WP 41"

Gift of the Estate of Mrs. Pat Emmons, 77.22

168 Louise Nevelson Orfeo: Gold Throne I and II

170 Waldo Peirce Fire at East Orrington

Paulette Goddard Rolling Tennis Court, 1946

Oil on Masonite, 19⅝ x 15⅝

Signed and dated lower left, "WP '46" and lower right, "to Nate for Paulette"

Bequest of Nathan Berliawsky, 80.35.39

Children Reading, 1946

Watercolor on paper, 8¹⁄₁₆ x 11¹⁄₁₆

Signed and dated lower right, "W. Peirce 46"

Museum purchase, 44.313

Working on a Maine Farm, n.d.

Oil on canvas, 20⅜ x 24½

Signed lower right, "WP" in monogram

Gift of Mrs. Elizabeth B. Noyce, 96.13.8

CHARLES HOVEY PEPPER
(1864–1950)

Born Waterville, Maine; died Brookline, Massachusetts. 1889 and 1891, B.A. and M.A. from Colby College. 1890, attended ASL. 1893–97, studied at Académie Julian, Paris, under Benjamin Constant and Jean-Paul Laurens. 1894 and 1896–99, exhibited at the Paris Salon. 1897, settled in the Boston area. Exhibited at PAFA, BAC, and as a member of the progressive Boston Five group. Member of Boston Water Color Club, Copley Society, St. Botolph Club, and New York Watercolor Club. Member and president of the BAC. Credited with helping to introduce modern art to Boston. Summered at Attean Lake, near Jackman, Maine.

Attean Lake No. 2, 1944

Watercolor on paper, 13⅞ x 10¹³⁄₁₆

Signed lower left, "Charles Hovey Pepper"

Gift of Charles Hovey Pepper, 44.368

Attean Lake, n.d.

Watercolor on paper, 11⅛ x 8⅛

Museum purchase, 44.361

The Island, n.d.

Watercolor on paper, 21⅛ x 14⅛

Signed lower right, "Charles Hovey Pepper"

Museum purchase, 44.366

The Squall, n.d.

Watercolor on paper, 20⅞ x 14

Signed lower center, "Charles Hovey Pepper"

Museum purchase, 44.367

ALLEN ERSKINE PHILBRICK
(1879–1964)

Seven Tree Pond near Union, 1935

Oil on canvas, 28⅜ x 37⅛

Signed and dated lower right, "Allen Philbrick 35"

Gift of Jane Philbrick Kofler and her brother, Allen K. Philbrick, 80.23.1

Reflections (The Sheepscot at Head Tide), n.d.

Watercolor on paper, 16¾ x 21¼

Signed lower right, "Allen Philbrick"

Gift of Jane Philbrick Kofler and her brother, Allen K. Philbrick, 80.23.5

FAIRFIELD PORTER
(1907–1975)

Study for Bear Island, 1966

Oil on board, 14 x 18

Signed and dated lower right, "Fairfield Porter 66"

Bequest of Mrs. Elizabeth B. Noyce, 97.3.43

171 Charles Hovey Pepper
Attean Lake

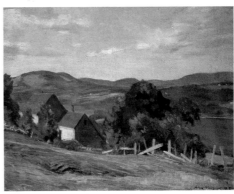

172 Allen Erskine Philbrick Seven Tree Pond near Union

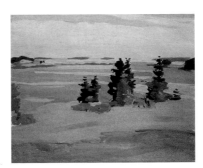

173 Fairfield Porter Study for Bear Island

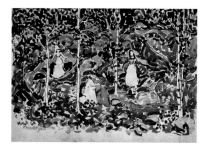

174 **Maurice Brazil Prendergast** Figures among Rocks and Trees

MAURICE BRAZIL PRENDERGAST
(1858–1924)

Figures among Rocks and Trees,
c. 1910–13

Watercolor and graphite on paper,
14 x 19⅞

Signed lower left "Prendergast"

Gift of Mrs. Charles Prendergast,
91.32

WILLIAM MATTHEW PRIOR
(1806–1873)

Born Bath, Maine; died East Boston, Massachusetts. Self-taught itinerant portrait and landscape painter. Traveled throughout New England, working for a time out of Portland, Maine. 1831, exhibited a portrait at the Boston Athenaeum. 1841, settled in Boston, where he maintained a busy portrait studio, assisted by his wife, his brothers-in-law (the Hamblens), and sons. Established a sliding fee scale for portraits based on the degree of detail desired; best known for the less expensive paintings executed in a primitive style. Also made a number of copies on glass after Gilbert Stuart's "Athenaeum" portrait of George Washington. Authored several religious books.

Portrait of a Maine Barber, n.d.

Oil on canvas, 24⅛ x 20¼

Museum purchase, 82.20

IDA SEDGWICK PROPER
(1873–1957)

Born Bonaparte, Iowa; died Monhegan Island, Maine. 1894, enrolled at ASL, studying with William Merritt Chase and John H. Twachtman, among others. 1896, won a three-year scholarship to study in Munich. About 1907–11, studied in Paris, where she worked closely with American painter Richard Emil Miller and exhibited at the Salon de la Société des Artistes Français and the Salon de la Société Nationale des Beaux-Arts. 1911, on return to New York, became active in the suffrage movement, serving as art editor of *Woman Voter.* 1915, organized *Exhibition of Paintings and Sculpture by Women Artists for the Benefit of the Woman's Suffrage Campaign* held at New York's Macbeth Galleries. After serving as a cataloger for the U.S. Army Ordinance Department during WWI, spent several years as a drawing instructor at the University of Puerto Rico at Mayaguez. Mid-1920s, settled on Monhegan Island where she devoted her time to writing, publishing *Monhegan, The Cradle of New England* in 1930.

Puerto Rican Washer Women, n.d.

Oil on panel, 9½ x 13

Signed lower right, "Proper"

Anonymous gift, 90.28.4

French Gossipers, n.d.

Oil on canvas, 10½ x 13⅝

Signed lower right, "Proper"

Anonymous gift, 90.28.5

Four Women, n.d.

Oil on canvas panel, 10⅝ x 13¼

Anonymous gift, 90.28.6

French Nursemaids, 1910

Oil on canvas panel, 10½ x 13⅞

Signed and dated lower right, "Proper-1910"

Anonymous gift, 90.28.9

HOWARD PYLE
(1853–1911)

Born Wilmington, Delaware; died Florence, Italy. 1869, began training with Adolph van der Weilen in Philadelphia and attended classes at PAFA. 1876, published first illustrated poem in *Scribner's Monthly* and moved to New York where he enrolled at the ASL. His illustrations, often accompanying his own stories, appeared in the leading contemporary periodicals including *Scribner's* and *Harper's*, as well as in children's magazines such as *St. Nicholas*. Illustrated over 100 books and authored and illustrated a number of popular books for children. An influential teacher, Pyle served as an instructor at the Drexel Institute of Art, Science and Technology in Philadelphia during the 1890s, and after 1900 ran his own art school in Wilmington. His students included N. C. Wyeth and Maxfield Parrish. Considered the founder of the Brandywine School of painters and illustrators.

Dids't Thou Tell Them I Taught Thee?,
c. 1896

Oil on academy board, 17⅞ x 12

Signed lower right, "H. P."

Museum Purchase, 65.1473

175 **William Matthew Prior** Portrait of a Maine Barber

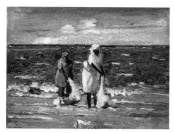

176 **Ida Sedgwick Proper** Puerto Rican Washer Women

THOMAS ADDISON RICHARDS
(1820–1900)

Born London, England; died Annapolis, Maryland. 1831, came to the U.S. where his family lived in Hudson, New York, and Penfield, Georgia. 1844, moved to New York City. Studied at NAD, where he was elected academician in 1851 and served as corresponding secretary 1852–92. Exhibited regularly at the NAD and Brooklyn Art Association. Had a number of paintings selected by the American Art-Union for its annual lotteries. 1858, became first director of the Cooper Union Art School. 1867–87, professor of art at New York University. Traveled widely throughout the United States, publishing several illustrated articles recording his journeys in *Harper's*, as well as serving as the author-editor of *Appleton's Illustrated Hand-book of American Travel* (1857).

The Delaware at Dingman's Ferry, n.d.

Oil on canvas, 9⅟₁₆ x 14¹³⁄₁₆

Signed lower right, "T. A. Richards"

Gift of Mrs. Mary Boudreau, 59.1138

Village and Lake in Switzerland, n.d.

Oil on canvas, 12⅛ x 20⅛

Signed lower left, "T. A. Richards"

Gift of Mrs. Mary Boudreau, 59.1139

MARY NEAL RICHARDSON
(1859–1937)

Born Mt. Vernon, Maine. Studied at the MFA,B School, at the Académie Colarossi, with A. Koopman in Paris, and Charles H. Woodbury in Ogunquit, Maine. Established successful portrait studio in Boston. 1917, became the second woman to have a solo exhibition at the BAC, where she had exhibited regularly. Also exhibited at the Paris Salon, AIC, and Portland Museum of Art, Maine. Member of the Copley Society and American Artists Professional League. Summered in Canton, Maine, where she painted a number of Maine landscapes.

Portrait of Ruth E. Robinson, 1909

Oil on canvas, 40¼ x 30

Signed upper right, "Mary N. Richardson"

Gift of Mrs. Elmer C. Johnson (Ruth E. Robinson), 72.1842

NORMAN ROCKWELL
(1894–1978)

Born New York City; died Stockbridge, Massachusetts. 1909, left high school to attend NAD. Transferred to ASL where he studied under George Bridgman and Thomas Fogarty. 1913, became art director for *Boys' Life*, a publication of the Boy Scouts of America. 1916, *Saturday Evening Post* published the first of its more than 300 covers by Rockwell; his illustrations appeared in numerous other magazines including *Life*, *Ladies' Home Journal*, and *Look*. 1935, commissioned by Heritage Press to illustrate Mark Twain's *Adventures of Tom Sawyer* and *Adventures of Huckleberry Finn*. 1939, moved to Vermont. WWII era, reproductions of his *Four Freedoms* series used for war fundraising efforts. 1953, moved to Stockbridge, Massachusetts.

Tom Sawyer Whitewashing the Fence, 1936

Oil on canvas, 18¹⁵⁄₁₆ x 14⅜

Signed lower right, "N/R"

Bequest of Mr. Clifford Smith, 85.4.4

JOSEPH ROPES
(1812–1885)

Born Salem, Massachusetts; died New York City. 1840s, began art career in New York, studying with John R. Smith and at NAD. 1851–65, maintained a studio in Hartford, Connecticut. 1865–76, lived in Italy. 1876, settled in Philadelphia; several of his landscapes shown at the Centennial Exposition. 1870s, exhibited regularly at the PAFA and Brooklyn Art Association. Drawing instructor who published two art manuals: *Linear Perspective* (1850) and *Progressive Steps in Landscape Drawing* (1853).

Marine of East Harpswell, Maine, 1872

Oil on canvas, 18⅛ x 27⅟₁₆

Signed and dated lower right, "Ropes '72"

Museum Purchase, 44.161

177 Howard Pyle Dids't Thou Tell Them I Taught Thee?

178 Norman Rockwell Tom Sawyer Whitewashing the Fence

RALPH ROSENBORG
(1913–1992)

Born Brooklyn, New York; died Portland, Maine. 1929, won scholarship from the School Art League in New York to study art at the American Museum of Natural History, New York. 1930–33, studied with Henriette Reiss, a former student of Wassily Kandinsky. 1935, solo exhibition held at the Eighth St. Playhouse, New York, the first of fifty organized during his lifetime. 1936–40, taught art in the New York public school system and at the Brooklyn Museum as part of the Federal Art Project. Late 1930s, exhibited with The Ten, a radical group that included Mark Rothko and Adolph Gottlieb, and with the American Abstract Artists. 1942, included in *Artists under Thirty-Five* exhibition at the Art of This Century Gallery, New York. 1951–52, member of the Federation of Modern Painters and Sculptors. 1961, received the Childe Hassam Award from the American Academy of Arts and Letters.

Untitled, 1941

Watercolor on paper, 15⅛ x 7⁷⁄₁₆

Signed and dated lower left, "Rosenborg 41"

Gift of Diana MacKown, 84.24.6

Untitled (Circles and Shapes), 1941

Ink on paper on board, 7¹¹⁄₁₆ x 14⁹⁄₁₆

Signed and dated lower right, "41 Rosenborg"

Gift of Louise Nevelson, 84.23.4

The House on 30th Street, 1945

Oil on canvas, 18¼ x 24⅛

Signed and dated upper left, "Rosenborg 45"

Gift of Louise Nevelson, 84.23.3

Summer Day—Landscape, 1946

Oil on canvas, 27 x 42

Signed and dated upper left, "46 Rosenborg"

Bequest of Nathan Berliawsky, 80.35.41

Floral Kingdom, 1949

Oil on board, 26¼ x 31¼

Signed and dated upper right, "Rosenborg 49 / Michigan"

Bequest of Nathan Berliawsky, 80.35.43

Heart of the Night, 1950

Charcoal and ink on paper, 8¾ x 14⁹⁄₁₆

Signed and dated lower left, "Rosenborg 50"

Gift of Louise Nevelson, 84.23.6

Ancient Garden and Village
1983

Watercolor on paper, 9½ x 13¾

Signed and dated lower left, "Rosenborg 1983"

Gift of Diana MacKown, 84.24.4

179 Ralph Rosenborg
Untitled

ROBERT SALMON
(1775–1848/51)

Packet Ship "Bolton," 1822

Oil on panel, 19⅝ x 30⅛

Signed and dated lower right, "R. S. 1822"

Museum purchase, 45.523

View of Burn Moor, 1827

Oil on panel, 12¼ x 16¾

Signed and dated lower right, "R S 1827"

Museum purchase, 44.342

Boat and Shore, 1832

Oil on panel, 12⅜ x 16½

Signed and dated lower right, "R S 1832"

Museum purchase, 44.343

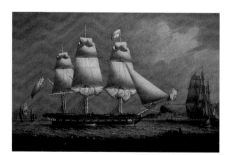

180 Robert Salmon Packet Ship "Bolton"

181 Paul Starrett Sample Winter Racing in Canaan

PAUL STARRETT SAMPLE
(1896–1974)

Born Louisville, Kentucky; died Norwich, Vermont. 1921, graduated from Dartmouth College. 1923, studied art with Jonas Lie while being treated for tuberculosis in an Adirondack sanatorium. 1925–26, attended Otis Art Institute, Los Angeles. 1926–38, taught at the University of Southern California. Summer 1932, attended class on fresco offered by Mexican muralist David Alfaro Siqueiros at the Chouinard Art Institute, Los Angeles; in subsequent years, Sample would receive several corporate and government mural commissions. 1938–62, artist-in-residence at Dartmouth College. Worked as illustrator for a number of magazines including *Fortune* and *Life*; the latter employed him as an artist-correspondent during WWII. Maintained a close relationship with the NAD, exhibiting there regularly, becoming a full member in 1941, receiving numerous academy prizes, and serving as a juror for many of its annual exhibitions. His paintings of rural New England executed during the 1930s helped to broaden the scope of the American Regionalist movement; New England was also the subject of many of his late, painterly landscapes.

Winter Racing in Canaan, n.d.

Watercolor on paper, 20⅛ x 28¼

Signed lower right, "Paul Sample"

Museum purchase, 69.1637

Morning on Clark Steady, n.d.

Watercolor on paper, 9½ x 19¼

Signed lower right, "Paul Sample"

Gift of Boston Society of Independent Artists, 53.928

Cossinghams, Snow Bound, 44.162

Watercolor on paper, 15 x 22 (framed)

Museum purchase, 44.162

Old Club Takes the Sun, n.d.

Watercolor on paper, 13 x 19½

Signed lower left, "Paul Sample"

Gift of Mrs. John Fulton, 64.1305

KARL SCHRAG
(1912–1995)

Born Karlsruhe, Germany; died New York City. Studied, 1931, Ecole des Beaux Arts, Geneva; 1932, Ecole Nationale Supérieure des Beaux-Arts, Académie Ranson, Académie de la Grande Chaumière, Paris. 1938, came to U.S., studied print making at ASL. 1945, joined Stanley William Hayter's Atelier 17; 1950, director. 1954–68, taught, Cooper-Union. 1947, joined Kraushaar Galleries, Inc., New York. One-man exhibitions: 1942, Whitney; 1945, National Museum, Smithsonian; 1986, Associated American Artists; 1992, Farnsworth, traveled to Bergen Museum of Art & Science, New Jersey; Sordoni Art Gallery, Wilkes University, Pennsylvania; Center Gallery, Bucknell University, Pennsylvania. Awards: 1947 and 1950, Purchase Award, Brooklyn Museum; 1966, grant Academy of Arts and Letters; 1973, Childe Hassam Purchase Award, American Academy and Institute of Arts and Letters; 1981, 1983, 1994, NAD, First Benjamin Altman Prize in Landscape Painting; and 1986, NAD, Carnegie Prize. 1945 until his death, summered on Deer Isle, Maine.

Island Night, 1978

Oil on canvas, 48⅛ x 54⅛

Signed lower left, "Karl Schrag"

Gift of Mr. Paul J. Schrag, 85.6

The Green Night, 1982

Oil on canvas, 40¼ x 49¼

Signed lower right, "Karl Schrag"

Gift of Mrs. Elizabeth B. Noyce, 96.13.4

JOHN WHITE ALLEN SCOTT
(1815–1907)

Born Roxbury, Massachusetts; died Cambridge, Massachusetts. About 1830, apprenticed to Boston lithographer William S. Pendleton, whose employees also included Nathaniel Currier and Fitz Hugh Lane. About 1844–47, he and Lane were partners in their own lithographic firm. 1840s, began painting. Exhibited at the BAC, of which he was a member, and at the Boston Athenaeum. Known for his landscapes of the Catskills and White Mountains.

Owl's Head Light, 1872

Oil on canvas, 18¼ x 30⅛

Signed and dated lower right, "JWA Scott '72"

Museum purchase, 77.1766

Old House at Thomaston, n.d.

Oil on canvas, 12 x 20⅛

Signed lower right, "JWAS"

Museum purchase, 60.1154

FRANK HENRY SHAPLEIGH
(1842–1906)

Born Boston, Massachusetts; died Jackson, New Hampshire. About 1860, studied art at the Lowell Institute, Boston. 1864, exhibited landscape at the Boston Athenaeum. 1867, traveled to Europe, studying with Emile Lambinet in Paris. 1869, after return to Boston, shared space in the Art Studio Building with John Appleton Brown. 1870, made a trip to California, painting several views of Yosemite. 1874, elected member of the BAC; exhibited there regularly during the next decade. 1877–93, artist-in-residence at the Crawford House, a summer resort hotel in Crawford Notch, New Hampshire. Specialized in landscapes of the White Mountains. 1880, illustrated *The Poetical Works of Henry Wadsworth Longfellow* for Houghton Mifflin Co., Boston. 1886–92, maintained a winter studio in St. Augustine, Florida. 1896, began construction of a summer home and studio in Jackson, New Hampshire. Made a number of painting trips to Maine during the 1870s and 1880s.

Old Road in Scituate, Mass., 1886

Oil on canvas, 22 x 36

Signed and dated lower left, "F. H. Shapleigh 1886"

Gift of Mr. and Mrs. Philip Hofer, 74.1926

The Camden Hills from Sherman's Point, n.d.

Oil on canvas, 10⅛ x 18

Signed lower right, "F. H. Shapleigh"

Museum purchase, made possible by gifts from Mrs. James E. Barlow and Mr. Abraham S. Burg, 82.19

AARON DRAPER SHATTUCK
(1832–1928)

Born Francestown, New Hampshire; died Granby, Connecticut. 1851, studied with Alexander Ransom in Boston. 1852, after move to New York City, enrolled at the NAD. Exhibited at the NAD, Boston Athenaeum, PAFA, and Brooklyn Art Association. 1854, began making summer sketching trips, ultimately traveling throughout New England (particularly the White Mountains) and New York State. 1859–90s, maintained a studio at the Tenth Street Studios Building, New York. 1861, elected member of the NAD. 1864, held joint exhibition-sale with Samuel Colman (his brother-in-law) and Jervis McEntee at a New York auction house. 1864, Matthew Vassar presented six paintings by Shattuck to the art gallery at Vassar College. 1870, moved to Granby, Connecticut. 1883, invented and patented stretcher key for canvases that proved financially lucrative. 1888, stopped painting after a serious illness. 1850s and early 1860s, visited Maine regularly, sketching at various locations along the coast.

Landscape with Mountain, 1857

Oil on canvas, 10⅛ x 16

Signed and dated lower left, "A. D. Shattuck 1857"

Gift of Mrs. R. D. H. Emerson, 58.1275

182 John White Allen Scott Owl's Head Light

183 Frank Henry Shapleigh The Camden Hills from Sherman's Point

XANTHUS R. SMITH
(1839–1929)

Born Philadelphia; died Weldon, Pennsylvania. Son of painters Russell and Mary Wilson Smith. 1851–52, traveled to Europe with his family. 1855–58, enrolled at PAFA while pursuing medical studies at the University of Pennsylvania. 1862–64, served in the Navy during the Civil War; his sketches from this period became the basis for later paintings of marine subjects and battle scenes. 1876, painting shown at the Centennial Exposition, Philadelphia. Contributed illustrations to the multivolume *Battles and Leaders of the Civil War* (1887–88) published by the Century Company. During his later career, published extensively on photography, a longtime interest. Known for his views of Mount Desert Island executed during his nearly annual visits there during the 1880s and 1890s.

Untitled (Rocky Headland), 1893 and 1910

Watercolor and graphite on paper, 6⅛ x 9¹¹⁄₁₆

Signed and dated lower right, "X.S./ 1893/ and Feb. 26th/ 1910"

Bequest of Mrs. Elizabeth B. Noyce, 97.3.46

Owl's Head Light, Maine, n.d.

Oil on canvas, 13⅛ x 21¹⁄₁₆

Gift of Dr. Franklin R. Smith, 79.32.2

Somes Sound, n.d.

Oil on paper, 7½ x 11⅛

Bequest of Mrs. Elizabeth B. Noyce, 97.3.45

MOSES SOYER
(1899–1974)

Born Borisoglebsk, Russia; died New York City. 1912, family immigrated to the United States, settling in New York. About 1914–20, studied art in New York at the Cooper Union, NAD with George Maynard, Educational Alliance Art School, and Modern School (Ferrer Center) with Robert Henri and George Bellows. 1925–26, exhibited with the Whitney Studio Club. 1926–28, traveled to Europe on fellowship sponsored by the Educational Alliance. 1920s–early 1930s, taught at the Educational Alliance, Contemporary Art School, New Art School, and New School for Social Research, all in New York. 1929, first solo exhibition at J. B. Neumann's New Art Circle Gallery, New York; numerous solo exhibitions at Macbeth Galleries and ACA Gallery would follow. 1930s, executed several commissions for the WPA/FAP, including a portable mural series installed in various children's libraries and hospitals in New York, and murals for the Kinglessing Post Office, Philadelphia, painted with his twin brother, Raphael. 1963, elected member of the NAD. 1964, authored *Painting the Human Figure*. 1966, elected to the National Institute of Arts and Letters.

Carol Pregnant, c. 1970

Oil on canvas, 30¹⁄₁₆ x 24⅞

Signed upper right, "M Soyer"

Gift of Mr. David Soyer, 86.24

CAROLA SPAETH (HAUSCHKA)
(1883–c. 1948/50)

Born and died Philadelphia. Studied at PAFA and Graphic Sketch Club, Philadelphia. Member, Philadelphia Alliance. Executed a series of portraits of Nobel prize–winning physicists for the textbook *College Physics*, published in 1959. 1929–46, taught portraiture at the Anson Kent Cross Art School, Boothbay Harbor, Maine.

Mrs. George Rodney Whipple, c. 1932

Oil on canvas, 24¹⁄₁₆ x 20⅛

Signed lower right, "Carola Spaeth"

Estate of Blanche W. Smithwick, 78.65.1

CARL SPRINCHORN
(1887–1971)

Cosmos, 1936

Oil on board, 17⅞ x 24

Signed lower left, "Carl Sprinchorn"

Bequest of Mrs. Elizabeth B. Noyce, 97.3.47

The Crystal Cage (or Cave)—Nat Henson's Camp at East Branch Penobscot at Matagamon, 1945

Gouache and crayon on paper, 11⅝ x 17⅝

Signed lower left, "Carl Sprinchorn"

Museum purchase, 92.6

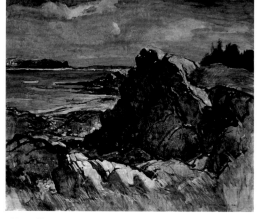

185 **William Lester Stevens** Low Tide—Vinalhaven

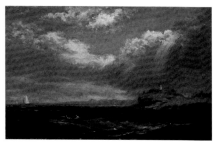

184 **Xanthus R. Smith** Owl's Head Light, Maine

WILLIAM LESTER STEVENS
(1888–1969)

Born Rockport, Massachusetts; died Greenfield, Massachusetts. Studied with Parker S. Perkins in Rockport. 1909, won four-year scholarship to attend the MFA,B School, where he studied with Edmund C. Tarbell, Frank W. Benson, and Philip Leslie Hale. Returned to Rockport after completing training. 1921, founding member of Rockport Art Association. Member of American Watercolor Society, BAC, Boston Water Color Club, NAD (National Academician, 1944), New York Watercolor Club, and Springfield Art League. 1921, first solo exhibition at the BAC. Exhibited regularly at PAFA and NAD. 1920s, taught at Boston University and Princeton University, as well as summer classes in Rockport. 1944, settled permanently in Conway, Massachusetts. 1957, solo exhibition at the Farnsworth. An avid traveler, spent several summers beginning in the 1950s painting and teaching at Vinalhaven, Maine, and Grand Manan Island, New Brunswick, Canada.

Low Tide—Vinalhaven, 1950s

Oil on Masonite, 30 x 36

Signed lower right, "W. Lester Stevens N.A."

Gift of Mr. and Mrs. Heiman Gross, 81.51

ALICE KENT STODDARD
(1893–1976)

Born Watertown, Connecticut; died Newtown, Pennsylvania. Studied at PAFA under Thomas Eakins and Thomas Anschutz, and at Philadelphia School of Design for Women. Known as a portraitist. WWI, served with the YMCA in France, where she executed a number of war-related works. Exhibited regularly at PAFA, NAD, and AIC, winning many prizes. 1938, made an associate of the NAD. Maintained a summer studio on Monhegan Island.

Portrait of Andrew Winter, 1953

Oil on canvas, 24⅛ x 20⅛

Signed and dated lower left, "Alice K. Stoddard / 1953"

Gift of Mr. J. J. Taylor, 83.3.1

The Artist Sketching, n.d.

Oil on board, 16⅛ x 20⅜

Signed lower right, "Alice Kent Stoddard"

Gift of Dr. James Powell, 95.7.2

GILBERT STUART
(1755–1828)

Born North Kingston, Rhode Island; died Boston. 1761, family moved to Newport, Rhode Island. Instructed by Cosmo Alexander, with whom he traveled to Scotland about 1770–71. 1775, sailed for London. 1777–82, attached to Benjamin West's studio as a student-assistant. 1782, after winning acclaim for *The Skater* exhibited at the Royal Academy, set up his own portrait studio. 1787, moved to Dublin, largely to escape his London creditors. 1793, returned to the U.S., working first in New York City. 1794, settled in Philadelphia, where he later painted George Washington from life; he would ultimately execute over 100 portraits of the revolutionary hero. 1803–05, worked in Washington, D.C. 1805, established a studio in Boston, where he spent the remainder of his life. 1828, Boston Athenaeum held a major retrospective exhibition of his work.

Portrait of George Hamilton as a Baron of the Exchequer, c. 1790

Oil on canvas, 48 x 37⅟₁₆

Gift of Mr. and Mrs. J. Philip Walker, 68.1594

Portrait of Mrs. George Hamilton, c. 1790

Oil on canvas, 30 x 25

Gift of Mr. and Mrs. J. Philip Walker, 68.1595

WILLIAM PIERCE STUBBS
(1842–1909)

Born Bucksport, Maine; died Medfield, Massachusetts. Apparently a self-taught artist, turned to painting about 1876 when he moved to Boston and established a studio. From a Maine seafaring family and worked as a mariner. He specialized in ship portraits. 1889–90, exhibited a number of paintings at the International Maritime Exhibition held in Boston. 1894, diagnosed with melancholia and committed to the Worcester State Hospital, Massachusetts.

The Brig "Joseph Clark," n.d.

Oil on canvas, 22¼ x 36 ³⁄₁₆

Signed lower left, "Stubbs"

Gift of the Estate of Jasper J. Stahl, 70. 1738

The Bark "Alice Reed," n.d.

Oil on canvas, 22⁵⁄₁₆ x 36

Signed lower left, "W. P. Stubbs"

Gift of the Estate of Jasper J. Stahl, 70.1739

Ship "Ada A. Frye," n.d.

Oil on canvas, 21⅞ x 35¼

Gift of Laura E. Fish, Rockland, Maine, 72.1837

"Augustus Welk," n.d.

Oil on canvas, 26 x 42

Gift of Laura A. Fish, Rockland, Maine, 72.1838

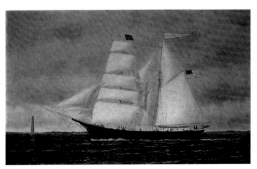

186 William Pierce Stubbs The Brig "Joseph Clark"

CLEMENT NYE SWIFT
(1846–1918)

Born and died Acushnet, Massachusetts. 1867, traveled to France, studying with landscape painter Henri-Joseph Harpignies in Paris. 1870–81, after the outbreak of the Franco-Prussian War, joined the growing artist colony at Pont-Aven, France. Painted many works featuring the Breton region. 1881, returned to the U.S. While abroad, exhibited almost annually at the Paris Salon; also showed paintings at the NAD, PAFA, and BAC.

A Journey into Dreamland, 1870–71

Oil on canvas, 37⅜ x 27½

Signed lower left, "Clement Swift"

Gift of Miss Sylvia H. Knowles, 73.1890

"Bon Voyage," n.d.

Oil on canvas, 27¼ x 46¼

Signed lower right, "Clement Swift"

Gift of Miss Sylvia H. Knowles, 73.1889

JAMES BRADE SWORD
(1839–1915)

Born and died Philadelphia. Early 1860s, left career as a civil engineer and began studying art at PAFA and with George W. Nicholson. 1870s–c. 1900, exhibited regularly at PAFA and NAD. Also exhibited at the Brooklyn Art Association, BAC, and AIC. 1885, won medal at the New Orleans Expo. 1902 and 1903, won gold medal at the American Art Society, Philadelphia. 1911, commissioned by U.S. Congress to paint portrait of John W. Jones, former Speaker of the House. Active in Philadelphia arts organizations, he was a founder of the Art Club of Philadelphia as well as a member of the Artists' Fund Society and Philadelphia Society of Artists.

Old Mill, 1874

Oil on canvas, 10⁹⁄₁₆ x 18⅝

Signed lower left, "J. B. Sword"

Gift of Mrs. C. R. Boardman, 63.1296

REUBEN TAM
(1916–1991)

Born and died Kapaa, Hawaii. B.A. in Education from University of Hawaii. Studied at California School of Fine Arts; New School for Social Research, New York; studied art history with Meyer Schapiro at Columbia University; 1941, studied with Hans Hofmann. 1946–75, taught at Brooklyn Museum Art School; 1966, Oregon State University; 1973, Queens College of the City University of New York. 1948, awarded Guggenheim Fellowship; 1974 and 1977, NAD awards; 1978, American Academy of Arts and Letters Award in Art.

Monhegan, 1950

Watercolor on paper, 8 x 10⅞

Signed and dated lower right, "tam 50"

Bequest of Nathan Berliawsky, 80.35.53

Dark Mountain, 1951

Oil on Masonite panel, 28 x 40

Signed and dated lower right, "Tam © 51"

Gift of Geraldine King Tam, 96.4.1

Cliff, Cloud, 1959

Oil on Masonite panel, 27⅞ x 33

Signed and dated lower right, "TAM 59"

Gift of Geraldine King Tam, 96.4.2

Monhegan Headland, 1968

Oil on academy board, 20⅛ x 24

Signed and dated lower right, "Tam 68"

Gift of Mr. James T. Wallis, 72.1864

Stars, #4, 1978

Acrylic on paper, 12¹³⁄₁₆ x 14⅛

Signed lower right, "Tam"

Gift of Geraldine King Tam, 97.8.2

Calm Sea in Fog, 1979

Acrylic on paper, 13⁵⁄₁₆ x 12⁵⁄₁₆

Signed lower right, "Tam"

Gift of Geraldine King Tam, 97.8.1

ANTHONY THIEME
(1888–1954)

Born Rotterdam, the Netherlands; died Connecticut. Studied at Royal Academy, The Hague, and under Georg Hacker in Düsseldorf and Guisseppe Mancini in Italy. 1920s, came to New York. Settled in Boston and became member of the summer art colony at Rockport, Massachusetts. In addition to the Rockport Art Association, he belonged to the BAC, Boston Society of Arts and Crafts, North Shore Arts Association, Springfield Art League, Salmagundi Club, New York Watercolor Club, American Watercolor Society, Art Alliance of America, and American Artists Professional League. Late 1920s–early 1930s, exhibited regularly at the NAD and PAFA. Numerous awards included 1928, first prize, Springfield Art League; 1929, 1931, Shaw Prize, Salmagundi Club; 1930, Delano prize, New York Watercolor Club; and 1931, purchase prize, Los Angeles Museum of History. Directed Thieme School of Art in Rockport.

Dutch Scene, n.d.

Oil on canvas, 25 x 30¹⁄₁₆

Signed lower right, "A. Thieme"

Gift of Robert T. Markson, 51.701

187 **Reuben Tam** Monhegan Headland

188 **Ernest Thorne Thompson** January Thaw, Rockland

190 Beatrice Whitney Van Ness Whitecaps

ERNEST THORNE THOMPSON
(1897–1992)

Born Saint John, New Brunswick, Canada; died Bremen, Maine. Studied at Massachusetts School of Art, MFA,B School, and independently in Europe. 1922–29, professor of art and director, School of Fine Arts, University of Notre Dame. 1929–67, professor of art and chairman, Department of Fine Arts, College of New Rochelle, New York. 1947–51, director, Huguenot School of Art, New Rochelle. 1954, solo exhibition, *Coastal Maine*, at Farnsworth. Exhibited widely in the United States and Europe. Member of New Rochelle Art Association, Allied Artists of America, American Watercolor Society, and Salmagundi Club, among others. Recipient of numerous awards including the Rudolf Lesch Award and Medal, American Watercolor Society (1956). Author of *New England: Twelve Woodcuts* (1928), and *Technique of the Modern Woodcut* (1928). Summered in Maine, settling permanently in Medomak after 1967.

January Thaw, Rockland, c. 1952

Watercolor on paper, 17¼ x 24⁵⁄₁₆

Signed lower center, "Ernest T. Thompson"

Museum purchase (Charles L. Fox Fund), 74.1911

Daughters of Neptune, n.d.

Watercolor on paper, 28⁵⁄₈ x 20

Signed lower right, "ERNEST T. THOMPSON AWS"

Gift of Ernest T. Thompson, 75.1964

Waldoboro Farm, n.d.

Watercolor on paper, 14⅜ x 21½

Signed lower left, "Ernest Thorne Thompson"

Gift of Ernest T. Thompson, 74.1910

ALLEN TUCKER
(1866–1939)

Born Brooklyn, New York; died New York City. 1888, graduated from Columbia University, with degree in architecture. Studied with John H. Twachtman at ASL, later serving as an instructor there. 1895–1904, partner in the architectural firm McIlvaine and Tucker. Exhibited at the Paris Salon, NAD, and PAFA. As a member of the Association of American Painters and Sculptors, helped organize the 1913 Armory Show, exhibiting five paintings himself. 1917, founding member of Society of Independent Artists. 1918, solo exhibition held at the Whitney Studio Club, New York. Author of *Design and the Idea* (1930) and *John H. Twachtman* (1931), as well as many articles on art.

Toward Camden, 1935

Watercolor on paper, 13⁵⁄₈ x 19⅜

Signed and dated lower right, "Allen Tucker 1935"

Gift of Allen Tucker Memorial, 60.1170

189 Allen Tucker Toward Camden

BEATRICE WHITNEY VAN NESS
(1888–1981)

Born Chelsea, Massachusetts; died Brookline, Massachusetts. 1905–13, studied and taught at MFA,B School, working with Frank W. Benson and Edmund C. Tarbell. Later studied with Charles Woodbury in Ogunquit. Exhibited regularly in Boston area as well as at NAD, Carnegie, AIC, Corcoran, and PAFA. 1910–11, her portrait of sculptor Bela Pratt submitted to NAD on Pratt's election as an associate member. 1914, won Julia A. Shaw Prize at NAD. 1915, awarded silver medal at PPIE, San Francisco. 1921, solo exhibition at Copley Gallery, Boston. 1921–49, founded and directed art department at Beaver Country Day School, Chestnut Hill, Massachusetts. Lectured and wrote extensively on art education. Summered in Maine, buying a house at North Haven in 1927.

Camden Hills, c. 1925

Oil on canvas, 18⅛ x 22¼

Museum purchase, 95.26.1

Whitecaps, c. 1926

Oil on canvas, 18⅛ x 22⅛

Museum purchase, 89.3

North Haven, Maine, c. 1930

Watercolor on paper, 14⅞ x 20⅞

Signed lower right, "Beatrice W. Van Ness"

Museum purchase, 95.26.3

Summer Spruces, c. 1935

Oil on canvas, 30⅛ x 36⅛

Museum purchase, 95.26.2

Deep Channel, 1977–79

Watercolor with tempera, 19⅞ x 25⅛

Signed lower right, "Beatrice Whitney Van Ness"

Gift of Mrs. Mary Van Ness Crocker and Mrs. Sylvia Van Ness Martin, 84.9

ELIHU VEDDER
(1836–1923)

Born New York City; died Rome, Italy. Studied with Tompkins H. Matteson in Sherburne, New York. 1856, traveled to Europe, studying with François-Edouard Picot in Paris and Raffaello Bonaiuti in Florence, where he was also influenced by the Italian artists known as *il Macchiaioli*. 1861–65, settled in New York after his return to the U.S. Supported himself as a commercial illustrator until critics and collectors began to show interest in his work. 1865, returned to Europe, eventually making Rome his permanent home. Exhibited at NAD (National Academician, 1865), Boston Athenaeum, BAC, Brooklyn Institute, PAFA, and Carnegie, as well as at several international expositions. 1884, edition of the *Rubáiyát of Omar Khayyám* published in Boston with illustrations by Vedder. In later career, executed a number of murals, including those at the Walker Art Building, Bowdoin College (1894) and the Library of Congress (1896–97). About 1900, stopped painting to devote himself to writing poetry and his memoirs; his autobiography, *The Digressions of V.*, published in 1910.

The Spinner, 1869

Oil on canvas, 6¼ x 10¼

Signed and dated lower left, "18 V. 69"

Gift of Mrs. Dorothy Hayes, 59.1183

191 Elihu Vedder The Spinner

ABRAHAM WALKOWITZ
(1878–1965)

Born Tuiemen, Siberia, Russia; died Brooklyn, New York. 1889, family immigrated to U.S., settling in New York. Attended classes at the Cooper Union, Educational Alliance, NAD, and ASL. About 1900–05, taught at the Educational Alliance. 1906–07, traveled to Europe where he studied with Jean-Paul Laurens at the Académie Julian in Paris. 1912, met Alfred Stieglitz, becoming a member of the avant-garde circle surrounding Stieglitz's 291 gallery; 291 would present four solo exhibitions of his work. In addition to exhibiting at more traditional institutions, participated in the Armory Show (1913) and Forum Exhibition of Modern American Painters (1916), both of which helped introduce modern art to a New York audience. Active member of and exhibitor with the People's Art Guild, Society of Independent Artists, and Société Anonyme. 1930s, his eyesight began to fail, diminishing his artistic output.

Bathers in a Rocky Cove, c. 1920–25

Watercolor on paper, 14¾ x 21⁵⁄₁₆

Signed lower right, "A. Walkowitz"

Gift of Zabriskie Gallery, New York, in Memory of Tessim Zorach, 95.10

FREDERICK JUDD WAUGH
(1861–1940)

Born Bordentown, New Jersey; died Provincetown, Massachusetts. 1880, studied at PAFA with Thomas Eakins and Thomas Anschutz. 1883–84, studied at the Académie Julian in Paris under Adolphe-William Bouguereau and Tony Robert-Fleury. 1892–1907, returned to Europe. Settled in England, where he worked as a magazine illustrator in London and began specializing in paintings of marine subjects. Beginning in the 1880s, exhibited at the Paris Salon, Royal Academy in London, and regularly at PAFA and NAD. 1911, became full academician of NAD. 1934–38, won the Popular Prize for five consecutive years at the Carnegie International Exhibition. After visiting the Maine coast in 1905, spent several summers painting on Bailey Island and Monhegan Island.

Point and Inlet, c. 1911–13

Oil on board, 25 x 30

Signed lower right, "Waugh"

Gift of Mr. and Mrs. Edward Freeman, 64.1303

Lifting Gale, n.d.

Oil on Masonite, 25⅛ x 30⅛

Signed lower right, "Waugh"

Bequest of Mrs. Elizabeth B. Noyce, 97.3.50

The Moon, c. 1911

Oil on Masonite, 30½ x 40¼

Signed lower right, "Waugh"

Bequest of Mr. Clifford Smith, 85.4.2

NEIL WELLIVER
(b. 1929)

Red Canoe, 1968

Oil on paper mounted on plywood, 23½ x 18½

Signed lower right, "Welliver"

Gift of the artist, 86.25.2

Brown Trout, 1986

Oil on canvas, 20¼ x 24⅛

Signed lower right, "Welliver"

Gift of the artist, 86.25.1

PAUL WESCOTT
(1904–1970)

Born Milwaukee, Wisconsin; died Wilmington, Delaware. 1925, attended AIC School. 1927–30, studied at PAFA, where he won the Cresson Memorial Travel Fellowship. 1931–52, taught art at the Hill School, Pottstown, Pennsylvania. Exhibited regularly at PAFA, Philadelphia Sketch Club, and NAD. 1953 and 1966, solo exhibitions held at the Farnsworth. Received numerous awards; he won the NAD's Edwin Palmer Prize for excellence in marine painting three times (1956, 1965, and 1967). 1970, elected academician of NAD. After summering on Grand Manan Island, New Brunswick, Canada (1934–39) and at Medomak, Maine (1942–44), bought a house on Friendship Long Island, Friendship, Maine. With his wife, artist Alison Farmer Wescott, designed and illustrated Jasper Jacob Stahl's *History of Old Broad Bay and Waldoboro* (1956).

Grand Manan Cove, c. 1934–39

Oil on canvas, 18¼ x 30¼

Signed lower left, "Paul Wescott"

Gift of Mrs. Paul Wescott, 72.1824

Searsport Tug, 1945

Oil on canvas, 14⅛ x 25³⁄₁₆

Signed lower left, "Paul Wescott"

Gift of Mrs. Paul Wescott, 72.1824.1

192 Abraham Walkowitz Bathers in a Rocky Cove

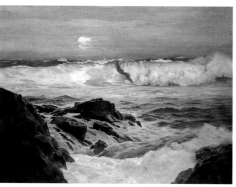

193 Frederick Judd Waugh The Moon

Gull Rock, 1955

Oil on canvas, 26⅛ x 42

Gift of Mrs. Paul Wescott, 72.1824.6

Southwest Breeze, 1958

Oil on beaver board, 20¼ x 36⅛

Signed lower left, "Paul Wescott"

Gift of Mrs. Paul Wescott, 72.1824.4

Old Hump Ledge, 1959

Oil on canvas, 21¾ x 39½

Signed lower right, "Paul Wescott"

Gift of Mrs. Paul Wescott, 72.1824.11

Lettie's Place—Late October, 1960

Oil on canvas, 14¼ x 29³⁄₁₆

Signed lower left, "Paul Wescott"

Gift of Mrs. Paul Wescott, 72.1824.10

The Harbor, 1966

Oil on canvas, 12³⁄₁₆ x 22³⁄₁₆

Signed lower right, "Paul Wescott"

Gift of Paul Wescott, 67.1543

Hall Island, 1969–70

Oil on canvas, 23⅝ x 31⅛

Signed lower left, "Paul Wescott"

Gift of Mrs. Paul Wescott, 72.1824.2

Edge of the Sea, 1970

Oil on canvas, 29⁹⁄₁₆ x 49⁹⁄₁₆

Gift of Mrs. Paul Wescott, 7.1824.7

JOHN WHORF
(1903–1959)

Born Winthrop, Massachusetts; died Provincetown, Massachusetts. Attended MFA,B School. 1917, moved to Provincetown, where he studied with Charles W. Hawthorne, George Elmer Browne, and E. Ambrose Webster. Traveled extensively in Europe and North Africa; when in Paris, attended classes at the Académie Colarossi and Ecole des Beaux-Arts. 1924, first solo exhibition at the Grace Horne Gallery, Boston. 1925–26, studied with John Singer Sargent. 1938, awarded honorary M.A. at Harvard University. Exhibited at AIC, NAD (National Academician, 1947), PAFA, and Whitney. Member of the American Watercolor Society and Provincetown Art Association.

The White Sail, 1925

Watercolor on paper, 5⅞ x 9⅛

Signed and dated lower right, "John Whorf '25"

Museum purchase, 43.64

195 John Whorf The White Sail

ANDREW WINTER
(1893–1958)

Cape Neddick Light, 1940

Oil on canvas board, 11⅝ x 17⁹⁄₁₆

Signed and dated lower left, "A Winter 40"

Gift of Mrs. Leo Meissner, 77.46.25-A

Monhegan Twilight, c. 1943

Oil on canvas, 24 x 40

Signed lower center right, "A Winter"

Gift of Mr. William Goadby Lawrence, 76.2030

Monhegan Harbor in Winter, 1944

Oil on canvas, 25⅛ x 30

Signed and dated lower right, "A Winter 44"

Gift of Mr. and Mrs. Leo J. Meissner, 71.1795.77

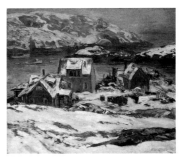

196 Andrew Winter Monhegan Harbor in Winter

Monhegan Village in Winter, c. 1944

Oil on Masonite, 24 x 40

Signed lower right, "A Winter"

Museum purchase, 59.1136

Monhegan Wharf, n.d.

Watercolor on paper, 14⅝ x 21½

Signed lower right, "A Winter"

Gift of Mr. and Mrs. Leo J. Meissner, 71.1795.107

194 Paul Wescott Grand Manan Cove

197 Andrew Winter Monhegan Twilight

CHARLES HERBERT WOODBURY
(1864–1940)

Born Lynn, Massachusetts; died Jamaica Plain, Massachusetts. 1886, graduated from Massachusetts Institute of Technology with degree in mechanical engineering. Attended evening life classes at BAC. 1887, first solo exhibition held at J. Eastman Chase Gallery in Boston. 1888–89, worked as an illustrator for *Century* and *Harper's* magazines. 1890–91, made the first of many trips to Europe, studying at the Académie Julian in Paris with Gustave Boulanger and Jule Joseph Lefebvre. Exhibited widely and recipient of numerous prizes including a gold medal and medal of honor at the PPIE of 1915 in San Francisco. 1907, elected full member of NAD. Also active in several Boston area art associations including Boston Water Color Club and Guild of Boston Artists. 1896, built studio in Ogunquit, Maine, becoming one of the founding members of its art colony. A lifelong and influential teacher, he offered the first of more than thirty years of summer art classes in Ogunquit in 1898.

Coasting—Boston Common, c. 1920

Oil on canvas, 20 x 27

Signed lower right, "Charles H. Woodbury"

Gift of Mrs. Charles Bruen Perkins, 52.877

Before the Storm, 1926

Watercolor on paper, 12 x 21

Signed lower left, "Charles H. Woodbury"

Museum purchase, 43.21

Self-Portrait, 1937

Oil on canvas, 27¼ x 20¼

Signed and dated lower left, "Charles H. Woodbury '37"

Gift of Mrs. Charles Bruen Perkins, 52.870

Two Girls Bathing, n.d.

Oil on board, 12 x 15³⁄₁₆

Signed lower right, "Chas H Woodbury"

Museum purchase, 44.362

ANDREW NEWELL WYETH
(b. 1917)

Clouds and Shadow, 1940

Watercolor and gouache on paper, 18 x 22⅛

Signed lower right, "Andrew Wyeth"

Museum purchase, 44.155

The Road to Friendship, 1941

Watercolor and gouache on paper, 22¾ x 30½

Signed lower right, "Andrew Wyeth"

Museum purchase, 44.156

Off Teel's Island, 1944

Watercolor and graphite on paper, 15¾ x 19¾

Signed lower right, "Andrew Wyeth"

Museum purchase, 44.422

Rocks and the Sea, 1944

Watercolor on paper, 21⅞ x 30

Signed lower right, "Andrew Wyeth"

Gift of the American Academy of Arts and Letters, Childe Hassam Fund, 48.714

The White Dory, 1944

Watercolor on paper, 14⅝ x 21

Signed lower left, "Andrew Wyeth"

Museum purchase, 44.421

Young Fisherman and Dory, 1944

Graphite with gouache and watercolor on paper, 29¼ x 39¼

Signed lower right, "Andrew Wyeth"

Museum purchase, 54.906

Anderson's, 1945

Watercolor on paper, 22¼ x 30½

Signed lower right, "Andrew Wyeth"

Gift of the Estate of Stephen Wheatland, 87.8

Cat Nap, 1963

Watercolor and gouache on paper, 20 x 14

Signed upper right, "Andrew Wyeth"

Gift of Anne and Kennedy Crane, Jr., 80.28

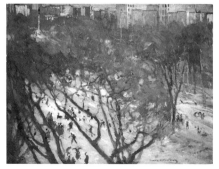

198 Charles Herbert Woodbury Coasting—Boston Common

199 Andrew Newell Wyeth The Road to Friendship

JAMES BROWNING WYETH
(b. 1946)

Blueberry Mulch, 1963

Watercolor and gouache on paper, 18⅞ x 23¹¹⁄₁₆

Signed lower right, "Jamie Wyeth"

Gift of the Boston Safe Deposit and Trust Co., 79.58

Island Friendship, c. 1980

Watercolor on paper, 21⁵⁄₁₆ x 29¼

Signed lower right, "J. Wyeth"

Bequest of Mrs. Elizabeth B. Noyce, 97.3.57

Coast Guard Anchor, 1982

Watercolor on paper, 21½ x 29½

Signed lower right, "J. Wyeth"

Bequest of Mrs. Elizabeth B. Noyce, 97.3.56

NEWELL CONVERS WYETH
(1882–1945)

Three Men on a Raft, 1919

Oil on canvas, 34¼ x 25⅛

Signed lower center, "Wyeth"

Museum purchase (Roswell Dwight Hitchcock Fund), 65.1437

King Edward, 1921

Oil on canvas, 40 x 32⅜

Signed lower left, "N. C. Wyeth and © C. S. Sons"

Gift of Mr. and Mrs. Robert H. Burrage, Jr., 91.1

The Blind Leading the Blind, c. 1927

Oil on canvas, 45 x 40¼

Signed lower left, "N. C. Wyeth"

Gift of Charles D. Childs, 63.1300

Cannibal Shore, 1930

Oil on canvas, 30 x 47⅛

Signed lower left, "N. C. Wyeth"

Museum purchase, 63.1286

Bligh Fights Purcell, 1940

Oil on Masonite, 30 x 20½

Signed lower left, "N. C. Wyeth," and lower right, "To Jim and Elizabeth / from Convers 1941"

Gift of Mrs. Sherwood Cook, Mrs. Dudley Rockwell, and Mrs. Andrew Wyeth, 65.1420

MARGUERITE ZORACH
(1887–1968)

City of Bath, c. 1927

Oil on canvas, 18 x 30

Signed lower right, "Marguerite Zorach"

Gift of Tessim Zorach and Dahlov Ipcar, 86.20.1

WILLIAM ZORACH
(1889–1966)

Autumn, Maine, c. 1920–32

Watercolor on paper, 15½ x 22⅝

Signed lower right, "Zorach"

Gift of Mr. and Mrs. Bert Thome, 80.36.1

Bay Point, Maine, c. 1940

Oil paint wash and watercolor on paper, 15⁷⁄₁₆ x 22½

Signed lower right, "Zorach"

Museum purchase, 44.315

Study for Seated Dancer, 1950

Bronze, 11¼ x 4½ x 3½

Signed lower left, "Zorach," and back, "Zorach / 1/6"

Gift of Tessim Zorach and Dahlov Ipcar, 80.13.1

The Wisdom of Solomon, 1963–66 (cast 1971)

Bronze, 39½ x 28 x 24

Signed and dated back, lower right, "Zorach 1963–1966 / 6/6"

Gift of the Zorach and Ipcar Children, 92.1

Sunset, 1964

Watercolor on paper, 19⁹⁄₁₆ x 26⅛

Signed lower right, "Zorach"

Gift of Tessim Zorach and Dahlov Ipcar, 80.13.2

On the Bridge at Night, n.d.

Watercolor on paper, 15¼ x 22⅛

Signed lower right, "William Zorach"

Gift of Tessim Zorach and Dahlov Ipcar, 80.13.10

200 Newell Convers Wyeth Cannibal Shore

Notes

Foreword

1. Rockland's population is approximately 9,000 residents and less than 40,000 located in nearby towns and offshore islands. Among other independent museums located in small towns are the Parrish Art Museum in Southampton, Long Island, the Brandywine River Museum in Chadds Ford, Pennsylvania, and the Hyde Collection in Glens Falls, New York.

2. Elizabeth Noyce also gave in her lifetime and through bequest a number of works to the Maine Maritime Museum in Bath, the Monhegan Museum on Monhegan Island, and the Maine State Museum in Augusta. In every instance these works were given with the collector's intimate knowledge of where these works would best fit the existing museum collections.

History of the Collection

1. Wendell S. Hadlock, "The Farnsworth Museum and Its Growth since 1948," 1964 annual report, Farnsworth Art Museum Archives.

2. William A. Farnsworth (1815–1876) amassed his wealth from the Rockland lime works and by trade. He was also the founder of the Rockland Water Works. His son James (1841–1905) added to the family wealth as a merchant and ship owner. Lucy Farnsworth (1838–1935) inherited the bulk of her father's and brother's estates and through astute investments in real estate, stocks, and bonds increased the family fortune to over a million dollars at the time of her death.

3. Robert P. Bellows, *Fiftieth Anniversary Report of the Harvard Class of 1899* (Cambridge, Mass.: Harvard University Press, 1949), 54–55.

4. Robert P. Bellows, "Six Art Museums," 8–11 October 1941, and "Museum Round-Up," October 1943, unpublished reports, Farnsworth Art Museum Archives.

5. Jane Gray to Roger D. Swain, 26 April 1942, Farnsworth Art Museum Archives.

6. Boston Safe Deposit and Trust Company, internal memorandum, 15 July 1943, Farnsworth Art Museum Archives.

7. Robert P. Bellows, "Preliminary Suggestions on the William A. Farnsworth Library and Museum," 19 March 1941, 7, unpublished report, Farnsworth Art Museum Archives.

8. Ibid., 3.

9. Philip Hofer, "Recollections of the Early Years of the William A. Farnsworth Library and Art Museum in Rockland, Maine," May 1982, unpublished essay, Farnsworth Art Museum Archives.

10. Ibid.

11. "Philip Hofer, 86, Art Collector and Former Curator at Harvard," *Boston Globe*, 10 November 1984.

12. Philip Hofer to Robert P. Bellows, 8 July 1945, Farnsworth Art Museum Archives.

13. Bellows's acquisitions for the Farnsworth Museum collection included: 432 books, 304 prints, 101 watercolors, 66 oils, and 9 sculptures.

14. "Then and Now," *New York Times*, 18 March 1945, in Robert P. Bellows, "Farnsworth Gallery Book of Possessions," 30 June 1943 to 1 July 1948, Farnsworth Art Museum Archives.

15. Hofer, "Recollections."

16. Robert P. Bellows, "Three Days in New York Picture Shops: or Watson and the Shark," 15–17 March 1944, 2, 6, 7, unpublished report, Farnsworth Art Museum Archives.

17. Ibid., 8.

18. A second drawing for *Road to Friendship* was purchased directly from the artist's wife, Betsy, later that same year.

19. *Turkey Pond* was donated to the museum in 1995, gift of Mr. and Mrs. Andrew Wyeth, in memory of Walter Anderson.

20. S. Morton Vose II, "Farnsworth Recollection," July 1982, unpublished essay, Farnsworth Art Museum Archives.

21. One of these groups, the Boston Society of Water Color Painters, of the Boston Art Club, held annual exhibitions at the Museum of Fine Arts.

22. Bellows, "Preliminary Suggestions," 8.

23. Ellwood C. Parry III to Pamela J. Belanger, 23 December 1993, Farnsworth Art Museum collection files.

24. "Director James M. Brown III, Is Well Fitted for the Position," *Rockland Courier-Gazette*, 13 August 1948.

25. James M. Brown III, "A Small Art Museum's First Year," *College Art Journal* 9, no. 1 (Autumn 1949): 29.

26. Ibid., 27.

27. James M. Brown III, "Plans for the Future," 1 April 1949–31 March 1950, Farnsworth Art Museum Annual Report.

28. Brown, "A Small Art Museum's First Year," 28.

29. Brown, Farnsworth Art Museum Annual Report.

30. Hofer, "Recollections."

31. "The William A. Farnsworth Library and Art Museum," *The Bulletin of the Maine Library Association* 12, no. 2 (May 1951).

32. "Rockland's Farnsworth Museum," *Maine Trail*, September, 1958.

33. Farnsworth Art Museum promotional brochure, c. 1964, Farnsworth Art Museum Archives.

34. "$65,000 for a Wyeth," *Boston Globe*, 12 October 1963, and Brian O'Doherty, "A New Wyeth Painting Brings 65,000," *New York Times*, 12 October 1963.

35. Andrew Wyeth, *Alvaro's Hayrack*, 60.1194, gift of Mr. and Mrs. Andrew Wyeth, *Cat Nap*, 80.28, gift of Anne and Kennedy Crane Jr.; James Wyeth, *The Capstan*, 63.1302, gift of Dorothy Addams Brown; N. C. Wyeth, *The Blind Leading the Blind*, 63.1300, gift of Mr. Charles D. Childs, *Bligh Fights Purcell*, 65.1420, gift of Mrs. Sherwood Cook, Mrs. Dudley Rockwell, Mrs. Andrew Wyeth.

36. The artist's brother, Nathan Berliawsky, also made significant gifts, as did her sister Anita Berliawsky Wienstein. Nathan Berliawsky donated a collection of his sister's papers and later in 1980 Nevelson herself

added to the archive, making it the largest museum collection of her papers.

37. Until 1985 the Boston Safe Deposit and Trust Company was the museum's sole trustee. Following discussions among the advisory board it was determined that the collection, buildings and grounds, and all tangible property would be transferred to a new independent Board of Directors. This transfer of governing authority occurred in 1995. The original endowment, established through the will of Lucy Farnsworth, would remain with the bank. This agreement was finalized through the action of the Maine Probate Court. Part of the museum's first, formal long-range plan, the new Board authorized a revised Statement of Mission that outlines the major purposes of the museum and its emphasis on American and Maine art.

38. In the summer of 1993 the Farnsworth mounted James Wyeth's first thematic exhibition, "Jamie Wyeth: Islands," 27 June to 22 August.

39. MBNA America, headquartered in Wilmington, Delaware.

40. See documentation associated with the 1998 building program "The Farnsworth Center for the Wyeth Family in Maine," and the 1994 expansion and renovation under the "Maine in America" Capital Campaign, Farnsworth Art Museum Archives.

41. Robert P. Bellows, "Preliminary Suggestions on the William A. Farnsworth Library and Museum," 19 March 1941, 7, unpublished report, Farnsworth Art Museum Archives.

Maine in America

1 Jonathan Fisher

1. For sources on Jonathan Fisher, see Janet S. Byrne, "An American Pioneer Amateur," *Princeton University Library Chronicle* 6 (June 1945): 152–170; Mary Ellen Chase, *Jonathan Fisher: Maine Parson, 1768–1847* (New York: Macmillan, 1948); Abbott Lowell Cummings, "Jonathan Fisher House, Blue Hill, Maine," *Old-Time New England* 56, no. 4 (1966): 1–17; Priscilla B. Adams, *The Arts and Crafts of the Versatile Parson Fisher, 1768–1847* (Rockland, Maine: Farnsworth Art Museum, 1967); Alice Winchester, "Rediscovery: Parson Jonathan Fisher," *Art in America* 58 (November–December 1970): 92–99; Winchester, *Versatile Yankee: The Art of Jonathan Fisher, 1768–1847* (Princeton, N.J.: Pyne Press, 1973).

2, 2a Robert Salmon

1. Charles D. Childs observed that Salmon was the first American artist to produce good pictures of whaling vessels. See "Marine Painting: Flood Tide," *Antiques* 66 (July 1954): 54.

2. Indicative of the widespread national interest in the adventures of whaling, in 1848, a moving panorama by Benjamin Russell (1804–1885) and Caleb P. Purrington (1812–1876) entitled *Whaling Voyage Round the World* toured America for three years. See Kevin J. Avery, "*Whaling Voyage Round the World:*

Russell and Purrington's Moving Panorama and Herman Melville's 'Mighty Book,'" *American Art Journal* 21, no. 1 (1990): 50–78.

3. Typescript copy of Robert Salmon's "catalogue" contains not only information on his production of paintings but facts on patronage, income derived from the sale of work, and details of his whereabouts. The original is now lost, however a typescript copy, "Catalogue of Robert Salmon's Pictures, 1828 to 1840, From his own notes, now in the possession of Miss Darracott, 1881," is held at the Boston Public Library. The typescript copy is quoted in Appendix A, John Wilmerding, *Robert Salmon, Painter of Ship and Shore* (Boston: Boston Public Library, 1971), 89–98.

4. The Museum of Fine Arts' paintings are numbered 718 and 719 in Salmon's catalogue.

5. Formerly known as *Cutting Blubber,* the museum restored the artist's original title *Whale Fishing* to the painting.

6. Henry T. Tuckerman, *Book of the Artists* (New York: G. P. Putman & Son, 1867), 551.

3 Thomas Cole

1. William H. Truettner and Alan Wallach, eds., *Thomas Cole: Landscape into History* (New Haven: Yale University Press, 1994).

2. Alan Wallach, "Thomas Cole: Landscape and the Course of American Empire," 23–111, in Truettner and Wallach, *Thomas Cole: Landscape into History.* See particularly "Part III: Landscape as History," 51–77.

3. Quoted in William Dunlap, *History of the Rise and Progress of the Arts of Design in the United States* (1834; New York: Dover Publications, 1969), 2: 253.

4. See Edward Nygren, "From View to Vision," in Edward J. Nygren and Bruce Robertson, *Views and Visions: American Landscape before 1830* (Washington, D.C.: Corcoran Gallery of Art, 1986), 3–81.

4 Charles Codman

1. *Pirate's Retreat* is one of two known versions of the subject: the other is *The Pirate's Retreat*, 1830, 24½ x 27¾, collection of Mark A. Umbach. See Tracie Felker, "Charles Codman: Early Nineteenth-Century Artisan and Artist," *American Art Journal* 22, no. 2 (1990): 61–86.

2. Alice Knotts Bossert Cooney, "Ornamental Painting in Boston, 1790–1830," M.A. thesis, University of Delaware, 1978, 5–6, quoted in Felker, "Charles Codman: Early Nineteenth-Century Artisan and Artist," 83. Felker contends that Codman had probably established contact with Portland during his apprenticeship with Penniman. See her note 29.

3. *Portland Eastern Argus,* 19 July 1825, quoted in Felker, "Charles Codman: Early Nineteenth-Century Artisan and Artist," 64.

4. Harold Edward Dickinson, *Observations on American Art: Selections from the Writings of John Neal (1793–1876),* Pennsylvania State College Series, no. 12 (1943): 90–91.

5. Neal's articles on Codman include "Paintings,"

Yankee 1 (30 April 1828): 141; "Codman's Pictures," *Portland Advertiser,* 19 September 1829; "American Painters: Charles Codman," *Portland Magazine, Devoted to Literature* 1 (1 January 1835); "Charles Codman," *Portland Tribune,* 21 September 1842; "Painters and Painting," *Northern Monthly* 1 (June 1864): 265–67; "Our Painters: Charles Codman," *Northern Monthly* 1 (August 1864): 363–66; "Our Painters," *Atlantic Monthly* 23 (March 1869): 337–46; and "Our Landscape Painters: Charles Codman," *Portland Illustrated* (Portland, Maine) (1874): 28–29.

6. John Neal, *Seventy-six* (Baltimore, 1823), 234, quoted in Donald A. Sears, *John Neal* (Boston: 1978), 51.

7. Robert F. Perkins and William J. Gavin III, eds., *Boston Athenaeum Art Exhibition Index, 1827–1874* (Boston: The Library of the Boston Athenaeum, 1980), 37. The painting was listed as no. 84.

8. *Portland Advertiser*, 28 May 1830. Three years after Codman's death further praise of *Pirate's Retreat* was published in the *Portland Advertiser* noting that he "painted some ten or a dozen pieces that far outstripped the general run of his paintings, and this is one of them." *Portland Advertiser,* 14 August 1845.

9. John Neal, "Fine Arts," in *First Exhibition and Fair of the Maine Charitable Mechanic Association, Held at the City Hall, in the City of Portland, from Sept. 24 to Oct. 6, 1838* (Portland: Maine Charitable Mechanic Association, 1838), 38. The picture was exhibited as no. 18.

10. *Illustrations of the Athenaeum Gallery of Paintings* (Boston: Frederic S. Hill, 1830), 8–10.

5, 6, 7 Alvan Fisher

1. Fred B. Adelson, "Alvan Fisher in Maine: His Early Coastal Scenes," *American Art Journal* 18, no. 3 (1986): 64–65.

2. William Dunlap, *History of the Rise and Progress of the Arts of Design* (1834; reprint, New York: Dover Publications, 1969), 264.

3. Mabel Munson Swan, "The Unpublished Notebooks of Alvan Fisher," *The Magazine Antiques* 68, no. 2 (August 1955): 126.

4. Mabel Munson Swan, *The Athenaeum Gallery 1827–1873: The Boston Athenaeum as an Early Patron of Art* (Boston: The Boston Athenaeum, 1940), 32.

5. John L. Locke, *Sketches of the History of the Town of Camden, Maine: Including Incidental References to the Neighboring Places and Adjacent Waters* (Hallowell, Maine: Masters, Smith & Company, 1859), 182–83.

6. The painting was sold at auction to a buyer named Flagg—undoubtedly the well-known Boston art patron Dr. Josiah Foster Flagg, who was also Fisher's dentist. See Alvan Fisher, "A Catalogue of Paintings Executed after my Return from Europe in 1826," unpublished manuscript, c. 1826–60, n.p., private collection. See page 57, in photocopy of Fisher's account book (pages numbered by Robert C. Vose, Jr., of Vose Galleries of Boston), Archives of American Art, Smithsonian Institution, Washington, D. C., Carl and Olga Milles papers, reel 4314.

8, 9 Fitz Hugh Lane

1. W. B., "The Late F. H. Lane, Marine Artist," *Daily Evening Transcript,* 19 August 1865.

2. Clarence Cook, "Letters on Art, No. IV," *Independent,* 7 September 1854, quoted in William H. Gerdts, "'The Sea is His Home': Clarence Cook Visits Fitz Hugh Lane," *American Art Journal* 17, no. 3 (Summer 1985): 49.

3. Ibid., 47–49.

4. Ibid.

5. As early as 1848 Lane accepted an invitation from his friend and patron, the yachtsman Joseph L. Stevens, Jr., to join him in a sail to Castine, Maine, Stevens's parents' home. Lane joined him on several late summer cruises in 1850, 1851, 1852, 1855, and 1863. Because of a childhood illness Lane walked with a crutch and was most comfortable traveling in and painting on boats, sketching scenes while at anchor or cruising offshore. A letter from Stevens to a Mr. Mansfield reveals Stevens's relationship to Lane and his years spent in dedicated support of the artist: "I was with him on several trips to the Maine coast where he did much sketching, and sometimes was his chooser of spots and bearer of materials when he sketched in the home neighborhood . . . for his physical infirmity prevented his becoming an outdoor colorist." Joseph L. Stevens, Jr., Boston, to Mr. Mansfield, Gloucester, 17 October 1903, Cape Ann Historical Society, quoted in John Wilmerding, *Fitz Hugh Lane* (New York: Praeger Publishers, 1971), 51.

11 Martin Johnson Heade

1. The site is in dispute. In his important monograph on the artist, Theodore E. Stebbins, Jr., notes that the painting is "a view from Newport and includes on the horizon the small island known as Spouting Rock"; see *The Life and Works of Martin Johnson Heade* (New Haven and London: Yale University Press, 1975), 66. However, unlike the situation of the island in the painting, Spouting Rock is located only a few feet off the shore of Bailey's Beach. John Wilmerding suggests that the painting is a view off Cape Ann (*Fitz Hugh Lane* [New York: Praeger, 1971], 76). Yet in a letter to the author of 14 November 1992, Britt Crews, curator of the Cape Ann Historical Association, said that neither she nor Harold Bell, president of the association, recognized the distinctively shaped island as one in this area of the Massachusetts coast. The detail of a large tree growing on a rocky seaside ledge is far more typical of the Maine coast than that of Massachusetts or Rhode Island. For example, the details in *Storm Clouds* are not dissimilar to those depicted in drawings Heade made in 1862 of Passamaquoddy Bay from St. George, New Brunswick, close to the Maine border (see Stebbins, *Life and Works,* cat. nos. 396.2 and 396.31). Stebbins does not place Heade in Maine in 1859, but he could have been, given his frequent travels during this period.

2. Heade had previously painted only a few bay scenes, but no full-fledged seascapes like *Storm Clouds on the Coast.* For example, in 1856, at the Pennsylvania Academy of the Fine Arts, he exhibited a painting called *Scene on Narragansett Bay* (unlocated).

3. For a complete technical analysis of the painting, as well as a detailed summary of its condition history and 1994 restoration, see Claire M. Barry's technical note in Sarah Cash, *Ominous Hush: The Thunderstorm Paintings of Martin Johnson Heade* (Fort Worth: Amon Carter Museum, 1994), 70–71.

4. The sketch, originally part of the Housley sketchbook, measures 8¹¹⁄₁₆ x 11⅝ in. and is reproduced in *Ominous Hush*, 25; for more on the sketchbook, see 83, no.10.

5. For more on Beecher's probable role as the first owner of *Storm Clouds* and on the likely relationship of this and other Heade paintings to the Civil War, see *Ominous Hush*, 69–70 and passim.

12 Sanford Robinson Gifford

1. Ila Weiss, *Poetic Landscape: The Art and Experience of Sanford R. Gifford* (Newark, Del.: University of Delaware Press, 1987), 100.

2. Edmund C. Steadman and George M. Gould, *Life and Letters of Edmund Clarence Steadman* (New York: Moffat and Yard, 1910), 1:342.

3. The painting is derived from the sketch in sketchbook (Collection of Sanford Gifford, M.D.) titled *Bald Porcupine*, 1864, pencil on paper, 5⅝ x 8⅞, Archives of American Art, Smithsonian Institution, Washington, D.C., reel 688, frame 414.

4. "Art and Artists in New York," *Boston Evening Transcript*, 17 November 1864.

5. "The National Academy of Design," *New York Times*, 24 June 1863.

13 Jervis McEntee

1. James L. Yarnall and William H. Gerdts, *The National Museum of American Art's Index to American Art Exhibition Catalogues* 6 vols. (Boston: G. K. Hall & Co., 1986), 4:2358.

2. The most recent study of the artist is J. Gray Sweeney, *McEntee and Company* (New York: Beacon Hill Fine Arts, 1998).

3. See J. Gray Sweeney, "A 'very peculiar' picture: Martin Johnson Heade's *Thunderstorm Over Narragansett Bay*," *Archives of American Art Journal* 28, no. 4 (1988): 9.

4. See J. Gray Sweeney, "The Advantages of Genius and Virtue: Thomas Cole's Influence, 1848–1858," in William H. Truettner and Alan Wallach, eds., *Thomas Cole: Landscape into History* (New Haven: Yale University Press, 1994), 113–35.

5. For the source of this cruciform motif see J. Gray Sweeney, "Endued with Rare Genius: Frederic Edwin Church's *To the Memory of Cole*," *American Art* 2, no. 1 (1988): 44–71.

6. Henry T. Tuckerman, *Book of the Artists* (New York: G. P. Putnam & Son, 1867; New York: James F. Carr, 1967), 545.

7. John F. Weir, "Memorial Address: Jervis McEntee, American Landscape Painter," *The Liberal Review* (1891): 8.

8. T. Worthington Whittredge, John I. H. Baur, ed., *The Autobiography of Worthington Whittredge, 1820–1910* (1905; New York: Arno Press, 1969), 60.

9. See J. Gray Sweeney, "An 'Indomitable Explorative Enterprise': Inventing National Parks," in Pamela J. Belanger, *Inventing Acadia: Artists and Tourists at Mount Desert* (Rockland, Maine: The Farnsworth Art Museum, 1999), 131–56. For McEntee and Gifford at Mount Desert see Belanger, *Inventing Acadia*.

10. McEntee's diary runs to half a million words and has only been published to the year 1876. See "Jervis McEntee's Diary," *Archives of American Art Journal*, 8, nos. 3 and 4 (July–October, 1968): 1–29; and "Jervis McEntee's Diary, 1874–1876," 31, no. 1 (1991): 2–19.

14, 14a George Inness

1. George Inness, Medfield, Massachusetts, to Reverend Dwight Roswell Hitchcock, 19 November 1860, The Farnsworth Art Museum Collection files.

2. See Nicolai Cikovsky, Jr. and Michael Quick, *George Inness* (Los Angeles: Los Angeles County Museum of Art, 1985), 86.

3. George Inness, Medfield, Massachusetts, to Reverend Dwight Roswell Hitchcock, 2 December 1860, The Farnsworth Art Museum Collection files.

4. Ibid.

5. See Peter Bermingham, *American Art in the Barbizon Mood* (Washington, D.C.: National Collection of Fine Arts, 1975).

15 John Joseph Enneking

1. Julius Hammond Ward, "Moosehead Lake," *Harper's New Monthly Magazine* 51 (1875): 350. *Kineo* means "sharp peak" in the Abenaki language.

2. James R. Lowell, "A Moosehead Journal," *Putnam's Magazine* (November 1853).

3. A group of articles was published posthumously in 1864, as *The Maine Woods*.

4. George B. Wallis, "The Lovely Rivers and Lakes of Maine," *Harper's Weekly* 14, no. 707 (16 July 1870).

5. Ward, "Moosehead Lake," 350.

6. Ibid., 350–51.

7. Frank T. Robinson, *Living New England Artists, Biographical Sketches* (Boston: Samuel E. Cassino, 1888), 64.

16 Washington Allston

I am grateful to David Bjelajac for his scholarship on Allston and particularly for his extensive study of *Miriam*. See his "Washington Allston's Prophetic Voice in Worshipful Song with Antebellum America," *American Art* 5 no. 3 (Summer 1991): 68–87, and books *Millennial Desire and the Apocalyptic Vision of Washington Allston* (Washington, D.C.: Smithsonian Institution Press, 1988), and *Washington Allston, Secret Societies, and the Alchemy of Anglo-American Painting* (New York: Cambridge University Press, 1997).

1. The three pictures (the other two being *Jeremiah Dictating His Prophecy of the Destruction of Jerusalem to Baruch the Scribe*, and *Saul and the Witch of Endor*) are related thematically to one another and to Allston's still uncompleted *Belshazzar's Feast*, as statements of God's unflinching wrath against injustice.

2. Allston to William Collins, 18 May 1821, Dana Papers, Massachusetts Historical Society, quoted in Edgar Preston Richardson, *Washington Allston: A Study of the Romantic Artist in America* (Chicago: University of Chicago Press, 1948), 139.

3. Allston to Charles R. Leslie, 20 May 1821, quoted in Jared B. Flagg, *The Life and Letters of Washington Allston* (1892; reprint, New York: Benjamin Blom, 1969), 167.

4. Two drawings at the Fogg Art Museum, Cambridge, Massachusetts, appear to be studies for the finished oil: *Female Head (Study for Miriam the Prophetess)*, 1821, and *Half-Length Portrait of a Lady*, c. 1821. See Kenyon Castle Bolton III, "The Drawings of Washington Allston (A Catalogue Raisonné)," master's thesis, Harvard University, 1977, 2: 72.

5. Henry T. Tuckerman, *Book of the Artists* (New York: G. P. Putnam & Son, 1867), 146–47.

6. Washington Allston, *Lectures on Art and Poems, and Monaldi*, ed. Richard Henry Dana, Jr. (1850; facsimile edition, Gainesville, Fla.: Scholars' Facsimiles and Reprints, 1967), 10.

7. Allston, quoted in Flagg, *The Life and Letters of Washington Allston*, 195.

8. Asher B. Durand, "Letters on Landscape Painting," 1855, quoted in William H. Gerdts and Theodore E. Stebbins, Jr., *"A Man of Genius:" The Art of Washington Allston (1779–1843)* (Boston: Museum of Fine Arts, 1979), 168.

9. Harding's Gallery, *Exhibition of Pictures Painted by Washington Allston* (Boston: John H. Eastburn, 1839), 4. The painting was listed as number 3, and this is the first published instance of the lengthy title—*The Triumphal Song of Miriam on the Destruction of Pharaoh and His Host in the Red Sea*. Prior exhibition, titles at the Boston Athenaeum were simply *Miriam* or *The Prophetess*.

10. Oliver Wendell Holmes, "Exhibition of Pictures Painted by W. Allston at Harding's Gallery, School Street," *North American Review* 50 (April 1840): 375–76.

11. Tuckerman, *Book of the Artists*, 149.

12. Elizabeth Palmer Peabody, *Last Evening with Allston, and Other Papers* (Boston: D. Lothrop, 1886), 35.

13. Sarah Clarke, "Our First Great Painter, and His Works," *Atlantic Monthly* 15 (1865): 133.

14. Robert C. Winthrop, Jr., *Memoir of the Honorable David Sears* (Cambridge, Mass.: John Wilson, 1886), 10, 29. During that time Sears established a series of endowments, later known collectively as the "David Sears Charity" and intended to assist the poor of Boston.

15. David Bjelajac, "Washington Allston's Prophetic Voice in Worshipful Song with Antebellum America," *American Art* 5, no. 3 (Summer 1991), 82; see also Conrad L. Donakowski, *A Muse for the Masses: Ritual and Music in an Age of Democratic Revolution, 1770–1870* (Chicago: University of Chicago Press, 1977), 5, 34, 207–09; and Lawrence

Frederick Kohl, *The Politics of Individualism: Parties and the American Character in the Jacksonian Era* (New York: Oxford University Press, 1989), 63–64.

17 Thomas Sully

1. E. Digby Baltzell, *Puritan Boston and Quaker Philadelphia: Two Protestant Ethics and the Spirit of Class Authority and Leadership* (New York: The Free Press, 1979), 313.

2. These changing roles resulted in the development of an industry devoted to the production of youth related items such as books, toys, and clothing. For discussions of changing attitudes toward children see N. Ray Hiner, and Joseph M. Hawes, *Growing Up in America, Children in Historical Perspective* (Westport, Conn.: Greenwood Press, 1985), and Joseph F. Kett, *Rites of Passage: Adolescence in America, 1790 to the Present* (New York: Basic Books, 1977).

3. Henry Budd, "Thomas Sully," *Pennsylvania Magazine of History and Biography* 42, no. 2 (1918): 120.

4. David M. Robb, "Thomas Sully: The Business of Painting," master's thesis, Yale University, 1967, 46–48.

5. Steven Eric Bronson, "Thomas Sully: Style and Development in Masterworks of Portraiture, 1738–1839," Ph.D. diss., University of Delaware, 1986, 247–250.

6. Henry T. Tuckerman, *Book of the Artists* (New York: G.P. Putman & Son, 1867), 159.

7. John Neal, "Our Painters," *Atlantic Monthly* 23 (March 1869): 337.

8. Thomas Sully, *Hints to Young Painters and the Process of Portrait Painting as Practiced by the Late Thomas Sully* (Philadelphia: J. M. Stoddart & Company, 1873), 37–38.

18, 18a (Jonathan) Eastman Johnson

1. Lizzie W. Champney, "The Summer Haunts of American Artists," *Century Illustrated Magazine* 30 (1884): 854, "[Johnson] . . . is a chronicler of a phase of our national life which is fast passing away."

2. Patricia Hills, *The Genre Painting of Eastman Johnson* (New York: Garland Publishing Company, 1977). Hills notes that *Corn-Husking* was Johnson's earliest work with a rural theme. This painting and *Winnowing Grain* not only relate to *American Farmer* in subject matter but are also very similar in size and shape, although the lack of anecdotal detail and its emblematic quality seem also to suggest the ritual mood of works like *Sugaring-Off*, 1866–72 (Rhode Island School of Design), and *Cranberry Pickers*, c. 1875–80 (Yale University Art Gallery).

3. Sarah Burns, *Pastoral Inventions: Rural Life in Nineteenth-Century American Art and Culture* (Philadelphia: Temple University Press, 1989), 259. Referring to "rural nostalgia" in nineteenth-century painting, Burns notes that the "impact of the war . . . made the country of the imagination all the more a ravishing dream world . . . which acted as a powerfully evocative symbol among the insecurities of the post-bellum decades."

4. Joshua C. Taylor, *The Fine Arts in America* (Chicago: University of Chicago Press, 1979), 101.

5. Letter to I. Coyle, 13 March 1864, Archives of American Art, Smithsonian Institution, Washington, D.C., reel D10.

6. Hills, *The Genre Painting of Eastman Johnson*, 87, 89. On the popularity of Millet's work in the United States, see also Laura Meixner, "Popular Criticism of Jean-François Millet in Nineteenth-Century America," *Art Bulletin* 65, no. 1 (March 1983): 94–105.

19, 19a William Michael Harnett

1. For a thorough discussion of Harnett's last years, see Jennifer Hardin, "The Late Years," in Doreen Bolger, Marc Simpson, and John Wilmerding, eds., *William M. Harnett* (New York: Harry N. Abrams, Inc., 1992), 185–92.

2. Barbara S. Groseclose, "Vanity and the Artist: Some Still-Life Paintings by William Michael Harnett," *American Art Journal* 19, no. 1 (1987): 56.

3. Ibid.

4. Ibid., 56–57.

20 Thomas Eakins

1. See Lloyd Goodrich, *Thomas Eakins*, 2 vols. (Cambridge, Mass.: Harvard University Press, 1982), 2:179–82; and Natalie Spassky, et al., *American Paintings in the Metropolitan Museum of Art* (New York: The Metropolitan Museum of Art, 1985), 2:622–26 (with quotations from Caffin on p. 624). See also Carol Troyen's entry on *The Thinker* in Theodore E. Stebbins, Jr., Carol Troyen, and Trevor J. Fairbrother, eds., *A New World: Masterpieces of American Painting, 1760–1910* (Boston: Museum of Fine Arts, 1983), 329–30; and H. Barbara Weinberg's entry in John Wilmerding, ed., *Thomas Eakins* (Washington, D.C.: Smithsonian Institution Press, 1993), 148.

24 James Edward Buttersworth

1. For an account of the race, see Herbert L. Stone, William Taylor, and William W. Robinson, *The America's Cup Races* (New York: Norton, 1970), 66–77.

2. Quoted in David C. Huntington, *Art and the Excited Spirit: America in the Romantic Period* (Ann Arbor: University of Michigan Museum of Art, 1972), 29.

3. Roger B. Stein, *Seascape and the American Imagination* (New York: Clarkson N. Potter, in association with the Whitney Museum of American Art, 1972), 62.

4. See Richard B. Grassby, *Ship, Sea, and Sky: The Marine Art of James Edward Buttersworth* (New York: South Street Seaport, in association with Rizzoli, 1994), 24. For another perspective on Buttersworth, see Rudolph J. Schaefer, *J. E. Buttersworth, Nineteenth-Century Marine Painter* (Mystic, Conn.: Mystic Seaport Museum, 1975).

25 William Trost Richards

1. Linda S. Ferber, *William Trost Richards (1833–1905): American Landscape and Marine Painter* (New York: Garland Publishing, 1980), 356–57.

2. W. T. Richards to T. W. Richards, 29 August 1855, quoted in Ferber, *William Trost Richards*, 66.

3. Corcoran curator William MacLeod to W. T. Richards, 14 May 1883. William T. Richards papers, Archives of American Art, Smithsonian Institution, Washington, D.C., quoted in Ferber, 383 n. 41.

4. "Mr. Richards's Works. Pencil Drawings and Small Watercolors by Him, on View at the Fogg Art Museum, Cambridge," *Boston Evening Transcript*, 11 March 1918, 11.

5. Samuel G. W. Benjamin, *Art in America: A Critical and Historical Sketch* (New York: Harper and Brothers, 1880), 75.

6. W. T. Richards to George Whitney, Newport, 20 August 1876, quoted in Ferber, 368.

7. W. T. Richards to George Whitney, Newport, 24 September 1876, quoted in Ferber, 368.

8. W. T. Richards to George Whitney, Wyke Regis, 14 July 1879, quoted in Ferber, 368.

26 Alfred Thompson Bricher

1. Jeffrey R. Brown, *Alfred Thompson Bricher, 1837–1908* (Indianapolis: Indianapolis Museum of Art, 1973), 31.

2. John Duncan Preston, "Alfred Thompson Bricher, 1837–1908," *Arts Quarterly* 25, no. 2 (Summer 1962): 150.

3. *New York Times*, 13 April 1874.

4. *Evening Post*, 25 April 1874.

27 Joseph Rodefer DeCamp

1. "The Fine Arts," *Boston Daily Advertiser*, 3 January 1892, 5, quoted in Laurene Buckley, *Joseph DeCamp: Master Painter of the Boston School* (New York: Prestel, 1995), 41.

2. Buckley, *Joseph DeCamp*, 41.

3. "Squibs from Squam," *Cape Ann Breeze*, 29 June 1891.

4. "Squibs from Squam," *Cape Ann Breeze*, 15 September 1891.

5. Donald Moffat papers, Archives of American Art, Smithsonian Institution, Washington, D.C., Microfilm Reel B2 (Chronology, 2).

6. Buckley, *Joseph DeCamp*, 42–43.

7. Ibid., 42.

8. Patricia Jobe Pierce, *Edmund C. Tarbell and the Boston School of Painting, 1889–1980* (Hinkham, Mass.: Pierce Galleries, Inc., 1980), 69.

9. Buckley, 86.

28 John Henry Twachtman

1. Dorothy Weir Young, *The Life and Letters of J. Alden Weir* (New York: Kennedy Graphics, Inc., 1971), 190.

2. *Winter Landscape* was exhibited at the 54th annual exhibition of the National Academy of Design, 31 April–31 May 1879.

3. "Snow Scenes on Oil Painting," *Art Amateur* 44 (March 1901): 99–100.

4. Clarence Cook, "Paintings in Oil and Pastel by J. H. Twachtman," *Studio* 6 (28 March 1891): 162.

29, 29a (Frederick) Childe Hassam

1. Sadakichi Hartmann, "Studio Talk," *International Studio* 29 (September 1906): 267.

2. Childe Hassam, "New York, The Beauty City," *New York Sun*, 23 February 1913.

3. Samuel Isham, *The History of American Painting* (New York: 1905), 500, quoted in H. Barbara Weinberg, Doreen Bolger, and David Park Curry, *American Impressionism and Realism: The Painting of Modern Life, 1885–1915* (New York: The Metropolitan Museum of Art, 1994), 186.

4. For recent works on the subject see Dona Brown, *Inventing New England: Regional Tourism in The Nineteenth Century* (Washington, D.C.: Smithsonian Institution Press, 1995), and William M. Truettner, and Roger B. Stein, *Picturing Old New England: Image and Memory* (Washington, D.C.: National Musuem of American Art, 1998).

30 Willard Leroy Metcalf

1. The first version of the picture *Ebbing Tide* is nearly identical to the Farnsworth painting. Another study, *Beach and Headlands,* was completed and made into a wall panel for installation in the dining room of the Florence Griswold House, in Old Lyme, Connecticut. See discussion of these two paintings in Elizabeth de Veer and Richard J. Boyle, *Sunlight and Shadow: The Life and Art of Willard L. Metcalf* (New York: Abbeville Press, 1987), 90–91.

2. Christian Brinton, "Willard L. Metcalf," *Century Illustrated Magazine* 77 (November 1908): 155.

3. *New York Sun*, January 1908.

4. Ibid.

31 Maurice Brazil Prendergast

1. The most complete source on Maurice and Charles Prendergast is Carol Clark, Nancy Mowll Mathews, and Gwendolyn Owens, *Maurice Brazil Prendergast, Charles Prendergast: A Catalogue Raisonné* (Munich: Prestel-Verlag; Williamstown, Mass.: Williams College Museum of Art, 1990). For information on Prendergast and the firm of Peter Gill, see Ellen M. Glavin, "Maurice Prendergast: The Boston Experience," *Art and Antiques* 5 (July–August 1982): 64–71.

2. Maurice Prendergast likely received a certain level of training in drawing as a student in the public schools in Boston. For detailed information about the opportunities the school system provided, see Ellen Glavin, "The Early Art Education of Maurice Prendergast," *Archives of American Art Journal* 33 (1993): 2–12.

3. Sinclair Hitchings, "The Prendergast's Boston," in *The Prendergasts & the Arts & Crafts Movement* (Williamstown, Mass.: Williams College Museum of Art, 1989), 47.

4. William M. Milliken, "Maurice Prendergast, American Artist," *The Arts* 9 (April 1926): 182. Research on Sarah Sears has not revealed information that confirms this story, although it is not improbable. See Stephanie Mary Buck, "Sarah Choate Sears: Artist, Photographer, and Art Patron," M.F.A. thesis, Syracuse University, 1985.

5. There were at least three versions of the clock tower in Venice by Prendergast: the Farnsworth work; another painted in the same era that was last known in the collection of Mrs. D. P. Kimball in 1901 (catalogue raisonné no. 1808); and a later version from 1911 now in the collection of the Stanford University Museum of Art (catalogue raisonné no. 1011). The Stanford watercolor was painted in the same format as the Farnsworth watercolor and also has a frame designed by Charles.

32 Lilian Westcott Hale

1. For a discussion, see Annette Stott, "Floral Femininity: A Pictorial Definition," *American Art* 6, no. 2 (Spring 1992): 60–77.

2. Erica E. Hirshler to Pamela J. Belanger, 31 July 1992, Farnsworth Art Museum collection files.

33 Josephine Miles Lewis

1. Betsy Fahlman, "Women Art Students at Yale, 1869–1913: Never True Sons of the University," *Woman's Art Journal* 12, no. 1 (Spring/Summer 1991): 18, citing Matilda Lewis, "Giverny, 1894," typescript, files, Yale University Art Gallery.

2. Carroll Smith Rosenberg, *Disorderly Conduct: Visions of Gender in Victorian America* (New York: Alfred A. Knopf, 1985), 185.

3. Ibid., 187.

34 Frank Weston Benson

1. See Faith Andrews Bedford, *Frank W. Benson: American Impressionist* (New York: Rizzoli, 1994), for a good account of Benson's life and work on North Haven.

2. Ibid., 122.

3. From the artist's journal, private collection, as noted in Farnsworth Museum files. The title of the painting was originally *Portrait of a Boy,* and the present title was given by the sitter himself, 15 May 1957.

37 Walter Lofthouse Dean

1. Cited in Rolf H. Kristiansen and John J. Leaky Jr., "Walter Lofthouse Dean," in *Rediscovering Some New England Artists (1875–1900)* (Dedham, Mass.: Gardiner O'Brien Associates, 1987), 190.

38 Augustus Waldeck Buhler

1. Letter dated 17 February 1971, from Dorothy Buhler to Wendall Hadlock, in curatorial files of the Farnsworth Art Museum.

2. "With the Artists at Squam," *Boston Globe*, 6 August 1900.

3. For an account of the event, see Joe Garland, "The Wreck of the *Wilster*: How the Rockport Life Savers Used the Breeches Buoy to Rescue 23 Sailors on a Stormy Night 70 Years Ago," *North Shore*, 26 February 1972, 12.

4. "East Gloucester," *Cape Ann Shore,* 4 July 1908.

5. Quoted in Joyce Butler, "Augustus Waldeck Buhler: The Artist as Historian," *Log of Mystic Seaport* 37, no. 2 (1895): 63.

6. Ibid., 69.

39, 39a Samuel Peter Rolt Triscott

1. *Boston Transcript,* 16 April 1925; for further biographical information on Triscott, see the artist's file at the Monhegan Museum.

2. It is not known precisely when Triscott first worked on Monhegan as few of his watercolors are dated. None of the extant exhibition catalogues from the 1890s list Monhegan subjects, but he was active there by 1898, when some of his photographs were published as illustrations for an article by A. G. Pettengill, "Monhegan, Historical and Picturesque," *New England Magazine,* n.s., 19 (September 1898): 65–81. Triscott's newspaper obituaries from 1925 state that he had lived on the island for twenty years.

3. *Boston Globe,* 18 April 1925.

4. An undated review by A. J. Philpott in the *Boston Globe* mentions an exhibition at the Museum of Fine Arts that included watercolors by Triscott, Homer, Sargent, and W. Dodge MacKnight (see Triscott file at the Monhegan Museum). This reviewer implied that Homer and Triscott were acquainted, but according to Abigail Gerdts, who is preparing the catalogue raisonné of Homer's work, there is no documentary evidence to support this claim. The Museum of Fine Arts has copies of seven Triscott exhibition catalogues from the J. Eastman Chase Gallery in Boston, where both artists exhibited watercolors in the 1880s.

40 Paul Dougherty

1. Ameen Rahini, "The Marines of Paul Dougherty," *International Studio* 49 (April 1921): 54–58.

2. For a copy of the checklist, *Exhibition of Paintings by Paul Dougherty, N. A.,* Macbeth Gallery, New York, 1908, see the artist's file at the Farnsworth Museum. Other exhibition information is contained in the artist's file in the library of the Pennsylvania Academy of the Fine Arts, Philadelphia.

3. Edwin A. Rockwell, "Paul Dougherty—Painter of Marines: An Appreciation," *International Studio* 35 (November 1908): 3.

4. For biographical information on the artist see *Paul Dougherty, A Retrospective Exhibition* (Portland, Maine: Portland Museum of Art, 1978).

41 Robert Henri

1. Henri to his family, 12 July 1903, quoted in William Innes Homer, *Robert Henri and His Circle* (Ithaca and London: Cornell University Press, 1969), 112.

2. Henri to Sloan, 5 September 1903, quoted in Bennard B. Perlman, *Robert Henri: His Life and Art* (New York: Dover Publications, 1991), 59.

3. A reviewer for the following show at the Arts Club noted, in "Young American Painters," *New York Times*, 6 February 1904, 3, the high volume of "violent talk and divergent comment" concerning the Henri exhibition. However, in the article specifically about the exhibition, "Six Impressionists," *New York Times*, 20 January 1904, 9, the reviewer praised Henri for the "bold marines and landscapes, thick in impasto," noting that in them the water was "intensively alive" while the "rocks are characterless."

4. See Perlman, *Robert Henri*, 1–7.

5. Henri to his parents, 12 July 1903, as quoted in Perlman, 59.

42 Rockwell Kent

1. For the relationship between Henri and Maine, see Jessica F. Nicoll, *The Allure of the Maine Coast: Robert Henri and His Circle, 1903–1918* (Portland, Maine: Portland Museum of Art, 1995). There is some question about the date of Kent's first trip to Monhegan. In his autobiography, *It's Me O Lord: The Autobiography of Rockwell Kent* (New York: Dodd, Mead & Co., 1955), Kent described his 1905 visit as his first encounter with the island (117). However, a recently published painting of Monhegan dated 1904 from the Kent family collection suggests otherwise; see Scott R. Ferris and Ellen Pearce, *Rockwell Kent's Forgotten Landscapes* (Camden, Maine: Down East Books, 1998), 76. Sources that focus on Kent's work on Monhegan include "Rockwell Kent: A Monhegan Legacy," with essay by Eliot Stanley, *Island Journal* 5 (1988): 57–69, and *Rockwell Kent on Monhegan* (Monhegan Island: Monhegan Museum, 1998).

2. Although not generating any sales, a 1907 exhibition of his Monhegan paintings at the Clausen Galleries in New York garnered Kent favorable attention in the press and attracted the notice of fellow artists.

3. For a useful compendium of artistic depictions of Monhegan, see Jane Curtis, Will Curtis, and Frank Lieberman, *Monhegan: The Artists' Island* (Camden, Maine: Down East Books, 1995). Curtis, Curtis, and Lieberman observe that descriptions and images of Monhegan published in the popular press during the late nineteenth century helped attract both tourists and artists to the island (29).

4. The Farnsworth's *Maine Coast* received its title and approximate date during the early 1990s because of its close relationship to a painting in the Cleveland Museum: *Maine Coast* (signed and dated 1907; 34⅛ x 44⅛ in.). In the larger Cleveland work, Kent depicted the same scene as in the Farnsworth painting but opened up the view of the ocean to the right to include a boat on the horizon line. Similar views can also be found in *Maine Coast, Winter* (1909; Museum of Fine Arts, Boston) and *Maine Headland, Winter* (1907, later reworked; The State Hermitage Museum, St. Petersburg). I am grateful to Henry Adams, Curator of American Art at the Cleveland Museum of Art, for responding to my inquiry, and to Scott Ferris for shar-

ing his research on the Farnsworth's *Maine Coast* with me before his book's publication.

5. See Bruce Robertson, *Reckoning with Winslow Homer: His Late Paintings and Their Influence* (Cleveland: The Cleveland Museum of Art, in cooperation with Indiana University Press, 1990), particularly 101-06. Robertson suggests (103-04) that the calligraphic twigs in the foreground of the Cleveland *Maine Coast*—also included in the Farnsworth painting—may be a direct quotation of a similar motif in Homer's *Fox Hunt* (1893; Pennsylvania Academy of the Fine Arts).

6. The principal sources of biographical information on Kent are his *It's Me O Lord* and David Traxel, *An American Saga: The Life and Times of Rockwell Kent* (New York: Harper & Row, 1980). For Kent's paintings, see Richard V. West, *"An Enkindled Eye": The Paintings of Rockwell Kent* (Santa Barbara, Calif.: Santa Barbara Museum of Art, 1985), and Ferris and Pearce, *Rockwell Kent's Forgotten Landscapes*, which documents the works Kent gave to the former Soviet Union in 1960.

7. Kent later wrote, "Henri as an instructor, Henri as a leader of revolt against Academic sterility, Henri as an inspirational influence in American art, is possibly the most important figure of our cultural history," in *It's Me O Lord*, 81.

8. During the 1950s Kent's unpopular political activities would land him before the McCarthy committee and would become the basis of the artist's well-publicized feud with the Farnsworth Art Museum. In his autobiography, Kent excoriated the Farnsworth, its board of trustees, and its director, Wendell Hadlock, for the cancellation of a proposed exhibition of his work scheduled for 1954, claiming the museum had bowed to political pressure. *It's Me O Lord*, 594; 613–14. He also charged the Farnsworth with reneging on its bid to acquire his extensive personal collection (subsequently given to the Soviet Union). The correspondence and other documents in the museum's files suggest that Kent's controversial reputation did prompt the exhibition's cancellation but contain no evidence of an agreement between the artist and the Farnsworth regarding the Kent collection.

9. Rockwell Kent, "Personal," reprinted in *Rockwellkentiana: Few Words and Many Pictures by R. K. and, by Carl Zigrosser, a Bibliography and List of Prints* (New York: Harcourt, Brace & Co., 1933), 11.

10. Kent's air of heroic independence intrigued critics, who linked it to the "American" qualities they detected in his art; see, for example, C. Lewis Hind, "Rockwell Kent in Alaska and Elsewhere," *International Studio* 67 (June 1919): 105–12. In her study of the paintings of George Bellows—an exact contemporary of Kent and a fellow Henri protégé—Marianne Doezema probes the relationship between the masculine pursuit of the "strenuous life" in the United States at the turn of the century and the art of the period; see her *George Bellows and Urban America* (New Haven: Yale University Press, 1992), particularly chap. 2. Spurred by Kent's example, Bellows also painted on Monhegan beginning in 1911.

43 George Wesley Bellows

1. Bellows's biographer, Charles Morgan, *George Bellows: Painter of America* (New York: Reynal and Company, 1965), 171–73, notes that Bellows made 117 paintings during the summer and fall on Monhegan. In the month of October alone he did forty-two paintings.

2. Ibid., 171.

3. 17–31 January 1914.

4. The note about "cleverness of paint merely" was sounded in the *Sun*, 25 January 1914, 2. More sympathetic reviews appeared in the *New York Times*, 23 January 1914, 10; the *New York Post*, 24 January 1914; and *American Art News*, 24 January 1914, 3.

5. For a treatment of Bellows's interest in painting theory, see Michael Quick, "Technique and Theory: The Evolution of George Bellows's Painting Style," in Michael Quick et al., *The Paintings of George Bellows* (New York: Harry N. Abrams, 1992), 9–95.

6. See Franklin Kelly, "'So Clean and Cold': Bellows and the Sea," in *The Paintings of George Bellows*, 135–69.

7. Morgan, *George Bellows: Painter of America*, 140; and Kelly, "So Clean and Cold," 144. Bellows's letters from 1911 to Emma, now in the Bellows Archive at Amherst College, Amherst, Massachusetts, are filled with his musings about the sea. The letter in question dates from 21 August 1911.

8. Because the painting was the only seascape in the exhibition it was given more attention in reviews than it had received in 1914. In the *New York Herald*, 16 December 1915, 11, for instance, the author laments that this was the only seascape in the exhibition. The *American Art News* 18 December 1915, 3, said that the painting was "full of power and movement." And the *Globe and Commercial Advertiser*, 16 December 1915, 16, also praised the painting's "depth and movement."

44 George Wesley Bellows

1. *New York Times*, 17 March 1917, 12.

2. Local lore had it that Sherman Point was the site of the first tilled field in the Camden area. See Renel Robinson, *History of Camden and Rockport Maine* (Camden, Maine: Camden Publishing Company, 1907). It was also the usual spot for Camden Baptists to perform their baptisms.

3. See Franklin Kelly, "'So Clean and Cold': Bellows and the Sea," in Michael Quick et al., *The Paintings of George Bellows* (New York: Harry N. Abrams, 1992), 156–57.

47 Marsden Hartley

1. Hartley's affection for the Mason boys has been characterized as homoerotic; see Jonathan Weinberg, *Speaking for Vice: Homosexuality in the Art of Charles Demuth, Marsden Hartley, and the First American Avant-Garde* (New Haven: Yale University Press, 1993), 171–93. For a discussion of Hartley in Nova Scotia see Gerald Ferguson, ed., *Marsden Hartley and Nova Scotia* (Halifax: Mount Saint Vincent University Art Gallery, 1987).

2. Marsden Hartley to Adelaide Kuntz, 16 October 1935, Archives of American Art, Smithsonian Institution, Washington, D.C. (hereafter AAA), in *Marsden Hartley and Nova Scotia*, 37.

3. Marsden Hartley, "What Is Sacrament," in Gail R. Scott, ed., *The Collected Poems of Marsden Hartley, 1904–49* (Santa Rosa, Calif.: Black Sparrow Press, 1987), 293. See also "Fishermen's Last Supper" and "Two Drowned at the Gateway," 271, 263.

4. Gerald Ferguson, Introduction, in *Marsden Hartley and Nova Scotia*, 13.

5. Marsden Hartley, *Adventures in the Arts* (1921; New York: Hacker Art Books, 1972), 38–39. See Lorenz Eitner, "The Open Window and the Storm-Tossed Boat: An Essay in the Iconography of Romanticism," *Art Bulletin* 37 (December 1955): 281–90, and Roger E. Stein, *Seascape and the American Imagination* (New York: The Whitney Museum of American Art, and C. N. Potter, 1975).

6. See Gail R. Scott, *Marsden Hartley* (New York: Abbeville, 1988), 95; Weinberg, *Speaking for Vice*, 163–71; and Ferguson, *Marsden Hartley and Nova Scotia*, 154, for discussions of *Eight Bells' Folly* and *Give Us This Day*.

7. Ferguson, 148. A related study is *Off to the Banks* (1936; The Phillips Collection, Washington, D.C.).

8. See Marsden Hartley, "The Six Greatest New England Painters," *Yankee* 3 (August 1937): 14–16, and "On the Subject of Nativeness—a Tribute to Maine," in *Marsden Hartley: Exhibitions of Recent Paintings, 1936* (New York: An American Place, 1937). In his essay "Eakins, Homer, Ryder" (1930), Hartley claimed that Thomas Eakins's art lacked the poetic feeling that was integral to an indigenous expression, a feeling more evident in the work of George Fuller, Homer Dodge Martin, Ralph Blakelock, and George Inness. Hartley, "Eakins, Homer, Ryder," in Gail R. Scott, ed., *On Art* (New York: Horizon Press, 1982), 171–72. As early as 1921 he had labeled Martin, Fuller, and Ryder as originators of an indigenous painting and Eastern in flavor, "essentially of New England." See Hartley, *Adventures in the Arts*, 55. See also Donna M. Cassidy, "On the Subject of Nativeness: Marsden Hartley and New England Regionalism," *Winterthur Portfolio* 29, no. 4 (1994): 227–450.

9. Ryder was the subject of three essays by Hartley: the one cited in n. 8; another published in *The New Caravan* (1936) (*On Art*, 256–67); and "A. P. Ryder: The Light That Never Was," in William Innes Homer and Lloyd Goodrich, *Albert Pinkham Ryder: Painter of Dreams* (New York: Abrams, 1989), 227–29. See also Hartley's poem, "Albert Ryder—Moonlightist," in *Collected Poems*, 224. Photographs of Ryder's *Hunter's Rest*, *Diana's Hunt*, and *Weir's Orchard*, along with Frederic Newlin Price's monograph, are in the Marsden Hartley Memorial Collection, Bates College, Lewiston, Maine. The first Ryder Hartley saw was a seascape; see Marsden Hartley, "Somehow a Past: The Autobiography of Marsden Hartley," ed. Susan Elizabeth Ryan (Cambridge, Mass.: MIT Press, 1995), 67.

10. See Vivian Endicott Barnett, "Marsden Hartley's Return to Maine," *Arts Magazine* 54 (October 1979):

172–76; Haskell, *Marsden Hartley*, 101; and Bruce Robertson, *Reckoning with Winslow Homer: His Late Paintings and their Influence* (Cleveland: The Cleveland Museum of Art in association with Indiana University Press, 1990), 153–64.

11. See Hartley, "The Six Greatest New England Painters," 14–16, and "On the Subject of Nativeness," n.p. Homer was presented as *the* American artist at this time. In 1936 the Whitney Museum of American Art, Knoedler's Galleries, and Macbeth Gallery marked Homer's centennial with exhibitions honoring the artist, and reviews of these shows typically labeled him as a truly indigenous product. See, for example, "Philadelphia Shows Homer the Individualist," *Art Digest* 10 (June 1936): 37.

12. Sea adventure stories also fascinated Hartley at this time, and the following were in his library: Robert Tristan Coffin's *Last of Logan: The True Adventures of Robert Coffin, Mariner, in years 1854–59, wherein His Shipwreck on Rapid Reef, His Life among the Cannibals of Fiji, and His Search for Gold in Australia* (1941) and John Cabbage's *Eight Bells* (1932) and *Time and Tide* (1938). Hartley read Herman Melville's *Billy Budd* in May 1930, and his library contained *The Short Novels of Herman Melville* and Melville's *Journal Up the Straits* (1935 ed.). See Hartley to Rebecca Strand, 10 May 1930, AAA, reel X3, and Hartley Memorial Collection, Bates College.

13. See Barnett, "Hartley's Return to Maine," 172, and Cassidy, "On the Subject of Nativeness," 245, for a discussion of the financial success of the artist's seascapes.

48 John Marin

1. John Marin to Alfred Stieglitz, October 1919; rpt. in Dorothy Norman, ed., *The Selected Writings of John Marin* (New York: Pellegrini and Cudahy, 1949), 51.

2. Carol Troyen, "A War Waged on Paper: Watercolor and Modern Art in America," in *Awash in Color: Homer, Sargent, and the Great American Watercolor* (Boston: Museum of Fine Arts, and Bulfinch Press/Little, Brown and Company, 1993), xxxvi. Marin experimented with watercolor, adopting diverse techniques and tools. Typically, he combined transparent washes with charcoal and opaque pigments, and he applied color with varied unconventional instruments—brush ends, fingers, matchsticks, surgical syringes—onto richly textured handmade paper. See Troyen, "A War Waged on Paper," xliv.

3. For a discussion of Marin's 1919 style see Ruth E. Fine, *John Marin* (Washington, D.C.: National Gallery of Art; New York: Abbeville, 1990), 181, and Sheldon Reich, *John Marin* vol. 1 (Tucson: University of Arizona Press, 1970), 116, 122.

4. Marin to Stieglitz, 15 August 1919, in Norman, *Selected Writings*, 46.

5. Marin considered this balancing act central to composing a picture. For him, the structure of thirds governed the arts: "Which brings us to another great concept of the thirds—which has to do with the above the below the flat—on the face of it that brings us to the thirds—sky earth water—up level below—soft loud—heat tepid cold—little medium big—yellow blue red—

the three dominant chords in music." Undated manuscript, rpt. in Cleve Gray, ed., *John Marin by John Marin* (New York: Holt, Rinehart, and Winston, 1970), 107.

6. Marin spent 1914 in the Small Point area, from 1919 through the 1920s in Stonington-Deer Isle, and in the 1930s until his death in Cape Split.

7. Marin to Stieglitz, 1 August 1915, rpt. in Norman, *Selected Writings*, 20.

8. Marin to Stieglitz, 1917, quoted in Nanette Maciejunes, Introduction, in *Trees as Seen through the Eyes of John Marin and Charles Burchfield* (New York: Kennedy Galleries, 1991), n.p.

9. Marsden Hartley, "Maine Trapper" (c. 1930), 1, Marsden Hartley Archive, Yale Collection of American Literature, Beinecke Rare Book and Manuscript Library, Yale University.

10. Maciejunes, Introduction.

11. Marin to Stieglitz, 15 September 1944, Marsden Hartley Archive. The critic Paul Rosenfeld even compared Marin's nativeness to a tree: "Marin is fast in American life like a tough and fibrous apple tree lodged and rooted in good ground." From *Port of New York* (1924, rpt., Urbana: University of Illinois Press, 1966), 153.

12. Benjamin De Casseres, "The Renaissance of the Irrational," *Camera Work* special number (June 1913): 22. This journal was published by Stieglitz from 1903 to 1917.

13. See Matthew Baigell, "American Landscape and National Identity: The Stieglitz Circle and Emerson," *Art Criticism* 4 (1987): 27–47.

14. Paul Rosenfeld, "The Water-Colours of John Marin," *Vanity Fair* 18 (April 1922): 92, quoted in Troyen, "A War Waged on Paper," 44.

51 Charles Demuth

1. Emily Farnham, *Charles Demuth: Behind a Laughing Mask* (Norman, Okla.: University of Oklahoma Press, 1971), 137.

2. Ibid.

3. Forbes Watson, "Charles Demuth," *Arts* 3, no. 1 (January 1923): 78.

4. Hamilton Easter Field embraced Demuth's "objectivity" and "impersonal approach" to the subjects in his painting. Hamilton Easter Field, "Comment on the Arts," *Arts Magazine* 1 (January 1921): 31

52, 53, 54, 55 Edward Hopper

1. Garnett McCoy, "The Best Things of Their Kind since Homer," *Journal of the Archives of American Art* 7, nos. 3 and 4 (July–October 1967): 12.

2. These four works are recorded in the artist's Record Book, vol. 1, 1926, 64–65, Whitney Museum of American Art, New York. On 30 September 1926, while Hopper was in Gloucester, he sent these four and several other works to Frank Rehn in New York.

3. Gail Levin, *Edward Hopper: An Intimate Biography* (New York: Alfred A. Knopf, 1995), 198.

4. Gail Levin, *Edward Hopper: The Art and the Artist* (New York: W. W. Norton & Co., 1980), 47.

5. Guy Pène du Bois, *Edward Hopper* (New York: Whitney Museum of American Art, c. 1931).

6. Charles Burchfield, "Edward Hopper, Classicist," in *Edward Hopper Retrospective Exhibition* (New York: The Museum of Modern Art, 1933), 16.

56 Marguerite Zorach

1. Roberta K. Tarbell, *Marguerite Zorach: The Early Years, 1908–1920* (Washington, D.C.: National Collection of Fine Arts, Smithsonian Institution, 1973), 26.

2. Zorach saw artifacts and paintings in the home of Hamilton Easter Field during the 1910s, and her dealer, Edith Halpert, also promoted American folk art. Her 1908–12 trip to Europe also defined her art. In Paris, she studied at the informal art school La Palette, where she evolved a decorative style inspired by fauvism and symbolism—a manner reinforced during subsequent trips to the Mideast and India.

3. For illustrations and discussions of these works see Marilyn Friedman Hoffman, *Marguerite and William Zorach: The Cubist Years, 1915–18* (Hanover, N.H.: University Press of New England, 1987), 24 and cover; Tarbell, *Zorach: The Early Years*, 48–50; and Marya Mannes, "The Embroideries of Marguerite Zorach," *International Studio* 95 (March 1930): 32. The family group in this tapestry became a common motif in the work of both Zorachs. See, for example, William Zorach's drawing for a relief panel, *History of California* (1929), and *Memorial to the Pioneer Woman* (1936–37), in Paul S. Wingert, *The Sculpture of William Zorach* (New York and Chicago: Pittman Publishing Company, 1938), pl. 25, and William Zorach, *Art Is My Life* (Cleveland and New York: The World Publishing Company, 1967), fig. 37. The mother and child in *Land and Development of New England* recalls Zorach's sculpture *Mother and Child* (1927–30; The Metropolitan Museum of Art). I am grateful to Dahlov Ipcar for her generous response to my inquiries about this tapestry and her mother's work.

4. Zorach painted her own family in *Farm in the Hills* (1915; Kraushaar Galleries) as primitives in nature— an Americanized version of modernist pastorals like Henri Matisse's *Joie de vivre* (1905–06; Barnes Foundation, Merion, Pennsylvania). She admired Matisse during her student days in Paris and often used nudes in the landscape to evoke this image, as in *Adam and Eve* (1920; Museum of Fine Arts, Boston).

5. Two adult female figures also appear in *The Family of Ralph Jonas*. Here, there is a family group (father, mother, two children) and another woman. The central female holding the child is clothed, the other (along with the standing male figure) is nude. In this tapestry, two relationships are created—mother/ father/two children versus male and female nudes. The latter two evoke images of Adam and Eve in the garden, which Zorach uses to present an image of New England and the New England family as primitives in an arcadian paradise. While Marguerite Zorach rarely used allegorical figures in her work, such figures were common in 1930s art, especially public murals and sculpture. William Zorach worked

with this classically-derived language in *Spirit of the Dance* (1932; Radio City Music Hall, New York), *Builders of the Future* (1939; New York World's Fair), and *Untitled Allegorical Panels* (1930; Portland Museum of Art, Maine). The Zorach family have always considered this female figure a representation of an adolescent daughter in the family group, perhaps a "free wheeling spirit of youth." Letter from Dahlov Ipcar to the author, 23 September 1994.

6. Reviewers characterized Zorach as a "descendant of whaling captains and pioneers" and a "descendant of a long line of New England mariners." See Mannes, "The Embroideries of Marguerite Zorach," 29, and "Vanishing Americans," *Art Digest* 9 (November 1, 1934): 32. Zorach's house in Robinhood Cove was coincidentally a sea captain's house—a kind of ancestral home for Zorach whose ancestors were mariners.

7. "Vanishing Americans," 32.

8. Marlene Park and Gerald E. Markowitz, *Democratic Vistas: Post Offices and Public Art in the New Deal* (Philadelphia: Temple University Press, 1984), 29.

9. Dahlov Ipcar wrote about this work: "This was not done as a public works project. My mother did complete a mural project for the Public Works Authority a year or so before: two large panels for a courthouse in Fresno California. Unfortunately, these were never hung, as the judges objected to my mother's 'modern' style (the subject was agriculture; raisin growing and orchards etc.). These two panels have since been lost; we hope they have not been destroyed, but do not know what happened to them. I think she enjoyed working in the large mural scale, and just decided to do a large work for her own satisfaction." Letter to Farnsworth Art Museum, 24 May 1991. Zorach did at least three other murals: *New Hampshire Post in Winter* (1938) for the Peterborough, N.H., post office; *Hay Making* (1942) in Monticello, Ind.; and *Autumn* (1940) in Ripley, Tenn. See Barbara Melosh, *Engendering Culture: Manhood and Womanhood in New Deal Public Art and Theater* (Washington, D.C.: Smithsonian Institution Press, 1991), 241, 247, 257.

10. For a discussion of the Maine economy in the 1930s, see C. Stewart Doty, *Acadian Hard Times: The Farm Security Administration in Maine's St. John Valley, 1940–43* (Orono: University of Maine Press, 1991), 38–44.

11. Melosh, *Engendering Culture*, 53

12. Ibid., 1–3, for a discussion of gender ideology in the 1930s.

13. Thomas Hart Benton, "Interview," *New York Sun*, 12 April 1935; rpt. in Matthew Baigell, ed., *Thomas Hart Benton Miscellany* (Lawrence: University Press of Kansas, 1971), 78.

57 William Zorach

1. Carol Troyen, "A War Raged on Paper: Watercolor and Modern Art in America," in *Awash in Color: Homer, Sargent, and the Great American Watercolor* (Boston: Museum of Fine Arts, and Bulfinch Press/ Little, Brown and Company, 1993), xxxvi– xxxvii. Stieglitz's 291 hosted numerous exhibitions of watercolors by emerging modernists; see William Innes

Homer, *Alfred Stieglitz and the American Avant-Garde* (Boston: New York Graphic Society, 1977), 297–98.

2. On Zorach's watercolor style see John I. H. Baur, *William Zorach* (New York: Whitney Museum of American Art and Praeger, 1959), 14–18. Zorach's 1919 watercolors, done in Stonington, Maine, were indebted to John Marin's work; see Donelson Hoopes, *William Zorach: Paintings, Watercolors, and Drawings, 1911–1922* (Brooklyn: The Brooklyn Museum, 1968), 13. For more on Zorach's watercolor technique see Baur, 30, and Roberta K. Tarbell, *William and Marguerite Zorach: The Maine Years* (Rockland, Maine: Farnsworth Art Museum, 1980), 41.

3. William Zorach, *Art Is My Life: The Autobiography of William Zorach* (Cleveland and New York: The World Publishing Company, 1967), 59.

4. Ibid., 193.

5. Like earlier American painters, Zorach found the New England autumn visually exciting: "There is the glory of the Maine autumn with cerise laid over vermilion on the maples, and pale yellows under chartreuse, and the rich heavy reds, oranges, and purples of oaks becoming a wall of blackness in the deepening evening. The long beautiful black shadows reach across the green meadow from the woods even before the fall sun has reached its zenith and is slipping behind the tall pines and below them the lavenders of alders. Red apples cling to the leafless branches through ice and snow. I stand at the window looking out into the cold, set up my watercolors, and paint the apple tree." Ibid., 192.

6. See Baur, *William Zorach*, 14, and Theodore E. Stebbins, Jr., "The Memory and the Present: Romantic American Painting in the Lane Collection," in Theodore E. Stebbins, Jr., and Carol Troyen, *The Lane Collection: 20th–Century Paintings in the American Tradition* (Boston: Museum Fine Arts, 1983), 11–33.

7. Tessim Zorach notes in a letter to the Farnsworth Art Museum, 25 October 1980: "The two watercolors by my father were painted in the late twenties or early thirties. The one with the horses is a fall scene looking down the hill from Dahlov's and the other is a fall scene of Robinhood Cove." The accession record notes, "When received in 1980 FAM was told title was *Fall, Robinhood Cove*. And, on a 1988 conservation survey, the watercolor is noted as *Autumnal Meadows*."

8. Zorach, *Art Is My Life*, 192. He also wrote: "There is very little to distract me in Maine, except mosquitoes. The air is delicious, the rocks and sea a pleasure. There are exciting days out of the northeast and the sea is like indigo laced with white. The landscape is crisp and deep and edged with black pines and golden cedars. There are also the wild days when the whole world is in turmoil. . . . I can paint watercolors of the world in front of our house and they are always new and exciting. The scene is inexhaustible." Ibid., 191–92.

58 Allen Erskine Philbrick

1. Richard H. Condon, Joel W. Eastman, and Lawrence C. Allin, "Maine in Depression and War, 1929–1945," in Richard W. Judd, Edwin A. Churchill, Joel W. Eastman, eds., *Maine: The Pine Tree State from*

Prehistory to the Present (Orono, Maine: University of Maine Press, 1995), 516.

59, 59a Andrew Winter

1. Robert Thayer Sterling, *Lighthouses of the Maine Coast and the Men Who Keep Them* (Brattleboro, Vt.: Stephen Daye Press, 1935), 138–41.

2. Biographical information on Andrew Winter comes from the artist's file at the Farnsworth Museum, which held a retrospective exhibition of his work in 1982; see also Davis Thomas, "Wintering Over on Monhegan," *Down East*, February 1982, 38–39, 43.

3. *Philadelphia Ledger*, 2 February 1937, from the artist's file at the library of the Pennsylvania Academy of the Fine Arts. The artist's papers are held by the Archives of American Art at the Smithsonian Institution in Washington, D.C.

61 Henriette Wyeth (Hurd)

1. Paul Horgan, *Henriette Wyeth* (Chadds Ford, Pa.: Brandywine River Museum, 1980), 24.

2. As a result of her disability, Henriette learned to draw with her left hand but continued to paint with her right hand.

3. Paul Horgan, *Henriette Wyeth*, 41.

4. Another of Henriette Wyeth's "fantasy" paintings, recently rediscovered at the Westtown School, Westtown, Pennsylvania, is reproduced on the cover of *Rooted in Spirit*, ed. Alice B. Skinner (West Chester, Pa.: Chrysalis Books, 1999). Chrysalis Books is an imprint of the Swedenborg Foundation, Inc., and *Rooted in Spirit* is a collection of essays linking women's spirituality to the Swedenborg faith.

5. Quoted in Farnsworth Art Museum press release announcing the acquisition of *Death and the Child*, 24 December 1991.

62, 62a, 63, 64 Newell Convers Wyeth

1. Robert Hughes, *American Visions: The Epic Vision of Art in America* (New York: Alfred A. Knopf, 1997), 313.

2. N. C. Wyeth, in *The Wyeths: The Letters of N. C. Wyeth, 1901–1945*, ed. Betsy James Wyeth (Boston: Gambit, 1971), 802, letter no. 626, June 1940.

3. For a comprehensive analysis of N.C.'s profound identification with the theme of "home," see David Michaelis's *N.C. Wyeth: A Biography* (New York: Alfred A. Knopf, 1998). Wyeth's illustration *Blind Pew* for Scribner's edition of *Treasure Island* features the Needham homestead substituting for the Ben Bow Inn, which Michaelis interprets as grounding the entire series of illustrations as a semi-autobiographical narrative of the artist's owning venturing forth into the world and his own deep-seated feelings of loss and separation.

4. In a 1907 letter to his mother, N.C. wrote: "It has been absolutely evident to me in the past six months of the uselessness of clinging to illustration and hoping to make it great art. 'It is a stepping stone to painting,' so says Mr. Pyle—but I am convinced that it is a stepping stone backwards as well, which will in time leave

you in that most unsatisfactory position of 'a good illustrator, but he had not done his best work.'" *The Wyeths: Letters of N. C. Wyeth*, 211, quoted in James Duff, *Not for Publication: Landscapes, Still Lifes, and Portraits by N.C. Wyeth* (Chadds Ford, Pa.: Brandywine River Museum, 1982), 15. Changing attitudes regarding the status of illustration are indicated by the Guggenheim Museum's decision to present a retrospective exhibition of the work of Norman Rockwell in 2000.

65 Andrew Newell Wyeth

1. An exhibition of twenty-three watercolors at the Macbeth Gallery, 19 October–1 November 1937. Macbeth was among the first New York galleries to feature contemporary American art and represented such artists as Edward Hopper, Charles Burchfield, and Reginald Marsh. Earlier in the century Macbeth showed the Ashcan School painters including John Sloan, George Luks, and others in the controversial exhibition of The Eight in 1908.

2. Hurd introduced both Andrew and N.C. to tempera in 1937. Although N.C. also experimented with tempera during 1930s and 1940s, he apparently never felt comfortable with the medium, perhaps because it was ill suited to N.C.'s impatient temperament and the time-sensitive demands of commercial illustration.

3. Richard Meryman, *Andrew Wyeth: First Impressions* (New York: Harry N. Abrams, Inc., 1991), 78.

4. Wanda M. Corn, "Andrew Wyeth: The Man, His Art and His Audience," Ph.D. diss., Institute of Fine Arts, New York University, 1974, 92–94.

5. "Wyeth Donates Key Tempera Work To Farnsworth Art Museum," *Courier Gazette* (Rockland), 2 March 1995.

66, 67 Andrew Newell Wyeth

1. Merle James, an accomplished artist in his own right, and rotogravure editor of the *Buffalo News,* owned a farm on Broad Cove, a few miles from the Olson farm on Pleasant Point, where the family spent each summer. Betsy's father had become acquainted with N. C. Wyeth and N. C. had suggested to his son, that given their mutual interest in watercolors, Andrew might look up Mr. James. When Wyeth appeared at the Jameses' home, he was greeted by seventeen-year-old Betsy, who suggested they visit the Olsons.

2. Betsy James Wyeth, *Christina's World* (Boston: Houghton Mifflin Co., 1982), 153.

3. The other is titled *End of Olsons,* 1969, which is a view from the third-floor window, over the kitchen and shed and toward the cove where Alvaro had kept his fish weir.

4. Thomas Hoving, *Andrew Wyeth Retrospective* (Nagoya: Aichi Arts Center, 1995), 241. This exhibition traveled to museums in Japan and the Nelson-Atkins Museum of Art in Kansas City.

68 Andrew Newell Wyeth

1. Richard Meryman, *Andrew Wyeth* (Boston: Houghton Mifflin Company, 1968), 120.

2. Ibid. The seashells were gathered by Betsy Wyeth near Winslow Homer's studio in Prout's Neck.

3. Museum archives, press release announcing the acquisition of *Her Room*, 1964.

4. Adam Weinberg and Beth Venn interview with the artist, 18 December 1997, quoted in *Unknown Terrain: The Landscapes of Andrew Wyeth* (New York: Whitney Museum of American Art, 1998), 42.

5. *Her Room* perhaps marks Wyeth's high-water mark in terms of critical acceptance and popular recognition. Painted in 1963, the same year Wyeth was featured on the cover of *Time* magazine, the painting was noted in *Life* magazine in 1964 as attaining the highest price ever paid by a museum for a work by a living American artist. A few years later, his 1967 retrospective exhibition at the Whitney Museum of American Art broke all previous attendance records but also signaled an increasingly hostile critical press. Wyeth was dismissed by critics who were seemingly disenchanted with his mass appeal and a perceived willful disregard for mainstream art trends. Today this stance is increasingly challenged not only by critics but also by younger art historians who see Wyeth as extending, in a contemporary context, the continuum of American realism with his psychologically nuanced painting of the postwar period.

69, 69a, 70, 71 James Browning Wyeth

1. Wyeth is very knowledgeable about contemporary art, and during the 1970s was closely involved with the New York art scene through his friendship with Lincoln Kirstein, Rudolf Nureyev, and Andy Warhol, among others (even painting his own "celebrity" portraits at Warhol's Factory).

2. On Monhegan Island, as is the case with other Maine islands, children are educated in small one-room schools, usually through eighth grade, at which time they must leave their homes to enter high school in one of the state's several private/public boarding schools.

72, 72a Walt Kuhn

1. Bennard B. Perlman, "The World of Walt Kuhn," in *Walt Kuhn, 1877–1949* (New York: Midtown Galleries, 1989), 11. Perlman notes that Van Gogh, Cézanne, cubism, fauvism, and expressionism were the principal influences on Kuhn's art resulting from his involvement with the Armory Show.

2. Walt Kuhn, *The Story of the Armory Show* (Portland, Maine: Barridoff Galleries; New York: Salander-O'Reilly Galleries, Inc., 1984). In this personal account Kuhn talks of the galvanizing effect this landmark exhibition of contemporary American and European artists had on the American art world, introducing the American public for the first time to the work of impressionist, post-impressionist, cubist, fauve, and futurist painters and sculptors.

3. Philip Rhys Adams, *Walt Kuhn: His Life and Work* (Columbus: Ohio State University Press, 1978), 18, states that this was Kuhn's first work to be exhibited and sold in New York. "*Nocturnal Landscape* (number 2) is a small oil panel showing a team of horses

heading toward their barn; its colors are the Munich 'mud' he deplored in 1912. Of course by then he was a full-blown impressionist, and the color has been more kindly called 'brown sauce' in the case of Frank Duveneck and other Munich-trained painters."

4. Ibid., 9. Adams states that for Kuhn drawing was one of the most important elements in making art. As early as 1899, before he had any formal art training, Kuhn had traveled to California, where he was able to secure a position drawing cartoons for the *San Francisco Wasp*. Adams states that from 1905, to strengthen his drawing, Kuhn began a regimen of life drawing at the Artist's Sketch Class, ultimately turning out over three thousand life studies, of which only a handful remain.

5. Ibid., 35.

6. Recalled by Brenda Kuhn in an interview for an article written by Sherry Miller, "Walt Kuhn and the Resurgence of a Reputation," *Maine Sunday Telegram*, 1 February 1987, 38A.

7. Adams, *Kuhn: His Life and Work*, 82, states, "After the critical and financial success of his show at the de Zayas Gallery, Walt Kuhn bought a cottage at 18 Stearns Road in Ogunquit. It was to be a fixed summer base for his family and his summer painting until 1948. . . . He was not pinned down to it however, and often went instead to the Berkshires or the West for fresh landscape ideas, or to Europe, twice, with his family."

8. Lawrence B. Salander, *Walt Kuhn (1877–1949): The Landscapes* (New York: Salander-O'Reilly Galleries, Inc., 1987). In the introductory essay of this exhibition catalogue, Salander remarks on the similarities between the works of Hartley and Kuhn and the parallel achievements of their careers. "The similarity between Kuhn's landscapes and the work being made by Hartley in Dogtown, New Hampshire is astounding. Both artists' work from that point on, was direct and physical. The works of both artists were often set up the same way, as exemplified by the comparison of Kuhn's *A Stream in the Woods, Waterfall*, 1935 (cat. no. 9), and Hartley's *Kinsman Falls*, 1930 (fig. 15)."

9. Quoted in Sherry Miller, "Walt Kuhn and the Resurgence of a Reputation," 38A.

73, 73a Raphael Soyer

1. Raphael Soyer, "Resume of an Aged Artist," *Art & Antiques*, January 1988, 104–06. Soyer talks at length of his friendships and associations with the artists of his time. He mentions Hopper, Evergood, Marsh, Guy Pène du Bois, Arshile Gorky, Levine, Joseph Stella, Henry Varnum Poor, Nicolai Cikovsky, Leonard Baskin, and many others including the leaders of the abstract expressionist movement, Jackson Pollock and Willem de Kooning.

2. As early as the late 1920s, Soyer began to travel widely, either to Europe or to various locations in New England. Lloyd Goodrich, *Raphael Soyer* (New York: Harry N. Abrams, Inc., 1972), 336.

3. Ibid. Rembrandt was one of Soyer's chief sources of inspiration. He made many trips to the Netherlands to study the works of the master.

4. Raphael Soyer, *Diary of an Artist: Raphael Soyer* (Washington D.C.: New Republic Books, 1977), 135.

5. Ibid.

6. Ibid., 135–36.

7. *Raphael Soyer: A Return to Maine* (Rockland, Maine: Farnsworth Art Museum, 1986). In his statement in this exhibition brochure, Soyer says, "If art survives at all, I am certain that realism will outlast all the other isms. . . . Great realism consists of many elements—the abstract, the physical, the literary, the metaphysical, the psychological."

8. "Resume of an Aged Artist," 106. Soyer states that years later the painter James Brooks told him that Pollock remembered the incident and confessed, "I met Soyer and berated him for his realism. I should not have been so rude." Soyer commented, "Apparently there was a sensitivity to this hard-drinking, vomiting-in-public man."

74 Carl Sprinchorn

1. Sprinchorn was born in 1887 in Broby, Sweden. He came to the United States in 1903 at the age of fifteen to study art with Robert Henri at the New York School of Art. After several years of formal art training and working as manager of Henri's school, Sprinchorn lived primarily in New York, but, over the years, traveled extensively—to Puerto Rico, the Dominican Republic, California, back to Sweden. In 1952, after thirteen years in the Maine north woods, he was forced to return to New York as the result of a serious illness. Eventually he moved to Selkirk, near Albany, New York, where family could care for him after a succession of strokes. He died there in 1971.

2. The painting is not actually dated. The date of 1948 is based on its similarity to two related paintings discussed below.

3. I am indebted to the artist Chris Huntington who initiated and arranged for a series of interviews in May 1995 with people who knew Carl Sprinchorn. He invited me to join in the interview process and generously made time to escort me to sites around Shin Pond and Patten, where Sprinchorn lived and worked. Vincent Hartgen, former director of the University of Maine Museum, told us that when he first began to work at the museum in 1945, he used to see a man in the gallery about once a month, looking intently at the work. It turned out to be Caleb Scribner, game warden by profession, lover of art and painter by avocation. It was a year or so later that Hartgen learned of Sprinchorn's presence in the Patten-Shin Pond area and his friendship with Scribner. It was only after Sprinchorn left Maine, however, that Hartgen organized exhibitions of Sprinchorn's work in the university museum, one in 1954 and another in 1972.

4. Listed as an oil on canvas, 29¼ x 24¼ in the collection of Mr. and Mrs. Gregory J. Domareki in *On the Edge: Forty Years of Maine Painting 1952–1992* (Rockport, Maine: Maine Coast Artists Gallery, 1992), 52.

5. Exhibited, but not reproduced as an oil on canvas, 21 x 29 in the collection of the artist in *100 Years of Maine Painting* (Waterville, Maine: Colby College Art Museum, 1964).

6. Present whereabouts and other information about *Lumber Camps and Pulp Wood, Trout Brook* are unknown. It is reproduced in an article by Edmund Ware, "Spring Drive" published in *Ford Times*, 1949. In the Sprinchorn archives in the Special Collections of the Folger Library at the University of Maine (hereafter UMO), Sprinchorn's copy of this article contains a notation, "April Showers," in his handwriting next to the printed title *Lumber Camps and Pulp Wood, Trout Brook*.

7. According to Hadley Coolong, Baxter Park ranger, the different logging companies would clear trees on the edge of the rivers to build camp housing and to create hayfields to feed the horses. Logging had dwindled somewhat by the time Sprinchorn was there in the 1940s, although some lumber camps remained in operation; other sites consisted only of the remnants of field clearings, since the old buildings, as fire hazards, had been torn down. Sprinchorn owned numerous old photographs of lumbermen and their logging camps, some of which he donated to the Lumber-man's Museum in Patten; others are in the Sprinchorn Archives, UMO.

8. Autobiographical notes, UMO.

9. "Two Apples and Twenty-two," typescript essay from 1947, UMO.

75 Louise Nevelson

1. Robert Hughes, "Tsarina of Total Immersion," *Time*, 16 June 1980, 76.

2. Harold Weston, New York, to Wendall Hadlock, Rockland, Maine, 22 April 1954, unpublished letter, Farnsworth Art Museum collection files.

3. Nevelson's actual date of birth is unclear; later in life she chose 23 September 1899; for further discussion of Nevelson's family history and immigration to America, see Laurie Lisle, *Nevelson: A Passionate Life* (New York: Summit Books, 1990), 13–22.

4. Diana MacKown, *Dawns + Dusks: Louise Nevelson, Taped Conversations with Diana MacKown* (New York: Charles Scribner's Sons, 1976), 14.

5. "A mid-70s interview in the *Bangor Daily News* with the illustrious artist bore the screamer headline, 'Nevelson Hates Rockland.'" Jan Ernst Adlmann, *THE magazine*, September 1994, 23.

6. The use of stars appears in a number of Nevelson's sculptures and painted self-portraits from the 1940s, for example, *Woman with a Red Scarf*, c. 1947, in the Farnsworth collection.

7. Laurie Wilson, "Louise Nevelson, Iconography and Sources," Ph.D. dissertation, City University of New York, 1978, 167.

8. Lisle, *Nevelson: A Passionate Life*, 76–78.

9. Louise Nevelson, "Nevelson on Nevelson," *ARTnews*, November 1972, 68.

76, 76a Louise Nevelson

1. Her mother Minna "Annie" Berliawsky, died in March 1943; her father, Isaac Berliawsky, in October 1946; and her dealer and close friend Karl Nierendorf, in October 1947.

2. Nevelson's first exhibition at the highly regarded Nierendorf Gallery was held in September 1941; it was the first one-person show devoted to an American artist at the gallery, which was known for showing such contemporary European masters as Picasso, Braque, and Paul Klee. For the next six years, until Karl Nierendorf's death, Nevelson exhibited regularly at the gallery. Laurie Lisle, *Louise Nevelson: A Passionate Life* (New York: Summit Books, 1990), 132–58.

3. The Farnsworth collection includes a number of paintings from this period; one of the most thickly modeled is *Figure in a Blue Shirt*, 1952, in which the painted topknot of hair projects nearly an inch from the canvas.

4. Quoted in Carol Diehl, "Breaking the Rules," *Arts & Antiques*, April 1988, 74.

5. Quoted in Lisle, *Nevelson: A Passionate Life*, 105.

6. For example, *Four Figures*, pen and ink on paper, c. 1930, and *Female Figure*, carved wood, c. 1937, both in the Farnsworth collection. For discussion of totemic form in Nevelson's art, see Laurie Wilson, "Louise Nevelson, Iconography and Sources," Ph.D. diss., City University of New York, 1978, 196–203.

7. Ibid., 55.

8. Quoted in Una Johnson, *Louise Nevelson: Prints and Drawings, 1953–1966* (New York: The Brooklyn Museum, 1967), 9.

9. Among the most notable works is a series of intaglio prints produced between 1953 and 1955 at the highly regarded print workshop Atelier 17; a selection of these prints was included in Nevelson's critically acclaimed exhibition, *Ancient Games in Ancient Places* at Graham Central Moderns in 1956.

10. *Bronze Bird* is one of three sculptures by Nevelson recommended in 1954 to the Farnsworth Museum by the Federation of Modern Painters and Sculptors for acquisition through its gift program; the others were *Mountain Woman*, aluminum, *and Lady by the Sea*, bronze. Nevelson wrote that the acceptance of *Bronze Bird* by the museum "gives me great pleasure." Letters to Wendell Hadlock, director, FAM, from Harold Weston, president, Federation of Modern Painters and Sculptors, Inc., 22 April and 10 May 1954, and Louise Nevelson, 16 September 1954, Farnsworth Art Museum collection files.

11. Tattistone was developed by Alexander Tatti, a sculptor with whom Nevelson became friendly through a WPA-supported sculpture workshop on 39th Street run by Louis Basky. For further discussion, see Wilson, "Nevelson: Iconography and Sources," 73, and Lisle, *Nevelson: A Passionate Life*, 110–11.

77, 77a Louise Nevelson

1. Hilton Kramer, "The Sculpture of Louise Nevelson," *Arts* (June 1958): 26–29, as cited in Laurie Lisle, *Louise Nevelson: A Passionate Life* (New York: Summit Books, 1990), 211.

2. Dorothy C. Miller, introduction to *Louise Nevelson* (Rockland, Maine: Farnsworth Art Museum, 1979), 7–8.

3. Ibid., 8.

4. Diana MacKown, *Dawns + Dusks: Louise Nevelson, Taped Conversations with Diana MacKown* (New York: Charles Scribner's Sons, 1976), 138.

5. For further discussion of *Dawn's Wedding Feast*, see MacKown.

6. Other components of *Dawn's Wedding Feast* are in the collections of the Whitney Museum of American Art, the Museum of Modern Art, and the Vassar College Art Gallery.

7. A letter in the FAM collection files outlines the changes made to the piece since it was first exhibited in 1959: "What is now the bottom section should be the top portion. The top should be the bottom, but must be turned upside down. In addition, the two pieces were not bolted together on the same plane; the top was set diagonally on the bottom section." Marius Peladeau, director, FAM, to Richard Marshall, Whitney Museum of American Art, 19 February 1980.

8. In an interview with Jan Adlmann in May 1979, Nevelson observed: "You know, black is for me the shadow of the universe, white its reflection. Gold, now, represents the sun, the moon, and the stars. So, I identify closely with the elements that are so important in nature. And black, white, and gold are really not *colors, but elements.*" *Louise Nevelson*, Farnsworth Art Museum, 21 n. 2.

9. Willy Eisenhart, *The Art of Nevelson at the Farnsworth* (Rockland, Maine: Farnsworth Art Museum, 1985), n.p.

10. Ibid. Eisenhart went on to say, "This will not be the first time she has surprised people by changing a piece as perfection, that the human mind continues to open toward its full potential."

11. For discussion of the school and Kiesler's influence on Nevelson's art, see Laurie Wilson, "Louise Nevelson, Iconography and Sources," Ph.D. diss., City University of New York, 1978, 129–36.

78 Milton Avery

1. Barbara Haskell, *Milton Avery* (New York: Whitney Museum of American Art and Harper & Row, Publishers, 1982), 73ff.

2. Ibid., 156.

3. Robert Hughes, *American Visions: The Epic History of Art in America* (New York: Alfred A. Knopf, 1997), 488.

4. Robert Hobbs, *Milton Avery* (New York: Hudson Hills Press, 1990), 172–73.

79 William Kienbusch

1. In the summers of 1940–42, Kienbusch painted at Stonington, Maine; after military service during World War II he spent most of his summers at Trevett, Maine, while maintaining a winter studio in New York City. In 1962 he bought a house on Great Cranberry Island that became his summer residence and studio until his death.

2. "I spent that summer [1946] in Trevett, Maine . . . [and] painted . . . a good fifteen caseins and felt that for the first time I was beginning to paint in my own style." Quoted in John R. Wiggins, "William Kienbusch Assumes The Mantle Of 'Maine' Artist," in *The Ellsworth American*, 5 April 1967.

3. Graduated in 1936, with magna cum laude honors in art history. His senior thesis was "American Painting of the Seventeenth, Eighteenth, and Nineteenth Centuries."

4. The Armory Show, formally known as the International Exhibition of Modern Art, was seen in New York City in February and March 1913. It brought together some 1,300 paintings and sculptures by 306 European and American artists, many of whom represented the most avant-garde tendencies of the day. Davis, Hartley, and Marin were all well represented in this exhibition, which is regarded as a crucial dividing line between traditional nineteenth-century modes of American art and the ensuing engagement with modernist styles early in the twentieth century.

5. Harold Rosenberg, "The American Painter," *Art News* 51, no. 8 (December 1952): 23.

6. Quoted in John Yau, introduction to *William Kienbusch* (Waterville, Maine: Colby College, 1981), 11.

7. *Sea Gate and Goldenrod* was among the thirty-two paintings in the memorial exhibition honoring William Kienbusch (New York: Kraushaar Galleries, 1983).

80, 80a Fairfield Porter

1. *The Harbor-Great Spruce Head*, 1974, collection Andre Nasser, New York, as noted in the exhibition catalogue William C. Agee with Malama Maron-Bersin, Michele White, and Peter Blank, *Fairfield Porter: An American Painter* (Southampton, N.Y.: The Parrish Art Museum, 1993), 94.

2. For additional information on Porter's Hirschl and Adler exhibition and retrospective at the Heckscher Museum, the Queens Museum, and the Montclair Museum, see John T. Spike, *Fairfield Porter: An American Classic* (New York: Harry N. Abrams, 1992), 249–61.

3. Ibid., 225.

4. Fairfield Porter Papers, (1997 addition) Sketchbook, Box 5, Notebook 5, 14th unnumbered page, pencil on paper, 11 x 14 in., Archives of American Art, Smithsonian Institution (New York Branch), Washington, D.C. Another sketch, *The Harbor-Great Spruce Head Island*, c. 1974, is illustration no. 139 found in John Ashbery and Kenworth Moffett, *Fairfield Porter Realist Painter in an Age of Abstraction* (Boston: Museum of Fine Arts, 1982), 82.

5. Fairfield Porter Papers, (1997 addition), Sketchbook, Box 6, 11th unnumbered page, pencil on paper, 11 x 14 in., Archives of American Art, Smithsonian Institution (New York Branch), Washington D.C. A related sketch is illustrated in Spike, *Fairfield Porter*, 263.

6. Ibid., 224.

7. Ted Leigh, ed., *The Selected Letters of Fairfield Porter* (Ann Arbor: University of Michigan Press, forthcoming), noted as Leigh 276, 277. I would like to

acknowledge Ted Leigh and thank him for sharing several letters from the unpublished manuscript. He notes that the letter to David and Lindsay Shapiro dated 25 July is certainly from 1972.

8. *Fairfield Porter's Maine* (Southampton, N.Y.: The Parrish Art Museum, 1977), 4.

81 Lois Dodd

1. Lois Dodd, telephone conversation with author, Belfast, Maine, 25 January 1999.

2. Ibid.

3. Harry I. Naar, "A Conversation with Lois Dodd," in *Lois Dodd: Paintings—Views of Windows and Doors* (Lawrenceville, N. J.: Rider College Gallery, 1992), n.p.

4. Lois Dodd, interview by Joe Giordano, in *Bench Press Series on Art: Interviews with Contemporary Writers and Artists,* ed. Madeleine Keller (New York: Bench Press, 1985), 35.

5. Hilton Kramer, "Lois Dodd Is a Wonder; P.S.: I'm Still Rude," *New York Observer,* 11 March 1996, 19.

6. Naar, "A Conversation with Lois Dodd."

7. Mona Hadler, "Lois Dodd: An American Abstract Realist Reconsidered," in *Lois Dodd: Twenty-five Years of Painting* (Rockland, Maine: Farnsworth Art Museum, 1996), n.p.

8. Lawrence Campbell, "Some Notes on the Paintings of Lois Dodd, Theophil Groell, Samuel Gelber," in *Dodd-Groell-Gelber* (New York: Green Mountain Gallery, 1975), frontispiece.

9. Milton W. Brown, *Lois Dodd: Selected Paintings, 1969–1979* (Addison, Maine: Cape Split Place, 1979), n.p.

82 Beverly Hallam

1. Hallam received free samples of the material, then used in highway construction, from the Borden Milk Company in Leominster, Massachusetts, in exchange for reports on how it functioned as a binding medium for pigment.

2. In 1997 the Farnsworth Museum curator, Susan Larsen, organized the exhibition *Beverly Hallam: Forty Years of Flowers.*

3. Carl Little, *Beverly Hallam: An Odyssey in Art* (Washington, D.C.: Whalesback Books, 1998), 78. Hallam, unlike many of those associated with photorealism, is a skilled photographer. Her original intention, before settling on painting, was to pursue photography as an artistic career.

4. Photocopy of handwritten journal by Beverly Hallam. The artist considers the initial photograph to be the final conception of her work, thus the date of this painting is 24 August 1985.

83 Will Barnet

1. The dense, heavily worked, and atmospheric figure studies for Seurat's masterpiece, *La Grande Jatte* (1886, The Art Institute of Chicago), may be an important, direct source of inspiration. Barnet had direct access to two major studies housed in a private New York collection belonging to a couple who are among Barnet's closest friends.

2. Quoted in Robert Doty, *Will Barnet* (New York: Harry N. Abrams, 1984), 53.

3. Ibid., 10.

4. Ibid., 111.

5. Ibid., 111–16.

84 Neil Welliver

1. Mark Strand, introduction to *Neil Welliver: Recent Paintings* (New York: Marlborough Gallery, 1983), 3.

2. Mark Strand provides the most direct and succinct appraisal of Welliver's painting: "I believe Neil Welliver is simply the best landscape painter in America, and the best one there has ever been," quoted in *Maine View: Twenty Years of Landscape Paintings by Neil Welliver* (Gainesville, Ga.: Brenau University, 1996), 5.

3. For the technical processes, biographical information, and, to an extent, my interpretive analysis of Welliver's work, I am deeply indebted to Edgar Allen Beem's essay, "The Landscape of Loss," *Boston Globe Magazine,* 19 March 1995, 30ff.

4. *Maine View,* 10.

Index

List of Artists